ABOUT THE AUTHOR

Richard Power Sayeed is a writer and documentary maker based in London. This is his first book, and he has somehow managed to finish it without losing his love for the minutiae of nineties Britain.

1997

THE FUTURE THAT NEVER HAPPENED

Richard Power Sayeed

ZED

1997: The Future that Never Happened was first published in 2017 by Zed Books Ltd, The Foundry, 17 Oval Way, London SE11 5RR, UK.

www.zedbooks.net

Typeset in Haarlemmer by seagulls.net
Cover design by Alice Marwick
Cover photo © Rebecca Naden/PA Images

A catalogue record for this book is available from the British Library

ISBN 978-1-78699-198-0 hb
ISBN 978-1-78699-199-7 pb
ISBN 978-1-78699-200-0 pdf
ISBN 978-1-78699-201-7 epub
ISBN 978-1-78699-202-4 mobi

CONTENTS

ACKNOWLEDGEMENTS

Thank you to Ed, for being critic, best friend and brother combined; to Kim, for her excellent eye, for shaping all this into something publishable and for much more besides; and to Željka, because she told me, four years ago, that I should actually write this thing.

I am also deeply grateful for the assistance of the late Doreen Massey, as well as that of Anna, Annie, Chris, Daniel, Dmitriy, Ellie Mae, Florence, Huw, Jo, Joe, Jonathan, Jordan, Julien, Julika, Lars, Leo, Lewis, Nic, Pete, Rosa, Satiyesh, Serena, Tisha, Tom H and the staff of the British Library – the librarians, certainly, but also the catering subcontractors who gave me free cups of tea.

INTRODUCTION: YOU SAY YOU WANT A REVOLUTION

Noel Gallagher was celebrating Labour's election victory with his girlfriend, Meg Matthews, at their home in the fashionable north London suburb of Primrose Hill. He would recall how, that night in May 1997, 'It was all champagne, brandy and cigars round our house … Meg and me got pissed and went out into the garden and played *Revolution* dead loud.'[1]

The Beatles song that they chose had been written in the midst of worldwide protests and strikes, the 'events' of 1968. When many of John Lennon's generation had been sacrificing their safety and reputations in the hope of building a better world, this icon of 1960s pop counterculture had responded by singing 'you can count me out'. His lyrics had decried revolutionary 'destruction' and 'hate', but also dismissed changing 'the institution' or, indeed, 'the constitution'. His proposal was different and more focused on the self: 'You better free your mind instead'. As the Beatles track rang out from Matthews and Gallagher's hi fi, Lennon's words

mocking the utopian dreams of the sixty-eighters, Tony Blair was being driven from his parliamentary constituency in County Durham to London, where he would begin implementing a new kind of Labour politics, one that prized individual aspiration over class struggle.

On the other side of town, three intellectual luminaries of the British left were sitting on the sofa watching Blair's party triumph. Doreen Massey, Stuart Hall and Martin Jacques had spent much of the previous two decades describing and analysing the immense human cost of Thatcherism, Majorism, the new right – neoliberalism, they called it. They were, respectively, a feminist geographer brought up on a Manchester council estate, a cultural theorist who had come to the UK from Jamaica in 1951, and a senior journalist with a rather more comfortable background. They reflected the diverse, often fragmented, aims of the far left, which had long seemed powerless to halt the violent globalization of markets, the rich getting richer, and those with power acquiring even more of it.

Tonight, though, their enemies were being destroyed live on television. 'Portillo, Michael Denzil Xavier,' read the returning officer. A few of those who had assembled at Picketts Lock Leisure Centre, Enfield, laughed at the name of the right-wing defence secretary. Standing on stage behind the officer and in front of a high curtain of dramatic scarlet, he forced a smile. 'Conservative Party. Nineteen thousand, one hundred and thirty-seven.' There was polite applause. The result would be tight, but the prospect of Labour winning Enfield, stereotyped as a bastion of

working-class Thatcherism, was just too extraordinary. The result for the Christian Democrat candidate was read out. He had received 289 votes, and a solitary supporter at the back of the hall gave a huge cheer. Now the next candidate was up. 'Twigg, Steven. Labour Party ...' Standing beside Portillo, a young man with middle-parted hair and a red rose in his lapel looked nervous. '... Twenty thousand, fi—' The shouts and screams of celebration made the rest inaudible. It really was a landslide.

Massey, Hall and Jacques would have watched that night go by with mixed feelings. The 'new left' to which they belonged was a loose coalition of feminists, anti-racists, LGBT activists, environmentalists, anarchists and anti-capitalists that had been formed partly by the Paris 'events' and by the anti-Vietnam War movement – that is, by the revolutionary activism that Lennon's song had mocked. Members of this grouping argued that the class struggle embodied by the trade union movement should be only one component of a wider revolution for which they and their comrades should fight.

They had spent the Thatcher years building a power base in local government, while within Labour itself, they had aggressively fought the party's free market wing, of which Tony Blair and his right-hand man Gordon Brown were now the leading lights. However, Blair's 'New Labour' used the new left's insight that inequality and unfreedom were not determined only by class and wealth to bolster their own programme, one that aggressively downplayed the importance of economic inequality.

The following chapters describe a series of similar acts of appropriation, all of which happened in 1997, and through which those in power took advantage of subversion. These moments were junctures within histories that lasted much more than 365 days, but this book will show how New Labour's election triumph both reinforced the symbolism of the events of that year and increased their impact in concrete ways. New Labour acted as a fulcrum of progressive optimism, feeding into amorphous hope and drawing political capital from it. They gave practical assistance and ideological shape to the events taking place around them, from the mourning of Princess Diana to Noel Gallagher's political pronouncements. In turn, a liberal mass culture gave the party even more political space to expand the welfare state, to launch an enormously high-profile inquiry into police racism and to promote a multicultural image of the UK.

This book will tell how, in ways such as this, New Labour and Britain's culture industries took the ideas, slogans and sometimes the personnel of the new left, and of other radical projects, and they gave those concepts and people publicity and power.

As a result, there seemed to be signs of progress everywhere. The Spice Girls' 'girl power' filled the airwaves, the grassroots realism of Britpop was indie orthodoxy and the populist avant-garde of the Young British Artists was on newspapers' front pages. The Stephen Lawrence campaign forced a middle-class elite to listen to the anti-racist movement; Labour tried to construct a modern,

post-imperial union and it expanded social spending; and, after the shocking death of Princess Diana, the relationship between the monarch and her subjects seemed to modernize.

The UK seemed renewed, but it was becoming unstable. Pervasive misogyny, institutional racism, deep economic inequality, a culture that undermined and dispossessed marginal and radical groups – these were hardly dented by the spirit of 1997. The powerful individuals and groups that had made subversive ideas and people more visible used them either to enrich themselves or to advance their own, conservative agendas. That ploy, of powerful people exploiting radical messages, was by no means new, but it would define the year of New Labour's general election win, and its effects are still felt in the UK two decades later.

A credit crunch, a recession and austerity would follow from decisions made immediately before and after New Labour's general election triumph. Both this economic upheaval and the events of 1997 would then precipitate another series of crises for New Labour's legacy and for the faux-progressive culture it had promoted. Anti-migrant feeling has risen steeply, enabling the vote in favour of leaving the European Union. Jeremy Corbyn has moved ever closer to power, newly rejuvenated anti-racist and feminist movements have taken to the streets, and it has become increasingly likely that Scotland will eventually secede from the UK. This is the complex legacy of 1997.

At the Royal Festival Hall the Labour Party was celebrating. The semi-official soundtrack of the night boomed out of speakers hanging from the ceiling, and above

its heavy, pacing drumbeat drifted the infamous and slightly spaced-out vocals: 'Things can only get better'.

This song, playing over and over at the official celebrations, told of wide-eyed and instinctive hope. That was one side of the story of 1997, but the other was evoked by the Beatles track playing on Gallagher and Matthews's stereo, and particularly by its refrain, which casually dismissed the complaints of those who said that things needed to change.

'I had a ticket for the Labour Party party,' Noel would recall, 'but I had that much fun watching Portillo and the others done over I stayed home in front of the TV.' George Harrison and Paul McCartney's pining backing vocals strained through the still night air and floated over the garden walls of Primrose Hill. 'Don't you know it's gonna be …' they called out, punctuated by the sound of Noel and Meg's neighbours banging on the walls, and by John Lennon's snarling response: '… Alright'.

1 / NEW LABOUR, NEW BRITAIN

Prince Charles was puzzled as to why his seat was so uncomfortable. After boarding this chartered flight to Hong Kong, he had, along with his team, sat down on its upper deck. 'It took me some time to realise that this was not first class(!),' he wrote in the journal that he would send to a large number of friends and relatives, and which was, to be fair to the prince and his perception of the aircraft seat, frequently inflected with irony. Downstairs an array of officials, senior members of the government and former prime ministers were sitting, marginally more comfortable than the prince, in first. His Royal Highness remained in business class all the way to Hong Kong. 'Such is the end of Empire, I sighed to myself.'

On New Labour's watch, the symbols and institutions of an old and deeply divided country were supposedly being reformulated. A new nation seemed just around the corner, for the government's foreign strategy, long decried as reactionary and cynical by liberals, was being replaced by an agenda that some now described admiringly as 'internationalist',[1] the country's inequitable constitution was being reconstructed in an attempt to make England

less dominant within the United Kingdom while ensuring that its union did not split, and a society dominated by the aesthetics and mores of its white majority seemed to be becoming 'multicultural'.

Towards the end of 1997, a small political crisis would indicate that this liberal turn had a reactionary edge, although few outside the hard left perceived it at the time. Nearly a decade and a half before the 'migrant crisis' that began in 2015, New Labour would be faced with its first taste, both of thousands of people struggling to find a safer and happier home in Britain, and of the angry response those new arrivals received. The government's reaction would quietly signal that their liberal vision for Britain was already dissolving.

As Prince Charles ironically recognized in his diary, the demise of the British Empire had already begun – in the late nineteenth century, actually – and now, in 1997, the United Kingdom had only seventeen 'dependent territories', as its colonies were known. Hong Kong's sovereignty was among the most disputed of all these territories, partly because it was by far the most populous (more than six million people lived there, compared to the rough total of 160,000 living in the other dependent territories) and because, to a similarly dramatic degree, it was the richest of them. It was so wealthy that it was forced to send a remittance back to the UK.[2]

The Prince of Wales was on his way to Hong Kong because, in three days, at midnight on 30 June, the UK was going to hand control of the island and its surrounding areas to the Beijing government. The meaning of this event was

clear to many observers,[3] and to some it was disturbing, for the prince had been half right, even if he had been joking. The UK would still have protectorates and military bases in many regions across the globe. Indeed, its influence and control would continue to extend far beyond those relatively small territories. But Britain would no longer see itself as an imperial power.

The foundations of the United Kingdom would be remade that night in Hong Kong, and these changes were lamented by some, like Charles, for whom patriotism and national identity remained strong, albeit confused. That was exactly why others, like New Labour, saw in these developments an opportunity to channel the churning waters of national sentiment into the project of market globalization. If they spied any danger in using the nation to empower those global forces that could destroy it, they did not let it stop them.

Hong Kong had come under British rule during the First Opium War, during which Queen Victoria's forces had compelled China to accept British imports of the drug. Now, the UK government's lease on the New Territories, which formed the greater part of Hong Kong's landmass, was at an end. Most of the city was built on land that the British government was not legally obliged to cede, but given that Beijing could easily have turned off Hong Kong's water and energy supplies, it was not surprising that the UK had agreed to return all of its territories in the area to China. That did not, however, stop them from making things difficult for the Chinese. As the handover had neared, some

British officials, particularly British governor Chris Patten, had become increasingly keen on allowing Hong Kongers a modicum of democratic freedom.

But now the day had arrived, and it would be an extraordinary media spectacle. Nearly 8,400 journalists from 775 news organizations were estimated to be reporting from Hong Kong on the coming days' events.[4]

On TV sets around the world, the greenery creeping over the portico of Government House dripped with condensation and warm drizzle. Rising up behind its white neoclassical façade, viewers could see glimpses of the shining glass and steel trunk of the Asia Pacific Finance Tower. The voiceover of the BBC's correspondent, Matt Frei, described the events on the evening bulletin: 'One last leaving ritual from the governor: his car circled the courtyard three times, a Chinese custom that means "hope to be back".'

The press had been told that this was what would happen, and indeed both the television reporters and the next day's papers stated that was what had taken place, but Chris Patten, who was distressed by the prospect of his imminent departure, seems to have given his chauffeur different instructions. His black Rolls-Royce entered the driveway and circled it once, and after Patten and Lavender, his wife, got into the car, it travelled around the driveway only twice before leaving the compound.[5] The car would, indeed, be returned to the mansion, but the British were never coming back.

At about 16.30, Mr and Mrs Patten arrived at the Royal Yacht *Britannia* with their three teenage daughters,

somewhat creepily dubbed Posh, Sexy and Baby by *Private Eye* after three of the Spice Girls.[6] Prince Charles would recall that the family looked 'incredibly sad and somewhat shattered'. Patten was still cradling the Governor's Flag, a Union Jack featuring the governor's coat of arms that had, only half an hour before, flown above his official residence. Charles described how he 'tried to soothe their nerves with a cup of tea' before the party left again, this time for a farewell ceremony for British Hong Kong troops.

As the sun set, warm rain poured down on the Tamar Site, a vast plane of concrete that sat beside the harbour, and on which stadium terraces had been erected. 'Today is cause for celebration,' declared Patten to those assembled, 'not sorrow.' As his ash-blond hair fluttered in the breeze, however, he admitted both that he felt some sadness, and that imperial rule had involved 'events … which would, today, have few defenders'. Nonetheless, he continued by describing British occupation in terms of its rule of law, rather than its lack of democracy. As the sky poured down on the British ceremony, Patten sometimes struggled to hide his emotions. 'Now, Hong Kong people are to run Hong Kong. That is the promise and that is the unshakeable destiny.' As the crowd roared with applause, Patten sat down beside Prince Charles, looking shocked and a little winded. His head fell and he studied the floor. The applause continued. He bit his lips.

Sat on the other side of the governor, Tony Blair had an embarrassed look on his face.[7] His press secretary, Alastair Campbell, sitting a few seats away, had a similar reaction. 'I

felt Patten was overdoing the emotional side of things,' the spin doctor recorded in his diary. 'He gave the impression it was a personal act being committed against him.'[8]

Other elements of the British establishment felt differently about Patten's eulogy for British rule. 'I ended up with a lump in my throat,' recalled Charles, 'and was then completely finished off by the playing of Elgar's Nimrod Variation.' A small orchestra was working its way through the famous *Adagio*. Television viewers watched the musicians sat on a small temporary stage, surrounded by the crumpled and rain-sodden protective plastic sacks that they had, just a moment before, whipped off their instruments. As the trembling music rose, screens around the world flicked from one shot to another and viewers saw a vast harbour in the gloom, the lights of great ships bobbing in the mist and rippling waves that sparkled in the moonlight. The heaving momentum of the horn section forced the orchestra into a thunderous swell of timpani and strings, and the camera pulled out slowly to reveal the majestic neon-bannered towers of Causeway Bay. At the moment that the instruments exploded into their resurgent climax, the melody emerging from desperate pain into great but complex hope, these towering concrete omens of Hong Kong's future popped into the frame, glowing brightly in the dark blue sky: Toshiba, Conrad Hilton, Citibank.

The celebrations began. In Lan Kwai Fong, where Hong Kong's international residents met to party, an expat of European descent with an English accent was talking to the news cameras. She wore a wide-brimmed hat of charcoal

gauze. Men in baggy, brightly coloured shirts chugged Carlsberg on the pavements behind her. She did not want to leave. 'Darling, I'm Chinese. I have my eyes fixed every year,' she joked to the producer, holding her hands up beside her face. Her fingertips were pointed at her lower brow as if she were about to pull her skin back in order to narrow her eyes.[9]

Opinion polls showed that there were fears among Hong Kong's Chinese-majority population regarding the territory's political future under the rule of Beijing. However, most were pretty optimistic about the handover of the territory, or said that they did not care.[10]

In the vast hall of a convention centre, dignitaries sat watching the long ceremony. Its climax was marked by a ritual that had been repeated many times since India had become the first British colony to reclaim its independence. One set of flags was exchanged for another, and for Charles, this was the pinnacle of humiliations. 'At the end of this awful Soviet-style display we had to watch the Chinese soldiers goose step on to the stage and haul down the Union Jack ... The ultimate horror was the artificial wind which made the flags flutter enticingly.' The last notes of 'God Save the Queen' rang out from the band of the Scots Guards, dressed in scarlet and topped by their voluminous bearskin hats. The guards' cymbals had only just hissed out their last trembling note when a Chinese military band struck up the 'March of the Volunteers' and the Chinese flag was raised alongside the new flag of Hong Kong.[11]

Sitting in the audience, Tony Blair also found the Chinese triumphalism of the final handover somewhat humiliating,[12]

but the 'tug' that he felt was 'not of regret but of nostalgia for the old British Union'.[13] Indeed, two months later he was arguing, albeit to the president of Zimbabwe, Robert Mugabe, that Britain was no longer defined by its colonial past; it was simply something that Britons read about in their history books.[14] During the ceremony, foreign secretary Robin Cook had been spied standing around looking relaxed, his hands in his pockets,[15] and Charles recognized the same unconcerned attitude in Blair, complaining in his diary that the prime minister was on the island for only fourteen hours (it was more like twelve). As China's premier Jiang Zemin remarked to Blair, the Labour Party was not burdened by ideological ties to Britain's colonial past.[16] The empire was, in the prime minister's mind, simply outmoded. Blair later wrote, 'In the end, however benign we were, they prefer to run themselves and make their own mistakes.'[17]

He wanted to apply the same principle, albeit to a different extent, to Northern Ireland. With Labour in power and Mo Mowlam in the Northern Ireland Office, the peace process in the six counties of the north was now being led by a Westminster government which the republican and Irish nationalist movement still distrusted, but less intensely. Two and a half weeks after Hong Kong was returned to China, years of work in Belfast, Dublin and London paid off, and the IRA declared a ceasefire. A month and a half later, its political wing, Sinn Féin, announced its opposition to violent tactics, and entered formal talks. In less than a year, the Good Friday Agreement would devolve political power to Northern Ireland and lead the way to the gradual demilitarization of

a territory that was part of the UK, but which many of its inhabitants identified as a colonial province occupied by the British. The empire really was disintegrating.

Few people elsewhere in Britain appeared to care much at all, beyond either watching the spectacle of Patten crying and Chinese guards goose-stepping, or feeling that the already dim prospect of an IRA bombing was even more distant. One newspaper columnist reported, after the Hong Kong handover, that 'there is very little sense of loss in Britain'.[18] Northern Ireland felt similarly alien to most people in the UK, and Good Friday passed, in their minds, as a news story of modest significance.

After fifty years of decolonization, and decades of the Troubles, Britain's imperial story no longer appeared romantic or glorious, even to those who ignored the violence and racism that ran through that history. Many people felt an uncertain mixture of limited shame about this past, nostalgia for its glories and relief that the disputes over Hong Kong and Northern Ireland seemed to have disappeared.

Britain's elite was divided on the questions of what this confusion was, how to clear it, and who should benefit from that clarification. Charles, like many conservatives, thought this was a problem of national culture. He wrote of Blair: 'He understands only too well the identity problem that Britain has with the loss of an empire.' Blair's left-wing backbenchers would have had another view: the imperium of global markets was, indeed, disrupting elderly established empires and identities, and the meaning these had given to some people's lives had to be replaced with something

more inclusive and egalitarian. The prime minister himself agreed there were challenges posed by globalization, but he welcomed the freeing of global markets, which he argued was necessary for prosperity.

New Labour seemed, to many, to be poised to rearticulate post-imperial confusion as something internationalist and culturally diverse. The party had inherited a divided and apathetic country, and they saw this as an opportunity to reshape a nation.

One strand of these reforms had been previewed two months before. The foreign secretary, whose job it was to represent Britain abroad, was diminutive, extremely clever, relatively left-wing, and adorned with a rusty beard. Robin Cook was, in the words of journalist John Kampfner, 'Blair's most awkward minister'.[19] He loved attention, though, and rarely resisted an opportunity to grab a few headlines.

A week after New Labour's election victory he strode into the Foreign Office's Locarno room, a heavily gilded hall dominated by a turquoise vaulted ceiling.[20] There, for the assembled cameras, he made a rather impressive announcement. 'Every modern business starts from a mission statement,' he told the reporters and news crews. 'New Labour is determined to bring a businesslike approach to Government.' No foreign secretary had ever suggested such a thing. It just was not the Whitehall way.

However, as vestiges of imperial rule began to dissolve in East Asia and across the Irish Sea, Cook felt empowered to announce New Labour's new strategy. 'Our foreign policy must have an ethical dimension,' he told the media.[21]

Realpolitik, jingoism, defending the interests of the rich and powerful – British foreign policy had been accused of all these, but rarely of being ethical. Cook wanted a policy of liberal, but pragmatic, intervention, a plan to 'make Britain once again a force for good in the world'. The UK had to strike out positively across the globe, he argued, because if it allowed violence to take place elsewhere in this globalized, interconnected planet, its interests would eventually be hurt.

The announcement created exactly the impression that New Labour hoped to give. Cook had encouraged voters and commentators to perceive him as humanitarian, liberal and optimistic, and, because he had also promised to regulate arms sales, he had discouraged sniping from Labour's pacifist and anti-nuclear wing. He had boldly enacted a defining moment in New Labour's permanent branding revolution. They were internationalist, modern and muscular, and therefore Britain was too.

Across Westminster, Cook's announcement was greeted with horror. At Number 10, his policy was savaged by Jonathan Powell, Blair's chief of staff, a former diplomat and, informally, the prime minister's most influential foreign policy adviser. At the Department for Trade and Industry, Lord Hollick, a former director of arms manufacturer British Aerospace, was reported to be insisting that protecting contracts, profits and jobs in the weapons industry trumped regulating arms sales and promoting democracy.

It was not only Powell and the DTI who undermined Cook's ethical dimension, for it contained the seeds of its own undoing. In the Locarno room the foreign secretary

had announced that 'Britain ... has a national interest in the promotion of our values' and that he aimed to 'secure the respect of other nations for Britain's contribution to keeping the peace of the world and promoting democracy'.

It was on this basis that, two years later, Blair would lay out his foreign policy doctrine in a famous speech in Chicago. There, he proposed intervening against tyrants – he was focusing on Serb leader Slobodan Milošević at the time, but he also mentioned the president of Iraq, Saddam Hussein – and he promised to hoist on other states democratic free market capitalism. Such countries would ally and trade with the UK, Blair hoped. 'The spread of our values makes us safer.'

Cook was uncomfortable about such schemes, but he would soon be sidelined. New Labour operated on a fundamental assumption, that both at home and abroad those with power had to lay out the right way of doing things. Blair believed that other countries could legitimately be conquered, and their governments replaced, top-down, with more acceptable rulers. Similarly, in the UK, the government largely accepted the presence of deep class inequality, and would try to solve the social maladies that appeared as a consequence by jailing more criminals and by creating an aggressive new legal regime to combat antisocial behaviour.

Some on the left, and a few on the right, warned that this strategy was not sustainable, that ordinary people would not put up with it for ever. They were, however, overruled by an idea that lay at the heart of New Labour's vision. It was a principle shared with the neoconservatives in the USA: that

social and political order benefited everyone, nationally and internationally, and that it came at the price of some people being richer and in control. What was good for the powerful was good for the weak.

The members of the new group were not sure what to call themselves. 'We could opt for an abstract name,' suggested a secret briefing paper, citing the precedent set by a recently formed Blairite pressure group: 'like they did in England with "Progress".' Indeed, the new body soon did follow that trend; they settled on 'Network', which quickly gained the prefix of a definite article. Their opponents on the left of the Scottish Labour Party described them as 'some kind of shadowy Masonic outfit'.[22]

When the document discussing the new name was leaked, Jim Murphy insisted that he had not been its author. Nonetheless, from his office in Scottish Labour's imposing sandstone headquarters, which surveyed the elegant Victorian streets of Glasgow's West End, he was coordinating the Network's rise. Just out of his two-year tenure as president of the National Union of Students,[23] he was a handsome twenty-nine-year-old with a soft west coast accent and a trendy middle parting. However, the boyish auburn curls hanging over his brow belied his ambition and pragmatic approach. The new government seemed likely to devolve significant powers from Westminster to Scotland and Wales, and if that had to happen, then the Network was determined that, in Scotland at least, those changes should benefit the party's 'modernizers' – its free market right-wing.

Devolution looked, to some in England and across the world, like a local issue, but its implications were broader than that. In England, the majority of parliamentary constituencies generally voted Conservative, so if devolution led to Scotland, and maybe even Wales, seceding from the Union, or if it resulted in the creation of a devolved English parliament, then England faced almost permanent Tory rule and the undermining of its public sector and welfare state.

Some on the British left opposed the devolution plan because it posed an existential threat to England's modest social democracy, and many were against it simply because it was a nationalist project. By contrast, the Conservatives opposed devolution because it involved taking an almighty risk with the future of the British nation-state, its traditions and culture.

New Labour felt differently to both these groups. Although devolution represented a great threat to their own party, it was too popular in Scotland for them to ignore. Since the late 1970s, Scotland, Wales and the north of England had suffered rapid deindustrialization, and the Tories had haemorrhaged support in those areas, while their support in the rest of England kept them in power. Pollsters recorded in Scotland and Wales that long-standing antipathy to the influence of London had hardened and that more people felt their national identity to be important.[24] Just as the collapse of Britain's imperial polity was climaxing in Hong Kong, great fractures were appearing in the structure of the United Kingdom.

If the government gave more powers to Edinburgh, this might strengthen the Scottish left, and New Labour's free market agenda might face greater opposition. But, just as they planned to use British national sentiments emerging from the slow dissolution of the empire to strengthen their project, they intended to use Scottish nationalism to do the same. New Labour would simply ensure that a devolved parliament provided them with a new power base.

First, however, Blair needed Scottish Labour on side. The Network and its allies had to purge their enemies, and their chance came in Inverness. Blair was up in the Highlands for Scottish Labour's conference, but he was apparently confident that his supporters there had taken care of business, and he amused himself doing a photocall at the town's football ground, the Longman. As he dribbled up the side of the pitch, he demonstrated a style with the ball that was measured and controlled. A reporter from the *Inverness Courier* observed, perhaps with a little smile, that the Labour leader tended to stay on the right wing.[25]

Blair kept an eye on the ball as a pack of camera operators chased after him, running up and down the line in front of the static pitchside boards advertising local businesses, the crush barriers and the single-tiered terrace in the blue and white of the Saltire. Swaddled in a black Adidas puffa jacket, its maroon collar flicked up against the cold,[26] Blair made sure to pass the ball to the primary school boys with whom he was playing.

The real action was happening elsewhere. Beside the banks of the choppy River Ness stood Eden Court,[27] the

theatre hosting Scottish Labour's conference. It was a strange, heavy 1970s complex with a dirty grey roof that split at surprising angles to reveal huge diamond-shaped windows. The building's low glass walls reflected the heavy Highlands skies and, inside, Scottish Labour members had begun voting for their new executive. Modernizer and Network members were challenging eight of the current officials, all of them old Labour, home rulers or feminist socialists.

As much devolution as possible was very attractive to these figures on the left of Scottish Labour, and some were up for independence too. A Scottish parliament, whether independent or just devolved, would be dominated by centre-left nationalists, Labourites and Liberal Democrats, and for Blair's left-wing critics in Scotland, whether Labour members or not, that represented a thrilling opportunity. A strong Scottish parliament with wide-ranging powers would be their chance to fundamentally realign Scottish politics away from Thatcherism, and away from New Labour too, so that they could build a much stronger welfare state and public sector in Scotland. By contrast, their modernizer challengers wanted a weak Scottish parliament – a New Labour stronghold that would not threaten Blair in Westminster, but which would satiate nationalist demands for independence.

Blair's team also had a trump card: they would later devolve power to the English cities and regions. This would ensure that a democratic deficit south of the border did not form, and it would create an evenly decentralized system.[28]

The forces pulling the Union apart would, they hoped, wither away.

In Inverness, voting paused, meetings ended, those in the bar took their seats in the main hall, and the conference came to its climax. The auditorium was packed, and as the main speaker appeared modernizers and traditionalists alike stood to applaud. An announcement zipped across a red LED display board at the side of the hall: 'RT HON TONY BLAIR MP – LEADER OF THE LABOUR PARTY'. The man himself stood behind an angular lectern of translucent white plastic, decorated with the thin red rose of New Labour, ready to give his speech.

He made the usual remarks about the global future, fairness and a modern country, but he was not afraid to directly address the tensions within the Scottish party that the vote for the executive had laid bare. As he was nearing the end of his speech, he took the opportunity of a flurry of applause to close the brown paper folder containing his text. The clapping died down, and he threw his hands up in the air in pointed exasperation, his eyes cast down and his brow raised. He began again, implicitly addressing his left-wing and pro-independence critics. He was apparently ad libbing, his voice suddenly light, quavering, higher pitched. 'So in short what I'm saying is: have a bit of faith, right.' He smiled. 'Have a bit of faith.' He leant back on his heels, his eyes wide, and took an effortful, shallow breath. 'Have confidence in what we're about' – he held his fist in front of his chest, shaking it – 'and this country will have faith and confidence in us.' He was already picking up the folder from

the lectern and beginning to turn away. 'Thank you.'[29] The audience rose to roar its applause. Later a troupe of children (dubbed the 'Youth Cabinet') marched on stage to shout for the cameras: 'New Labour! New Scotland! New Labour! New Scotland!'[30]

Now, votes for the party executive had to be counted. A few months earlier, officials had cut the conference to a day and a half, with all the normal controversial debates postponed, and they had chosen as its venue a theatre seating only 800. It was little more than a leadership rally for the benefit of the press, so those members who had turned up in Inverness, and who could therefore vote in the executive elections most easily, were also those keenest to see Blair and Brown's speeches. That afternoon, results were announced in the auditorium: seven of the eight incumbents who had been challenged had been kicked out by modernizers. Traditionalist members wept as they learned the news. They had been purged.[31]

Rosina McCrae, one of the seven defeated, explained the day's events to a camera crew. 'It's a very open plot now,' she insisted. Dressed in a smart black suit, she looked up at the reporter, her eyes narrowed, perhaps in exhaustion. 'They're calling themselves "Network", I think is their new name.' She shrugged and raised an eyebrow, giving a hint of an ironic smile. 'It's fair enough.' Another shrug, another raised eyebrow. 'I mean, I organise under the Women's Caucus' – this was a feminist grouping in Scottish Labour that had been established for many years – 'but there's certainly a machine working here.'[32] Later, she described

how personal this defeat was: 'I feel for the first time that I am an enemy in my own party.'[33] She had been replaced by a twenty-three-year-old New Labourite, just out of university, and McCrae's allies knew who they blamed. 'Jim Murphy carved up Rosina,' complained another Labour feminist kicked off the executive. She dismissed the new executive's members as 'hollow careerists'.[34] 'It is no longer acceptable to be 85 per cent in agreement with Tony Blair,' observed another party member from the losing side. 'It is 100 per cent or you're out.'[35]

That night, several dozen conference attendees trudged ten minutes in the dark along the churning river to celebrate in the function room of the Inverness Ice Rink. Inside its boxy and industrial main building, brilliant white in the evening gloom, two men hopped onto a little stage erected in the rink bar. Their presence, together, indicated what kind of party Labour would now be.

The bright spotlights glowed hot on the high, shiny forehead of one, the night's MC, a man called Alan McGee. He was a Labour man from Glasgow and a great fan of Blair's. More importantly, he was also Oasis's label boss and the man credited with discovering the Gallagher brothers. He had brought along a couple of his smaller acts to play: long-standing alternative favourites Teenage Fanclub and, in support, a minor indie celebrity, Edward Ball, whose recent video promo had featured Chelsea defender David Lee and his former teammate, now of Blackburn, Graham Le Saux. They had been filmed playing football with salt and pepper pots in a greasy spoon, and

Anna Friel, just out of *Brookside*, had played the video's love interest.[36]

McGee knew what some in the crowd were expecting. These party members, familiar with Red Wedge fundraisers and Rock Against Racism gigs, had become accustomed to pop musicians making ideological speeches full of ethical insistence ('embarrassing', McGee called them later that evening), but he was a businessman who knew how to target an audience. He hooked them with their identity, rather than with their values. 'The Tory supporters are Phil Collins and Cilla Black,' he shouted over the PA. 'The Labour Party have Oasis and Teenage Fanclub. Whose side are you on?' The crowd roared with approval.

Beside McGee stood the night's host. Gordon Brown was still in his suit and tie, and a shadow fell over his heavy brow, cast by the bright spots hanging from the bar's small lighting rig. Taking the mic in his meaty hands, their nails bitten to the quick, Brown spoke amiably to the crowd. He assured them that he would not be the 'GJ' for the night, provoking laughter in the audience – it was unclear whether this neologism was part of the joke or a mistake – and thanked everyone, including 'The Fanclub – just been talking to them – great guys'.[37]

With the awkward squad north of the border taken care of, Blair could safely call a referendum on the question of devolution for Scotland; it would take place on 11 September 1997. The ballot paper would give voters a third choice, after devolution with tax-raising powers and things staying the same: 'devo-lite', which would create a

weak Scottish Assembly with no tax-raising powers. New Labour's expectation was that such a halfway house was always likely to gain the most support, and that such a win would justify ignoring future calls for independence. That would undermine the Scottish National Party, it would strengthen Labour and it would reinforce the Union. The next stage of their plan to control devolution, the creation of English regional assemblies, would come later, building on the momentum created by Scotland.

On 11 September 1997, the 700th anniversary of William Wallace's victory over English forces at the battle of Stirling Bridge, just under three-quarters of voters in Scotland opted for devolution. The day was hailed as a great triumph for New Labour, but the tax-raising powers that many modernizers had hoped would be rejected had, instead, been supported by 63.5 per cent of voters.[38] An SNP source told journalists: 'The system has been breached. The whole system of change will speed up.'[39] The next week Wales also opted for devolution, although only with the tiniest of margins: 50.3 per cent of Welsh voters supported Labour's plans. It did not augur well for the rest of their strategy. In 1998, London would be given an elected assembly, but when the north-east of England was offered devolution, 78 per cent of voters rejected it. All further plans to balance out devolution, and thereby stabilize the Union, were dropped.

Years later, analysts would confirm what the SNP had long hoped: not only that support for independence had been rising for decades, but also that many Scots had voted for devolution because they believed it would lead to secession.

Moreover, it was the promise of independence within the European Union that had prompted so many new supporters to move to the Yes camp.[40] The British Empire had fallen, but it had been replaced by a new cosmopolitan organization, one in which a small nation could feel secure. Devolution was not going to satisfy demands for independence.

It was the Conservative Party conference, October 1997. A woman in her seventies swept into the long, echoing room, her retinue around her, and awakened a slight tremor of excitement in the avenues of corporate stalls. Beneath the high curved glass ceiling and the Victorian stucco painted in tasteful creams and yellows, heads turned, startled a little by the figure's piercing blue coat dress. A few onlookers nudged their less observant companions – this, really, was who you hoped to see, and Denis was with her! – and then she was gone. The Blackpool Pavilion's long horseshoe promenade filled again with the murmur of delegates and company reps.

At the British Airways stand, a few crisply turned-out representatives were chatting, tidying, rehearsing, waiting. Above them, a company logo printed on a huge shiny square of card hung from a chrome frame. And there she was, suddenly, beneath the logo, her entourage a few steps away.

The BA executives tried to engage their VIP guest with news of the company's current ventures, but something in particular caught her eye. A small model of a Boeing stood at the edge of the booth, held aloft by a thin bar piercing its underside. The Union flag that had long decorated the tailfins of BA's 747s had been replaced, on this model, by

a motif of leaves coloured in powdery green, pink and blue. This example of the airline's new livery, which had been revealed late that summer, had apparently been inspired by the art of a tribe from the Kalahari Desert. The company's publicists had explained that they were trying to appeal to a more international client base.

The press described the new tailfins as 'ethnic',[41] and a BA spokesperson told news crews: 'Research shows our new identity portrays a modern, fresh and dynamic Britain.' This notion, that ethnic and cultural diversity were key to how the UK should be portrayed in 1997, and that the country's future economic success would be dependent on this portrayal, was also a favourite theme of the new prime minister. A week before, in a much-heralded passage of his first conference speech since entering office, Tony Blair had decried the complete absence of black High Court judges, chief constables, civil service permanent secretaries and army generals, and the paucity of black and Asian MPs. 'Not a record of pride for the British establishment,' he had noted. Blair was nodding to the influence of the new left in the Labour Party – the anti-racists, feminists and members of other liberatory social movements that had gained ground since the 1960s – but he was binding them into his liberal, market-based approach. 'We cannot be a beacon to the world unless the talents of all the people shine through.'[42]

At the British Airways stall, the guest was not impressed with the new tailfin. 'We fly the British flag!' She intoned the words rhythmically, sharply, her finger wagging in time and resting, finally, on the arm of the BA executive who was

escorting her that afternoon. 'Not those awful things you are putting on the tails.' An air hostess conscripted from cabin duties for the weekend looked on. Her royal blue hat, trimmed with white and scarlet, was low and wide brimmed, but could not quite obscure her unimpressed expression. 'It's terrible,' the guest continued. Then, disappointed and trailing off: 'It's absolutely terrible.'

For members of the Tory faithful gathered in Blackpool, the Union flag represented the values their country should have, and supposedly had once had: stoical and entrepreneurial individualism, balanced by traditional family morality and respect for the Crown and the armed forces. They believed that spirit of striking out and succeeding, but doing so within a strict hierarchy, was perfectly embodied by England's imperial history, and later Britain's, but that any relationship these values perhaps had to anything that Britain might have done wrong, long ago, was irrelevant. Those values remained right, this view maintained, and they were also useful. Without a unifying culture, one rigidly dominated by those values, there would be social disorder, and consequently little prosperity or freedom for anyone.

Those allied to this perspective truly lamented the loss of Hong Kong, and their reasons for wanting to keep the Union together, its government undevolved, had nothing to do with protecting the Labour Party, or the institutions of social democracy. They wanted to save the United Kingdom because it meant strength at home and against the rest of the world, and because it meant tradition. Thus, in the mind of this visitor to BA's conference stall, the tailfin mattered.

She delved into her boxy black patent leather handbag, rummaging through its contents as her husband and the airline's executive sparred. 'But why can't we have British designs?' Denis demanded. She ignored the men, puzzling through her bag until she found and extracted a paper handkerchief. She bent towards the tail of the miniature 747 and, with a flourish, wrapped her tissue around the offending African imagery. The gents from BA, half wincing, quickly produced a few smoky, mechanical laughs, and the guest bent back up and turned to her chaperone, who chuckled nervously. She paused, peering into his eyes. He, in turn, looked away, somewhere in the direction of her paper handkerchief. Lady Thatcher did not flinch. She said nothing, and as she shuffled away, her eyes held fast on his.[43]

Blair's intention to make Britain's ethnic and cultural diversity visible was, he and his colleagues insisted, indicative of their broader political instincts. Once safely out of office, New Labour's leaders would seek to promote the idea that, although they had enacted authoritarian and nationalist policies, they had often done so out of political necessity. In his memoirs, New Labour's first home secretary Jack Straw defended his asylum policy in such tactical, perception-driven terms: 'The voters, especially the bulk of lower-middle-class and working-class Labour supporters … felt insecure.' Tellingly, Straw did not go so far as to say that they actually were insecure. Indeed, the patronizing quality of New Labour's attitude to its voters was barely concealed. Their asylum policy was a sop to what

they perceived as an irrational complaint. 'They wanted to know that our borders were controlled, that the system was in safe hands.'[44] An acquaintance at a dinner party given by Straw told the Labour MP that he, the guest, was fed up with New Labour's generally authoritarian approach. Straw was delighted: 'Good. You're supposed to be, because those policies are not for you.'[45]

Straw's successor as home secretary, David Blunkett, also indicated that New Labour had developed this approach for the sake of political expediency. He would later tell his biographer that, had it not been for the War On Terror, he would have been able to follow his favoured approach of 'talk tough and act tough *and* liberal'.[46] This plan involved creating a base of conservative policies that demonstrated that he was 'tough'. He would then be able to use this political capital to enact some 'liberal' policies, but without 'talking liberal' and thereby risking electoral pain by articulating progressive values that he feared would alienate voters.

It was a dangerous strategy. Blunkett acknowledged that in order to avoid being outflanked by neo-fascist parties like the British National Party, he had tried to accommodate the hard right. That, he said, meant not just the mainstream conservatism of the *Sun*, but also the 'ultras' themselves.[47] In any case, as a consequence of the War On Terror, he did not even get to act, let alone talk, liberal.

Blunkett and Straw were following their prime minister's lead. Tony Blair would recount how Gordon Brown had warned him that their policies on immigration were not

going to assuage public anger, that they were only going to shift attitudes to the right and create greater demands for more repressive policies. Evidently, all those concerned knew that their party's asylum policy had been designed to please a particular group of voters, and that migrants were, consequently, the rarely lamented fall guys of New Labour's electoral triumphs.

The division between migrants and the rest of the working class was yet another fracture in the nation that New Labour was mending in only the most temporary way. It was a few months after the 1997 general election when Labour was forced to decide whether or not it would pursue this precarious approach. Roma were arriving from eastern Europe on the shores of Kent. They had sold everything they had,[48] and they had travelled the 750 miles from the Czech Republic or Slovakia to the UK by coach, often dressed in their smartest clothes and generally with their life savings carefully tucked away. They rarely had more than a couple of hundred pounds.[49]

High unemployment was encouraging Roma to leave eastern European countries that were not yet part of the European Union. Moreover, the Dublin Convention had just come into force, making it legal for people to claim asylum in the EU country of their choice, rather than the first country in the union that they entered. So several hundred Roma headed for a wealthy country that was also known for it relative tolerance: the UK.

In the two years preceding the autumn of 1997, every week or so, one or two Czech or Slovak families had

travelled, generally via the French port of Calais, to the English port of Dover. The initial response of most locals and their officials had not been hostile.[50] 'It was nice and calm in the beginning,' reported one man who was among these early arrivals. 'People used to smile at me when I said I was Slovak.'[51]

By the time Labour came to power, several hundred Roma asylum seekers – estimates ran all the way from 400 to 800 – were living in and around Dover, waiting to see if their application would succeed.[52] None of this, however, had been reported in the national press, and for a few months after the election, the topic of asylum, whether in Dover or otherwise, barely registered in Britain's political landscape. Labour felt free to make relatively liberal pronouncements on the subject.

Slowly, though, stories about 'bogus asylum seekers' had begun to appear in the local papers. Resentment of the new arrivals circled around the stereotype of the money-grabbing, dark-skinned gypsy. A letter-writer in the *Dover Express* complained that 'Chemists are going flat out providing free prescriptions – and they are collected by hands covered in more gold than Tutankhamen'.[53] One local claimed that people selling their goods at car boot fairs were 'taking special care not to turn their backs – these gangs can move quickly'.[54] This was how some, especially those on the right, perceived the increasing instability of the UK, its culture and its prosperity. The empire was over, the Union was weakening and now ethnic others were incurring on Britain's soil.

Local Labour MP Gwyn Prosser, generally known as a left-winger, dismissed 'the vast majority of incoming Slovaks' as 'actually bogus asylum seekers' who were targeting Britain because of its more 'relaxed' immigration rules. He insisted 'it's clear the behaviour of some claiming asylum has been abominable', but he also warned that 'organised blatant racists' were exploiting the situation and emphasized that 'any reasonable person would support the right of genuine asylum seekers literally fleeing their homeland for their life'.[55]

For Prosser's most vocal constituents, their MP's position was unacceptably liberal. Dover had long been the most accessible and affordable entrance to the UK and Kent had a long history of electing politicians who took an aggressively anti-migrant stance. A local man writing to the *Dover Express* observed: 'Mr Prosser referred to those "fleeing torture, execution and oppression." How about what Dover puts up with?'[56] Another complained about 'free loaders and spongers' despite, he noted dryly, 'the risk of Gwyn Prosser MP thinking that this criticism will promote further xenophobia'.[57]

After Roma families arrived in Dover and applied for asylum, officials split them up: women and children went one way, and men the other. Neither group knew what was happening to the other, and many of the Roma asylum-seekers said they were given documents to sign that they did not understand.[58] Women and children were placed in Dover's many £10-a-night bed and breakfast hotels, where whole families were often crammed into one small room.

The adult men seeking asylum had committed no crime, but were nonetheless locked up in immigration detention centres, where inmates had reported bullying by officers, freezing temperatures and poor healthcare: one detainee, not Roma, at a mixed-gender centre where the Roma men were jailed had told staff there that she had stomach pain; they had given her sleeping tablets.[59]

Locking up male applicants was supposedly aimed at stopping them from absconding. But detaining migrants was extremely expensive, so that the cost of locking up a single person in a detention centre for a week was higher than that of providing benefits and normal accommodation to an entire family for the same amount of time.[60] Extensive research has shown that measures as simple as registering asylum applicants and providing them with documentation are not only cheap, but are also highly effective at cutting absconding rates.[61]

The aim of the government's aggressive measures, it seemed, was to send a message, both to voters at home and to potential migrants abroad. That was because, when considering political controversies around migration, New Labour primarily saw neither an ethnic threat to national culture, nor an unacceptable drain on the welfare state, nor a political threat to solidarity and compassion. Indeed, they perceived an electoral threat to their party. The presence of hundreds of Roma in Kent had still not reached the national press, but if it did, Labour knew they would suffer. Anti-migrant public feeling was especially strong among many lower middle- and skilled working-class voters in the

southern English constituencies, whose support for Labour had fallen considerably during the 1980s, and whose votes the party needed for a healthy majority.

Prosser's stance reflected that of the prime minster, which sociologist of race and racism Les Back later described thus: 'Blair, like the Roman god Janus, is standing at the threshold of the new century looking both ways at once.' The New Labour leader was not simply two-faced, and tactically trying to please everyone, Back argued. He was caught between paradoxical impulses: to force Britain to adapt to globalization by attracting skills and cheap labour from abroad, but also to calm anti-immigrant press and voters; to allow minority ethnic communities to express and identify as they wanted, but also to prevent minority ethnic groups from promoting views that he considered extreme and destabilizing.[62]

In their seaside bed and breakfast, an attractive young family sat on chintzy furniture, singing as the mother strummed a guitar. Later, the three children and their parents strolled along a sunny promenade beside the English Channel and threw pebbles into the gentle waves. The father, who had worked as a bricklayer and a cook before coming to Britain, told the Czech documentary-maker who was following them how wonderfully humane the UK's asylum system was.[63] He praised the quality of the education his children would receive now, and explained how grateful he was that they were finally safe.

It was late September, and hundreds of thousands of Czechs, many of them Roma gypsies, were watching *Gypsies*

Go to Heaven,[64] a television feature that followed Zdenka and Ladislav Scuka and their children as they travelled from Prague to Dover and applied for political asylum there. Viewers listened to Ladislav describe the widespread discrimination that he and his family had experienced back home in the Czech Republic. 'My daughter was refusing to go to nursery school because they called her "gypsy" and "nigger",' he explained in Romani. 'We couldn't live there any longer.' He felt that he deserved decent treatment by the British, given how long Europe's Roma had suffered: 'I believe this is our compensation.' He expected to get a work permit in about three months, but explained: 'I don't care that I will lose social welfare because I will be working and paying taxes, and I will make enough to feed my family'. He had come here for safety, he told the film-makers. 'I didn't come here because of the money.'[65]

The UK government did not deny that Roma were at the sharp end of racism in eastern Europe, but this was not, they said, the systematic kind of persecution that would justify a claim for refugee status. Hardly any Roma asylum applicants would be successful, and on this basis they were widely dismissed, even by well-informed officials, as 'only economic migrants'.[66]

This was the principle that mainstream anti-migrant feeling would continue to be founded on, even eighteen years later when a much larger number of refugees entered Europe, but the experiences of these new arrivals to Britain showed there was no clear distinction between refugees fleeing systematic oppression and economic migrants

wanting to make a better life. In eastern Europe, Roma had suffered particularly from the high levels of unemployment that had followed the collapse of the Soviet empire, and it was not uncommon to see, outside businesses that refused to employ so-called 'foreigners', a sign reading: 'No Gypsies, no Polacks, no Russians'.[67] Even at the government's labour exchanges, the '*gadjze*' (white, non-Roma, people) were given preference.[68]

Racist persecution in these countries was often ignored by the police[69] and by politicians, and it was sometimes officially encouraged. After the break-up of Czechoslovakia, the new Czech government had refused to give citizenship to 250,000 Roma, most of whom had been forced to move to Slovakia. The government there had, in turn, cut child benefit to Romany families in order to curb the 'reproduction of socially unacceptable people'.[70] These experiences, many Roma in Dover said, had prompted them to come to Britain, and justified their asylum claims. 'Czech Republic is a racist state,' explained a woman in Calais. She was one of the 40 per cent of the recent arrivals who had been turned back at the border after having failed to claim asylum immediately.[71] Like the sixty other Roma camping in the French ferry terminals,[72] she was desperate not to go back to eastern Europe. 'There is no possibility for gypsies to live in there.'[73]

In the two weeks after the documentary featuring the Scuka family aired, about 150 more Roma arrived at the port of Dover.[74] The coastal town's new inhabitants were very visible to the locals. Because whole families were living

in cramped and bare B&B rooms, and because adults were not allowed to work, the new arrivals spent much of their time on the streets.[75] A reporter later described how, 'With their olive skins and shell-suits the Czech and Slovakian immigrants are unmistakable.'[76]

Kent County Council was not going to be left significantly out of pocket by the arrival of hundreds of migrants – almost all its costs would eventually be reimbursed by central government – but in the meantime, budgets would have to be juggled and services were going to be under strain.

The council was run by the Conservatives, who, while in government in Westminster, had identified immigration as a weakness in the platform of their Labour opponents, and the council's press office had the previous week been taken over by a former journalist from the *Sun*, known for its hard-right editorial line.[77] 'At the moment England appears to be a soft touch,' said the head of social services in the county. She was concerned about the budget. 'If it goes on at this rate we're well over a million, maybe two million pounds. And that is money that could be better spent on Kent residents.'[78] That summer alone, the county council had spent £600,000 looking after 31 new families, 17 unaccompanied children and 71 lone adults.[79] During their time in government, the party in charge of her council had worked hard to cut the size of the welfare state, but she was presenting immigration as a threat to such state provision, and therefore to working-class and lower middle-class nationals: potential Labour voters.

Aycliffe Primary sat at the edge of an estate of 1950s semis on the south-east corner of Dover. In its small playground, surrounded by modern low-rise red-brick buildings with steep terracotta roofs, children ran about, yelping and chatting. Six kids were wearing name badges. This was to encourage the other children to speak to them, the head teacher explained in a letter to parents. The little children spoke no English and, he reminded his letter's recipients, they were 'frightened and shy'. More young Roma would soon join them,[80] and across Kent there would eventually be 200 who needed school places.[81] They also needed special support during lessons, and the head teacher admitted: 'I cannot say with my hand on my heart that there will be no difference to your child's education.'[82] 'It's disgusting,' one parent told a journalist. 'They should send them home. They have got to learn somewhere, but I don't see why our children should suffer. There are kids at that school who have been waiting for special needs teaching for ages.'[83]

The *Dover Express* reported that '[local] feeling about the refugees' was escalating. 'People from other countries who have lived and worked in Dover for many years say they have been subjected to racial abuse in the past week for the first time.'[84] Roma in the town described how shop workers had refused to sell them food, and how locals had thrown stones at Roma children.[85] A shopkeeper organized a petition complaining that 'so-called' asylum-seekers were 'raping our social system'. In a town of 33,000, a reported 3,000 people eventually signed the document.[86]

One local man had written to propose that asylum-seekers in the town 'be gathered together in a secure location prior to their return to their countries of origin'. However, another wrote, in horrified response, that this 'sound[ed] like an echo of the Final Solution'. He observed that 'During the last war the people of this country fought against Nazism. This is a principle we should not forget.'[87]

The Roma were trenchantly defended by some locals – church groups and priests were prominent among them – and they worked hard to provide new arrivals with shelter, furniture, clothes and toys.[88] These Doverians represented a very different perspective in the argument about migration. People coming to this country were not generally a threat, they believed, but anti-migrant feeling was. By allowing new arrivals the benefits of the welfare state and residency rights, Britain was embodying solidarity, even compassion, and the breakdown of these values would cause immense suffering to everyone.

New Labour ignored the significant minority of voters who felt this way, and they never extended welfare provision to the degree that might have built some solidarity between UK-born Britons and migrants.[89] Their policies were never fiscally generous enough to ensure that UK-born working class Britons did not lose out, and did not appear to lose out, as a result of migration.

'INVASION OF THE GIRO CZECHS,' screamed the headline of the *Sun*,[90] warning readers of the gypsies who were coming here 'to milk our cushy benefits system'.[91] Three weeks after the documentary aired, the number of Roma

arriving in Dover from eastern Europe suddenly jumped and in three days in late October, about two hundred people from Slovakia and the Czech Republic arrived in Dover. They had been allowed to apply for asylum and now they were news.[92] Quite suddenly, every national paper was covering these events, several with front-page headlines, and two UK TV documentaries were quickly produced to cover the story.[93]

The only evidence that could be found that some Roma were 'milking' the benefits system was that of isolated anecdotes, but these were dramatic. A *Daily Mail* reporter described several letters sent by Roma asylum-seekers to their relatives in eastern Europe, and then carried back west by those family members when they travelled to the UK. The letters described what Roma asylum applicants should say in order to persuade immigration officers to let them into Dover. One letter suggested that its recipient tell the authorities that 'I came to ask for asylum because I am a gipsy. At school I was constantly bullied and humiliated because my skin colour was darker. They kicked me, calling me gipsy ... into the gas chamber with her.' The letter continued, suggesting the woman tell interviewers that she had been spat at by colleagues at work, and that her child had been killed at birth.

Despite hard evidence backing up Roma claims of racism, Gwyn Prosser responded aggressively. 'It blows away the myth that this is a humanitarian, libertarian issue,' he said. 'This is blatant organised fraud.'[94]

After a week, the 'Roma in Dover' left the front pages, but some papers managed to make another four days of

stories out of it – 'Immigration chiefs fear influx of more gypsy "refugees"',[95] '25,000 say kick out the gipsies',[96] 'Boot out spongers',[97] 'Labour hypocrisy over asylum seekers'.[98] Finally, the Home Office buckled, announcing that individuals appealing against rejections of their asylum applications would now have only five days – cut drastically from twenty-eight – before immigration officials 'bounced' them out of the country.[99] Until this moment, Jack Straw had allowed a junior minister to talk to the media about the Dover issue, but now that his department had a strong, populist policy, he proudly took responsibility for its decisions.

Amnesty International's refugee officer was appalled: 'It penalises the genuine. Torture victims don't tell their full story immediately on arrival.'[100] But the new policy had the desired effect. 'Straw blitz on gipsy spongers,' crowed the triumphant *Sun*.[101]

In the last week of October, only five Czech and Slovak refugees arrived in Dover. Prosser celebrated in the papers, thanking Jack Straw for his 'tough new measure' and praising the government's policy of detaining the male 'heads' of refugee families.[102]

New Labour would repeat this process of throwing off its liberal and new left inheritance many times, so that when they were finally out of government, Blair would recall: 'We had come to power with a fairly traditional but complacent view of immigration and asylum.' It had been a view steeped in the memory of Jews fleeing fascism, only to be turned away from Britain. That, he said, meant that such a view was 'completely unrealistic in the late twentieth century'.[103]

When the papers had finally tired of the Roma story, the National Front called a rally in Dover. The Front had for many years been the largest far right group in the country, and although they were now being eclipsed by the British National Party, they remained a powerful voice of white supremacy. As the day of the march neared, dozens of Roma living in Kent fled to London, telling housing officials there that locals in Kent had threatened and spat on them, and that they were terrified by the prospect of skinheads descending on Dover.[104] They were turned away.

The NF arrived on a Saturday in mid-November. On the Dover seafront, the hands of the clock tower marked half-past twelve. It stood above the old lifeboat house, a squat, neo-Gothic monolith of rough ragstone adjoined by a pretty hexagonal turret that stared out over the ferry terminals, the harbour and the choppy grey water of the Channel. About fifty members of the Front had been waiting there in the salty breeze, and now they set off along the seafront. Young men, some sporting shaved heads and bomber jackets and others dressed less ostentatiously, sang 'Rule Britannia' and carried home-made signs: 'Gipsies GO BACK', 'NO ROOM HERE'. Voices chanted: 'The National Front is the white man's front! Join the National Front!'[105] Union flags and an Ulster Banner fluttered above them in the sea winds, and behind the skinheads marched a line of men in ties and overcoats, their wispy grey hair caught in the breeze, their shadowed eyes staring ahead.[106]

They were followed all the way by a slightly larger group of anti-racists under the aegis of the Anti-Nazi

League, most of them young white men, some in baseball caps, others with a grungier look. Several held lollipop-shaped, professionally printed ANL placards ('STOP THE NAZIS'). Others shoved against a line of police officers in baggy light-reflective yellow coats, the stiff collars of their regular black suits popping out at the neck from underneath and their traditional domed helmets secured by a strap round the chin.

This messy crowd made its slow way past occasional ice cream vans and the line of empty wooden benches that looked out over the pebble beach. The NF kept marching, the anti-racists shoved and the police jabbed their fists into both groups. From overhead, they could hear the juddering drone of a surveillance helicopter circling. A broken bottle thrown by an NF member fell on an ANL protester, slashing open his eye.[107] Still, the crowd edged along the seafront, past a lawn dotted with neat geometric flower beds and, behind it, a long block of red-brick 1950s flats. From a balcony, an elderly man in his pyjamas waved a Union flag, but local reporters looking for quotes could find few members of the public who supported the far right marchers. Indeed, most Doverians entirely rejected the notion that anti-asylum-seeker feeling might be connected to racism. The police largely kept the two groups apart, but the NF eventually abandoned the march and piled back on to their coach.[108]

The weekend that the Roma controversy had hit the front pages, the Queen and Tony Blair had stood to listen to the national anthem as it echoed around the cavernous

varnished wood interior of Edinburgh's International Conference Centre. It was, of course, a tune that both had heard countless times before, and it was customary to play the song at the Commonwealth Heads of Government Meeting ('CHOGM'), as the Queen was the honorary leader of the Commonwealth. That day, however, it sounded distinctly unfamiliar.

The song had been sped up and played on synths and marimbas, a wooden instrument, similar to a xylophone, which had been created by African slaves in Central America. The Queen, dressed entirely in garish daffodil yellow and sitting under bright lights at the front of the stage, was at this moment somewhat conspicuous. As she listened to this new version of the national anthem she looked 'bemused', according to one reporter.[109] Another noted that 'she did rather screw her face up when it was played'.[110]

The British press also professed to be shocked by this modish performance, and one surprised reporter wrote that the music had been played by a Caribbean steel band,[111] while another compared it to the music of the Lighthouse Family, the soulful easy-listening duo who were popular at the time, and who were led by a British-Nigerian singer.[112] These comparisons were not accurate, but the reporters had correctly interpreted the intended message. The new arrangement of the national anthem, which had been commissioned by the government, indicated that a modern Britain was a multi-ethnic one.

Blair had earlier told *Time* magazine: 'When I see pageantry in Britain, I think that's great, but it does not

define what Britain is today.'[113] It was widely claimed that, in an attempt to prevent any ancient customs spoiling the Commonwealth meeting's icily modern atmosphere, he had banned bagpipes from the Edinburgh event.[114] The rumour turned out not to be quite true, but it stuck because it fitted with the image that Blair had created himself.

The prime minister even spoke, publicly and repeatedly, of trying to 'rebrand' Britain. It was an extraordinary and daring position to take, representing national culture as a stylistic choice that could be swapped at a whim for something that would more efficiently attract investment and talent. New Labour, instinctive internationalists who sometimes tried to use anti-migrant feeling for their political gain, treated national identity, and its shadow of xenophobia, as malleable tools. Few in the party seemed to fear that those tools might one day overpower them.

Blair was sometimes accused of fetishizing modernity, of treating it as valuable in itself, but his position was more reasoned than that. Like many, he viewed the globalization of markets as a historical juggernaut, as inevitable, and his political programme required that both the British government and its citizens – its workers, its consumers – should unquestioningly adapt to such an unstoppable force. That was what being 'modern' meant to him. Tradition and comfort were irrelevant; this was a matter of national strength.

The same juggernaut of globalization, specifically the movement of labour and the trading of goods that could now be produced more cheaply abroad, was making the

working- and lower-middle classes in the UK vulnerable. Blair was not willing to shelter ordinary people from those harsh conditions, but he was, it seemed, willing to use immigration policy to ensure that migrants, and not New Labour, were blamed for the shortcomings of both the market economy and the welfare state. In the coming years, the Immigration and Asylum Act, its dispersal schemes, its voucher system and its widening of the use of detention would demonstrate that New Labour's 'direction of travel' had been signalled in Dover.

After the marimba 'God Save the Queen', guests at the opening ceremony were entertained with a video, the title of which was so strongly associated with the New Labour project that it had been used to name a collection of Blair's speeches: *Britain: The Young Country*. The film was flashy, loud, fast – nine minutes of the country's recent achievements. Such videos would soon become a staple of conferences, presentations and promotional events, but at the time this was perceived as distastefully ostentatious and was widely remarked upon. Among other highlights, the film featured clips of the Notting Hill Carnival organized by members of London's Caribbean community. The British government was not just flatteringly projecting part of the Commonwealth's contribution to the UK back at representatives of its member states. It was identifying Commonwealth migrant communities as being integral to the UK.

The design of the opening ceremony in Edinburgh, its anthem and its video, pointed to the formation of a political

project known as 'multiculturalism'. This was a programme of enabling the cultural differences between different minority ethnic communities, most members of which were migrants, or were the children or grandchildren of migrants. In one sense, multiculturalism was not an aspiration; it was a fact. You only had to walk twenty minutes east of the conference centre to find an area that had two mosques and several curry houses.

About ten minutes north of that area was the Waverley Shopping Centre. A group that promoted Tamil culture in Britain had planned to rent the roof of the Waverley for a festival that would run concurrently with the CHOGM, and 600 supporters were going to take the train up to Scotland from London. However, the Sri Lankan High Commission heard about the event and wrote to Edinburgh City Council, the police and British government officials claiming that the event's organizers were a front for the separatist Tamil Tigers, who had killed eighteen people only a week earlier in a series of bombings in Colombo. They did not write to the shopping centre itself, but someone – it was widely presumed a Home Office official – did so, and at the last minute, the shopping centre told the cultural event's organizers that they were backing out of the agreement. The local police allowed thirty Tamil protesters to stand outside the CHOGM, but evidently multiculturalism only went so far. The radical politics of many minority ethnic groups were not the sort of cultural differences that New Labour wanted to encourage.

Multiculturalism was often, then, a superficial approach. The Notting Hill Carnival's appearance in the promotional

film was part of what critics called the 'three Ss' approach to multiculturalism: 'saris, samosas, and steel bands'. This multiculturalism was a simplistic representation of minority ethnic experience in the UK, and it was studiedly apolitical. Like many members of the British anti-racist movement, writer Arun Kundnani argued that although, or because, many black and Asian Britons were politically angry and engaged with fighting racism, New Labour's definition of diversity ignored these elements of minority ethnic experience.[115] As well as obscuring views that might challenge those in power, multiculturalism encouraged conservatism. Kundnani and others showed how official attempts to recognize minority ethnic 'community leaders' gave power and influence to men who were from wealthy families, and who espoused conservative values.[116]

The right criticized multiculturalism for its supposed moral relativism, for encouraging a multiplicity of opinions and customs that included, they said, immoral practices and extreme ideas. The left, by contrast, argued that forced marriage, female circumcision and other supposedly traditional practices were enabled by multiculturalism only when it suppressed a true diversity of radical and progressive ideas. Minority ethnic communities were not homogeneously conservative; they were made to look that way by their 'community leaders' and by white officials.

Towards the end of the CHOGM opening ceremony, Blair walked across the stage to the dais, lit in bright purple and tagged with white faux-graffiti that, again, evoked black British culture. His speech purported to describe what

the country was, but he was saying more about how he wanted it to be: 'You are here today in New Britain. There is a new British identity – modern, enterprising, outward, open and compassionate ... The new Britain', he said, 'is a meritocracy where we break down the barriers of class, religion, race and culture.'[117]

Many Britons believed the hype, and that hope energized Blair's political project. Devolution, an ethical foreign policy and multiculturalism were projecting a vision of a UK that would be more tolerant, cosmopolitan, free and fair.

Despite the press outcry over the Roma in Kent, the most authoritative surveys showed that the vast majority of the public were preoccupied neither with what pollsters labelled 'concern about race relations' nor, more specifically, with anxieties about immigration. This was the time for New Labour to act with courage, and even to sacrifice some political capital, in order to stabilize and secure the turn towards relatively tolerant attitudes that they were witnessing. Supporters of migrant rights advocated for shifting public discourse to a more respectful register, and channelling the economic benefits of immigration from Britain's super-rich to its much less wealthy communities.

Similarly, it was the moment for the United Kingdom's geographically unbalanced constitution to be mended, whether by a more even-handed form of devolution, as New Labour planned, or by federalization and a proportional electoral system – plans that they had hinted that they were interested in. A more balanced and less fractious Union, one that did not obstruct social democracy or radical challenges,

progressive and reactionary, might have been achieved. The counterfactuals are endless. Robin Cook might have been allowed to enact a foreign strategy that was significantly less jingoistic, and the UK's involvement in a series of wars, not least the war in Iraq, might have been avoided. The government's multicultural rhetoric might have pushed beyond its superficial and market-oriented starting point to embrace the radically diverse, sometimes confrontationally different, people and ideas of the UK today.

This future that never happened would have gone far beyond 'Cool Britannia', a popular slogan that had started life as the name of an ice cream flavour produced by the US-based firm Ben & Jerry's. Associated with that proclamation of national renaissance was the February 1997 edition of *Vanity Fair* featuring actress Patsy Kensit in a bra and her boyfriend, rock star Liam Gallagher, under a Union flag duvet: 'London Swings Again!' the magazine's cover shouted. Tellingly, these totems of Britain's liberal revolution, an advert and a headline, were little more than marketing ploys, and both the ice cream and the famous magazine edition were distributed only within Britain. Whatever the UK was turning into, it was of less consequence than establishment observers claimed, but exaggerating how much the country was changing suited the interests of people in power.

New Labour's combination of Thatcherite economics and egalitarian marketing that echoed the new left made the party appear shiningly modern in a way that those constituent elements, when they stood alone, could not. Blair's party was strong, but the polity on which it stood was

decomposing. Some perceived a threat to national culture, whether that meant empire, whiteness or something else; others felt it was social democracy that was in danger; and New Labour had identified structural weaknesses in their party's electoral base.

These tensions within the nation-state, which looked so different to various observers, had been growing for years. Partly by accident, and partly because New Labour had entered government in 1997, the party's response to those tensions was largely determined during that year. The disintegration of the empire was going to be solved with an ethical foreign policy, the ethics of which were dubious, the weakening Union would be saved by a devolution strategy that was in danger of becoming counterproductive, and a short-term compromise was going to obscure the potential antagonism between migrant communities, those who considered themselves natives, and Britain's elites.

The prospects for new Britain were not good. Labour was compromising between allowing large numbers of migrant workers who would work for low wages into the country, rhetorically celebrating multicultural diversity, and pleasing the hard right with policies that were punitive, although they had little impact on the number of people moving to the UK. Over the next twenty years, immigration and what pollsters labelled 'race relations' would rise from a marginal position in lists of public concerns to the top of those lists, and they would become the central issue of political contention.[118] Foreign policy would be marked by military interventions, a War On Terror that promoted Islamophobia at home, and,

eventually, the splendid isolation of Brexit. The division of the United Kingdom would come to seem all but inevitable. New Labour's gleaming vision would never materialize.

At Prague's central bus station, a crowd of reporters were waiting. Julius, a Roma man from South Moravia, got off the coach. He had never made it into Britain, and instead had slept rough in the port of Calais for several days. 'I wanted to find myself a job, but I was forced to stay in a camp,' he told the journalists standing on the pavement. The other passengers refused to speak – perhaps they were distressed, or maybe they were too angry after discovering how they had been represented by the press – but Julius explained to the reporters that if they wanted to know why he had tried to get to the UK, they might consider the actions of the Czech government. 'They should make the laws for us, and those people would not be leaving,' he said, before walking to his next bus, the one that would take him back to the home he had tried to escape. 'The hatred here is so big. There are no laws.'[119]

2 / MURDERERS

The most notorious journalist in Britain was having lunch with the country's highest-ranking police officer. Paul Dacre, editor of the *Daily Mail*, had a strong relationship with the Metropolitan Police – Britain's senior constabulary, known as 'the Met' – and he was taking a break from his busy day to meet with its Commissioner, Sir Paul Condon. They sat in Dacre's Kensington office, a large, light room lined with books and panelled in cream. A dramatic gilt-framed naval scene hung above a shelf of the day's papers. Older, taller and thinner than the editor, Condon's heavy brow fell over bright, thoughtful eyes as he expounded on various items in the day's news.

One of these stories was about a coroner's inquest into the murder, four years previously, of a black teenager called Stephen Lawrence. Five young white men had already been accused and acquitted of his murder, but today, Wednesday, 12 February 1997, the same five were giving evidence on the death at Southwark Coroner's Court. It was a murder, but the victim was black, and perhaps consequently the case had rarely received great press attention. Nonetheless, Dacre was interested, and Condon revealed that he thought the five 'were as guilty as sin'. Later, the editor cast his eye over pictures that had come in from the inquest. He noted

how, after giving evidence, the five 'came strutting out of the coroner's court'. Their apparent arrogance rather irritated Dacre – and then he had an idea.[1]

It was a headline. A front page that would punish these men for their impudence, further the *Mail*'s hard-right agenda and give publicity to the case of a murdered black boy whom other white newspapers had ignored. This was exactly the kind of campaigning journalism in which Dacre was an expert, but he could not have predicted either the size or the nature of its impact. Like the other formative shocks to British society that would take place in 1997, it was going to push powerful conservative institutions, including Dacre's newspaper and the British government, into an uneasy alliance with supposedly less powerful subversives – among them Stephen's mother Doreen.

It would seem, to many, as if radical campaigners were gaining access to the levers of power, and that a post-racial age was dawning. Apparently, the UK would soon be a safer and fairer place for its minority ethnic communities, as well as being a multiculture in which its diversity would be visible.

Such immense change could be effected only by radical policies, but those would be blocked by the establishment groups and figures with whom the Lawrences would have to cooperate. The family's struggle to expose racism would play a great role undermining individual racist prejudice in Britain, but it was not going to dissolve the country's more insidious, institutional forms of racism. Nonetheless, British media and political elites would behave as if it had

done so, and they would benefit from that sunny vision of a new Britain.

A decade and a half after the appearance of Stephen Lawrence's murder in the white public's consciousness, the police killing of another young black man, Mark Duggan, would result in thousands of young people, most of them black and mixed-race men and boys, fighting with the police on the streets of England. A few years later, the Black Lives Matter movement would emerge in the UK. Inequality, its fallout and the struggle to end racism would continue.

The coroner who presided over inquests into deaths in south London, which is home to most of the capital's Afro-Caribbean community, was Sir Monty Levine. Stories like that of the Lawrences were familiar to him, and two days before Condon's lunch with Dacre, Levine opened the inquest into Stephen's killing.

There, Doreen Lawrence repeated the accusation against the Met that she had been making for four years: the force's investigation into her son's murder had been impaired because its officers were racist. Why, she asked, had they not cared for him as he lay dying, why had their attitude to her family been so patronizing, even aggressive? Why had there been so many delays and mistakes in their detective work, and why had her son's killers never been punished?[2]

Faced with the inattention of the press, politicians and the public after the murder of her son, Mrs Lawrence had not only demanded justice for him. She had also argued that there was a connection between Stephen's murder, the

police's treatment of his case and her family, and how, in general, black people in Britain were treated by institutions dominated by white people. That connection was racism.

Mrs Lawrence had a platform from which to speak, but at best the inquest seemed likely to provide a final opportunity to wheedle information about the murder out of the five white men who had previously been suspected of killing Stephen. Those attending the inquest had heard how, at about half-past ten on the evening of Thursday, 22 April 1993, Stephen and his friend Duwayne – both of them eighteen, and both of them black – were waiting for a bus on Well Hall Road in Eltham, suburban south-east London. Suddenly, five or six white men were running across the street towards them. Someone shouted 'What, what, nigger!', and one of the men knocked Stephen to the ground. Duwayne thought he saw one of them hit his friend with something, but the man had not hit him at all. He had stabbed Stephen with a kitchen knife.

It plunged five inches into the boy's chest. The man pulled the knife out and stabbed Stephen again, this time five inches through his arm. Duwayne was running away and, somehow, Stephen got up and followed. The men did not follow him, and he managed to run about a hundred and fifty yards before slowing. Desperate and confused, he called out to his friend, 'What's wrong with me?' He stopped, collapsed, and only then did his friend see that Stephen was covered in blood. Duwayne tried to flag down passing cars. The only person who stopped was an off-duty policeman, who called for an ambulance and back-up.

Within minutes, a neighbour heard that Stephen had been attacked, and contacted Mrs Lawrence and her husband Neville. They jumped in their car, driving around nearby streets, desperately hoping to find their son. Soon they headed for the local hospital. Yes, their son was there, but no, they could not see him. Before they were allowed to do so, he died.

Two young white men who lived near the Lawrences, Neil Acourt and Luke Knight, were eventually charged with Stephen's murder, but the Crown Prosecution Service decided there was not enough evidence to mount a case against them. However, buoyed by financial donations and by a huge number of supporters, the Lawrences brought private prosecutions against Knight, Acourt and three friends of theirs: David Norris, Gary Dobson and Acourt's brother Jamie.

Prosecutions initiated by individuals rarely succeed in the British justice system, but the Lawrences thought they could win this one. 'The five' had long been known to local police as members of a loose gang who often started fights in the pub or attacked other kids on the street. However, the family's case depended on witnesses identifying the attackers accurately and consistently, and none was able to do so, least of all Duwayne Brooks.

The boy who had seen racists stab his friend to death had been deeply disturbed by his experience, and two months after the murder he had been found wandering near the scene of the crime, screaming to no one in particular about the events of that night.[3] Duwayne's post-traumatic stress

disorder was a normal response to his experiences, but it made it difficult for him to give a reliable witness statement. The police investigation and various prosecutions might have benefited hugely if the police and medical services had ensured that Duwayne received proper emotional support, but like many black men in Britain who experience mental health problems, he had not been helped adequately.[4] It was therefore unsurprising that, during the Lawrences' private prosecution against the five, Brooks changed his account of the hurried attack several times. In court the judge criticized Duwayne's credibility, saying he did not know whether he was 'on his head or his heels'.[5] The judge dismissed the case and ordered an acquittal.

Although Duwayne's memories of that night became clearer, further prosecutions were impossible. Even if stronger evidence were one day discovered, the accused were protected from being twice prosecuted for the same crime by the law preventing 'double jeopardy'. With no further prosecutions likely, it was time for a coroner to determine officially what had caused Stephen's death. This was the inquest that so fascinated Dacre.

From the witness stand of the coroner's court, Doreen Lawrence described to the jury and to press in the gallery the tensions, struggles and humiliations that she had experienced as a result of police behaviour in the four years since Stephen had died. She told the court how, less than a week after her son had been stabbed to death, she had gone to the police station near her home with a list of names on a piece of paper. The names were those of the men

who, according to other locals, had killed Stephen. Doreen described how Detective Chief Superintendent Bill Ilsley had taken the piece of paper and how, as he spoke to her, he had casually rolled it up into a ball. The anecdote suggested that some officers had behaved extraordinarily insensitively towards the Lawrences, but confronted in court with this accusation, Ilsley protested with outrage. He had done no such thing, and had simply folded the note to keep it safe.

The coroner, Sir Monty Levine, was a charismatic man with a white handlebar moustache waxed carefully into curls. Having spotted an opportunity for a little theatre, he decided to perform an experiment. He took the paper, which had been presented as evidence, examined its creases and, in view of all those in court, he folded it along the first crease so that it was now half its original size. Then he folded it once more, and again, and again, and then again, still following the lines made by Ilsley's original folding of the paper four years earlier. Evidently, the officer had not rolled it into a ball, but he had taken potentially vital evidence from the mother of a boy who had been stabbed to death only days before and, as she had spoken to him, he had folded it into a minuscule packet right in front of her face. Mrs Lawrence had not claimed that Ilsely had done this because he was filled with conscious racist hatred; her point was that his callous behaviour was the result of a wider racist culture.[6]

Mrs Lawrence went on to describe a series of humiliating and unpleasant experiences that she had had with the police, knowing that she would then have to sit in court and watch

the five – the men whom her private prosecution had failed to imprison – give their version of events on the night her son had been killed. There would be nothing to stop them sticking to a few simple, rehearsed lines, and there was little prospect that they would reveal anything important. It was unclear where her family's campaign could go from there.

Soon enough, it was the turn of the five to give evidence. Representing the Lawrences was Michael Mansfield, QC. He asked David Norris what his name was, but the young man replied: 'I am claiming privilege on that question.'[7] There was laughter from the public gallery. Mansfield tried to get Norris to state whether or not he would answer his questions, and again the young man insisted upon his legal right to silence. Indeed, when each of the five was called to give evidence about the night Stephen had died, they all stuck to the same line: 'I claim privilege'. It was highly provocative and it was a huge miscalculation, one that would have extraordinary consequences.

Luke Knight's mother later defended the boys' silence during the inquest. 'They done that on legal advice,' she explained. 'We go in a courtroom, we don't understand everything that's going on. We're normal people. We take out legal advice as advice. It's as simple as that.'[8]

The five thought that they were playing it safe, but Mansfield had them in a corner. 'It's completely pointless,' he proclaimed to the court. 'These young men have decided to say absolutely nothing on any occasion to absolutely anything.'[9] He made the same point again and again, but although this process was repetitive, and no doubt boring,

it worked in his favour by dramatically emphasizing to the judge, jury and court reporters just how much the five did not want to talk about the night of Stephen's death. Later, as Mansfield tried to question Jamie Acourt, and again was informed by the witness that he claimed privilege, the barrister interrupted himself theatrically: 'There has been a wall of silence about this case. There is somebody who knows much more than they are prepared to admit and therefore I must be entitled to ask questions which perhaps touch the conscience of those who know.'

Mrs Lawrence was appalled by the behaviour of the five: 'I was not sure whether I was in a courtroom listening to evidence, or at a circus watching a performance. It became a mockery of trying to get to the truth.'[10] Their 'wall of silence', which Mansfield emphasized and which he presented as self-organized arrogance, frustrated Mrs Lawrence, Paul Dacre and also another group: the jurors.

On Thursday morning, Levine asked the jury to consider their verdict. He reminded them that, this being an inquest, they were required to return a verdict only on what had caused Stephen's death; its date, time and circumstances; and whether it was unlawful or accidental. If they could not be sure which, they were to give an 'open' verdict. Levine told the jury explicitly that they must not try to identify who the murderers were. Any attempt to do so would create the impression of legal confirmation that a particular individual or individuals had killed Stephen, when, in fact, no criminal court had been able to come to such a conclusion. With the inquest's end fast approaching, not many in attendance can

have doubted that the twelve jurors would simply return a verdict of unlawful killing.

That is not what happened. Levine's warning against identifying Stephen's killers could not erase the jurors' memory of these five young men shuffling in and out of the witness stand, claiming privilege, upsetting Stephen's family and frustrating their barrister. Instead, the jury said what they believed. Directed to announce the jury's verdict by Sir Monty, the foreman stood and announced to the court that Stephen had died 'in a completely unprovoked racist attack by five white youths'.[11] Inquest juries were not allowed to do this. They had gone much farther, they had spoken much more emotively, and they had been much more accusatory, than they were supposed to. It was as close as it could be to a guilty verdict.

Justice, however, had still not been done and many in Britain's black community were certain that the police and the country's racist culture were to blame. Dacre, by contrast, was more sympathetic to the police. As the editor of the *Mail* saw it, five arrogant men had made fools of British law and order, and this was the wrong that he would right with the headline that he was planning. His front page needed to insist that the five had escaped justice, and the jury had now given him far more leeway than he could have hoped for in making this public accusation against the former suspects.

Over four years, Mrs Lawrence had consistently argued that the Met had failed to catch her son's killers, not only

because some individual officers were prejudiced against black people, but also because the police was a racist organization, and part of a racist society. Her statement to the inquest had been clear:

> When my son was murdered, the police said my
> son was a criminal belonging to a gang. My son was
> stereotyped by the police – he was black, then he
> must be a criminal – and they set about investigating
> him and us. The investigation lasted two weeks. That
> allowed vital evidence to be lost. My son's crime is
> that he was walking down the road, looking for a
> bus that would take him home. Our crime is living
> in a country where the justice system supports racist
> murderers against innocent people. The value that
> this white, racist country puts on black lives is evident,
> as seen since the killing of my son.[12]

Her words reflected the language of a very specific radical political movement that in Britain had taken on the broad label of 'anti-racism'. As her media profile rose over the following years, she, like many people trying to change Britain in 1997, would make the language of her speeches and statements more amenable to the public and to journalists, but her frank and passionate words would still echo those of anti-racist campaigners. She was going to force their ideas into British public life.

The anti-racist movement had been built by a diverse group of activists: some came from African or Caribbean backgrounds and some were from South Asian communities,

but almost all identified as black. It was the 1970s and 1980s, a time of especially intense police violence against black people in Britain, with constabularies regularly undertaking brutal raids in black, working-class areas. These raids were often nominally aimed at confiscating drugs or weapons, but they frequently disrupted the whole community, and on many occasions they developed into violent clashes between police officers and black people. Racist police violence was not limited to such large-scale confrontations. Black detainees reported that officers had attacked them while they had been held in the back of a police van or in cells, and most black men expected to be stopped and searched on the street frequently.

Anti-racists therefore sought to target the racism of whole organizations, especially the police. This idea – that not only individuals, but also groups and organizations, could be defined as racist – was revelatory. Whether or not a group's members had racist thoughts or feelings, the way a group worked could end up seriously disadvantaging people from minority ethnic backgrounds and, as in the case of the police, might lead to violence against them.

In the late 1960s, US black power activists Kwame Ture and Charles V. Hamilton had brought these ideas under an umbrella phrase that would eventually have a significant bearing on the story of the Lawrence campaign. They had coined a new term, 'institutional racism': the systematic inequality between black people and white people that was produced, regardless of intention, by an organization's norms and policies.[13]

Lord Scarman had famously insisted that this term could not be used to describe British police forces or society in the report of his 1981 judicial inquiry into the events known as 'the Brixton riots', which are also known, especially by some of those involved, as 'the Brixton uprising'. Scarman misunderstood what institutional racism was, defining it as 'knowingly, as a matter of policy, discriminat[ing] against black people'. This, he said, did not happen in Britain. However, in his report he also described how some police and public servants were consciously racist, and how the policies of public bodies might unwittingly discriminate against black people. In doing so he implicitly acknowledged that British public life was, indeed, characterized by institutional racism, as anti-racists defined it.[14]

The most notorious expression of institutional racism in Britain was, and would continue to be, the disproportionately high number of black people stopped and searched by police. Police often claimed this inequality reflected higher levels of 'criminality' in black communities. They noted that although officers used their sus powers against a higher proportion of black people ('sus' was short for 'suspected person'), black individuals were no more likely than whites to be arrested after being stopped and searched.[15] The implication was that black people deserved to be stopped and searched more often.

Campaigners have countered these arguments by claiming that, whether or not a black individual has broken the law, police will often arrest them if they express significant irritation about being stopped and

searched. Plenty of anecdotal and video evidence exists to support this claim, but there is no certain way of knowing what generally takes place. The Met have admitted that 40 per cent of arrests following a stop and search are unrelated to the officer's original reason for searching the individual,[16] seeming to strengthen the anti-racists' claims, but that conclusion is not watertight. There are no records detailing when an officer has arrested someone just because they stood up for themselves. However, given the lack of conclusive evidence regarding this question, it is particularly striking that successive governments and police commissioners have accepted that this is an issue that has to be resolved.

Anti-racist campaigners argued that because such inequality was spread so widely across Britain, it could not be the result of the racism of a few individual officers. It had to have been produced systematically by the culture of the UK's constabularies and police stations.

However, other forms of police racism seemed even more intractable because they stemmed from the force's role in a society that was increasingly divided between rich and poor. Writers and activists like Lee Bridges argued that black communities suffered more than others from the aggressive policing of working-class communities because they were poorer, on average, and because their history of politically resisting the authorities made them more of a threat.[17] Hiring black police would not solve this, argued many black activists, because all officers to some extent become socialized by the police community and, moreover,

they have to execute the government's policing priorities, regardless of whether or not they are personally prejudiced.

Around the same time, socialist and critical race theorist Ambalavaner Sivanandan identified other reasons why police racism might be unstoppable without wholesale political and economic change.[18] He observed that capitalism and the modern state had often thrived on racism because it stopped black and white workers fighting together as one class. In that case, defeating racism would require a systemic transformation of both state bureaucracies and the economy, and consequently the anti-racist movement was generally anti-capitalist, and often anarchist. It was a revolution, but it also had simple, pragmatic demands. Activist and writer Cecil Gutzmore emphasized that policing priorities and resources were aggressively focused on the crimes that young black men were more likely to commit, and on young black men themselves, despite the fact that they committed only a small proportion of all crime.[19] Some causes of inequality were difficult to influence, but anti-racist activists observed that the Home Office could immediately alter its policing priorities to be less institutionally racist. It did not do so.

In the immediate aftermath of Stephen's murder, the Lawrence family had been overcome by grief and shock. Stephen's fifteen-year-old brother Stuart had waited at home after the family were initially told that Stephen had been attacked, and Stuart was still awake, waiting for more news, when his parents got back from the hospital. Mrs

Lawrence has described how, when she finally told him that his elder brother was dead, he just 'cried and cried'.[20] When his ten-year-old sister Georgina woke the next morning, her mother told her what had happened. She 'went mad', and ran around the room, screaming.[21] By contrast, her father, Neville, was stunned into silence, unable to find the words to explain to friends what had happened. Mrs Lawrence found the strength to speak about what had happened, but nonetheless she 'could not take it in'.[22]

Soon, however, the Lawrences' grief was joined by anger. From the very beginning, it seemed to them that they were experiencing the lack of police attention that so many in the black community had previously reported. For a few days, they kept their suspicions private, even while Neville was calling journalists for whom he had done painting and decorating jobs, desperately trying to persuade them to give the case publicity.

However, on 27 April, five days after the murder, Stephen's parents gave a news conference during which they tore apart the police investigation. The officers working on their son's case had been lazy and neglectful, they said, and their treatment of the family had been insensitive and rude. Why did the police feel it was necessary to investigate so thoroughly the possibility that Stephen and Duwayne had been criminals, or that the stabbing had resulted from a fight between two black boys? And why, given that there were suspects already, had no one been arrested? Later, the family would ask why those suspects had not been placed under surveillance immediately, and why, when that

surveillance had begun, the men being watched had been allowed to take black bin bags of unknown objects out of their homes and throw them away, without the police ever examining the refuse.

While several officers were remarkably insensitive in their interactions with the Lawrences, others briefed against the family to the media. Something else was going on, as well. In the weeks and months after Stephen's death, his mother noticed how the Met's family liaison officers seemed suspicious and unnerved by the presence of anti-racist campaigners supporting the Lawrences, and regularly asked her for their names. Were the police hoping to undermine her family by highlighting their connections to radical groups? 'It's something I suspected,' she would admit many years later. She had always thought that 'the Met wanted to make us look [like] we were asking for things we shouldn't have … All they wanted to do was discredit us.'[23]

More pressing, however, was the Lawrences' anxiety about how little attention was being paid to their son's murder by the white media and by white politicians. The killing had been more widely covered than other racist murders that had taken place in their area, probably because Stephen came from a middle-class, churchgoing family, and he was therefore considered a sympathetic victim. However, even a glance at the newspapers of that period shows that the murders of white children generally received much more publicity than the couple of short articles that resulted from Stephen's death. The Lawrences responded by courting the media, by making speeches that were sometimes deeply

angry, and by taking every opportunity they could to highlight their son's killing.

Help came in the unexpected form of Nelson Mandela. The Lawrences had secured a meeting with the man who would soon become president of South Africa when he briefly visited the UK, a fortnight after Stephen's death. The media attention to his tour was huge, and to get to his hotel, the Lawrences had to wade through a crowd of fans and journalists stationed outside the building. After their short meeting, the three of them participated in a photocall on the steps of the hotel. Mandela understood what needed to be said. 'I know what it means to lose a child under such tragic circumstances. Such brutality is commonplace in South Africa, where black lives are cheap … Their tragedy is our tragedy.'[24]

A famous face was now attached to the story, and his controversial quotes were on the evening news. It was clear that this news story was getting bigger, and early the next morning police officers smashed down Jamie Acourt's front door, and forced their way into the homes of his brother Neil and of Gary Dobson. Norris and Knight were arrested later that day. Detective Superintendent Brian Weeden later denied that Mandela's intervention had influenced his decision to arrest the five, but it was not a very convincing claim.[25] There had been no new evidence to trigger the arrests.

In the short term, the arrests mattered because it seemed that, by engaging directly with the mainstream media, the Lawrences and the anti-racist activists who supported them had forced the police to act. The arrests would turn out to

be important in the long term too. Without them, four years later, the jury at the coroner's inquest into Stephen's death would probably have had no one to accuse in its oblique but powerful fashion. Nonetheless, the arrests were also too late. It was too late for the police to gather the evidence of knives and bloodstained clothes that, in the days after the attack, some of the five might still have had in their possession, and it was too late for the Met to rebuild their relationship with the family.

The police tried to blame failings in the investigation on its officers' lack of time and resources, but that bore no relevance to what may have been the police's greatest investigative mistake. After Stephen's death, dozens of locals had approached them with information, including names of people they believed to be the murderers, but the police had delayed acting on this information. None of the locals who had gone to them had witnessed the crime itself, but the rumours had been enough to lead to arrests, and if those had taken place earlier, harder evidence might well have been found.

The weekend of the arrests, a march against the British National Party near the place where Lawrence had been killed was organized by largely white anti-fascist groups and by a new black Troskyite organization. There was a large fight, and about nineteen demonstrators and several police were injured.

The view of the Lawrences' representatives, who were members of other anti-racist groups, was clear: they disagreed with these tactics because they feared that they

encouraged police violence. Nonetheless, the *Daily Mail* reported that Mr Lawrence was 'bewildered by it all' and that 'an ordinary family might be being used for political gain'. The paper quoted an anonymous police officer who described the Lawrences as the 'pawns' of anti-racist organizations. The article's authors described as 'chilling' the warnings of activist groups that police violence might incite an aggressive response from young black people, and highlighted connections between those who criticized the police and Sinn Féin.[26]

Stephen's parents were appalled when, a few days later, they saw photos of their own faces in the *Mail*, surrounded by images of the scuffle. Mrs Lawrence was already concerned that the police might be trying secretly to discredit her family using their connections to political campaigners, but now the right-wing press was using that tactic quite openly.

A week after the protest, however, the family gained the upper hand. The *Daily Mail* sent a black reporter, Hal Austin, to interview the Lawrences. He later admitted that he had been detailed by the news desk to write a story 'knocking' the campaign, and in any case the family knew that the *Mail* was not on their side. After the interview, Mr Lawrence asked Austin about his boss, the editor of the *Mail* – was he a tall, balding man with a house in Islington? Austin confirmed that indeed he was.[27]

It was extraordinary luck: Mr Lawrence had done a painting and decorating job for Dacre only a few months before. He was on the phone to the editor that afternoon, and he was angry. 'How could you do that, and you know

me?' he demanded.[28] The editor's response is not a matter of record, but Austin later described to the *Observer* how 'the following day my instructions were suddenly changed … I was told by the news desk to forget the previous instructions and that they now wanted a positive story.'

After the meeting with Austin, a truce had been maintained between the *Mail* and the Lawrences. The family never pretended to like the paper, but they did not complain about them as they might have done. This was exactly the kind of sacrifice that the radicals and reformists coming to the fore in 1997 had to make. Such compromises would define this period, and this particular compromise was about to have a dramatic impact.

After the inquest closed, Dacre had given orders for his headline. It was now late at night, and more than two million editions of the *Daily Mail* were being printed, their front pages covered with the faces of Dobson, Knight, Norris and the Acourts: the five white youths who had been acquitted, who had claimed privilege, and whom the jury had, a few hours earlier, all but found guilty. Above their photos was a headline screaming: 'MURDERERS'.[29]

It was an astonishing and powerful act of journalism: crude, shocking, potentially illegal and deeply moralistic. As far as the law was concerned, these men were innocent, but nonetheless the *Mail* was accusing them publicly of a vicious and racist killing. For more than a week, front pages, leader columns, comment sections, radio phone-ins and TV debates buzzed with surprise and excitement.

The headline surprised many observers because the paper had a shameful history of reporting on people of colour.[30] However, it seems less surprising if we interpret it, not as a defence of Britain's ethnic minorities, but as a defence of the pride and power of the nation and its overwhelmingly white elite. According to the paper's editorial, the five's wall of silence had put at stake the reputation of British justice, and it seemed that Dacre and his staff had felt this insult so keenly because it had been issued by members of a particular section of the British working class whom conservatives often dismissed as undeserving. The *Mail* emphasized repeatedly that Neil and Jamie Acourt were 'jobless brothers' and 'hooligans'. The whole lot were 'layabouts' and 'moronic thugs' who, it was observed, smoked cannabis and slept in all morning.[31]

The paper claimed that justice had not only been insulted by the men's refusal to answer Mansfield's questions, it had been prevented from running its course during the initial investigation by another silence, one that the five had imposed on their neighbourhood. Class played a key role in this part of the story too. On 'the estate struck dumb by fear', reported the *Mail*, 'the police investigation ran into a frightened silence'. The paper indicated that, after Stephen had died four years earlier, many of those living on the 'mean streets' of Eltham had refused to cooperate with the Met because they feared the five and what they might do to them.[32]

These reports entirely ignored evidence to the contrary that had long been in the public domain, and which had

been laid out during the inquest. The Met itself had stated, clearly and on multiple occasions, that dozens of locals had readily and repeatedly offered the police information from the day after Stephen died. These individuals included three witnesses who had been standing at a bus stop near the scene of the murder when it happened. That evidence had not been very fruitful, but the witnesses had nonetheless been forthcoming: they had not been 'struck dumb'.

The paper was shifting the blame for any injustices that had taken place after Stephen's killing away from the police and on to not only five racist working-class boys, but also a whole working-class community. As anti-racist activists had described, black and white working-class people who might have struggled against oppression together were being divided by some of the most powerful people in the country. In the same way that New Labour would cover its anti-migrant policies with liberal rhetoric on multiculturalism, the *Mail* was using its support for some of the Lawrence campaign's goals to protect the police. As would happen many times that year, a part of the establishment was using its proximity to a progressive cause to further its own reactionary agenda.

The *Mail* had consistently featured the story more often than any other paper, and now their line on it was picked up by several news columnists from across the political spectrum. Supposedly liberal papers printed comment pieces dramatically characterizing east London's white working classes as homogeneously racist, and backing up this image of the area's population by reminding readers of

a recording that the police had made secretly a year and a half after Stephen's murder. The Met had hidden cameras in the homes of some of the five men, and in one video David Norris tells his friends:

> I would kill every black cunt, every copper, every
> Paki … I would go down to Catford … with two
> sub-machine guns. I would take one of them, skin the
> black cunt alive, mate, torture him, set him alight. I
> would blow his legs and arms off and say: 'Go on. You
> can swim home now.'[33]

Norris's mother would later dismiss her son's words as insignificant: 'Put a bug in every household in Britain, I should think most of them would say a racist word.'[34] Regardless of its veracity, that statement was a weak excuse for her son's vicious boasting. Later in the video, he jokes with Knight and Neil Acourt about the people who had killed Stephen Lawrence. The five seem to have guessed that the police might be bugging them, and they attempt to subtly indicate their innocence to whoever is listening to their conversations. The real people who had killed Stephen Lawrence, Norris says in one of the tapes, must be 'laughing their nuts off'. 'Yeah,' says Acourt, who has been chuckling at Norris's description of what the murderers must be feeling. 'They're definitely doing that.'

The *Mail* was widely praised for the supposed daring of its front page, especially after several senior members of the legal establishment publicly insisted that the paper's headline had broken the law. In fact, it soon became apparent that the

Mail's coverage had risked very little, legally or financially: there was no criminal case to answer, the five's case in a civil court would have been thin, and in any case they could never have afforded to sue their accusers. Nonetheless, as a provocation, Dacre's headline was an exceptionally powerful weapon. It eloquently reminded readers that these men were unwilling to have their lack of alibi exposed in court, and it dramatically insisted that this was because they were guilty.

Britain's journalistic establishment was terrifically excited about what the *Mail* had done, and it was reported on the front page of the *New York Times*, and in Canada, France, Germany and the Netherlands.[35] Analysis of aggregated British newspaper data shows that in the single year following the publication of the headline, there were more mentions of Stephen Lawrence's name in the British press than there had been in the four years since his death, and most of that new coverage took place immediately after the *Mail*'s controversial front page.[36] This seemed to be a moment when Mrs Lawrence's campaign might start to create a new, liberal Britain, one that would make the dream of a more equal country real.

News and current affairs programmes that had not covered Stephen's murder now responded with items that focused so entirely on the *Mail*'s front page that, with the notable exception of a hastily rescheduled Channel Four documentary,[37] broadcasters seemed to have largely ignored the subject of racism. Far less attention had been paid to the murder of a black boy from a family of modest

means than was now being paid to what had been said about the case by a newspaper owned and run by wealthy white people.

Some praised the paper for demonstrating that all Britons, including the *Mail*'s conservative readers, cared about a dead black teenager. Others tutted about the paper's disregard for legal niceties, but agreed that this had been a minor and necessary sin. Labour MP Diane Abbott, the first black woman to sit in the House of Commons, was one of many black voices who criticized this navel-gazing angle taken by journalists.[38] Because the story had been made more conventionally attractive – because its message had been deradicalized – its coverage was enormous, but making Stephen's murder mainstream news had required that it be given a mainstream meaning, and that meant a white meaning. In a pattern that would be repeated many times that year, radicalism had been exchanged for visibility.

It was not only admirers of the *Mail*'s front page, but also its white critics in the legal profession, who saw this story as being about something other than race. The Bar Council, several senior judges and a senior Tory backbencher were angry that the *Mail* had undermined the judicial process and the course of justice.[39] Journalist Pat Younge, who would eventually become one of the most senior black figures in British television, but who was then a columnist for the *Voice* ('Britain's Favourite Black Newspaper'), also argued that the *Mail*'s front page threatened the future of justice, but he emphasized the potentially racist impact that this was going to have.[40] Younge candidly admitted to 'the elation I

felt when I saw the headline'. He concluded, however, that this was nonetheless 'mob rule, organized by essentially a right-wing paper', and that it would 'leave the institutions and wall of silence unchallenged'. The notion of innocent until proven guilty was especially worth protecting, Younge wrote, because poor and black people made up 'the bulk of the misrepresented and maligned on that paper's pages', but could rarely afford to sue it for libel.

The *Daily Mail* ignored this diversity of critical voices when it issued a withering response: 'if the legal establishment had spent as much energy on the Lawrence case as it is now spending denouncing the *Mail*, the outcome would have been happier for justice'.[41]

Those in charge of the paper's editorial line were keen to anaesthetize the Lawrences' criticisms of police racism, but they had another strong motive for portraying judges and the barristers who supported them as soft on crime, and for blaming them for the acquittal of the five. That week, many senior members of the judiciary had complained publicly about Conservative home secretary Michael Howard's plans to force judges to apply minimum sentences for particular crimes and to limit the right of defendants to trial by jury. In his bulbous tortoiseshell spectacles and grey pinstripe suit, Howard had stood in the House of Commons, leaning against the dispatch box and telling MPs that 'far too many career burglars regard a short spell in prison as nothing more than an occupational hazard'. Behind him, the green leather benches were filled almost entirely with men, also in grey suits, who nodded their heads. 'Hear, hear,' they murmured.

Later, in his reedy and insistent tones, Howard spoke of his fear 'that lenient and inconsistent sentencing can undermine public confidence in the criminal justice system'.[42]

He would be able to prevent such leniency, he explained, if he could tighten his grasp on the judiciary. The *Mail* had long supported the home secretary and his hard-right agenda and, accordingly, it had also criticized the legal establishment, which had resisted Howard's threats to its autonomy. Now, with the general election approaching, the paper was becoming even more enthusiastic in its cheerleading for Howard and his party. If that political context did not motivate Dacre's decision to print the 'MURDERERS' headline then, certainly, that front page created an exceptionally convenient and lucky opportunity for the *Mail* to attack an old opponent. The *Mail* was shifting the blame that radicals had placed on its allies, the Met, on to their rivals within Britain's elite, its relatively liberal legal establishment.

The family was circumspect in their praise for the paper's front page. 'Hopefully we'll get some kind of response from it,' said Stephen's aunt, Cheryl Sloley. Mrs Lawrence admitted years later that 'I felt some small satisfaction when I saw the headline'.[43] She had spent years campaigning, acting as the figurehead of a movement and trying to draw publicity to her son's cause, but it had required a powerful figure like Dacre to attract mass white attention to Stephen's case. That attention had come at a price, and Mrs Lawrence noted that 'The paper was careful not to accuse the police of any misconduct in the case'.[44] Like others pushing their way

into the mainstream in 1997, she was getting used to relying on others who acted, not in order to help her, but in their own interest, and who therefore would never do everything she hoped. She wanted recognition of the police's failings, and the force's racism generally. For that, she would have to seek assistance elsewhere in the establishment.

Since 1993, Mr and Mrs Lawrence had repeatedly demanded a public inquiry into the police investigation of their son's death. As home secretary, it was in the gift of Michael Howard to initiate such an inquiry, but he wanted the Police Complaints Authority, which he claimed was 'entirely independent', to look into matters.[45] The Lawrences were not impressed and, much to their disappointment, Labour's shadow home secretary, Jack Straw, had also refused to give his full support to a judge-led inquiry.

Then the *Mail* published its headline. Straw, always in touch with the conservative social attitudes of middle England, believed the paper's dramatic intervention had profoundly altered public sentiment. Accordingly he continued to meet with Mrs Lawrence, and also with Paul Dacre, who was supporting the Lawrences' demands for an inquiry. However, Straw promised nothing to either side of this very loose coalition, and when Labour won the election and he became home secretary, that did not change. His civil servants were pressing him to offer only a general inquiry into race and community relations, and he worried that the inquiry for which Mrs Lawrence was calling would upset Sir Paul Condon. Straw suspected that the Met Commissioner

was scared his career would be defined by any failings highlighted during an inquiry.[46]

The new home secretary hoped that the *Mail*'s headline had made Stephen's case so significant that he might be free to make his own decision, regardless of his mandarins or Condon, and yet he remained nervous about acceding to the Lawrences' demands. He granted Mrs Lawrence another meeting, this time announcing the event to the press, and on 25 June the Lawrences and a small number of supporters visited Straw at his office on Queen Anne's Gate. Around the corner was the Met's HQ, a block covered entirely by opaque mirrored windows. At the foot of the building stood its famous unusual sign, a slowly rotating triangular prism with the words 'New Scotland Yard' on two sides. The Lawrences arrived, down the road, at the Home Office, which rose up into the sky, fourteen floors of dirty grey concrete, the last two of which jutted several metres out from the rest of the building so that they hung over the street. Their crenellations created the impression of a turreted medieval tower, unnaturally huge and looming over Westminster.

Sitting in a luxurious conference room with her team, Mrs Lawrence felt profoundly pessimistic. 'The furniture was massive,' she remembered. 'The curtains were thick and expensive and everything gleamed.' She was a small woman, simply dressed; her husband was a big, quiet man who spoke with a Jamaican accent; one of their team wore his hair in dreadlocks; and another, their solicitor Imran Khan, was a thoughtful figure with sad, questioning eyes.

The contrast was obvious when Straw walked into the room, accompanied by 'squads of aides in well-cut suits'. They repeated to the Lawrences that it would be better for an inquiry to look generally at police relations with the black community in south-east London.[47]

The two teams sat arguing for an hour. Mrs Lawrence was furious. She had heard it all before. As Straw led her out after the meeting, she repeated what she had told him many times: 'What I want to find out is how Stephen was killed and what happened afterwards – what the police did or didn't do, why they didn't catch the killers.' He listened, and she continued to make her case. Perhaps she persuaded him then, or maybe he had already been persuaded and it had benefited him to withhold his assent until this moment, but by the time the home secretary and Mrs Lawrence had reached the door, he had agreed to her demands. Crucially, New Labour's electoral triumph had kicked Howard out of the Home Office and put Straw in power, and it was the combination of the *Mail*'s headline and Mrs Lawrence's campaigning, he has said, that prompted him to initiate the Stephen Lawrence inquiry.[48]

Sir William Macpherson was a slim, balding, pink-faced man with a Roman nose. The chief of a Scottish clan, he would often wear a tie patterned with its tartan. He had attended Eton and served as a captain in the Scots Guards. He had just retired as a High Court judge, but was considered something of a liberal. Impeccably establishment, but not too ideologically distant from New Labour, Sir William

could be trusted to reach a conclusion that the government would find satisfactory, but it would be hard for anyone on the right to accuse him pre-emptively of being biased.

He was, then, an obvious choice for the government when it was selecting a judge to lead the inquiry. His choice of venue for its proceedings, however, was less obvious. The Elephant and Castle shopping centre might have seemed monolithic and forbidding, painted pink like a dirty birthday cake, surrounded by traffic and decried by the Fleet Street reporters who had to travel south across the river every day to get to it. However, for much of the area's community, a large proportion of whom were black or Asian, its shopping centre was an icon and a vital utility, a place crammed full of stalls and filled with teenagers laughing as they ran between the brightly coloured pillars. Different radio stations played from each shop, the smells of fast food stands competed, toys and games beeped and squealed. And on top of this mall sat the modernist office block of Hannibal House, the third and fourth floors of which hosted Macpherson and his team.

There, they set up the inquiry chamber in the style of a courtroom. It was cramped and busy, with a pine-effect witness stand, tables and chairs for seven legal teams, 150 seats for members of the public, and the judge sitting at a table with his advisers beside him. The wide, pale blue and unadorned walls were dominated by large swing windows with slender steel Venetian blinds. Electric cables webbed messily around them.

In this busy atmosphere, Macpherson allowed proceedings to run in an even more combative manner than that

of Sir Monty Levine's inquest. When the Lawrences gave evidence describing their four years of struggle and repeating their accusations against the police, members of the public remained politely quiet, but Met officers who came before the judge described how, 'From the time we walked in, we were abused, jeered at, laughed at' by the public gallery. One said he 'felt the chairman allowed [it to] happen'.[49]

This may have been true. Macpherson was a liberal within Britain's elite. He defended the country's institutions, but he was relatively sympathetic to those who suffered under them and struggled against them. During his inquiry, he appeared relaxed about verbal attacks against conservative or powerful individuals and groups, and that included the five who had previously been accused of murder. Luke Knight's mother described 'chanting and shouting' while he gave evidence at the end of June 1998, and she claimed that she was called a 'white whore'.[50] Later the same day, when Jamie Acourt was answering questions, the UK leader of black power group the Nation of Islam, Leo Muhammad, barged past police, intending to interrupt the questioning. Officers started spraying CS gas outside the chamber, but Muhammad made it to the witness stand, and stood face to face with Acourt. His head shaved, Muhammad was wearing sunglasses and a scarlet bow tie bearing the star and crescent. He started talking to Acourt, and the former suspect showed Muhammad two fingers.[51]

When Acourt and his fellow former suspects left the building, they had to walk down the 30-metre concrete ramp that runs along the side of the shopping centre

and down on to the main road. A crowd of mostly black young people were waiting in the street, beside the ramp but a couple of metres beneath it, and they could just see the five as they stepped into the fresh air. Dobson was in an unbuttoned waistcoat. Norris, Knight and Neil Acourt were in spacious, long-collared shirts, their hair gelled carefully. Jamie Acourt had his hair slicked back and, as ever, his shades on.

As they marched quickly out of the building, a cry rose from the crowd. The ramp, long and exposed, made them a perfect target. Protesters standing on the pavement below began to run towards them, chucking eggs that smashed open on the five men's flashy clothes. A few people managed to scale the sides of the ramp, and started to throw punches and more eggs. The five looked terrified. Jamie Acourt hit back, his face screwed with fury. David Norris flung out his arms to the sides, his hands open, in a 'what do you want?' gesture, before hitting back too. Now the dozens of police around them were running, surrounding the five and shoving them forward. Just as more protesters were breaking through the police lines protecting the men, officers bundled them into an anonymous white van. From the hundreds of voices shouting, one word could be made out: 'Murderers. Murderers. Murderers.'

It was during the inquiry that Macpherson introduced to mass white discourse in the UK the concept of 'institutional racism'. The day had arrived when Sir Paul Condon was to be questioned by Sir William and his advisers. But the Met Commissioner disappointed those who had hoped he

might follow the lead of Manchester's Chief Constable, who had recently acknowledged that his own constabulary was guilty of this kind of systematic discrimination. The Commissioner admitted to Macpherson that the resources and skills used to investigate most crimes had not routinely been applied to tackling racist incidents. However, he insisted that even unconscious racism was not widespread in the Met, implying that he believed something else was causing the systematic differences between the way his officers treated racist incidents and the way they treated other crimes. It was unclear what that something else was, and his claim provoked consternation in the public gallery, which was filled with the Lawrences' supporters.

Despite admitting that the Met's policing was systemically discriminatory, Condon would not admit that his police force was institutionally racist. This looked like quibbling over semantics, and as the crowd became louder and more angry, Sir Paul even seemed to imply that he thought the Met might indeed be institutionally racist, but that to say so would not be helpful. He explained that 'labels can cause more problems than they solve', and observed that if he did accept the term, the average police officer and the average member of public would believe he was declaring all Met officers to be consciously, wilfully or deliberately racist.[52]

In his long final question to Condon, Macpherson's adviser, Richard Stone, tried desperately to find something that would motivate the Commissioner to make the grand admission that many wanted to hear. Stone sat, squashed

into the corner of the room beside Sir William and the other advisers, each of them on a precarious green swivel chair and, in front of each of them on the long pine desk, a chunky grey laptop. He looked at Condon. Acknowledging the existence of institutional racism in the Met would allow everyone closure, he suggested, and Sir Paul would be able to get on with implementing reforms to the force. Could he not do this today? Condon remained calm. He told them quietly that although it might please Sir William, the public gallery and the media, he would not accept that phrase.[53]

The inquiry closed. Months passed. Finally, on 24 February 1999, six years after Stephen had been killed and two years after the inquest and the *Mail*'s headline, Mr and Mrs Lawrence and their solicitor Imran Khan were sat in special seats at the back of the House of Commons, knowing, Mrs Lawrence would recall, 'that hundreds of MPs and journalists were watching us'. Jack Straw was standing at the dispatch box, presenting Macpherson's report. In a tailored suit and purple tie, the home secretary wore his usual tired look, his thin eyes staring through brass-rimmed glasses. Behind him Tony Blair sat on the front bench, looking anxious.[54] Only three Afro-Caribbean members of parliament had ever sat on the benches behind them, but that day Diane Abbott, Paul Boateng and Bernie Grant were all there.

The home secretary told MPs that the Met's handling of the affair had been 'marred by a combination of professional incompetence, institutional racism and a failure of leadership by senior officers'.[55] Condon could refuse to acknowledge

it all that he liked, but now it seemed to make little difference. The murder investigation's failures, mistakes, misjudgements and lack of direction and control could be explained only by 'pernicious and persistent institutional racism'. Khan and the Lawrences sat there, at the symbolic heart of Britain's ruling class, observing the outcome of their struggle and their compromises: New Labour and a member of the judiciary, attacking the police, and savagely so. It might almost have seemed to the Lawrence campaign that a less racist Britain was coming. It might have seemed like they were winning.

The report backed the Lawrences' claims, and it rubbished the Met's defence. Stephen's killers might have been apprehended if the police had done a better job in their investigation, said Sir William, and they had done their job so badly because the victim of the crime they were investigating was black. Indeed, their sloppiness, laziness and insensitivity would have been unimaginable if Stephen had been white. The report dismissed the idea, put forward by the *Mail*, that locals had shrunk from trying to help the police, either as a consequence of racism or owing to fear of reprisals.

Macpherson also revealed that the government's system for regulating the police had failed miserably, and it was clear that Michael Howard had been entirely wrong to put his faith in the Police Complaints Authority, which would eventually be shut down. Macpherson showed how the Met's review into its own investigation of Stephen's killing had allowed officers to conceal failings, and how Kent Police, having

been commissioned by the Police Complaints Authority to carry out a similar review, had been laughably uninquisitive in its minimal attempts to identify police racism. The people who were supposed to guard the guardians did not seem to care if those guardians were bigots.

Of course, not everyone agreed with Macpherson. Some police might be bad at their jobs, said senior officers, but there was no proof that racism had caused this. A report by the think tank Civitas claimed that Macpherson had invented his own 'institutional' definition of racism, and that this supposedly new concept was illegitimate because he used it to define and criticize the unconscious thoughts of individual officers, which he could not know and which were therefore all in his imagination.[56]

Macpherson was confident that some examples of inadequate policing could convincingly be blamed on racism, and testimony from Greenwich Borough Council's barrister backed this up. The lawyer had told Macpherson's inquiry that if Stephen's skin had been white, 'history suggests that the police would have probably swamped the estate that night and they would remain there, probably for … however long it took, to ensure that if the culprits were on that estate something would be done about the situation'.[57] Instead, they had repeatedly failed to deploy adequate resources and they had repeatedly delayed making arrests.

Sir William had also detailed numerous other examples of racism by several investigating officers, including hostile stereotyping, as well as a pattern of patronizing behaviour and insensitive treatment of recently bereaved

family members that would have been unthinkable if the victim's family had been white. This behaviour was unlikely to have affected the investigation, but it confirmed that racism, conscious or unconscious, was widespread on the investigating team. That, in turn, reinforced the conclusion that the unusual carelessness of this murder investigation was not the result only of incompetence.

Sir William's aggressive criticism of the Met's operations stood firm, but there was a weak link in his fundamental argument. He made clear that institutional racism had caused the police to handle the case so poorly, but his definition of the term was drained of all its radical content. It was, he said:

> The collective failure of an organisation to provide
> an appropriate and professional service to people
> because of their colour, culture, or ethnic origin. It
> can be seen or detected in processes, attitudes and
> behaviour which amount to discrimination through
> unwitting prejudice, ignorance, thoughtlessness and
> racist stereotyping which disadvantage minority
> ethnic people.[58]

Sir William was broadcasting to the country an idea that anti-racist activists had used for decades, with or without the label of 'institutional racism'. They had proposed versions of this concept that were much angrier and more subversive than his, but they had only been able to communicate them to a much smaller audience. Macpherson was taking a revolutionary idea, excising it of any criticism of the state

and of capitalism, and using it in a way that might encourage a modicum of reform but which might also discourage calls for greater change.

Like the other landmark events described in this book, the Macpherson inquiry and its report represented an exchange of radicalism for visibility. The Lawrences' campaign had taken every possible opportunity to get their core message broadcast to wide audiences, even though they knew that this process would somewhat mute their more subversive criticisms, and this strategy seemed to be working. For many white people in Britain, the claim made by the activists through the mouthpiece of Macpherson, that racism was widespread in their country, was completely new.

As news media dissected the report, those watching and reading the unfolding coverage discovered even more complex and challenging ideas emerging from the inquiry. One ITN report explained that Macpherson had accused the Met of institutional racism, 'which isn't to say that individual police officers are racist, but that the system they work in is'.[59] Media consumers were shown how someone's unconscious adherence to unfair rules and assumptions might be disadvantaging people from ethnic minorities. Their repeated actions might seem small and normal to themselves, but they could harm others. Moreover, the deep personal prejudice of many officers was not ignored.

As claims like these received nationwide attention, journalists from across the political spectrum insisted that Britain was being given an extraordinary opportunity to deal with the racism of its most important institutions. Abuse

had been named, detailed, exposed and castigated by some of the most powerful people in the UK. They were all white men, and that made their admissions all the more dramatic.

After Straw had presented Sir William's report he had spoken to the Lawrences, and it seemed to him that the family 'were pleased and relieved that its conclusions had been so trenchant'. [60] However, at a press conference in the Home Office, Mrs Lawrence was critical of both the report and British society, which seemed inadequately equipped to respond to Macpherson's conclusions. 'Black people are still dying on the streets and in the back of police vans,' she told reporters. In the long, low-ceilinged, acid-yellow hall that was used for big press conferences at Queen Anne's Gate, big wash lights had been set up beside the dozen or so assembled news crews. They shone brightly into her eyes. A wall of photographers pushed against the narrow table at which she sat, their lenses pointing straight at her as their shutters clattered loudly in chorus. She looked down at her paper, then straight at them. 'The police on the ground are the same as they were when my son was killed … Nothing has changed.'[61]

Given the seriousness of these problems, she said, Macpherson should have gone farther, especially in his policy recommendations. He should have proposed that the police be monitored externally, and stripped of their stop and search powers. Moreover, she insisted that opportunities to punish Stephen's killers had been missed, and had to be salvaged.

Anti-racists had shown that the economy and the state were structured in a way that produced inequalities between white and black people. However, when Sir William had created his own version of 'institutional racism' and when he had written his policy recommendations, he had removed from the concept and its implications any criticisms of state and capitalism. With this elision, he had moderated the scope of the proposals that he could possibly have been expected to make, excluding the more radical reforms that were necessary and, particularly, those that were broader and more structural.

It was unsurprising, then, that 'institutional racism' seemed to many people to be focused on the personal prejudice of (many) individuals. *Police Review* was a popular and venerable magazine for members of the force, an 'independent voice ... somewhere to air their grievances', according to the crime correspondent of the *Times*.[62] Its thin, glossy pages were illustrated with stock photos, its layout was bright and square and its subeditors habitually based their titles on puns. After Macpherson published his report, *Police Review*'s letters pages indicated that most of its readers thought that, by referring to institutional racism, Sir William had accused them all of personal prejudice. The magazine did little to dissuade them.

If Macpherson had intended to make such a point, he might not have been far wrong. The tone and content of the magazine indicated that personal prejudice was very possibly widespread among its readers: an editorial in the magazine suggested that if officers did have negative

perceptions of people from ethnic minorities, that might be the result of violent attacks by black individuals against the police, and might therefore 'be a case of understandable as opposed to unwitting racism'.[63]

The misunderstanding of the magazine and its readers about the definition of 'institutional racism' meant that it became even easier for them to ignore the need for institutional reforms. This problem was not confined to the police. Many politicians, journalists and media consumers also treated the term as an indication simply that many officers were personally prejudiced. Consequently, there was almost no pressure on those in power to enact the reforms that were necessary if institutional racism was to be undermined: a reduction of the class gap between the white majority and minority ethnic communities, and the transformation of policing and its priorities that critics such as Sivanandan had long demanded.

Government policy took the path of least resistance by carrying out Sir William's recommendations, which were treated as an aggressive liberal challenge by the police, but which nonetheless could never have tackled racism to a sufficient degree. The Home Office made some efforts to tame the police, ensuring that the proportion of police officers from minority ethnic backgrounds began to increase, even as constabularies were shrinking. However, even today London's force remains very white, and until recently other parts of the country were policed by constabularies that did not employ a single Afro-Caribbean officer.[64]

Perhaps even more worrying is the possibility identified by anti-racists that changes to police demographics may never be able to reduce institutional racism significantly. Campaigners have argued for many years that if black officers follow the culture and policies of the constabulary they join, they will simply maintain the inequalities in policing that white officers have built over the decades. Moreover, all officers, regardless of their ethnic background, are bound by the policing priorities set by the Home Office, which have remained focused on the kinds of crimes that black people are disproportionately likely to commit. Consequently, the impact of officers' actions may be racist, even if they themselves are not consciously so.

Another recommendation of Macpherson's that New Labour implemented might have appeared to have little to do with undermining racism. Labour's Criminal Justice Act 2003 dissolved the ancient legal principle of preventing 'double jeopardy' by making it possible to retry defendants for serious crimes. If a suspect had previously been acquitted, they could be retried if this was considered to be in the public interest, and if new and compelling evidence had been found to support a new prosecution.

It was not only the law that had changed. The practical applications of genetic science had advanced in extraordinary ways since 1993 and, with a retrial of the five now legally possible, the Met began a microscopic examination of every article of clothing taken from suspects in the Lawrence case. Every fibre of their jumpers, jackets, T-shirts and trousers was inspected, and every speck of dirt had to be accounted

for. After months of searching, the force's lab found something, and in September 2010, David Norris and Gary Dobson were arrested once again. At the Old Bailey, Mark Ellison, QC, showed the jury magnified images of just one microscopic blood spot found on Dobson's jacket and of a single two-millimetre hair stuck to Norris's jeans. Both were from Stephen's body, for when the kitchen knife had plunged into him, Norris and Dobson had been stained with the evidence. That proof had lain on those clothes, stored in a police warehouse, for nearly two decades, and on 4 January 2012, the two men were sentenced to life in prison.[65] There was a great sense of relief after the imprisonment of Norris and Dobson, one of whom had so memorably been secretly recorded fantasizing about torturing black people, but there is little prospect of prosecutions against Luke Knight or the Acourt brothers, and in 2014 the CPS had to abandon attempts to prosecute a sixth man, who remains anonymous.

Mrs Lawrence later revealed that her view of Macpherson's report had changed. It had indeed made an impact, she wrote in her memoirs, and the very fact that the inquiry had taken place was significant. When her son had died, she said, 'I would never have dreamed that an ordinary black couple could challenge the police and the government and end up changing the way they conduct themselves.'[66] She made clear that these changes in conduct needed to go much farther, but she has maintained that one of the greatest effects of the report was the extension of the Race Relations Act so that it became illegal for all public bodies, including the police, prisons and immigration services,

to discriminate against people on the basis of race. Mrs Lawrence concluded that 'There were some truly substantial changes, in the end'.[67]

They had substance, but they were limited. The amendment to the Race Relations Act. A small increase in the number of black police officers. Two of Stephen's killers in jail. These were the successes to which the actions of the *Daily Mail*, New Labour, Macpherson and, most of all, the Lawrences could lay claim. They are of consequence, especially for minority ethnic communities, but they fall short of the broad and deep change that anti-racists had hoped for.

Soon after Norris and Dobson were jailed, the Lawrences were required to absorb yet another revelation. In 2012 and then again in 2014, former police spies admitted publicly that during the 1990s they had posed as anti-racist activists while working for the Met's Special Demonstration Squad. The Lawrences had trusted the political groups around them; they had given them information and had allowed them to influence their own campaign. Now, they discovered, the organizations that had protested with them against police violence and racism had also contained undercover Met officers, part of whose job had been to discredit the Lawrences.

These dirty tricks reached extremely close to the top of the Met. In the late 1990s, it had been the job of an officer called Richard Walton to brief Condon regularly on issues relating to the Lawrences, and at the time of the inquiry he had drafted the Commissioner's statement to Macpherson in which Sir Paul had refused to acknowledge that the

Met was institutionally racist. While working in that role, Walton had also been meeting with police who were working undercover in anti-racist groups in order to spy on them. One undercover officer said he had been under 'huge and constant pressure' to 'hunt for information' that could 'smear' the Lawrences and their supporters. 'They wanted the campaign to stop,' he said. Condon denied he knew that officers had spied on the Lawrences, but once again, the UK's police force had been exposed as employing, in some of its most senior and influential positions, individuals who were willing to exploit and manipulate innocent people for the benefit of their institution.[68]

Macpherson had revealed how one part of the Met – those officers who initially assessed the police investigation into Stephen's murder – had allowed another part of the force – the local police who had undertaken the investigation – to cover up their misconduct and maltreatment of a victim's family; and Sir William had also exposed how the Met's neighbouring constabulary, Kent Police, had later shown an extraordinary lack of interest in exposing racism within the capital's force after being commissioned by the Police Complaints Authority to re-examine the initial investigation. Now yet another part of the force, the Met's anti-extremist undercover squad, had been exposed as having poured resources into attacking and undermining the Lawrences. This long list of revelations backed up what black activists had said all along: racist oppression was so deeply rooted in the state, and especially in the police, that it could not be fixed by a small number of narrow policies.

Even when Macpherson and New Labour did seek to target elements of police racism, they failed. In 1999, the year the report was published, a black person's chances of being stopped and searched were about six times higher than those of a white person.[69] After much wrangling, the police were forced to accept one of Sir William's most controversial recommendations: officers would have to make a record of all their stop and searches, including details such as the ethnicity of the person they stopped. But in 2012, fifteen years after the *Daily Mail* headline that had seemed to mark a shift in attitudes to race, black people were still about six times more likely than white people to be stopped and searched by the police.[70] On this crucial measure, Macpherson had tried, but he had failed.

Sir William had warned that any police chief 'who feels unable … to respond [to accusations of institutional racism] will find it difficult to work in harmony and co-operation with the [black] community in the way that policing by consent requires'. Three years after Macpherson, one of the force's own chief inspectors was among many expert voices indicating that Sir William's prediction had been entirely accurate: 'Despite the initiatives,' he wrote, the perception of Macpherson's report by the 'police leadership, at all levels, has remained distinctly ambivalent'. 'This in turn has encouraged a negative response among police staff.'[71]

Consequently, it was not only when using their sus powers that the police were safe to mistreat black people. Detainees from ethnic minority backgrounds were still far more likely to die in police custody. This might have

been evidence of, for instance, policies that inadequately provided for the protection of vulnerable detainees, who were more likely to be black. Nonetheless, it indicated that the criminal justice system operated in a way that did not just hurt black people more; it actually allowed more of them to die. This picture of systematic failings, which might conceivably be blamed entirely on unconscious prejudice or on officers following accidentally unfair rules, looks even more sinister in the context of coroners' judgements regarding these deaths. Since 1990, coroners have ruled that nine individuals from minority ethnic communities who died in police custody were unlawfully killed, but not a single officer has been successfully prosecuted for any of these killings.[72] In light of such evidence, it appears that twenty years after the murder of Stephen Lawrence came to the attention of most of the UK, the police remain responsible for systemically racist violence, and that the law that they are supposed to execute is not, in turn, applied to them.

Many Britons – some of them black, but most of them white – believe that racial equality has improved since the Macpherson inquiry. Of the optimistic stories inherited from 1997, this is one of the strongest and most widely accepted and, in a very particular way, there is some truth to it. It is now less socially acceptable, in most places and in most communities, for individuals to behave in the most explicitly racist ways, and that seems to reflect a decline in white people consciously feeling extreme kinds of prejudice.

We can see this in the falling numbers of people who are concerned by the idea of 'intermarriage': in 1989, researchers found that more than half of Britons would have been unhappy if a close relative of theirs had married someone of a different ethnicity, but by 2012, that proportion had collapsed to less than a quarter of Britons.[73] People in the UK are also less tolerant of racist language than they used to be. A year after Macpherson's report, analysts found that, although Britons were becoming increasingly inured to swearing in the media, they were far less tolerant of racist language than they had been just two years earlier, when Sir William's inquiry had begun.[74]

These changes did not take place only because of the actions of the Lawrences, Dacre, New Labour and Sir William. The presence of black people had become a normal part of the everyday lives of an increasing number of white Britons since the 1950s, when mass migration from the Commonwealth had begun. As a result, most people born in the UK since then are less racist than their forebears, and 'average' views have changed as older generations have disappeared. The cultural theorist Stuart Hall called this 'multicultural drift'.[75]

The significance of those grand structural shifts does not make the actions of Mrs Lawrence and her temporary allies irrelevant. Sometimes, big, sociological trends only affect us the way they do – for instance, by undermining the prevalence of racist attitudes – because of how a few individuals act. That is especially the case if those individuals pull the levers of government, or influence those who do. As a direct result

of Macpherson's report and therefore of the Lawrences' campaigning, New Labour curtailed the power of housing associations to adopt surreptitiously segregationist policies. Given that numerous analyses have shown that people who live in more ethnically diverse communities are less likely to hold racist views,[76] it is probable that this policy was one way in which influential individuals ensured that demographic change resulted in multicultural drift.

Macpherson's inquiry had been able to make such an impact because it had acted as the fulcrum of a year and a half of loud, progressive media conversation, and that impact was visible in how it forced journalists to pay attention to the murder of Stephen Lawrence. After the *Mail*'s headline, the number of newspaper stories published in one year that mentioned his name had quadrupled. However, during the inquiry, that number had multiplied by five, and in the year after the report was published, *that* number had doubled.[77]

This process had constantly reminded white Britons that racism was, at very least, considered socially unacceptable by the country's white elite, as well as by its minority ethnic communities. At the same time, New Labour was forcing almost all parts and partners of the state to take on legally binding guidelines for dealing with racism. An example of the far-reaching consequences of that process is that a children's library filled only with books about white people, which had been normal in the 1970s, and was still normal in many parts of the country in the 1990s, is unthinkable today. In ways like this, the Lawrences, Sir William and New Labour significantly altered the culture surrounding individual

Britons. Their different motives led them all to contribute to making the inquiry the most significant event in the decline of racist attitudes among individuals in a generation. It was not just a totem of this change; it accelerated it.

Partly as a result of the decline in individual prejudice, since Macpherson Britons have believed that their country is becoming generally less racist.[78] That is what they tell the pollsters, and it is a perspective that the media encourage with exactly the statistics about intermarriage and racist language that have been quoted here. It appears that this focus on whether or not white people have racist views, and how that has changed, obscures black people's inequitable and underprivileged experiences, and how, in many ways, those have stayed the same. Fewer racist jokes on the TV, and fewer white people with racist feelings, are important improvements, but they also mask the less visible but nonetheless racist truth of society's structure.

The myth that Britain was altogether less racist allowed anti-racism to fall off the political agenda. As home secretary between 2010 and 2016, Theresa May was tasked with cutting police numbers, she fought surprisingly hard against the police rank and file, and she acceded to the Lawrence campaign's demands for further investigations into police corruption. However, it is telling that the primary effect of her attacks was to make it politically easier for her to force constabularies to restructure and cut costs as she saw fit. In any case, she enacted few reforms, beyond verbal pressure, to reduce the over-policing of black communities, and she strengthened police powers of stop and search.

The Lawrence campaign, the *Mail*'s headline and the Macpherson inquiry and report had accelerated long-term changes to the feelings about race of white people in the UK. But there was no such acceleration of the empowerment of minority ethnic communities or of improvements to their experience of life in Britain, which are far more important and which are far less often articulated in mainstream arenas than the views about race held by white Britons. Individual racism declined but institutional racism survived.

Black people are still more likely to experience poverty and to earn less than their white colleagues, however talented and clever they are, and they are still more likely to suffer harm at the hands of the police. The decline of individual racism has encouraged the view that Britain has now largely dealt with racist oppression, and that further change is not urgent, or even that it is unnecessary. The events following the inquest into Stephen's death made some forms of racism unacceptable, but they made the forms that remained invisible. The myth of a post-racist Britain only strengthened the privileges that white people enjoy.

On a hot August evening in 2011, two ethnographers were standing on a street in Birmingham. They recorded what they saw: 'A youth clad all in black, his hood up and face masked by a bandanna, and, carrying a concrete street brick in his hand, turns to the crowd. The police occupy the far end of the street. His mate encourages him: "come on, throw it at them [the police]", he looks at him and then retorts: "Fuck off. I'm gonna need this to put through a

[shop] window. I didn't come here for a protest; I come here for garms [clothes] man".'[79]

Over five nights, between 10,000 and 15,000 people joined riots across several of the cities and towns of England.[80] In Birmingham, three men not involved in the riots were killed when they were hit by a speeding car, and thousands of people looted about 2,500 shops, some of which were locally owned.[81] The *garms* were one side of the story, but that did not reduce the significance of the other: the man telling his friend to attack a group of cops.

In mostly working-class areas of cities across England, young people threw bricks and bottles at the police, pushed wheelie bins at high speed into lines of officers, petrol-bombed squad cars and attacked police vans and stations. Sometimes the police fought back, but often they were forced to retreat.

Thousands of people were trying to maim, and even to kill, police officers, and this reflected widespread and intensely felt antipathy towards those who were supposed to uphold the law and protect property. A black man from north London told criminologist Tim Newburn and his researchers: 'After all the brutalizing I have seen the police doing to people, it was a sweet moment, a sweet moment in my life to see police getting some of their own medicine.'[82]

For those involved in the August riots, mostly young working-class people, the liberal hopes that had blossomed in 1997 had not made it possible to hold those in power accountable, or to access their privilege. This was especially true of those who were black and mixed-race. Macpherson

and multiculturalism had not built a new or more equitable country. Instead, the riots revealed that in many communities hatred of the police was entirely normal.

Experiences of police violence, and a broader sense that the police were aggressive and unaccountable, were widespread. Thirty-two per cent of those charged with riot-related offences in 2011 were identified as white and 8 per cent as being of South Asian backgrounds, but the majority were identified as mixed race or as black, which in this instance indicated an African or Caribbean background.[83] As with previous riots in England, the riots of 2011 were clearly linked to violent police racism.

Indeed, the riots had been precipitated by the police killing of a mixed-race man. On 4 August, police in Tottenham, a working-class area of north London with a large Afro-Caribbean community, had shot and killed Mark Duggan, who was unarmed. They said they believed he had a gun and was planning an attack. Tensions quickly built between the family's supporters and the police, and riots began in Tottenham and nearby Wood Green. Two days later, rioting began in Birmingham, and over the following two days riots took place in Bristol, Manchester, Salford, Nottingham, Gloucester, Liverpool and several other towns and cities.

Duggan's death was linked by members of the Afro-Caribbean community, and by many others, to wider grievances about police violence, rudeness, unaccountability and racism. Many black, mixed-race and Asian people who were involved in the riots would later identify police racism

as a strong motivation for attacking officers, and the focus of this resentment was often stop and search.[84] 'Because they stopped me for no reason, I was getting pissed off,' a nineteen-year-old mixed-race man would later explain to Newburn's team. He was involved in the riots in his home town of Birmingham. 'So I thought "Fuck it. Now I'm getting back on them."'[85]

Across England, individuals arrested, charged or found guilty of riot-related offences were far more likely to come from poorer streets and areas. Moreover, those involved in the London riots were more likely to come from boroughs where the Met's own research showed that the police were perceived as disrespectful.[86] Successive studies had shown that people were more likely to resent the police if they did not believe that 'procedural justice' was being done.[87] The racialized use of stop and search and the shooting of Duggan were only the most obvious indications that there was no such justice.

A seventeen-year-old from Peckham, south London, said: 'My dad told me about the Brixton riots, and now, like, I can tell my son, my daughters about "Oh yeah, the riots that happened [in 2011]."'[88] The Stephen Lawrence campaign had tried to reform the authorities, but the bright future than New Labour envisaged had never emerged. The riots, it seemed, were partly caused by this failure.

About a hundred people have been murdered in Britain because of their ethnicity since 22 April 1993.[89] Few people can name any of them, but we all know the name

of Stephen Lawrence, the boy killed that day. His murder remains totemic because it has been loaded with so many contradictory meanings. It is an example of personal bigotry, institutional racism and police prejudice; a tragedy that prompted a heroic campaign and which eventually led to the political career of Doreen, now Baroness, Lawrence; an opportunity for white media types to demonstrate their 'politically correct' credentials while gossiping about each other's front pages; and a chance for leftists to criticize the police. The killing of Stephen Lawrence has also become famous because the fallout from Paul Dacre's front page briefly made many white Britons conscious of their shame about racism. But that shame created few demands for dramatic change, and instead ensured that many Britons welcomed moderate reforms with satisfied contentment.

In a pattern that will be described throughout this book, the establishment's support for anti-racism gave its exponents a platform, but it silenced their more subversive ideas. The vision of a future that never happened obscured the racism that survived. If the Lawrences, Dacre, Straw and Macpherson had not cooperated, it seems likely that personal prejudice in the UK would be more common today than it is. However, it is also possible that in such a visibly bigoted society, there would be a wider spectrum of people calling for radical, structural change. We cannot know.

What is certain is that a shift took place in the way Britons perceived race and racism, and that this happened partly because, in February 1997, the interests of an extraordinary mix of individuals quite suddenly overlapped.

Paul Dacre, a white, millionaire editor, had become con-
cerned about the case because of his relationship with
Neville Lawrence, a black painter-decorator, and the editor
chose to give the story publicity after five white boys from
the East End 'claimed privilege'. It was because that story
was used by white, upper middle-class journalists and
politicians to talk about each other that public attention
was finally brought to the killing of a black teenager. And
it was that uproar, accompanied by the demands of Doreen
Lawrence, a Jamaican migrant from an estate in Eltham,
that forced the hand of the home secretary and shaped the
inquiry of a High Court judge.

Both random encounters between individuals and vast
social developments were crucial to the shape of this story.
The chances of Mr Lawrence and Dacre knowing each other
were preposterously small, but if they had never previously
met, the MURDERERS headline might not otherwise have
been written, and Macpherson's inquiry might not have
been initiated. And none of this would have been possible
if migration to Britain after the Second World War had
not already liberalized the views of many white Britons.
However, this is neither a story of pure chance, nor one of
total sociological fate. These particular changes to Britain's
culture and politics would not have taken place in the way
that they did if Doreen Lawrence had not struggled for two
decades for what she believed in. Her campaign took her all
the way to the Home Office, and she and other scions of the
anti-racist movement's moderate wing now hold significant
positions of official authority. Lawrence is both a strident

critic of racism, violence, inequality and privilege, and a member of the House of Lords.

Her campaign is not over. She tried to undermine the way in which organizations disempower and attack black people in Britain. The result, however, was a decline in individual forms of discrimination. That apparently optimistic news functioned as a public relations coup for an entire society. It seemed that the country had moved into a bright and shining era of liberal tolerance, and that obscured the survival of deep institutional racism. Britain was still racist, but in a modern way.

3 / THE PEOPLE'S PRINCESS

'For the whole summer they'd given photo-ops time and time again … Why would they hide away in Paris?'[1] So wondered one paparazzo, on a warm late-August afternoon, as he and a gang of photographers chased Diana and Dodi's limo along the motorway that headed east into the French capital. Pulling up, finally, to the grand entrance of the Ritz hotel, the couple was greeted by the clatter of camera shutters and the flashing of bulbs. They ran inside and headed up to the hotel's Imperial Suite, but no sooner had the princess escaped the journalists outside than she was on the phone to another. This was 'Ricardo',[2] Richard Kay of the *Daily Mail*. He was her confidant and mouthpiece, and she was his livelihood. Describing their call in his column two days later, he reported that she and her new boyfriend had been, 'to use an old but priceless cliché, blissfully happy'.[3]

His conversation with Diana had been typical of her media performances. These were sometimes calculated, sometimes wild and sometimes deeply honest, but they were always humane and consequently, although she was the daughter of an earl, Diana had established herself as one of 'the people'. Her death early the next morning would initiate

a week of criticism of the royal family unlike anything since the 1936 abdication of Edward VIII. That week would be recorded as having forced her former in-laws, the Windsors, to copy her egalitarian and open approach to public life and to build a new era of informal and modern monarchy. New Labour and the press would report that henceforth the relationship between Britons and their monarch was going to be more equal.

This was a democratic fairy tale that fitted perfectly into the story that media and political elites told about 1997. It obscured how little actually changed after the death of Diana, and how reactionary the changes that did happen were. For centuries the royal family's symbolic power had been weakening, and just as the fallout from the Macpherson Inquiry would be represented as building a post-racial future for the UK, the impact of Diana's death was projected to usher in a levelling of Britain's relationship with its royals. However, after the crash in Paris, the slow weakening of the Crown actually halted. Indeed, it reversed, and royal courtiers took a firm hold of public perceptions of the royal family.

Consequently, the Windors have enjoyed an asto-nishingly successful two decades. Despite the potentially controversial behaviour of one prince characterized for several years as a playboy, and of another characterized as a political meddler, their popularity is wide and strongly felt. While recession and austerity have caused enormous harm, leading to illness, anxiety or deep distress for millions of Britons, the royal family's enormous wealth has remained

accepted as a key component of what so many enjoy about monarchy. And after the wife of the heir to the throne endured appalling sadness, the wife of the next in line to the throne has established what looks like a much more stable position.

At the same time, however, the family has been forced to accept humiliating changes. They are only temporarily stronger, but although their position is more precarious, that has made us no more equal to them.

At about seven in the evening on that Sunday in late August, Dodi and Diana left the service entrance at the back of the Ritz, and drove ten minutes to a perfume shop. So many photographers followed that they left immediately. They were driven to Dodi's apartment, beside the Arc de Triomphe, but there, again, they were greeted by a group of paparazzi so large that guards had to shove the men with cameras back as the couple leapt from their Mercedes into the building. About two hours later, they got back into their car, this time heading for an expensive bistro. Again, however, photographers got the better of them, and the couple made a detour back to the Ritz. There, predictably, they were once more surrounded by screaming, jostling photographers. Security forced the couple inside towards the hotel restaurant, but only minutes later, the guards identified two fellow diners as covert paparazzi, and moved Dodi and Diana to their suite.

Outside the hotel's entrance, a crowd of photographers and onlookers stood waiting for a glimpse of the famous faces. In the restaurant, two rather surprised tourists were

getting back to their dinner, having persuaded the guards that they were not professional photographers. Upstairs, Diana and Dodi ate dinner alone.[4]

Once more, however, Dodi changed their plans, deciding that the couple would spend the night at his place by the Arc de Triomphe. Henri Paul, the hotel's acting security chief, volunteered to drive them there, and his offer was accepted.[5] The past weeks had been peppered with unremarkable and unlucky events but for which Diana and Dodi might have survived that night. This decision, however, was the single great preventable mistake that led to the deaths of three people in a Paris underpass, to a week of crisis for Britain's establishment, and to a small surge of amorphous resentment against the royal family. Paul had been off duty for three hours,[6] and back at his flat he had been drinking and taking medication that should not have been combined with alcohol. When he had got back to the hotel, he had drunk another couple of digestifs.[7] He was not wasted, but he certainly was not sober.

As Diana and Dodi prepared to leave, Paul stepped outside to chat with the photographers. He was now three times over the French limit.[8] One paparazzo claimed he was taunted by the drunk security man: 'Don't bother following. You won't catch us.'[9] Evidently, Paul was having some fun. There were paparazzi waiting at Dodi's flat, so any escape from these photographers would have been illusory. He was going to try to run away from them, but it was just a laugh. Evidence would later emerge indicating that Diana was not happy with this joke, but in different cities, and with

different paparazzi, she, Paul and Dodi had all played this game before.

And so it began again. On Dodi's command,[10] two decoy vehicles sped away from the front entrance at twenty past midnight, while Diana, Dodi, his bodyguard Trevor Rees-Jones and Henri Paul slipped into a Mercedes limousine outside the service entrance round the back of the hotel. Five photographers who had been waiting there jumped on the backs of their drivers' motorbikes and pursued the car down the rue Cambon, heading south towards the Seine.[11] The paparazzi out at the front of the Ritz were quickly alerted to their mistake, and immediately joined the chase. The hunt had only just begun, but the photographers were already catching up with their prey, and three of them were closing in on the Mercedes as it sped towards a junction on the Place de la Concorde. The lights were red. Paul had to stop. Two paparazzi in a car, and another, named Romuald Rat, who was being driven on a motorbike, were speeding towards the limousine,[12] but just at they were about to reach it, the lights turned green. Dodi's limo bombed down towards the embankment, and sped away along the riverside.

The photographers have always insisted that they were not able to keep up. A handful of motorists on the embankment that evening have claimed they saw paparazzi on motorbikes swarming around a Mercedes, and even that they saw them block the car's way. But a number of those claims came from highly unreliable witnesses,[13] and many more eyewitnesses reported to French police that the photographers were travelling about 100 metres behind

the limousine.[14] There is no convincing evidence that the paparazzi kept up with the car.[15] Diana, Dodi and Paul had won the game.

As their Mercedes began to descend towards the tunnel that passes under the north end of the Alma Bridge, the car was moving at between seventy and a hundred miles per hour[16] on a road with a thirty limit. Its passengers were used to breaking the traffic rules, and had not chosen to fasten their seat belts.[17] (If they had done otherwise, they would likely have survived, a fact that undermines claims that the couple was assassinated.) The car sped past a much slower Fiat Uno, grazing it heavily, and Paul braked violently before jerking the car to the left, then to the right. As they entered the tunnel he swerved left again and, still travelling at sixty miles per hour, drove straight into a concrete pillar.[18]

The force of the crash against the front of the car was such that its engine flew almost half a metre out of the bonnet and towards the windscreen, the hood bent up at a right angle, and the whole vehicle spun around towards the oncoming traffic. Pieces of metal exploded through the driver and some of his passengers.[19] Diana was shielded from the flying debris, but she was thrown forward into the back of the passenger seat. The impact ripped open her pulmonary vein. As she lay on the car floor, her heart began to pump blood into her chest and lung cavity.[20]

In the dark tunnel, the car's lights were still shining. Dodi Fayed and Henri Paul were dead. Above the horn's blaring, motorists could hear Rees-Jones screaming. He had suffered head injuries and his face was torn apart.

Moments later, photographers riding on the backs of bikes and scooters arrived in the tunnel. Romuald Rat was the first, along with his driver. An ambitious twenty-four-year-old, he was just as used to snapping war zones as he was to photographing Parisian VIPs,[21] but it was several seconds before he was sure that the mangled wreckage before him was the Mercedes he had been following.[22]

'I was in shock for a few moments. I backed off from the car. And then I came back towards the car so that I could … see what I could do.'[23] He took three pictures of the glistening wreck,[24] then opened its right-hand passenger door, behind which Diana was lying, hunched on her knees. He took a carpet mat that had fallen on her and placed it across the mangled body of Fayed, some of whose clothes had been ripped off by the force of the crash.[25]

'I leaned over the Princess to see if she was alive. I leaned over to try and take her pulse, and as I touched her, she moved and breathed a little bit. And I spoke to her in English. I said: "I'm here. Be cool. Doctor will arrive."'[26] Trapped in the front, Trevor Rees-Jones was still crying out intermittently. The car's horn continued for some minutes. Smoke rose from the car's crushed bonnet.[27]

Within seconds, several more photographers had arrived, and a small crowd of them had surrounded the right side of the car. Diana was lying, semi-conscious, in the footwell between the back seat and the front. Rat, crouching beside her, was heard screaming 'She's alive!' and seen shoving back other paparazzi as they tried to pile in around him.[28] They began to take pictures of her, and soon he started to do so too.[29]

A passing off-duty doctor, Frederic Mailliez, pulled over and, without recognizing the crash victims, spoke to the woman and placed an oxygen mask over her face. As he did so, the bright blue lights of the photographers' flashbulbs burst across her face, but later he would insist that the paparazzi had never got in his way.[30]

Police arrived and formed a line to hold back the photographers, including Rat.[31] A member of the public heard one paparazzo shout: 'We are earning our money out of that. Please let us do our job!' Another photojournalist called his picture agency's boss, Laurent Sola, for advice. Sola tried to calm him down: 'We're photographers. We have to take pictures … Take some very quick photos, get out of the tunnel, give me the films, and I will handle it.'

Rat himself was on the phone to the *Sun*'s picture editor, Ken Lennox, demanding £300,000 for the pictures of Diana. Lennox agreed, preliminarily.[32] Meanwhile, Sola was talking to newspapers all around the world: 'It was fantastic … I was practically at twenty million francs.'

Lennox looked at the pictures that had come through on his computer. The photos of Fayed were unprintable. The force of the crash had ripped his jeans off and shrapnel had torn his flesh. Diana, however – she was lying prone on the floor of the car, semi-conscious, blemished only by a trickle of blood. It was smeared slightly across her forehead and through her hair. He told his editor that they should print them if she lived, and never if she died. But 'She didn't look badly injured. There were no horrific

injuries. It was a great, publishable story. It was going to be absolutely sensational.'[33]

When Diana had first met Charles, he had been dating her sister. 'I'm not the one for him, but I know who is,' Lady Sarah Spencer is reported to have said. Diana was an inexperienced sixteen. Charles was twenty-nine, and always 'popping in and out of bed with girls', according to the boasts in *Time* magazine of Louis Mountbatten, his great-uncle, close mentor and the man he called 'Grandpappa'.[34] Lady Sarah concluded that Diana 'would be perfect for him'.[35]

Although Charles's courtship of Diana had been more formal than Dodi's would be, it had been subject to almost as much intrusion. Men with cameras had followed her everywhere: it was almost always men, whether they were photographing her in 1980 with the prince, in 1990 by herself, or in 1997 with Fayed. Diana appeared to be just as seduced by the idea of her romance as the media and much of the public were but, by most accounts, she did not suspect Charles was sleeping with other women until November 1980, when she read in the newspapers that she herself had joined the prince on board the royal train late one night. The press did not realize that the blonde woman they had spotted was a lover of Charles's called Camilla Parker-Bowles,[36] but Diana knew what was going on.

Nonetheless, she married Charles in July the next year, accepting a compromised and unhappy romance, and sometimes making the most of it. Charles had Camilla, and Diana, for better or worse, had the public and the media.

Newspaper commentators and politicians described the public's fascination with the princess as evidence of her 're-energizing' the royal family, but her popularity was, in fact, quite independent of theirs. This was obvious when she and her husband performed walkabouts to meet adoring fans. If they split to talk to different groups, those who realized that they had been saddled with the attentions of the prince would sometimes emit a low, disappointed moan.[37]

The princess was popular, in part because she combined royal superiority with a familiar, vulnerable and open persona, while the Windsors kept their distance. She had little control over the way in which her sexuality and body were treated as fair game by the media and the public, but she cultivated a reputation for seeming approachable to people who met her. Her openness began to appear almost wild by royal standards, when, in the late 1980s, she became involved in distinctly un-Windsor charitable causes. Some, including counselling centres, marriage guidance and anorexia prevention, reminded observers of what were widely rumoured to be Diana's personal problems. Moreover, her involvement with AIDS campaigning and women's refuges indicated that her outlook tended farther towards liberal and feminist views than that of any other senior royal. Her personal problems and vaguely egalitarian attitudes may not have contributed directly to her popularity, but they ensured that she was perceived as humane and authentic.

Diana's open persona eventually exploded into explicit self-revelation. In 1991 she granted journalist Andrew Morton many hours of secret interviews, recorded by an

intermediary, so that he could write her biography. Its publication ruined Charles's reputation. The princess told Morton that when she had been pregnant with her first child, she had become so unhappy and lonely that she had threatened to throw herself down a flight of stairs. 'Charles said I was crying wolf and I said I felt so desperate, and I was crying my eyes out and he said "I'm not going to listen. You're always doing this to me. I'm going riding now."' Her husband had walked away, she reported, and 'I threw myself down the stairs.' The Queen had apparently found her on the floor, and was 'absolutely horrified, shaking – she was so frightened'.[38] On another occasion when Charles had refused to listen to Diana, she described picking up a penknife from his desk and scratching heavily at her chest and thighs, so that they bled. His reaction, she said, was minimal.[39]

After the book was published, there ensued the 'War of the Waleses', during which the friends and employees of both Diana and Charles desperately briefed against each other to the press, divulging the most intimate details of each individual's cherished moments with their children, of family rows and of adulterous affairs. It was a frenzied fight and at the end of 1992, a year that the Queen memorably described as her *Annus Horribilis*, they separated. Nonetheless, they continued to fight in public. Remembering those halcyon days for a royal reporter, the veteran BBC correspondent Jennie Bond recalled: 'They were leaking like sieves and singing like canaries.'[40]

In a famous 1995 *Panorama* interview with Martin Bashir, Diana announced, with reference to Camilla, that

'there were three of us in this marriage, so it was a bit crowded'. Princes of Wales, and royals generally, were not used to this kind of public humiliation. The sovereign had once acted as the legal source of national morality, but that role had been in decline since being established under the Tudors, and in the 1990s, this slow social change was coming to a head. Just as the other shocks of 1997 would crystallize long social developments, the crisis that would ensue after Diana's death was going to accelerate and reinforce the breakdown of the royal family's symbolic and moral power into a simple celebrity status. This would be portrayed as the dawn of a new age, one in which the royals would be more like their subjects.

Royal life had long maintained a pattern of vacillating between carefully staged media triumphs and ill-disciplined scandals. Like other Princes of Wales before him, Charles had swapped his parents' austere theatricality for a public battle with his wife for status, cash and access to their children. However, the War of the Waleses did not just represent a short-term replacement of palace order by tabloid chaos, for by the early 1990s, the Queen's subjects were beginning to treat her family and even the most serious events in their lives as entertainment, and part of the reason these events were no longer taken seriously was that Britons were not sure they were even true. Successive surveys had shown that the public distrusted royal reporting, and knew it contained a large dose of fiction.[41]

Even as the press's treatment of the royals became rougher, the family continued to accumulate tax monies, and

in this financially powerful but politically almost powerless role, the Windsors survived by remaining increasingly visible. In order to do so, they had to act like celebrities, offering for our consumption a half-true soap opera based on their lives. The response of Britain's establishment to the Paris crash would precipitate another transition, this one from the chaos of Charles's rows with Diana to the precarious order of slick PR, but it would not replace the royal soap opera with egalitarian monarchy. It would make the soap opera permanent.

The royal family was asleep in Balmoral Castle when news of a crash was first transmitted. Since that night, angry and conflicting stories have been told about what happened at their Highlands retreat in those early hours of Sunday, 31 August. The Queen and her son have both contested the other's version of events through their friends and courtiers, with the prince's camp briefing against his mother, and vice versa, in the most public war between a monarch and heir for several generations.

Charles's spin doctor, Mark Bolland, landed the first blows in the week after Diana's death, telling Channel 4 that after the news had reached him, the prince had been devastated, but in charge. He had ensured that his ex-wife was treated with dignity, while the Queen refused to help. Supporters of the Prince of Wales kept to this tack, and a year after Diana died, Penny Junor published a biography of Charles, based, she says, on extensive briefing by his media team. (His office has never denied this.[42]) According to

Junor, the Queen and her son had sat all night in adjacent rooms, never speaking directly and arguing only via their aides about what to do. The Queen, writes Junor, had objected to her son's demand that the Royal Squadron should fly Diana's body back from France, and that it should then be kept at the chapel at St James's Palace. Her Majesty's closest adviser on public and political matters, her private secretary Robert Fellowes, apparently agreed with the Queen. Charles travelling to Paris to collect Diana's body 'would be … too much fuss'.

Fellowes was very much on the side of the Windsors, despite being Diana's brother-in-law, but his deputy, Robert Janvrin, is purported to have asked the Queen: 'Would you rather, ma'am, that she came back in a Harrods van?' It seems improbable that he would have made such a sardonic reference to the department store owned by Dodi's father or that, as Junor also claims, Charles would have protested pre-existing plans for royal deaths stipulating that the body undergo normal legal procedures at Fulham Mortuary. 'Sort it. I don't care who has made this decision. She is going to the Chapel Royal.' Whether or not the quotes were accurate, Diana's body did indeed go to the mortuary in west London, where legal formalities were completed, before travelling to the Chapel Royal at St James's Palace.[43]

Her Majesty's aides remember that morning very differently. One of the Queen's courtiers told her sympathetic biographer, Robert Lacey: 'Charles was like a wet weekend at Balmoral. He was poleaxed with guilt, and any suggestion that he was taking charge is ridiculous.'[44] If

anyone in that family was thinking practically, they said, it was the Queen. As soon as she had heard the news, she had been thinking of how her grandsons would be informed: 'We must get the radios out of their rooms,' she told Charles.[45] This is the strangely vulnerable world of the Windsors, where feuds are enacted through biographies, and family tragedies might first be heard on the radio.

The news of a crash involving Diana and Dodi had been broadcast around the world even before emergency crews had removed the injured princess from her car's wreckage. The details of what was happening, however, remained scant. Few people outside Pitié-Salpêtrière Hospital knew that she was suffering multiple heart attacks and severe internal haemorrhaging,[46] and Buckingham Palace, Downing Street and the Élysée would tell journalists nothing.[47] In London, reporters on the night shift were calling their papers' printers, demanding they hold until some sort of announcement was made, and a new front page could be written.[48]

Diana died at about four o'clock, French time, but the official channels remained silent. Around the world, hundreds of millions of people were waiting, and for two hours newscasters repeated that Dodi and the chauffeur were dead, but that the news about Diana was unclear. One eyewitness had reported seeing her walking away almost unscathed. She had a broken arm, a concussion, or was it severe injuries?

On government business in Manila, British foreign secretary Robin Cook eventually confirmed to journalists travelling with him that the princess was dead, and asked

them to hold the news until Buckingham Palace confirmed publicly. However, it was not long before the Press Association broke the embargo. Two hours after Diana had died, on BBC Worldwide Nik Gowing announced the PA's alert, citing unnamed British sources, that Diana, Princess of Wales, had died.

At about seven that morning, UK time, Charles woke his sons and informed them of what had happened. It is estimated that just an hour after they were told the news, half the country knew that the princes' mother was dead, and that by eleven that morning, there was only one person in every ten in Britain who had not heard.[49]

It was a Sunday, and William and Harry dressed for that morning's service at Crathie Kirk, the imposing Gothic Revival church where the royal family worships when they stay at Balmoral. Most accounts of that morning at the castle describe Charles or Prince Philip asking the boys if they wanted to go to church, and encouraging them to see it as a chance to reflect on things quietly. The boys said yes, but the kirk's minister chose, or was asked, not to alter the service, and he stuck to the sermon he had already prepared: a light-hearted musing on moving house, including Billy Connolly jokes. The Windsors had hurried into the kirk, their faces politely serious but apparently untroubled by strong emotion, and they left with the same expressions. The next day's *Times* reported: 'No Mention of Accident'.[50] This polite journalistic incomprehension, which implicitly demanded that the Windsors somehow show their feelings in public, was a sign of the coming storm.

Two hundred miles south, Tony Blair was demonstrating his rather more obviously emotional, but just as carefully staged, approach to public communications. As he walked through the churchyard of St Mary Magdalene, Trimdon, where he was to read the Sunday lesson, he stopped and turned to a bank of waiting cameras. In his apparently improvised speech, which had, in fact, been prepared earlier that morning on the phone with his press secretary, Alastair Campbell, the prime minister succeeded in redefining Diana, using the energy of her royal glamour as fuel for his political aims. To describe her, he used an epithet that combined her regal and aristocratic position, her mass-culture brilliance, and her combination of patriotic and demotic sensibilities. Like New Labour's project, it would substitute soft nationalism for real egalitarianism. Campbell would later claim that Diana herself had been characteristically 'New Britain',[51] but for now, that message remained implicit. The prime minister called her 'the People's Princess'.

During his short speech, Blair also claimed, in a slightly choked voice, that 'I feel like everyone else in this country today, utterly devastated. We are today a nation in a state of shock, in mourning, in grief.' The preposterous idea that everyone was experiencing the same emotions could simply have been the product of a lazy turn of phrase, but New Labour were famously careful in their identification of the country's thoughts and feelings. The success of these kinds of falsities was reflected the next day in front pages around the globe: 'The World Wept',[52] 'Britain Will Be United',[53] 'World In Shock'.[54]

The prime minister was using this fiction as part of his wider political plan to change British culture. He believed passionately in the free market revolution that Margaret Thatcher had initiated in the UK two decades earlier, but he hoped to discourage the distrust and selfishness that he felt those changes had encouraged in everyday life, and he wanted to do this by promoting a sense of community among Britons. In part, that meant a unified national community. Multiculturalism and an ethical foreign policy were supposed to be elements of this new nationalism, that of a post-imperial country that embraced long-ignored minorities. The royal family were not natural inhabitants of this New Britain. However, any attack against them, whether by the government or by the people, looked too much like class war, and that was definitely excluded from Blair's consensual vision.

His conjuring of a unified nation would hide how diverse and how divisive its mourning for Diana would be, and this mirrored New Labour's liberal and centrist kind of pluralism. Many members of the oppressed groups whom the party was claiming now to include in mainstream political culture – black people, women and gay people, most obviously – had radical criticisms and proposals that they wanted to make, but Blairism studiously ignored these. This was the broad approach from which developed the more or less conscious tactic – it was what Straw and Macpherson did in their dealings with Doreen Lawrence and the anti-racists – of taking the ideas of radical groups, watering them down significantly, and presenting them as policies for real change.

New Britain was divided between a significant number of people who cared quite a bit about Diana's death, an even larger number who were vaguely interested, a smaller number who did not care at all, and, as would soon become clear, a minority who really cared a lot. These divisions first began to appear early afternoon on Sunday, when one in six Britons was watching the rolling TV news.[55] Those were good ratings but they do not, by any stretch of the imagination, represent a homogeneous national audience joined together in grief, or even in fascination. Viewers called the BBC to complain about how much airtime the Corporation's channels were giving to the Diana story, and by the early evening, only 4.5 million Britons watched a quickly pulled-together documentary about the princess on the Beeb, while 13.5 million chose to watch soaps on ITV.[56]

Something similar happened to the press over the following week. Media analyst Mallory Wober has shown that although the country's consumption of newspapers during the crisis rose above previous years' levels, it did so only suddenly and very briefly. Given that journalists continued to pay so much attention to the story – some papers gave it dozens of pages for more than a week – it was clear that the public was far less obsessed with the story than the media were.[57]

Alastair Campbell, however, seems to have convinced himself that the rhetoric of a unified Britain was true. He wrote in his diary that public opinion was 'a tide that had to be channelled' away from anger with the Windsors' *ancien régime* and its antagonistic relationship with Diana. Those

feelings could be directed into support for New Labour's own vision for Britain if they were represented as having forced the monarchy to modernize.[58] The government would seem progressive, but not too much so, if it could give the impression that those on the margins were making gains, but that it was containing their anger, whether that was directed at the Windsors or at an institutionally racist police force.

Over the coming week, Blair and Campbell would indeed channel the tide of public opinion. It did not exist in the homogeneous way they imagined, but if they were going to act decisively to save the Windsors and promote their own political project, they had to act as if the public was unified. Dealing with the real and varied truth might have required them to publicly acknowledge how disunited the country was – hardly a PR coup – and it would also have been paralysingly complicated.

Just like his belief in unity, Blair's emotional response was apparently sincere, but nonetheless very well spun. On the phone to Campbell early on the Sunday morning that Diana died, his press secretary remembered him being 'really shocked … gabbling'. By contrast, those who presumably felt considerably more intense emotions, Diana's children and her sisters, showed little of their grief that day. But just as Blair had needed to act as if an entire nation of 60 million people was mourning one woman, just so that no one would say he was insulting her by denying that she was popular, so too, standing outside St Mary Magdalene, eulogizing the People's Princess, he had been required to restage his emotions for the camera. If Blair's

feelings and Diana's importance were going to look real, and if public opinion was going to be homogeneous and therefore politically manipulable, then they all had to be faked, consciously or otherwise.

The prime minister's wife was more receptive to these lessons than Her Majesty would later be. While they waited at RAF Northolt for the plane carrying Charles, Diana's sisters and the body of the princess herself, Tony reminded Cherie not to look happy: 'Someone says hello; the natural inclination is to smile. Someone snaps the picture.'[59] Like her husband, if she did not exaggerate her sadness to the point of acting, she might be perceived as not sad at all.

Waiting at the airbase alongside them were much of the Westminster elite, military top brass and those senior courtiers not with the Queen at Balmoral. All were white, male, upper middle-class, and many had counted among the princess's enemies, but under grey skies, sixteen hours after Diana had died, they waited together for the jet from Paris. The plane landed, and when the cortège had driven away with the coffin, Blair offered his spin doctor's services to the royal aides. A man of strong republican sympathies, Campbell has admitted that he was surprised to find himself fighting on the Windsors' side. However, this was one of many times in a year of establishment retrenchment when old and new elites joined together to defend their shared interests.[60] They watched Charles return to the plane and fly back to his mother and sons at Balmoral.[61]

By midnight, when the coffin arrived at the Chapel Royal, St James's Palace,[62] thousands of bouquets were already

lining the railings outside Buckingham Palace, the Queen's London residence 300 metres up the road from St James's. Even more flowers had been laid outside Kensington Palace, three kilometres to the west and home to an ever-changing array of royals, including the late princess.

Over the following week, members of the public placed vast quantities of flowers, teddy bears, candles and postcards outside London's royal residences (the improbable figures of 10,000 and 15,000 tonnes were quoted, even by Reuters).[63] In an attempt to reflect this dramatic expression of collective feeling, journalists collected anecdotes – there were only a very small number – about members of the public chiding each other for inadequately solemn behaviour following Diana's death. Blair's idea of 60 million people grieving together flowed easily into the equally fictional assumption that Britons were becoming more emotional in some vaguely 'American' manner. Indeed, many observers claimed that this was the greatest impact of the princess's passing. It had, they said, accelerated a much broader change in British society: the spread of a kind of 'grief fascism', a social pressure to demonstrate sadness at a given time and to do so publicly.[64]

There is no evidence that most ordinary people felt any pressure to mourn. In fact, 70 per cent of those responding to one large survey said that they did not participate in public mourning of Diana in any way.[65] Many of the minority who did mourn publicly did so out of curiosity, or even for the sake of an interesting excursion to a royal sightseeing attraction, but very few did so in a state of hysteria. At Kensington Palace, news presenter Jon Snow

witnessed 'up to 15,000 people walking across Kensington Gardens … it was curiously serene – hushed tones, no raised voices'.[66] According to the *Guardian*'s reporter, outside Buckingham Palace 'some people, mostly elderly, were in tears. But more were eating ice creams.'[67] The number of people there who wanted to take a photo – an activity that could indicate reverence, but not necessarily of the grief-stricken sort – became so large that the police created photography-only queues.[68]

There was little pressure on members of the public to grieve, and Britons did not suddenly learn to express their feelings more openly. Rather, those in power were simply behaving as if everyone was mourning Diana. This allowed New Labour to 'channel the tide' and promote their political project, and it was going to help Number 10, the tabloids and the palace's courtiers reinforce the royals' role as celebrities.

Some people mourned Diana, and others were entertained by reading and hearing about her life and death, but an in-depth survey of Britons' experiences of the fallout from the crash found that many had both responses.[69] That is not as surprising as it sounds. Psychoanalysts often describe individuals as being ambivalent about those they see as authority figures: we fear, resent and want to punish them, but we are attached to, identify with and want love from them too. That does not mean that most people felt these ambivalent emotions about the Windsors as strongly as they might have felt them about individuals they knew personally, but for a small minority who were emotionally invested in the week's events, these feelings became very intense.

The resentful part of Britons' ambivalence towards the royal family had been represented by the tabloids with particular alacrity over the previous three decades. As fewer people had felt a strong sense of belonging to a social class, it had become much easier for ordinary Britons not to defer to their social elite, and to take a dehumanizing, fascinated pleasure in the royals' unhappy lives. Support for abolishing the monarchy grew only slightly and temporarily during the War of the Waleses[70] – you do not want to destroy the figures to whom you are ambivalent; you want to draw them closer and make them suffer – but in this soap opera, the royal role looked increasingly like that of an ordinary celebrity. Spurred by the death of the princess at the heart of that story, New Labour and the media were going to demand that the Windsors respond in a way that reflected these changes. The Queen and her family were going to have to act like stars. That, it would be claimed, was progress.

During the first forty-eight hours after the crash, Buckingham Palace's courtiers were intensely keen to attract New Labour's help. At least, it seemed that way to Alastair Campbell, who lavished them with tips and strategy.[71] Charles was similarly inclined, asking his aides if Peter Mandelson, formerly Labour's head of communications and now a key Cabinet ally of Blair's, could call him with PR advice, pro bono.[72] And, whether the palace liked it or not, when the funeral was pitched to the media, it was given a Blairite branding. The Lord Chamberlain's Office, which is responsible for official royal occasions, had

thrashed out a rough plan over a long Sunday night, and in the morning it was presented to the media. Following the lead of Downing Street's press officers, they dubbed it the 'People's Funeral'.[73]

Through the French windows of Buckingham Palace's Chinese Dining Room, members of the Lord Chamberlain's funeral planning committee could see TV crews setting up camp in Green Park. The journalists were waiting for the Queen's return to London, which they seemed to think might be imminent. Inside, the committee was sat around a long mahogany table that dominated the heavy, scarlet room. They had seen the headlines. Many were unfriendly.

After Diana's death had been announced, some, but by no means all, flags over royal buildings had been lowered to half-mast, and Monday morning's papers were peppered with complaints about this supposed dishonour. The day that Diana had died, dozens of people had called the tourist helpline at Windsor Castle, complaining that its Union flags had not been lowered.[74] Crowds at Balmoral had complained to reporters that the Royal Standard there was still at the top of the flagpole.[75] At Buckingham Palace, there was no flag at all.

The Queen's press office had gone on the defensive, repeatedly explaining to journalists that the Standard represents the sovereign, and because the moment a monarch dies their heir becomes king or queen, the Standard is never, ever raised or lowered to half-mast. Publicly, that was the protocol. In private, senior courtiers confronted the Queen with less old-fashioned requirements: the newspapers

were complaining, Alastair Campbell was anxious that something be done, and lowering the Standard would be a simple gesture that might solve both problems. When the Queen's officials reported back to Campbell, they were disconsolate. For Her Majesty, 'it was a broken tradition too far'.[76]

Alastair Campbell explained his basic method to the Queen's aides. They needed to make big announcements, and to do so every day. Just as he and Blair could not squash public feeling, but might be able to channel it for their own purposes, Buckingham Palace could never persuade its critics, but it might be able to marginalize those voices with flashy photocalls and press releases filled with exciting detail. Later, he suggested 'that Charles made some sort of gesture towards the boys, a touch, a hug, something that said father and son, not just royal family'.[77]

Tuesday's papers focused, as the courtiers had hoped they would, on how the world was mourning and on the Lord Chamberlain's big announcement of the funeral plans. But on Wednesday the palace detected a new rumbling of public frustration and press criticism. Journalists were judging the mood of the entire country on the basis of bitterly irritated words that they heard from mourners in Kensington Gardens and on the Mall outside Buckingham and St James's Palaces.[78] A bouquet had been left with the message 'You were a rose among a family of thorns',[79] and members of the public were quoted demanding that the Windsors return to London. A woman in the crowds outside St James's Palace told ITN: 'I think somebody should be here

to represent us.' A couple who had travelled from Derby to lay flowers in London told a reporter from the *Scotsman* that it was 'a great shame that the royal family have not come back down from Balmoral'.[80]

These were the complaints of an increasingly visible minority, but there was no reason to think that such anecdotes were representative of wider feeling. However, the Queen and Charles's media advisers believed they were so, perhaps because this was a year when subversive ideas were gaining traction in Britain's mainstream culture. Even these feelings, unconnected to any articulated political vision, let alone a republican one, looked like a huge and threatening surge in the slow decline of deference. The courtiers confided to Campbell that they feared this was turning into 'the people against the family'.[81]

Royal aides who were up in Balmoral have described to Robert Lacey their insistent attempts to 'convince the family – the Queen, Prince Philip, Prince Charles – all gathered in the sitting room, that there was a crisis and they couldn't just look at it in the traditional family way'.[82] The senior royals had several courtiers in their apartments, plus a few others on the phone from Buckingham Palace, and all these aides had united in insisting that their bosses choose exactly the course of action that they did not want to take. They had to go back to London, and a solution had to be found to the flag problem.

The Windsors refused angrily. One courtier quoted the Duke of Edinburgh complaining, 'What's all the fuss about? It will calm down,'[83] but the royal aides would not concede,

and their struggle with their employers was so bitter that it left several of them 'heavily scarred'. The Queen's private secretary, Robert Fellowes, argued tirelessly with his boss, insisting on the need to compromise during a series of deeply wounding confrontations with her and Prince Philip. The royal couple 'got angry with their advisers, and in an ugly fashion'.[84] Those days in Balmoral were tumultuous, confusing and humiliating for both the royals and their household.[85] It seemed that 500 years of usually slow change in the role of the royal family were coming to a head, and that the monarchy itself was threatened. The Windsors' courtiers were trying to save their employers, but they were doing so by forcing them to adopt Blair's practice of carefully performing emotion.

Later on Wednesday, one last official decided to put pressure on the Queen. Unlike her senior courtiers, Her Majesty's prime minister did not have the confidence to be blunt with the sovereign, but presumably he recognized that if she continued to anger 'the public', this week was not going to act as a unifying experience that pointed to a progressive new dawn. So he called her son. Charles sounded 'done in' to Blair, but 'was clearly of the same mind. The Queen had to speak … He agreed to take the message back.'[86] The prince would tell her that their family 'had to come down to London to respond to the public outpouring'.[87]

Was it the public's outpouring that they were responding to, or the media's? In a poll conducted three days later, 39 per cent of Britons said they felt less favourable towards

the royal family since Diana's death, but very few felt strongly.[88] There was a degree of public irritation, then, but most people did not care at all. Republican feeling supposedly rose, but the statistics showing support for the monarchy as an institution fell so slightly, and so briefly, that the change in the numbers may just have been a result of polling inaccuracies.[89] Like Blair and Campbell, with their useful vision of national unity, the palace aides were not just *imagining* a fantastical version of what was happening – a surge in anger that was taking place in the papers and on TV, but not in the minds of most of the public – they were also responding to and trying to mould that non-existent nation of subversive subjects. The courtiers benefited from responding, not to the truth, but to this gross media exaggeration. It motivated the urgency of their demands, and Charles's, that the Queen return to London. It allowed them to respond more decisively.

Those quoted in Wednesday's papers who were angry about the Queen's distance from her people were not representative of the rest of the country, but it was their feelings that were amplified and exaggerated in Thursday morning's front-page headlines. 'WHERE IS OUR QUEEN? WHERE IS HER FLAG?' demanded the *Sun*,[90] while the *Mirror*'s headline – 'YOUR PEOPLE ARE SUFFERING SPEAK TO US MA'AM' – framed an old photo of a sullen-looking Queen and images of mourners sobbing.[91] Just as Macpherson had redefined the concept of 'institutional racism', editors were reframing this dissent as something publicly controversial but not politically

challenging. Although this bad press undermined the Queen, it was also a demand that she display her majesty.

The *Sun*'s editor, Stuart Higgins, was so desperate for an opportunity to turn the story positive that he called Alastair Campbell. 'He said I had to persuade [Tony Blair] to get Charles to persuade the Queen to put a half-mast flag up there.'[92] Higgins's editorial that day had insisted that the royal family really did care, and that they just had to show it: 'We know that … the Queen Mother is heartbroken … the Queen and Prince Philip are in a state of shock … But from the outside looking in, the House of Windsor seems a cold, compassion free zone.'[93] It was a baseless soap opera framing of what was happening inside a real-life and largely unknown family.

'SHOW US YOU CARE', the front page of the *Express* had demanded that morning, beside another old photo of the Queen, this one looking down her nose at the photographer.[94] Presumably, caring was what the Queen was already doing. Indeed, no media sources openly questioned the palace's defence of the Queen's decision to stay at Balmoral: she was there to support her grandsons, two boys who had woken on Sunday to discover not only that their mother was dead, but also that half the world already knew about it. Nonetheless, their well-being was entirely ignored in criticism of their grandmother's decision to remain in Scotland. Diana had shown real emotions, sometimes wild ones, but the papers wanted the Queen to come to London and perform emotion for them. Nobody expected her to truly want to join her royal fans in London.

Outside the windows of the Chinese Dining Room, it looked like rain. Campbell and the courtiers had read Thursday morning's awful front pages when they sat down to work out a few last details of the funeral, which was forty-eight hours away. Afterwards, they began a tougher job. Robert Fellowes opened a conference call with his deputy, Janvrin, at Balmoral. Campbell and a few others sat with Fellowes in London, and at some point, on the other end of the phone, Janvrin was joined by Her Majesty the Queen.

She had changed her mind. The accumulation of insistent courtiers, her son, her prime minister and, finally, those dreadful and unexpected headlines – the exact reason for her decision has remained private, but those on the other end of the line were now free to design the Windsors' attack strategy, which was really a full capitulation. After a forty-five-minute call, they had worked it out. The royal family would return to London early, they would visit the coffin and inspect the public's flowers, and the Queen would broadcast a message on television. On Saturday morning, when she left for the funeral, a Union flag would be raised to half-mast above Buckingham Palace.

Quickly, Campbell leaked to ITN that the Queen would give a televised address, and with the story all over ITV's *Lunchtime News*, she was unable to change her mind.[95] That afternoon, the young Prince Harry provided a more spontaneous and accidental PR triumph when he, his brother and their father inspected the flowers left outside Balmoral. During the photocall, he briefly held Charles's hand. It was tender and natural, but it was also a moment

of genuine affection that news teams around the world had to package for their customers' satisfaction. It did the trick. The Windsors' photocalls had always been formal, and their statements of emotion absurdly choreographed, so on the next morning's front pages the photo of a little boy holding his father's hand perfectly illustrated a positive shift in the narrative. Charles could now be seen caring for his sons, just as the Queen was coming to London to be seen to care for the public. Apparently, the Windsors were becoming like us.

The next day, the Queen and Prince Philip sat in the back of their limousine, driving the short way down the Mall to meet mourners waiting outside St James's Palace. The couple was deeply anxious. Their press secretary was concerned that members of this 'potentially antagonistic crowd' might somehow express their anger in the monarch's presence,[96] and the Met were so worried that they tried to post a wall of police between the Queen and the mourners whom she was there to meet.[97] In hindsight, their fears still seem reasonable. Much of the country was, at least slightly, critical of Her Majesty, but the committed fans, the minority whose views were on the front pages, were the ones standing at this moment behind the steel street barriers, and they might well have been enraged. However, the sovereign's presence did not anger the fans. Instead, her presence mollified most feelings of resentment. A few smiled. Most thrust out their hands at her to be shaken. Many clapped.

Outside Diana's home at Kensington Palace, William, Harry and Charles were confronted by a wall of bouquets

several metres deep. News footage shows members of the public cramming against the metal barriers, stretching their arms out at the boys, shaking their hands and forcing hugs on them. William smiles toothily, repeating his thank-yous. His eyes are slightly too wide; his voice is uncertain. The smile is rictus, then falters. This was one kind of fake emotion that had nothing to do with modern PR methods. As aristocrats, and as males, they were expected to mask their grief.

Meanwhile, Blair and Campbell – two men who, a few years before, might have cheerfully described themselves as republican – were writing the Queen's television message. Such were the alliances between rival elements of Britain's establishment when they felt threatened. A draft went to Fellowes, and he sent back a few edits. He did not like one of Campbell's lines, the one in which the monarch told viewers that she was speaking 'as a grandmother'. Campbell insisted it had to stay in. Fellowes, eventually, relented.[98]

Over the last five days Campbell had simply held the courtiers' hands, but this was the moment when New Labour's influence became vital. Having helped force the Queen to come down from Scotland, Blair was now transmitting his talent for carefully staged emotion to her. She had until this point been able to leave demagogic manipulation to her prime ministers, partly because her status had never been under threat from an election. This spread of New Labour's PR tactics to even the most remorselessly reserved corners of the establishment was one of the greatest changes spurred by the Paris crash.

On Friday afternoon, the eve of the funeral, a camera crew set up in the Chinese Dining Room. They drew aside the net curtains and opened the windows so that viewers would be able to see and hear the crowds of mourners milling about in front of the palace. The Queen entered the room. She was wearing black. In front of the windows, and accompanied by the mumble of those outside, she addressed her subjects:

> What I say to you now, as your Queen and as a grandmother, I say from my heart. First, I want to pay tribute to Diana myself. She was an exceptional and gifted human being. In good times and bad, she never lost her capacity to smile and laugh, nor to inspire others with her warmth and kindness. I admired and respected her – for her energy and commitment to others, and especially for her devotion to her two boys. This week at Balmoral, we have all been trying to help William and Harry come to terms with the devastating loss that they and the rest of us have suffered.[99]

The live broadcast – a risky choice – flowed immediately into the BBC's *Six o'Clock News*. Anna Ford, presenting, said how 'warm and relaxed' the Queen had looked, and Royal Correspondent Jennie Bond described in detail how impressive she thought Her Majesty's performance had been.[100] It was agreed that the atmosphere of the crowd was improving,[101] and Campbell felt it was a job well done: 'That day, when I walked back from the Palace to Number Ten it was a different mood.' He was so certain of the impact of the speech he had written that he decided, 'That was the

turning point. You could feel that happening.'[102] As far as he was concerned, a tide of resentment had been channelled into optimism. Her Majesty had completed the Windsors' transformation into a soap opera.

Saturday's papers were full of praise and relief, just in time for the funeral.

These events would be mythologized as representing great progress, but Blair's intervention had no more levelled the relationship between the monarchy and its subjects than the Macpherson inquiry would end institutional racism. Nonetheless it had made the prime minister look strong, compassionate and in touch with ordinary people. He had apparently saved the Queen without kowtowing to her, and this week would often be cited as his greatest. Moreover, he had redefined Diana, the People's Princess, in his nationalist, pseudo-egalitarian terms, and the media had spent several days loudly echoing the themes of his broader modernizing project.

The demands of crowds of Diana fans and the media that the Queen do what they wanted had partly been motivated by amorphous democratic desires. It had been similar to the 'out of control' public mourning, the coming together and making Diana one of us, that some observers had found so frightening that they imagined it to be pervasive: 'grief fascism'. However, the wish to bring a superior figure down to our level was not distinct from the wish merely to be close to that figure, and it had easily been satisfied by Her Majesty's arrival in London.

As the Met was being challenged by the anti-racist radicals of the Stephen Lawrence campaign, the Windsors had in some sense been confronted by a part of the public. In the middle of these stand-offs had stood both New Labour, always on the winning side and never allowing the status quo to be disrupted, and the media, echoing and exaggerating some of the anger felt by those with less power, but never threatening the position of those in authority. Those ambivalent fans lining the Mall had been powerful and subversive, but only to the very limited extent that the media had made them so.

In the course of many of 1997's other crucial events, people in power took advantage of specific, radical ideas created by the groups they were trying to control. By contrast, during the Diana crisis it was amorphously subversive feelings of resentment against those in power that the royal family and New Labour had exploited. These might have been harder to manipulate because they were less articulately identified, while Macpherson, by contrast, could quite simply remove the anti-capitalist and anti-state elements from the supposedly single, clear concept of 'institutional racism'. During the week after Diana died, the public could not be used in that way because they were too diverse and unknown, but luckily for Blair, Campbell, the Queen and the courtiers, they were not actually responding to a real public with a heterogeneous array of feelings. They were able to appear decisive and effective because they were channelling the feelings, not of the public, but of a fictional version of it.

The Liberal Democrats' leader, Paddy Ashdown, claimed that in the days after Diana's death, the British had transformed from subjects into citizens.[103] With his vision of a future in which royalty was modernized, Blair was also trying to reframe public resentment of those in authority as something unthreatening. However, most monarchists admire royalty for its traditional qualities and a humbled Windsor dynasty would have been unstable because it could not have provided royal fans with what they wanted. Rather than the subjects of the Crown, it was the tabloids and Blair that had asserted themselves. By forcing the Queen to behave like a celebrity they had not encouraged the monarchy and the public to 'walk hand in hand, as opposed to be[ing] so distant', as Diana had told Martin Bashir that she hoped they might. The Windsors' social status had not been affected, and neither had their constitutional role or their immense wealth. The future that never happened was a contradiction, and a New Labour fantasy, from the beginning.

This had not, however, been an entirely successful week for the British establishment. The Queen had given in, and had allowed her thoughts and feelings to be treated as a soap opera featuring the nation's favourite celebrities. For this, she was praised, and the encroachment of contemporary PR methods into the life of the royal family was complete.

The funeral planning committee had agreed that a gun carriage was preferable to a hearse.[104] It would be much easier, that way, for the crowds to see Diana's casket as it travelled along the roads from Kensington Palace to

Westminster Abbey, followed by five men walking side by side: the two sons she had loved, and three men with whom she had had extremely complex relationships: her brother, ex-husband and former father-in-law.

When the Queen left Buckingham Palace to join them, her Royal Standard was lowered and a Union flag was raised to half-mast. It was not the last media-friendly innovation of the day. The service had been trailed by the Lord Chamberlain as 'a unique funeral for a unique person', which was a tactful way of refusing the princess a royal ceremonial funeral or a state one. But it was also an opportunity to combine the pomp of protocol with charity workers and pop songs.

The event fused the militaristic camp of the nineteenth century with both the informality and the slickness of the 1990s. Excerpts of Verdi's Requiem were joined by Elton John's reworking of his song about Marilyn Monroe, 'Candle in the Wind'. Heads of state, members of the Privy Council and international nobility were joined by Hollywood stars and about five hundred representatives of charities and other organizations to which Diana had been connected, many of them dressed not in the starchy black and white of a Church of England funeral, but in the soft, bright bibs and T-shirts of the voluntary sector. Similarly, what might have seemed to be an antiquated practice – a huge crowd turning out to mourn the passing of an aristocrat – was enabled by the quick installation of huge video screens along the route of the cortège and in nearby parks.

Earl Spencer's eulogy dominated the day with its ostentatious, albeit implicit, criticism of the Queen. Her Majesty had previously revoked Diana's use of the style 'Her Royal Highness' but, her brother observed, 'She needed no royal title to continue to generate her particular brand of magic'. He went on to question Charles's parenting. Addressing his late sister, to whose sons he had never been close, the earl pledged 'that we, your blood family, will do all we can to continue the imaginative and loving way in which you were steering these two exceptional young men, so that their souls are not simply immersed by duty and tradition, but can sing openly as you planned'. More explicitly, he attacked the media, explaining their treatment of Diana thus: 'Genuine goodness is threatening to those at the opposite end of the moral spectrum ... Of all the ironies about Diana, perhaps the greatest was this: a girl given the name of the ancient goddess of hunting was, in the end, the most hunted person of the modern age.'

He finished, his voice faltering, and without pause, almost as if it had been planned, the sound of clapping could be heard. Hundreds of thousands of people watching the funeral on screens around the abbey were applauding the most visible and angry attack on a British monarch in living memory. The congregation could hear what was happening outside, and almost immediately the clapping entered the church. Hundreds of the great and the good who had been invited to mourn Diana were applauding, and doing so at a Church of England funeral, where clapping is not considered appropriate. The angry crowd was now

at its most visible, and it seemed to many like an act of bare aggression against the Queen and Charles. Once more, members of the public were calmly, but insistently, mourning Diana in their own way.

Thirty-two million Britons – 56 per cent of the population – had watched some of Diana's funeral live,[105] and it drew the second-biggest British television audience ever recorded. That was a necessary component of the spectacle (it had to be watched for it to be important) and it confirmed Diana's significance. It was not, however, a unified national audience. On a Saturday afternoon, when few people really had to be anywhere, nearly half the population did not bother watching the programme. The nation was never, and is never, as one.

Those who had watched the gun carriage roll towards the abbey glimpsed something laid on Diana's coffin: an envelope leaning against a bouquet of tiny white flowers. The camera held this shot for a moment, focusing on the card, which seemed to undermine all the ceremony, planning and spectacle around it. It was familiar, intimate and real, but it was also broadcast to nearly a billion viewers around the world and, as such, was very explicitly intended by courtiers, politicians and the media to be part of an event that would pacify an ambivalent nation, whether or not that nation was actually ambivalent. David Dimbleby's commentary fell silent. The card was addressed: 'Mummy'.

About a year before the crash, Charles had hired a new press secretary. Mark Bolland was comprehensive-educated, an oddity in Charles's office at Clarence House, but he was

supposed to be different, because he would succeed where others had failed: in modernizing Charles's press operation, and making the prince less unpopular.[106]

Bolland's tactic was spin, and his goal was a long-term PR strategy for Prince Charles and his sons, one that reflected the lesson that Blair had forced on the Queen. The press secretary was going to recast the honesty and wildness of both the War of the Waleses and Diana's personality – her misery, her subversive philanthropy, her control of her own sexuality – as a semi-fictional and well-controlled royal melodrama. The public would pay attention to this entertaining constructed reality, and their sympathies could then be influenced.

Armed with Bolland's muscular new strategy, Charles's team discovered that their supposed opposition were still licking their wounds. The media had been criticized widely for paying paparazzi to hound Diana, and were now far more averse to risky royal stories. The prince's PR team had the upper hand and when, in 2002, Rupert Murdoch's *News of the World* told Clarence House that they were going to run a story about Prince Harry having smoked cannabis, the press office confidently insisted that Charles was showing his son the error of his ways. Reporters at the paper, then edited by Bolland's friend Rebekah Wade, did not disagree. Instead, when they published the story, they chose to place alongside it pictures of Charles taking Harry to see a drugs rehab clinic. The visit had taken place months earlier, but the paper purposefully gave their readers the impression that the visit had been a father's reaction to

discovering that his son had smoked some weed.[107] For such a right-wing paper, the story was perfect. The story had scandal, drama, a resolution, and it made the future monarch look good.

Most UK media outlets were now accepting without question an obviously fabricated soap opera that benefited the royals. The journalists' motives are fascinating. In a controversial BBC documentary, the *Daily Mail*'s Richard Kay admitted: 'We want a story and we don't really mind what it is, as long as it's a story.'[108] Royal correspondents may not be convinced of the veracity of a new narrative presented to them by royal spin doctors, Kay noted, but they may nonetheless accept it because they need something new to give their readers. Bolland, then, was providing the press with what they wanted.

Following Diana's death, the royals had modernized, not by becoming more democratic, but by providing better copy for reporters. It worked because both sides shared a mutual interest. 'That was the direction the story was moving,' insisted Kay. Diana was gone, and the Queen and Philip were ageing, so 'Charles, William and Harry were the story now'. That, it seems, meant that press criticism of the Prince of Wales had to be muted, even if public opinion would therefore have to be manipulated: 'We needed to move our readers along with us.' This supposedly more authentic, Diana-like royalty was, in fact, a Byzantine industry of storytelling.

Bolland was briefing the media heavily, just like his predecessors had during the War of the Waleses, but that

era's panicky to-and-fro of embarrassing leaks was over. Without Diana's camp to compete with, Charles's team could pass information to journalists more safely and it was easier for Clarence House to influence how the media represented that information.[109] As a result of the crisis of September 1997, Buckingham Palace and Clarence House have even more control over what the public know about the royals, and to some extent what they feel about them.

Charles's popularity soared and a majority of the public came to accept his relationship with Camilla. His job done, Bolland was encouraged to resign. The spinning slowed, the elaborate detail of the soap opera seemed to dissolve, and the 2011 wedding of Catherine Middleton to Prince William appeared to reinforce these changes. At the beginning of a summer of protests and riots, two young, attractive and warm-hearted people, very much in love, were married in a ceremony watched by tens of millions of people around the world. Security cost the government £20 million, and the public holiday announced for the wedding reportedly cost the economy billions of pounds, although estimates varied wildly. This extravagance, the royal family's hard-won hauteur in its relations with the press and the widespread support for the young couple confirmed that Blair's fabled modernization of the Windsors had failed. They were popular, not despite their refusal to modernize, but because of it.

The Victorian constitutionalist Walter Bagehot wrote that 'A princely marriage is the brilliant edition of a universal fact, and, as such, it rivets mankind'.[110] The flurry of gold

carriages, Beckhams, McQueen dresses and street parties produced exactly the kind of blown-up version of a family wedding that he had imagined. Fourteen years after the Diana crisis, the Windsors not only seemed to have regained control of their symbolic role, they also appeared to have reconstructed their former hauteur.

In September 1997, it had been widely remarked that the Windors were being forced to remake themselves in Diana's image. Virtually all commentators agreed that the monarchy had 'Changed beyond recall ... she showed it up as dull and remote'.[111] By the time of her elder son's wedding, a decade and a half later, the process of modernization had apparently reached its apotheosis. Commentators insisted the young couple's behaviour demonstrated that the royal family – and, in particular, this new generation of Windsors – had followed Diana's lead in adopting a more open and informal style. This, it was promised, would help secure the institution of monarchy for the future. The *Sun* claimed that 'Kate will breathe new life into a 1,000-year-old monarchy', just as Diana had supposedly done,[112] while the *Mirror* praised 'Kate and William's fresh, unstuffy approach to the monarchy' during their wedding, which apparently echoed the attitude of William's mother to her own nuptials, three decades before.[113]

However, the young Windsors' confident smiles do not echo Diana's unpredictable and politicized intimacy, there are far fewer stories of wildness for the media to dig out, and there are few soap opera titbits offered by press officers

from which reporters can extract their copy. Talking to the BBC, ITV News's royal editor, Tim Ewart, expressed his understandable frustration at the new distance between him and his royal subjects, while hinting at the co-dependency that is normal between journalists and their contributors: 'These are the first people I've ever covered, ever, who will not speak to me at all and more than that, the people who represent them … won't tell me anything about what these people think. Now that's weird.'[114]

Diana's death, Blair's intervention and Bolland's tactics have given the royals great power over what everyone else knows about them. Earl Spencer had promised that his nephews would be freed from duty, at least a bit, but the funeral at which he had been speaking played a central role in touching up old, dutiful Britain with a modern gloss, and thereby saving it. Evidently it is those traditions of class hierarchy, defended by a pliant media, that have allowed the princes' a tolerably private life. In the long term, minor scandals have done them little damage, for although William's wedding took place during the longest collapse in real wages since the 1870s, the happy couple's popularity soared while support for the monarchy never wavered.[115]

The empowering of the palace over the media is not the only effect of 1997 that has lasted. The Queen's speech on the eve of Diana's funeral had pointed to a startling truth. The royal family benefit greatly from their position – they still sit at the top of a rigid class system, the past generations' taxes that funded the Crown Estate now pay for a luxurious lifestyle, and current generations' taxes are spent on the

family's militarized security – but the public and the media exploit the royals too.

Some time in August 2013, Michael Middleton, father of Kate, snapped a few photos of his daughter and son-in-law, their newborn son and their dogs. The images were selected by Kensington Palace as the first official pictures of Prince George,[116] the child who is heir to the throne. The photo is smiley, cute, instantly familiar and homely. It went viral online, and featured on the front pages of several national newspapers.[117] Middleton's photo, its poses relaxed and its background highly overexposed, looks spontaneous, but the choice to deploy it, the professional calculation of its impact that will have been made, and the very standard PR methods used to disseminate it, turned a family snap into a choreographed act of spin.

This is the new soap opera. A sample of real life was taken and used to maintain the family's privilege by providing the public with something approximating to entertainment. Bagehot warned that 'We must not let in daylight upon magic',[118] but the Windsors would face catastrophe if they heeded his advice today. The family has won, but they are forced to involve their children in the game. This is not just a tactic of crisis management, as it appeared before 1997 and its week of upheaval for the royals. It is an absolutely necessary element of maintaining the monarchy. The family's status survives, but at a high cost, and one that signals no great springtime for democracy.

4 / GIRL POWER

In August 1996, the arts desk at the *Guardian* received a strange fax. It included a telephone number that anyone should call, the anonymous author wrote, if they were seriously interested in the true origins of the Spice Girls.[1]

When the video for the band's first single had been launched two months earlier, the PR team of their label, Virgin Music, had provided journalists with a simple version of the Spice Girls' biography. After meeting at drama school, the band had shared a flat, developing their singing and dance routines together in front of a bedroom mirror. Then they became famous. The group's members happily reinforced this image of five independent women. 'We do everything ourselves,' explained Melanie Brown, one of the band's line-up, the other members of which were Geri Halliwell, Emma Bunton, Victoria Adams and Melanie Chisholm. 'There's nothing us lot can't handle.'[2] Later, she tried to convince a doubtful young member of the public that 'we don't need men controlling our lives. We control our lives.'[3]

In 1997, the Spice Girls would become the biggest band in the world. Their success would act as a symbolic climax of feminism's gradual movement towards the mainstream and of changes in how the fight against sexism was represented. It would therefore seem to signal that a new, 'post-feminist'

age was on the horizon. The Spice Girls' branding projected a vision of a world in which sexual equality was no longer incompatible with individualistic endeavour as a consumer or as an entrepreneur. Sexism was to be defeated by 'being who you want to be'.

The business model constructed by and around the band assumed that feminism, or something like it, could be cool. In the process, it would actually help make it so. However, just as the way in which anti-racism was mainstreamed would help to reinforce some kinds of racism, and just as the changes hailed as an egalitarian modernization of the monarchy constituted a reinstatement of its traditions, the legacy of making feminism trendy was going to be ambiguous. It would enlarge the scope of a radical idea while deradicalizing it. That method was not created in 1997, but it was becoming more popular in a culture that encouraged subversive demands while decrying radical tactics. Previous chapters have shown how New Labour engineered the absorption of radical people and ideas into Britain's establishment, but the Spice Girls' story, and the following two chapters, will show that this process was also taking place in the wider culture, independently of those in government.

When the *Guardian*'s reporter rang the number provided in the fax, a middle-aged man picked up. The journalist mentioned the message that the desk had received, but the man at the other end of the line insisted that he hadn't been the one who sent it. His name was Bob Herbert. In the mid-1980s, this accountant from Surrey had spent three years creating a boy band, only to have them snatched from his

control by a more established manager. They changed their name to Bros, and had a series of hits, including the number one song 'I Owe You Nothing'. He admitted that he did know something about how the Spice Girls had emerged into the world. The rumour that they had been put together after they had individually responded to an advert placed in the press – that was true. But he refused to say anything else. His silence had been bought by a record company in 1995. Yes, it was Virgin. Yes, for 'a significant sum'.

Over the following years, various Spice Girls creation myths would emerge. This confusion was largely a consequence of attempts by the band's management to portray their employees as free-spirited, as women who asserted their desires, interests and wills in a world where men were trying to control them.

It was Herbert who had put out the advert to which the five women had each responded. His disaster with Bros had been replicated with the Spice Girls, because after he had decided their line-up, and trained them for several months, they had left him. It would soon be reported widely that, after ditching Herbert, the band had managed themselves, writing two of their biggest hits, rehearsing together, organizing gigs and pitching themselves to labels.[4] The story appears to have come from their management and press team, and elements of it were even reported in the *New York Times*.[5] However, it later became known that veteran pop manager Simon Fuller had muscled in on Herbert's plan, paying him off for the band before pitching them to Virgin Music.[6] The band had not ditched Herbert and then chosen Fuller; they had been bought

from one by the other. The Spice Girls' management had been so keen to shore up the many-layered PR construction of their story about the band's genesis that they had paid Bob Herbert for his silence.

Although the appearance of the band's members as autonomous, ambitious, talented and strongly bonded to each other had some connection with reality, it was also carefully calibrated. A marketing expert later described how the Spice Girls were cheeky, even self-willed, but never too challenging: 'They can talk about pinching [men's] bottoms, and sing "Mama I love you," and seem to mean it.'[7]

Girl power would become a meaningful part of many girls' lives, but it remained a business gimmick used to encourage children to buy a product. The story of the Spice Girls was going to show that the ways in which they empowered their fans were intertwined with the ways in which the band was used to exploit those young girls. A decade and a half later, at roughly the same time that anger with the police would explode into thousands of people looting shops and fighting with the police on the streets of England, feminist anger would force its way back into public consciousness once more through online activism, a women's anti-austerity movement and the building of a public discussion that exposed everyday sexism. Among those involved, there would be more than a few former Spice Girls fans. What kind of influence the band might have had, however, was another question.

Feminism's journey towards the mainstream was a long process, and the consequent changes wrought on both the

women's movement and the rest of society were great. In the early twentieth century, suffragists and suffragettes had fought for votes for women. Many suffragettes had attacked property and, when many of those who were jailed went on hunger strike, they had been force-fed by the authorities. Around the world, other women had also struggled for their right to own property and to hold elected office, as well as for other civil, legal and political rights. These gains had particularly strong relevance to women from socially privileged backgrounds, who were most able to take advantage of them. This period was later identified as feminism's first wave.

In the 1960s and 1970s, a second wave emerged. Its members were less concerned with gaining entry to the business and political institutions dominated by men, and more focused on identifying how expectations of what women and men should be like were used to exploit and oppress women, often violently. They described and tried to alter the controlling and demeaning impact on women of conventional heterosexual relationships, they forced a society that was often silent about rape and paedophilia to acknowledge how widespread these were and, consequently, activists were often stereotyped as puritanical or man-hating.

Neither of these 'waves' of feminism had been homogeneous, but in the 1980s and 1990s, a third wave of feminists emerged, one which was, and remains, especially plural. Some of its members were black, lesbian or socialist feminists who were increasingly vocal in describing the different forms of sexism that many women experienced, and the different kinds of struggle that they had to undertake.

Others were women living in poorer countries, war zones and refugee camps, and they sought to highlight misogyny there. Others still were drawing the women's movement into popular culture, and at the forefront of this tendency was Riot Grrrl, a feminist punk subculture based mainly in the USA and online. Its aim was to rehabilitate girlhood and teenage years as a time in a woman's life when she might have space to be confident and wild.

One debate within the third wave concerned the extent to which a woman could have heterosexual relationships and behave in a conventionally 'feminine' way but still fight for liberation from men and their power. In this argument, the impact of wearing make-up and restrictive clothes was one of the more visibly contentious issues. Another concerned the extent to which women should adopt conventionally 'masculine' behaviour – professional ambition and asserting oneself socially were often cited as examples. Whichever side of these debates they were on, however, most feminists argued that a woman could not liberate herself simply by altering her individual behaviour, in these ways or others. Such a tactic would ignore the need for collective struggle in order to end violence and oppression by men, and it strayed into 'post-feminism': acting as if feminism was not necessary any more.

The rise of the Spice Girls, a pop band advocating female empowerment, looked like a moment of progressive change, like the acceleration of a long history.

Simon Fuller was on a flight to New York with Annie Lennox. In his late thirties, Fuller was the Eurhythmics

singer's manager and well established in the music business. He was usually tanned, generally in a smart suit – without a tie – and notable for his black hair, which was carefully arranged in a multitude of short thin spikes. In conversation he was enthusiastic and charming.

Fuller remarked to his client that he had recently signed a new girl band – no one had heard of them yet, but they had big personalities – and the two seasoned industry professionals discussed how to brand the group. Lennox told Fuller she wanted to meet them, and she proposed a novel idea, something that had been tried only rarely with boy bands, and perhaps never with a girl group. Given that these new potential pop stars were not so young, and if they were very different individuals, then, she suggested, they should be marketed as five strongly distinct characters. 'Almost directly,' remembered Fuller, 'she was the one who got them to be louder and more brash and more specific. So Emma Bunton, who was the sweet cute blonde girl, became "Baby Spice". She just played it and hammed it up. None of these names actually existed, but Annie gave them focus.'[8]

The lacklustre, patronizing names of the five women's 'Spice' alter egos would be dreamed up only later in a piece for *Top of the Pops* magazine,[9] but in the meantime Lennox and Fuller were shaping the personas that these names would label. Soon Adams was 'Posh Spice', which might have had something to do with her coming from a more comfortable background than the other band members: her father had been a successful electronics wholesaler in Hertfordshire. She was quieter than her band mates, generally dressed

in less brash styles, and rarely smiled. Brown was 'Scary', which probably had something to do with her tongue piercing, or even her Yorkshire accent, but which some observers interpreted as an unconsciously racist response to her being mixed-race. She was loud, she laughed, she told stories and jokes. She wore a lot of leopard print. Halliwell was 'Ginger', apparently on account only of her hair colour. She was as outspoken as Brown but more conventionally styled, and she had wanted to be famous for a long time, having previously attempted glamour modelling, acting and presenting a TV game show. Finally, Chisholm was 'Sporty' – because she quite liked some sports. Consequently, she spent much of the next few years in tracksuits and doing back flips on stage. She was also the band's best singer.

Other girl groups had generally been promoted with a single, homogeneous concept and look that erased the differences between their members. By contrast, the defining characteristic of this group was that the members' personas were each offered to fans, cultural analyst Sherrie Inness would later write, as different 'legitimate forms of femininity'. Each presented a distinct style and personality type, and with the exception of Bunton – appeasing, passive, fair haired, almost virginal – they were all presented as confident, self-contained individuals: sexy and loud Brown; the similarly sexy but relatively restrained, husky-voiced Halliwell; stuck-up Adams; and the tomboyish Chisholm. This cast of characters left a large proportion of women unrepresented, but they formed an approximation of 'diversity' and the band members were often portrayed as

'girls next door' who seemed approachable to their young fans, as individuals they could identify with. As feminist scholar Catherine Driscoll noted, there had been a time when girl pop fans had to use their desire for a male pop star to define their own identity. In the late 1960s the question had been: 'Do you like John or Paul?' Now, they could choose to identify directly with female stars.[10] The question in the mid to late 1990s was: 'Which Spice Girl are you?'

No one paid the band much attention at first. They had launched in the autumn of 1995, and they seemed to be having quite a lot of fun. When Virgin Records provided the band as free entertainment for their guests in the VIP tent at Kempton Park racecourse, the performance, apparently, got out of hand. The five were reported to have climbed onto the back of a bronze statue of Red Rum outside the venue, before singing their song from the saddle of Britain's most famous dead horse.[11] Another anecdote from their early days describes them dragging a group of music critics into the women's toilets and singing to them a cappella.[12]

The five were unusually confident and eccentric, and that seems to explain why, in the spring of 1996, during planning for the launch of the band's first single, someone at Virgin had a rather strange idea. Like so many details of the band's biography, exactly how this plan came to fruition is unclear, but quite suddenly the Spice Girls' branding changed significantly. Their PR statements started referencing phrases ripped straight from the early women's liberation movement, and the copy for their single sleeves would soon

be full of inspiring quotes about female empowerment, about the Spice Girls themselves being empowered, and about how they wanted to encourage girls to be the same. When Virgin published the band's first official book, it prominently featured the long-standing women's liberation slogan: 'The future is female!'

This was an extraordinary departure for pop music branding. For the management of an unknown, entirely mainstream and unthreatening pop act to market their clients using explicit references to a political ideology was unheard of. The Lawrences and their supporters had carefully tried to bring anti-racist ideas into the mainstream because they believed so strongly in those ideals, but they would in many ways be obstructed by the powerful institutions with which they were joining forces. Now elements of feminism were being brought into public view for more cynical purposes.

There was an ambivalent tone in both the copy for the band's merchandise and in what the five women said during interviews. They simultaneously supported many of feminism's aims and treated the ideology as distinctly embarrassing, and this ambiguity was encapsulated in the Spice Girls' grand slogan. 'Girl power' had a long pedigree, from Riot Grrrl to the name of a 1995 album by British pop band Shampoo. 'Feminism has become a dirty word,' observed a marketing blurb for the band. 'Girl Power is just a nineties way of saying it. We can give feminism a kick up the arse.'[13] Girl power was 'like feminism, but you don't have to burn your bra'.[14] Geri Halliwell told a reporter: 'We

have come up against a few guys who expect five bimbos. It just means you've just got to shout a bit louder to get your way. We're freshening up feminism for the nineties.'[15]

In trying to appear less threatening than the women's movement, their attempts to confront the way men systematically exercise power over women were limited to such occasional comments as 'I expect an equal relationship where he does as much washing up as I do'. Girl power was generally focused on promoting oneself (you should 'believe in yourself and control your own life') and about being the best person you could be. This was exactly the kind of individualist approach that feminists had warned against.

The band's marketing radically departed from how girl bands were generally promoted to Britain's mass culture, but their bland and uncritical politics fitted the arena perfectly. Girl power was not a coherent or pre-existing ideology. Rather, in the phrase of feminist researchers Coman and Kaloski, it was 'a jumble of female insights and hopes'[16] – 'feminism-lite', in the terms of feminist journalist Rachel Giese.[17] Like many of the progressive people and ideas that seemed to be changing Britain in 1997, it was consumer-oriented and liberal.

With the Spice Girls' new feminist marketing concept launched, Virgin geared up to release the band's first single. 'Wannabe' fitted the band's new branding perfectly. Its lyrics were a sustained, shouty demand by the group that they should get what 'they really really want', and its video, to be released ahead of the record, featured them running riot in what looked like a gentleman's club.

After months of touring, PAs, corporate junkets and roadshows, the band's big break came in May 1996, when their promoters gave exclusive rights to broadcast the video for 'Wannabe' to a newly popular cable music channel, The Box. The channel is now forgotten, but at the time it was MTV's biggest rival in the UK. Cable television in Britain had recently expanded out of the big cities to 4.5 million homes, and so The Box had suddenly become an extremely effective marketing force in the music industry.[18] The channel's director of programming, Liz Lakowski, gave the video for 'Wannabe' ten plays a day. It was a huge boost to the band: this much airtime was normally reserved for singles that had reached number one in the official charts.[19] Lakowski had liked the band when they visited her office, but she was astonished by the reception of their promo. Immediately, viewers were calling the channel's premium-rate line to request that they play the song again. 'The audience went berserk,' she recalled. 'At first, we thought there was a phoning posse at work out there.'[20] 'Wannabe' went straight to the top of The Box's viewers' chart, and it stayed there for thirteen weeks.[21] The channel was widely credited in the music industry with making the Spice Girls' debut a success.

In early July, a pre-release remix of the song started to rise up the club charts, which were compiled through surveys of DJs.[22] Radio and TV airplay was huge,[23] and when 'Wannabe' was released it became the first single by an all-woman band to go to number one since 1989, and the first by such a group ever to enter the charts at that position. It stayed there for seven weeks.

The Spice Girls' message that women should get what they 'really really want' was being broadcast to tens of millions of people, and British researchers Coman and Kaloski found that the band appeared to have had a very positive impact on many girls' perceptions of gender and sex.[24] The analysts interviewed pre-teen girls in England about the band, and the results were striking. Almost universally, their interviewees connected the Spice Girls with anecdotes about standing up to a brother or a male classmate who bullied them or demanded they acquiesce to his wishes; with the idea of girls playing the games they wanted to play, or occupying a room at home or a part of the playground at school; and, most of all, with stories of girls playing with each other and sharing interests.[25] Older fans were able to define 'girl power' as girls sticking together, standing up for themselves, and defying boys' demands and expectations.[26] And more generally, fans understood that 'girl power' valorized the behaviour and interests that they associated with girls and women.[27]

These feelings might not have been learned directly from the Spice Girls – rather, the band might have been the vehicle for girls' own self-confident feelings and views. But wherever these proto-feminist ideas came from, the Spice Girls' repetition of them seems to have reinforced them in girls' minds and actions. Across British culture, subversive ideologies and feelings, among them anti-racism, resentment of royal authority, and feminism, were being broadcast to new audiences, and that was happening precisely because those in power were trying to exploit radical ideas and groups, and their wide appeal.

In such a culture, there are opportunities for both sides to take advantage of the other. The Lawrences had used the *Mail* for their own purposes, knowing all the while that their message would be watered down by their very temporary allies. The Spice Girls' music and branding were constructed in order to make rich men richer but, almost accidentally, their feminist slogans were inspiring young girls.

The energy and characters of the band's members were foundational to their success, but the reality of the group's lives and careers was not so liberated. They were always dependent on rich and powerful men. Fuller earned much more than them, taking a 20 per cent cut, while each of the women in the band took home 16 per cent. They were also exhausted, working constantly while, they later claimed, Fuller was taking plenty of time off.[28] Moreover, there were troubling stories about his treatment of women. Journalist Miranda Sawyer reported that Fuller's all-female staff were encouraged not to have boyfriends, but that an exception was made for one member of staff. She happened to be living with Fuller[29] in his mansion in the wealthy London suburb of Richmond Park.[30]

In late October, Virgin released the band's second single. The label had slated 'Say You'll Be There' as the Spice Girls' debut because it was sexier and cooler than 'Wannabe', but the band had apparently insisted upon the cheesier and more 'girl power' track to launch their careers. Some of the second song's lyrics were the conventionally passive fare expected of a female group ('I'm giving you everything … Promise you will be there'), but its video made a greater, more ambiguous,

impact. The five women danced in the desert dressed in black PVC costumes that emphasized their cleavage and thighs; they practised using retro sci-fi kung fu weapons; they tied a handsome, half-dressed man to stakes driven into the desert rocks; and finally they kidnapped another man, driving away with him tied to the roof of their car.

The Spice Girls presented being conventionally sexy as a way of asserting yourself, and this was reflected in the way that their photo shoots eschewed the static and passive poses that are generally expected of female celebrities. They did not lie prone, staring at the camera and its 'male gaze', as defined by film critic Laura Mulvey.[31] Instead, feminist scholar Jude Davies noted, 'the group are often shown in motion, exchanging looks, or in other ways in dynamic relation'.[32]

Many third-wave feminists acknowledged that women might empower themselves by engaging with conventional forms of sexuality, which often involved attaining conventional standards of attractiveness. However, they generally argued that feminists had to pay attention to who was controlling this process, and who benefited from it. The answer was generally rich white men, and it was often feminists who had experienced racism and class prejudice who analysed these complexities. Political philosopher Monique Deveaux drew on black writers Audre Lorde, Patricia Hill Collins and bell hooks to argue that 'inquiries into the how and why of power ... might ask: what do relationships of power feel like from the inside, where are the possibilities for resistance, and what personal and collective processes will take us there?'[33]

Those women in the industry who had tried to steer a different course felt let down when they saw the Spice Girls dressed in tight and skimpy clothes while calling themselves feminists. 'I don't see how wearing a push-up bra and knickers on the front cover of a magazine has anything to do with moving forward the cause of female equality,' observed Shirley Manson of grunge-pop band Garbage.[34]

Referring to a famous 1994 advert for Wonderbra, Brown insisted: 'It's not just getting your bits out and saying "Hello Boys".'[35] The Spice Girls knew that there was a potential contradiction between advocating sisterhood and dressing the way that they dressed, but they insisted that they had solved it. 'This is about girl power,' explained Brown. 'This is not about picking up guys. Sending a positive vibe – kicking it for the girls.'[36] Asked if women pop stars were under greater pressure to strip than men, she made clear that she did not feel disempowered, compared to her male colleagues. 'I've never looked at it that way,' she explained. 'You've got Peter Andre getting his chest out all the time or Iggy Pop who likes to get his kit off and wear see-through trousers.'[37] When a male journalist suggested to her that by showing their bodies, the Spice Girls might be pandering to male desires, she was not impressed. 'If you do it and feel good about it, that's fine by me.'[38]

Other women in the industry countered that in a society in which women often had little control over how their sexuality was perceived and treated, the Spice Girls' position was very privileged, because most women were not able to gain parity with men. 'It would be wonderful if the world

was a safe place and young girls could all wander around half-naked,' observed Sinead O'Connor, 'but it isn't.'[39] The branding of 'Baby Spice', Emma Bunton, was a case in point. Bunton was consistently dressed in the pastel colours of a nursery, with her blond hair tied in childish bunches, even while her hemlines were as short as the more 'grown-up' band members and her dance routines just as sexualized. 'I may look sweet,' she said in a pop magazine, 'but I wear leather underwear.'[40]

This was an example of the gradual infiltration of children's culture by porn aesthetics and, appropriately, journalist Joy Press dubbed girl power 'softcore feminism'.[41] In late October 1996, a poll by cable porn network the Fantasy Channel found that the women its viewers would most like to see naked were the Spice Girls. In an act of thinly veiled press release guff, the channel made the band the empty offer of £1 million for a glamour shoot.[42] The *Sun* and *Daily Mirror* tried to attract kiss-and-tell stories about the band by repeatedly advertising their phone lines to the band's previous lovers ('Did you know the Spice Girls before they became nice girls? We want to hear from you if you had fun with the fabulous five now taking the charts by storm').[43] Many papers printed images from naked photo shoots that Geri Halliwell had done years before.[44]

The progressive potential of girl power was inverted by the way in which the band were advertised to men. It was a dynamic that their branding would replicate many times: the relatively diverse array of characters with whom girls could identify was, at the same time, a list of products at which

men could leer, depending on their tastes. Tabloid letters pages were full of missives from men explaining why they preferred this one or that. Former Labour Chancellor Denis Healey, apparently talking about Melanie Brown, told a journalist: 'I like the dark one. She's the only one who shows any sign of intelligence.' Film star Will Smith told the papers: 'I don't have a favourite – there's one for every mood.'

In a similarly unedifying spectacle, MPs were asked to name their favourite Spice Girl as part of a promotional stunt by music chain HMV. Thirty per cent of Conservatives who responded nominated Posh Spice, and none voted for Brown or Bunton. By contrast, Brown was the most popular among Labour MPs.[45] Neither group apparently saw any problem in publicly judging a woman's attractiveness. 'The collective effect [of the Spice Girls] is the essence,' said one MP. Referring to an expensive shopping district of London, he added: 'Individually, you can do better on the King's Road.'[46]

Surrounded by men judging the Spice Girls' bodies, it was at this time that Melanie Chisholm began to fixate on slimming. She told, years later, how on days that the band's schedule did not allow her time for the gym, she would not eat.[47] Journalists used careful euphemisms to describe her weight during this period: she was 'whip thin'.[48] Chisholm was also mocked with rumours that she was gay. The implication was not just that lesbians were worthy of ridicule, but also that a woman who very slightly broke with gender norms by being a 'tomboy' might well have broken the norm of heterosexuality. It was, however, Melanie Brown who

would later reveal that she had had a long-term relationship with a woman. The press response would be prurient.

The strong and confident image of the five women was being undermined in other, even less subtle ways. One article insisted that Chisholm was not a gender-nonconforming tomboy, but a ballet fanatic whose very slightly butch image was a façade: 'off-duty she turns back into the "girlie" her friends know and love'.[49] Other pieces were simply lecherous. One by *Sun* columnist Andy Coulson, which announced that former James Bond actor Roger Moore had agreed to feature in a movie starring the Spice Girls, was titled 'Spice Girls get a Roger in'.[50] This theme of representing the band members' apparent sexual confidence as sexual availability, denying it even the little radical power that it had, was widespread.

The Spice Girls' potentially progressive message was being poisoned and obscured by the sexist culture in which their product was made, but few of the group's fans read the *Sun*, and Coman and Kaloski found evidence that the Spice Girls' fans were not internalizing the reactionary sexual politics implied by some elements of the band's branding. The pre-teen girls who they spoke to did not notice, or were choosing to ignore, the band's more sexualized imagery and behaviour, so that girls aged six to eight years old interviewed by researchers repeatedly failed to identify Geri Halliwell as 'the sexy one', but instead noticed that she had red hair.[51] Meanwhile, many older girls noticed Geri Halliwell's sexiness and Brown's tongue piercing, which seemed to represent to them a wild kind of sensuality, but

they actively criticized them. Nonetheless they liked the band and approved of their statements about girl power. This was a complicated response – the fans' criticisms may have reflected their internalizing of a culture that tries to control women's sexuality – but clearly they were not passive consumers of a sexist culture.[52] The findings were convincing: another researcher found similar results among Israeli Spice Girls fans.[53]

With a few hits, the band's management were able to secure them bigger marketing gigs, which in turn gave them a highly visible position in British mass culture, and as the autumn of 1996 turned to winter, the group began to transform from a pop band aimed primarily at pre-teens and young teens into a mass-market pop phenomenon. On 7 November, they were hired to perform a British showbiz ritual, turning on the Christmas lights of London's most famous shopping district, Oxford Street.

Industry insiders predicted a media backlash of the sort that had hit highly exposed, manufactured acts before them. Cannily, Fuller hired a top litigation lawyer, Gerrard Tyrrell, who threatened fast libel action against journalists, and to withdraw their access to Fuller's clients, if they criticized the group too strongly.[54]

The band got bigger and bigger. Three weeks after turning on the Christmas lights, they won three *Smash Hits* awards, and a fortnight after that, Fuller's campaign to make grown-ups more aware of the Spice Girls, and thereby to make the band omnipresent, scored an unexpected coup.

The *Spectator*, a widely respected right-wing magazine, patrician and elitist but stylish and intelligent, published an interview with the band by a famous historian, Simon Sebag Montefiore.[55] It was something of a joke article, but because Halliwell praised Margaret Thatcher and criticized Tony Blair's tax policies and his support for the EU, it created dozens of headlines elsewhere in the press. A Labour party functionary later claimed that at least one member, Chisholm, was angry about being labelled a Tory,[56] but the band had played to the gallery, the press had taken the bait and for months afterwards, politicians and journalists used the Spice Girls' supposed Tory politics to add a little glamour or humour to dull articles and statements. The band was getting even more publicity, and in new and unexpected places.

Although some members of the band admired Thatcher, a great advocate of individualism who had said she was not a feminist, they continued to advocate their particular kind of sisterhood – 'you better get with my friends'. In their fan book, the band was quoted as saying: 'Women can be so powerful when they show solidarity … You stick with your mates and they stick with you.'[57]

Once again, their message lacked substance, but it appeared to be making an impact. Coman and Kaloski found that Spice Girls fans defined their own fandom, and each other's, not by owning merchandise, but by 'playing Spice Girls' with friends, mothers and sisters in bedrooms or the playground. Boys were excluded unless they were willing to do girl things: to 'play Spice', and not to disrupt

what the girls wanted to do. Through their fandom, then, Spice Girls enthusiasts asserted their shared interests, valued each other, and criticized the behaviour of outsiders – those uncooperative boys.[58]

It was unlikely that the Spice Girls had created these feelings, but they had promoted them, and in doing so the band had become a vehicle for girls to express such ideas and to encourage them in each other. Many feminists sensed that this kind of effect was possible, and lent qualified support to the band. Journalist Marcelle Karp proposed that women should 'Let [the Spice Girls] get up on MTV or in the movies and remarket feminism and call it girl power. Put that out there, let the girls soak it up and think about what girl power really means.'[59]

Christmas lights snowballed into a Christmas number one. '2 Become 1' topped the UK singles chart in the most important pop week of the year, and by the end of 1996 the Spice Girls' album had sold 1.7 million copies.[60] Through the Spice Girls, an imperfect representation of women's demands for liberation was penetrating far into British mass culture.

Nineteen ninety-six had been the year the Spice Girls had very suddenly manifested as a sort of tabloid wallpaper, but 1997 would be the year that their marketing machine propelled them, and girl power, into the heart of British culture. Near the beginning of that year, a series of photos were taken capturing a moment in the evening of 24 February that would come to define the Spice Girls' careers.

The Brit Awards were taking place in the convention centre at Earl's Court, west London, and the climax of the pop prizes ceremony was a performance by the Spice Girls of their new single 'Who Do You Think You Are'.

The song was a perfect image of individualistic ambition, and its lyrics were not subtle, announcing that 'the race is on to get out of the bottom', and arguing that 'giving is good as long as you're getting'. When Geri Halliwell had described Thatcher as the first Spice Girl, she had been pandering to the *Spectator*'s conservative readers, but apparently she had been right. Girl power now seemed to be concerned primarily with individual success, rather than a step forward for all women.

By the standards of today's music awards, the thin stage on which the band danced looked plain and dull, and the band's outfits were simple. At the time, however, this was what high production values looked like. A couple of minutes into the song, Halliwell and Emma Bunton strode to the front of the stage, singing lines in a call and response, and smiling for the cameras. Bunton wore a simple black slip and Halliwell was in a Union Jack minidress, so short that a couple of inches of the crotch of her black pants were visible. Up in the edit gallery, the producer repeatedly called for the TV broadcast to cut back to a camera that was focused squarely and solely on her groin.

As Bunton sung, Halliwell struck a pose that was caught by a couple of press photographers standing in front of the stage. In the image, she stands tall, her legs apart, clad in long, scarlet PVC platform boots that shine, dazzlingly,

with the reflected light from the rig high above. Her right arm, extended upwards, points to the sky nonchalantly, while her left arm bends down, its fist clenched around the mic while resting on her hip. There is something of *Saturday Night Fever* about it, but the Union Jack dominates. For a moment, she has stopped smiling and is staring, somewhere between confused and resentful, beyond the cameras and far into the dimly lit crowd.

'Union cracker' was the line on the *Sun*'s front page.[61] That paper used a different image of Halliwell in the dress, and although the pose that would become most famous was printed in some papers, it was placed on much less prominent pages that morning. But two months after the show, when hyperbole had presumably dissipated, PR experts writing in an industry magazine were still convinced that 'At this year's Brit Awards in February the Spice Girls proved without a doubt that they have become just about the hottest thing on the planet',[62] and that image of Halliwell in her dress – the photo with the *Saturday Night Fever* pose – gradually became the defining image of the band's success.

The Union Jack, never previously associated strongly with the Spice Girls, would thereafter appear in countless promotional images for them, and it would feature heavily in their film – covering the tour bus in and around which much of the action is set – and in its publicity. Geri Halliwell would leave the band in May the following year, the four remaining members continuing for another two and a half years before beginning an indefinite hiatus. Eventually there would be a reunion tour, a performance at the 2012 Olympics closing

ceremony, a terrible West End musical, and the possibility of yet another reunion. But what survives most vividly of the Spice Girls is that photo. It has defined Geri Halliwell's public image – during the reunion tour and at the Olympics, Halliwell wore dresses adorned with a Union Jack, she wore another to launch a fashion line, and the famous photo is featured in countless articles about her – but it has also defined her bandmates: at the London Olympics, fifteen years after the Brits, they performed in front of a London black cab lit with bulbs in the pattern of the flag[63] and their musical's logo was a hand-painted version of the flag, out of which exploded a young woman. The image of Geri Halliwell in a Union Jack, one arm up in the air, is the best-remembered image of the band.

The Union flag was a potentially highly politicised symbol. Later that year, the papers would report that an eleven-year-old girl had worn a Geri Halliwell-style Union Jack dress to a kids' disco in Northern Ireland, where the flag is perceived by much of the Catholic and nationalist communities as a symbol of colonial oppression, and that the girl had been ordered to change into something else.[64] Thus, combining girl power with the Union Jack – feminism with the flag – looked like the most extreme act yet in a long history of mainstreaming feminism. A movement that was generally socialist, and which in recent decades had generally been anti-war, was being identified with the male-dominated institutions of the nation, the state and the military.

However, Geri Halliwell's use of this symbol was so confidently blasé, and its context was so drained of all

other references to the UK, that it behaved just like a logo – famous but seemingly almost meaningless – rather than a national flag. Its power was blinding. In combination with a conventionally attractive body performing cartoonish dance moves, the dress shouted at an ear-splitting volume a nationalist statement that, on a conscious level, could easily be ignored. It was nationalistic in the same way that the Spice Girls were feminist, for both ideologies were being broadcast in a way that could easily be disregarded, but which pervaded the culture so that, it seemed, they might still have an effect.

In March, 'Who Do You Think You Are' gave the band their fourth UK number one in less than a year, and later that month they were hired for their biggest promotional job yet, earning £500,000 in a night for fronting the launch of a new terrestrial television network in Britain, Channel 5.[65] In the first week of April their album's sales reached 10 million and a few weeks later they became the first UK act to reach number one in the United States with a debut album. In May they made front pages around the world with just a photocall at the Cannes Film Festival – they were wearing Princess Grace-style shades and scarves while announcing their forthcoming movie. And at some point during the next month, their worldwide record sales passed the 25 million mark. When challenged about the business calculations behind the Spice Girls' joyous entertainment, Melanie Brown indicated that the band's extraordinary success justified the sometimes cynical means by which it was achieved. 'What is pop music? Pop music is popular music.'[66]

In the same month, on 9 May, the Spice Girls attended a gala for Prince Charles's charity. In front of a wall of photographers standing on the red carpet, Geri Halliwell flirted with the prince. 'You know, I think you are very sexy,' she told him, while her bandmates laughed, winked at the camera, pointed at his face and whispered to each other. He later wrote to her, referring to her 'wonderfully friendly greeting' on that occasion.[67] The band's press team put it about that one of the women had pinched his bum and, indeed, the band discussed his behind with reporters. 'It was lovely,' claimed Halliwell. 'It was wobbly!' insisted Melanie Brown.[68] Photos of Prince Charles blushing, apparently because Brown and Halliwell had kissed him on the cheek, leaving lipstick traces, became so famous that they still sometimes illustrate stories about the band.

A theme had gradually emerged in the band's promotional material, one that pushed harder than ever against the submissive norms of girl band marketing: the Spice Girls enjoyed sexually humiliating men. In the video for 'Wannabe', the five women had flirted with, teased and aggressively disrupted the evenings of cardinals and rotund men in formal wear, and the 'Say You'll Be There' promo had told a tale of kidnapping half-dressed men. About the same time, the writers of the band's official fan book had given, as an example of girl power which was often repeated: 'when you and your mates reply to wolf whistles by shouting "get your arse out!"'.

The Spice Girls' personal lives did not always reflect this domineering relation to men, and neither did their behind-

the-scenes professional life. Perhaps just as importantly, the image of women sexually dominating men was probably intended to titillate male consumers. Nonetheless, the biggest band in the world was being promoted with imagery that depicted women who had power over men. This looked, to many, like a step in the right direction.

The day after the Spice Girls met the prince, they joined a panel of journalists at the London Music Week trade fair. Above them loomed a large sign: 'Music Meets The Brands'. Fuller had already sold the group's brand to many companies, and plenty of merchandise covered with images of the five women was available. There were posters, pendants, magazines, sheet music, a flying jacket, a baby T-shirt, a mini-rucksack, a book, coffee mugs, calendars, key rings and homework lever files.[69] But now the band's managers announced an extraordinary new kind of deal between the Spice Girls and Pepsi. It was not the amount that they would net from the deal that excited the industry insiders, although the guaranteed £1 million, with potential to reach £5 million,[70] that Fuller and the band would earn was significant. What was shocking, at least to the industry, was how they would earn it.

Fuller was changing the rules of engagement with new marketing methods. The band would not, as before, simply let other companies place the Spice Girls' name and image on their products in return for a small royalty on the price of the merchandise. Instead, Fuller insisted that he was now going to form joint ventures with other companies,

even with huge corporations like Pepsi. These sometimes required him and the band to invest in another company's product, to help them develop ideas for it and to promote it, but such deals gained them a substantial portion of the final profits. The first attention-grabbing partnership would include the Spice Girls giving one of their songs, 'Step To Me', to Pepsi, promising not to use it elsewhere, and allowing them to distribute CDs of it to consumers who collected twenty special ring pulls.[71]

A string of similar deals followed. The next month, Fuller announced that he and the band would be paid £1 million to partner with Walkers Crisps, owned by Pepsi. Different bags of the snack, all cheese and chive flavour, would feature a different Spice Girl, highlighting the utility of the Spice Girls' five-brands-in-one structure, and the ease with which it could be used to drain girl power of its independent, sisterly qualities. Walkers paired the band with former England football captain Gary Lineker,[72] who by then had swapped top-flight football for a career dominated by adverts in which he professed his love of crisps. One ad featured Lineker choosing a bag of crisps, rather than accept euphemistic offers of sex from each of the band's members ('Scored lately sugar?' asks one; 'Wanna play ball?'). As the ad's creators may well have predicted, it was banned from children's television until it was altered, winning the campaign several mentions in the news in advance of its first airing.[73]

A fortnight later, the band announced that they would be launching another joint venture, Polaroid Spicecams,

which would retail at about £50 each,[74] and this high price led to a television advertising campaign being rolled out across multiple territories. In the promo, a group of St Trinian's-style public school girls, decked out in boater hats and blazers, stand in a dark room in front of nun and a clergyman while thunder crashes and a Gothic organ moans. The teachers are shocked and disgusted by a series of Polaroids that they hold in their hands, and the girls are kicked out of their grand school building. They are revealed to be the band, and the nun throws their naughty instant camera out of the door behind them.

At the time, a video was produced featuring clips of the band on set during production of the advert, criticizing two men in the production's crew for asking them to show their cleavage and their midriffs in the film. One of the men, smirking, tells them it would be 'every man's fantasy'. 'Well you can fuck off!' shouts Brown, the school tie around her neck half undone. 'That's showbiz,' insists the man, shrugging. Halliwell, her hair still in voluminous bunches, responds: 'You're a chauvinistic pig. That's such an easy cop out.' Adams steals the man's sunglasses and taunts him, pretending to try to sell his 'really nice shades' to someone in the crew for a fiver. Brown interjects: she'll take a quid for them.

There is something wrong with this 'making of' film. The two men whom the band criticize seem to be waiting for them. They do not appear remotely surprised by the attack, and a camera operator has prepared to capture the moment. It is, it seems, staged and somewhat hypocritical. The band's

members had not shown their cleavage and midriffs in the advert, but they had frequently done so elsewhere. The band apparently objected to men portraying the vulnerability of extreme youth as sexy – they were dressed as schoolgirls – but the characterization of Emma Bunton as 'Baby Spice' had long produced exactly such an effect. Immense contradictions ran throughout their message.

The deals continued. An agreement with BT earned Fuller and the five singers £2 million,[75] and soon the band were promoting Sony PlayStation and Impulse deodorant too. Edward Freeman, Manchester United's head of merchandising, became a consultant to the band, and an 'insider' at Freeman's company surprised some by claiming that 'Their merchandising has been under-developed, we're coming along late in the day.'[76] A deal with the Asda supermarket chain followed, and eventually there were Spice Girls dolls, clothing lines, chocolate bars, bedlinen and crockery, crisps, lollies, biscuits and balloons.[77] The Spice Girls broke a number of sales records for pop band merchandise.[78]

In anniversary write-ups published in the marketing industry press a decade later, friends and rivals of Fuller would still be lauding his Spice Girls strategy and hailing it as groundbreaking. The manager's innovation was to be unashamed, to take as many deals as possible, and to approach negotiations with high demands but much to offer. He was selling a strong brand, and had no need to defer to potential collaborators.[79]

The group's worth was being milked, making them

very rich, and making their manager even richer. Credible estimates of total earnings from the band's music and deals topped $50 million in about a year and a half. Each member of the band was said to have earned in the region of £6 million, and Fuller would have made somewhat more.[80]

The band's PR team had designed girl power to attract consumers to the band's music products, but it was also supposed to attract the kinds of deals that Fuller was constructing. His marketing team – who, with few exceptions, were men – persuaded advertisers that precisely because the Spice Girls' fans were savvy, they were not embarrassed about their favourite band being laden with endorsements. 'This audience doesn't mind being marketed to,' explained a senior manager at a PR company that looked after the Spice Girls. 'What Girl Power says is: "We know what you're doing. Be up front."'[81] Advice by another marketing expert indicated that the message was widespread, and deeply cynical: 'If you want to sell to the girl power crowd, you have to pretend that they're running things, that they're in charge.'[82]

The very unequal situation in which the band had been created was seeping into the product of the Spice Girls. It was not just in and around the band's members that men imposed their influence on women and profited from their work. Men were directing the redefinition of girlhood with the idea of 'girl power', and with this they were exploiting the girl consumers who made up the band's audience.

Deals like the Pepsi one were not only, or even primarily, intended by Fuller to sell Spice Girls records in new markets,

for in countries with middle and lower average incomes per capita, pop music was mostly heard on the radio or bought in pirated form. Instead of promoting CDs and cassettes, then, partnerships with global brands spread the Spice Girls' name, image and tunes across the world to markets where those products were already pervasive but British pop bands were generally unknown. Thus the Spice Girls were not only advertising Pepsi and Sony. From Fuller's perspective, Pepsi and Sony were advertising the band, partly as musicians but also as a brand with which other products might cooperate. Fuller was soon able to license the Spice Girls brand to companies that wanted to attach the band's Euro-American glamour to their products, and that meant both Asian, African and South American companies that wanted to sell on their home turf, and North American and European ones that wanted to penetrate new, developing, markets.

This was the strategy that underpinned and popularized girl power. It was not just a mild progressive message with an unfortunately sexist background; it was a strategy for influencing young girls. The feminist-lite qualities of the product's messaging were counteracted by the use of the product to manipulate young women – to 'pretend that they're running things, that they're in charge'.[83] The Thatcherite message of 'Who Do You Think You Are' had embodied the promise that liberation was close at hand and did not require collective struggle. But the words of the marketing men indicated that individualism provided little defence against sexism.

It was during this summer, when the band finally returned home to the UK for several weeks to film their upcoming movie, that they first fully understood how famous they had become, and how comprehensively their jobs had transformed their lives. It was not an entirely pleasant experience.[84] They were being worked harder than ever, getting their wake-up calls at 6.30 to be on set by 7.30. They would film until 17.00, at which point they would be taken to the studio to work on their new album until 23.00.[85]

The sense that everyone wanted to attach themselves to the Spice Girls brand became particularly obvious that autumn. The band was deemed sufficiently pervasive that the women were asked to launch the Poppy Appeal, the Royal British Legion's fund-raising campaign in the run-up to Remembrance Day. A fortnight later, the five were invited to join Prince Charles, Prince Harry and Nelson Mandela at the South African leader's home for a charity concert that made TV news headlines around the world. After meeting the band, Mandela told reporters, perhaps with a twinkle in his eye: 'these are my heroes'.

That autumn, one large marketing poll found that the Spice Girls' commercial for Walkers crisps was the most hated that year, and another found that 66 per cent of consumers believed that the Spice Girls were a turn-off when it came to selling products. *Marketing* magazine predicted the band would be over by Christmas.[86] 'The general feeling is that the Spice Girls have been marketed successfully to the detriment of the music. And that's down to Simon,' complained an employee at Virgin, which

profited from the band's record sales, rather than from their endorsements. 'It's been getting so cheesy. Eventually, it puts people off the music.'[87]

Most music and PR insiders, however, had always assumed that the Spice Girls would be a short-lived phenomenon. At the time a fellow band manager identified Fuller's strategy in pragmatic terms: 'a "prefab" group such as the Spice Girls has limited shelf life and both they and Simon Fuller knew it. Theirs is hardly a talent to be lovingly nurtured. Simon Fuller obviously decided to go for the burn and they concurred.'[88] But the band may not have understood that Fuller was overexposing them, and they may not have been pleased with him adopting that tactic. Years later, the band blamed this method for accelerating their demise and, perhaps less convincingly, they dismissed the idea that a longer-term strategy had been impossible.

Fuller's strategy may well have been the most profitable in the long run, as well as the short term, because at least some of those marketing deals had been necessary to inflate the band's publicity bubble. Indeed, eventually, their boss at Virgin would conclude that the Spice Girls had survived longer than expected, and that their marketing promotions had been responsible for maintaining their popularity. He and his fellow executives had 'thought it was something of a danger, that you were going to burn it out very quickly and burn the record side, too. But it didn't. It fanned the flames. They broke the mould with a pop act.'[89]

All that work had exhausted the five band members, however, and they were telling this to anyone who would

listen, including interviewers for high-profile features.[90] They were bored and irritable, but this was not entirely new. Their relationships had vacillated over time. When the band had first formed, Emma Bunton and Geri Halliwell had been a close team. But later Emma had become much closer to Melanie Chisholm, and when the two Mels had moved in together, not far from Bunton's home in Finchley, north London, the three had formed a tight unit. Halliwell and Victoria Adams were left out, and when the band had begun recording their second album, things had got worse. These two were not only isolated from the band, but also its weakest singers. As the album came together, it was increasingly obvious that their vocals would not feature heavily. Tabloid journalists, ex-boyfriends and 'sources close to the band' spoke of physical fights and shouting matches, but they also described how the five would make up, and how close they were to each other. An ex of Bunton's remembered: 'There was almost a fist fight between Melanie Brown and Adams's boyfriend, Stewart. He'd told Brown to keep her nose out of his relationship with Adams. She threatened to go round to his house and sort him out.'[91]

When *Spiceworld* was released on 3 November, the band was tired and irritable, but tightly bonded. Their new single, 'Spice Up Your Life', had managed only a week at number one in the UK, and sales in the USA were poor.[92] The mood was low, and two days after the LP was released, when Fuller was in an Italian villa recovering from back surgery, he got a call from the band's lawyer. He was sacked.[93]

For about twenty-four hours, the news remained secret. The band had just travelled from Cologne to Rotterdam, and the next day they performed their new single at the MTV Europe Awards, where they won a prize. It was only that night that their new spokesperson announced that they had dumped their manager.[94] A statement by Fuller confirmed the news a few hours later, and his assistant Julian provided the papers with quotes. Indeed, it appeared that, beyond a statement by the band's hastily employed new spokesperson, members of Fuller's team were the only sources journalists working on the story could access.

They were nimbly controlling the tabloids' narrative, and the headlines developed accordingly: 'SPITE GIRLS!',[95] 'Spice Girls sack man who made them £30m',[96] 'The Spice Girls have got too big for their boots'.[97] The views of an 'insider' in one paper and a 'source' in another all provided the same line, which was also rather similar to Julian's: the five women were all rather emotional, meeting Mandela and Charles had made them big-headed, and Geri Halliwell had pushed the others into sacking Fuller.[98] 'It's all gone very weird. They've been sleeping together … Not sexually – just like sisters do,' Julian told a reporter. 'And when outsiders visit, they go into a huddle.'[99]

After a couple of days, a new theory developed. Emma Bunton had been sleeping with Fuller, and the rest of the band had decided to sack him – again, led by Halliwell, who was now characterized not as 'emotional' but as 'jealous'.[100] When questioned, Bunton has always denied the affair,[101] but papers reported that the relationship had 'been an open

secret in music industry circles since the summer',[102] and someone who had worked on the band's new film was quoted as saying that 'They were always speaking privately. When I saw them kiss at the party, I wasn't surprised.' The story of their affair, and its role in the band's sacking of Fuller, would eventually be repeated in the press as established fact, often left unchallenged by its protagonists.[103]

Fuller's team was able to spin the affair story too. The band was travelling to play a gig in Rome, where Fuller happened to be recuperating, and a surrogate for Fuller presented the story to the *Mirror* thus: 'It's no coincidence he should be holidaying in the same country as the girls … Emma Bunton has been calling him, although she promised the girls she wouldn't. Finding herself so close to Simon in Italy proved too tempting and she nipped out to see him.'[104]

Two years later, Chisholm told *Q* magazine that the reason for their break with Fuller was less salacious but, if anything, more dramatic. The band had discovered that their manager had been playing divide-and-rule, complaining to each one about how the others were treating them, but insisting that they keep this secret. Late that night, when the five women were holed up in a Cologne hotel before travelling to the MTV Awards, they had discovered that he had been telling each of them that the others were acting against them. Popping in and out of each other's hotel rooms, they had unravelled his attempts to play them off against each other. 'It was the biggest therapy session in the world,' Chisholm later described. 'Like going on the road with the fucking Priory.'[105]

They had worked out what had happened, some of them cried, and then Halliwell asked to borrow the phone of one of their personal assistants. It was a sensible calculation – she copied out all the phone numbers they might need without Fuller – but it did not do them much good. Their manager had always ensured he was the direct employer of everyone of significance around them, from personal assistants to security to songwriters, so that those key figures owed nothing to Virgin or the band. The next morning the band's lawyers had, on their behalf, sacked Fuller, but according to his assistant, within a few days around twenty Spice Girls functionaries had flown to see him – he was still recuperating in Italy – and each had confirmed that their loyalty was to him, rather than the band.[106] He was soon paid off, though by how much remained a mystery – £10 million,[107] said one reporter, £15 million,[108] said another – and he continued to earn his share of the deals to which he had already signed the band.[109] Fuller admitted later to being 'very controlling' and to working the band hard.[110] Feminist critic Beatrix Campbell described his reported management style as 'professional patriarchy'.[111]

Halliwell, often described as the band's leader, was generally reported not only to have led the putsch, but also to be seeking a kind of captain-manager role in the band. She represented their sacking of Fuller as a strong act of feminist resistance. 'What we've shown is actual girl power in action,' she told a journalist.[112] It was a predictable claim, but one that was not easily dismissed. It had been a time of extreme pressure and constant in-

fighting for the band, they admitted years later, but this had been a rare moment of confident and collective decision-making.[113] The Beatles, the Clash, the Small Faces and many other 'authentic' bands dominated by men had previously sacked their managers, but in 1997 there was no similar history for a manufactured girl group to follow. The Spice Girls' choice may have been foolhardy, but it was defiant, brave and an act of both solidarity and self-determination. It was a moment when they were what they had always claimed to be.

Music and celebrity journalists were mostly unimpressed. The band 'struggled to find their footing after the worst week of their career',[114] observed one paper. 'Has the bubble burst?'[115] asked another. 'The media is still a very male-dominated industry,' Victoria Adams told the *Times*, 'and a lot of men liked the fact that they thought a man was behind the Spice Girls.'[116] Indeed, those men were treating the idea of the Spice Girls articulating their own feminist identities as patently ridiculous. Journalists were responding, observed Campbell, 'as if [women's] self-possession poses too great a threat to the public realm'.[117]

Evidently, powerful voices in the mass media, the music industry and the worlds of PR and marketing were not pleased, but the aversion of such industry figures to women taking control was not the only reason that the Spice Girls' good press had transformed into a negative story. Without Fuller, the five were no longer protected by his legal attack dog, Gerrard Tyrrell. Journalists who opted for an angle that made the Spice Girls look bad found they were no

longer threatened with legal action, or with the withdrawal of press access to the five women. The stories that followed were full of the negative and critical conjecture that Tyrrell would never have allowed. The media had resented the Spice Girls as a result of Tyrrell's regime, and that anger had now been let loose. 'We have been controlled, manipulated and exploited by the Spice Girls in a very intense fashion in the past few months. People don't like that,' declared the editor of *Sky* magazine.[118] Tabloid headlines declared the band was over: 'Girl Power starts running out of steam';[119] 'All is not well in Spice World';[120] 'the Spice Girls have lost their flavour'.[121]

191,000 copies of the band's new album, *Spiceworld*, had been sold in the UK in the week since it had been released,[122] and this had easily taken it to the top of the charts, but it was far short of what some had hoped. On the day of release, Virgin had announced that 1.4 million copies of the album had been ordered by British retailers, breaking a record set by Frankie Goes To Hollywood thirteen years before.[123] That now looked like hubris on the record company's part, and over-optimism on the part of their distributors.

Less than 200,000 sales looked like a poor showing just three months after Oasis's *Be Here Now* had shifted more than 800,000 units in seven days.[124] This was an invidious comparison, but it was somewhat unfair: indie rock fans tend to buy their own records, while most kiddy pop fans have to wait for their parents to get an album for them, and that might not be until Christmas. The industry press understood that, for a band like the Spice Girls, this was

a good showing, and described how the LP's sales were growing impressively in the USA, but the newspapers saw things differently. The band's sales, they said, were 'lacklustre'[125] and 'unimpressive'.[126] Aggressive criticism of Fuller's sacking had developed into a generally negative narrative around the band.

The album was supposed to provide marketing for the band's forthcoming movie, but within a fortnight of the record's release Virgin was trying to manage expectations of how well the film, which had been produced in just seven months, would do at the box office. 'We don't have huge ambitions for this,' insisted a senior marketing executive at Sony. 'We don't have to hit a home run'.[127]

The movie eschewed the romantic themes of many films aimed at young girls; indeed, it avoided focusing on male characters altogether. It was about friendship between women, a girl band riff on *A Hard Day's Night* with the Spice Girls replacing the Beatles. It had been hoped that at Euro 96 England would replicate their success at the 1966 World Cup, and now the Spice Girls – often dubbed the 'fab five' in reference to the Beatles – were reinforcing the sense of Cool Britannia as a moment of cultural awakening akin to Britain's 'swinging sixties'.

Spice World – The Movie opened on Boxing Day, hit the headlines and had good box office takings; the album continued to sell, and the band scored a second Christmas number one, defying predictions that they would be beaten by children's TV stars the Teletubbies. The Spice Girls were not about to disappear, but the industry's judgement

could not be reversed. However gradual and however well managed, this decline was terminal. They were now spoken of, albeit ironically, in the past tense. An end-of-year write-up declared: 'They were the Girl Power Rangers.'[128]

A fall from grace offered journalists a neat narrative turn and, helpfully, that story contained a significant degree of truth. Fuller's absence had deprived the Spice Girls of managerial talent, and the five singers were unhappy. Fuller, meanwhile, would soon become immensely rich from his *Pop Idol* TV format. This talent show programme, he explained, was 'purely invented to give me new leverage in the music industry, without my having to go cap in hand to the record companies'.[129] As their former manager went from strength to strength, Bunton and Adams appeared to regret having sacked Fuller, for both individually rehired him and his team, including Gerrard Tyrrell. Adams brought with her the captain of England's national football team – her husband, David Beckham, whose name she took.

The Beckhams' lives would be the most sustained British celebrity story of the next decade, and, consequently, much of what would remain of the Spice Girls was the attention given to David Beckham's career in football, Victoria Beckham's immense success building a career in fashion, David's alleged affairs, the couple's friendships with the great and the good, their children, their children's modelling jobs and the family's social media stunts. Girl power's most visible legacy was not the band members' quickly forgotten solo pop careers, but Victoria Beckham's impressive and

surprising comeback as a designer. However, having started in an uncool pop band, she was forced to build this with, and through, the fame, lives and profits of men.

The Spice Girls' rhetoric had pointed to a future without sexism that seemed imminent because it was supposed to be easily achievable: all it required was for individual women to assert themselves. Through this band, the slogans and imagery of feminism reached far into the misogynist mainstream without changing it.

In the UK, someone calls the police about domestic violence every minute, and women make the vast majority of those calls. It is estimated that 85,000 women are raped in Britain every year.[130] In the online world, misogyny is most blatant in the preponderance of sexually violent porn, and in the death threats and trolling that are often targeted at feminists and women who dare to build a public profile.

Sexism also operates institutionally. The 2008/09 recession hit the kind of jobs that women were more likely to perform – part-time and low-paid positions – and the government austerity programme that followed cut the services that women were more likely to depend on. A 2017 analysis by the House of Commons library estimated that by 2020, after a decade of austerity, women would have been hit by a total of £79 billion of cuts. The figure for men, the researchers predicted, would be £13 billion.[131] Other research showed that lone parents and single pensioners, groups that were dominated by women, would suffer especially from austerity measures.[132]

In a society where misogyny thrives, some women are more affected than others. At the height of the Spice Girls' fame, US journalist Joy Press noted that the band attracted '(mostly) white, hip, middle-class young women', and that other women faced greater misogyny and were therefore less interested in this 'softcore feminism'.[133] In the UK, at least, the Spice Girls' popularity extended over diverse class and ethnic groups. However, feminism-lite has done less to improve the experiences of women who are at what US legal scholar and campaigner Kimberlé Crenshaw describes as the 'intersections' between different oppressed and exploited groups. The Lawrence family's story reflected how the police violence experienced by minority ethnic groups is generally felt most keenly by those among the less economically privileged. Similarly, working-class women, and especially those from minority ethnic communities, bear the brunt of sexist attacks and obstacles.

Perhaps it was not surprising that, when the women's movement in the UK experienced a resurgence, it was an intersectional one. In the early 2010s, in the wake of a recession and public sector austerity that hit women hardest, an array of feminist groups emerged emphasizing the intersections between misogyny, class exploitation and other forms of oppression and exploitation. UK Feminista campaigned for a living wage and the Fawcett Society maintained an exacting, long-term analysis of the impact of austerity on women. The same dynamic could be observed in the work of groups like Women For Refugee Women and Climate Rush, a group of environmental activists who

organized spectacular protests dressed as suffragettes. Later that decade, Focus E15 Mums made headlines when they occupied empty council homes, and Sisters Uncut focused attention on cuts to domestic violence services and the ways in which these cuts were institutionally racist, among other issues. Similar forms of activism were taking place across the world, and where feminism led, pop culture followed. In 1997 the Spice Girls' often individualistic form of feminism had dominated the charts, but a decade and a half later Beyoncé held the world's attention with records and videos highlighting the lines between sexism and racism.

The individualistic and liberal interpretations of feminism that had been more visible in the 1990s were giving way to something more radical. However, 'feminism-lite' was credited by some members of the women's movement as having had a positive impact, albeit a modest one. In her research on girl power, Rebecca Hains interviewed young feminists who had been brought up in the USA when the Spice Girls were at their most popular. The women she interviewed were ambivalent about the band: some criticized girl power as meaningless and observed how restrictive the band's notion of femininity had been. However, most, while being aware of the band's failings as role models, had more positive recollections, and Hains concluded that the Spice Girls had provided them with 'a viable form of beginners' feminism – bringing empowerment rhetoric to girls in a gentle, easily digestible way, priming them for a more difficult, angrier, less mainstream feminist discourse later on'.

One interviewee, who had grown up in a conservative Roman Catholic family, identified Spice Girls fandom, along with other kinds of pop culture and her involvement with the Girl Scouts, as having encouraged her to reject her father's anti-abortion views. 'Given my family and my circumstances, that was the way feminism reached me ... I think one begets the other. Before you're old enough to really understand the history and the political action behind feminism, girl power is just a really fun, lighthearted way to celebrate being a girl and that there is nothing wrong with being a girl.'

The Spice Girls' careers were initiated for the purpose of making profits for men, rather than women's liberation. Nonetheless, their impact on Britain can still be compared to, as well as contrasted with, the other reformist projects that came about and climaxed in 1997. Their goals were different, and few observers would accord the same gravitas to the Lawrences and a pop band, but one commonality is striking: the softening of a progressive idea in a way that did it harm but which also brought it into the centre of public life.

Girl power, said American singer-songwriter Ani DiFranco, 'is where the life gets sucked out of feminism, and the word becomes a meaningless bumper-sticker'.[134] The notion that women are not treated equally to men, but that they should be, had become a bland values statement for virtually all cultural, political and business organizations – one often claimed, but rarely acted upon. This wider trend

had been reflected perfectly, and thus reinforced, by the Spice Girls. The contradictions and emptiness of feminism-lite made it very different things to very different people. The Spice Girls had been both sex objects for straight boys and men, and role models for a large number of girls.

This was the enormous and complex edifice of oppression and exploitation that a pop band claimed to be fighting. The Spice Girls had spread the message that women should both assert themselves against men, and show solidarity with other women, and their product had helped to make feminism more visible than it had ever been. However, feminism-lite had also watered down the ideas of the women's movement to an entirely new degree, hollowing it out by filling it with contradiction, and promoting marketing strategies that undermined girls' autonomy.

The pervasiveness of feminism-lite helped to spark a sexist backlash, and progress appears to have stalled. It might be that patriarchy and women's liberation can coexist indefinitely.

5 / SENSATIONALISM

A man in his forties began throwing red and black ink at the painting. 'You are all idiots to come and pay for this shit,' he screamed at those standing near by. The canvas stood, leaning against the wall, more than twice his height,[1] but he yanked its huge frame so that it fell to the ground with a great crash.

Another middle-aged man walked into the gallery, saw what was happening and then disappeared. When he returned several minutes later holding a box of eggs, two security guards, a couple of police officers and a curator were trying to wipe some of the ink off the painting before it dried.[2] He opened the box and began throwing the eggs, perhaps somewhat anticlimactically, at the ink-splattered canvas.[3]

The exhibition was *Sensation: Young British Artists from the Saatchi Collection*, and the image that was being attacked was a painting by a young, largely unknown artist. It was made up of hundreds of small handprints, each of which had been produced with the mould of a four-year-old's hand.[4] Beneath the egg and ink, these palm prints formed a vast, looming and blurred recreation of a famous black-and-white police mugshot: the face of child killer Myra Hindley. This was challenging art made visible and mainstream, for *Sensation* was intended to make contemporary art truly

popular in Britain. It was supposed to be the dawning of an age in which ordinary people – imagined to be a passive and conservative mass – would finally embrace experimentation, an epoch when culture would be freed from conventional assumptions and bourgeois good taste. The aim of making the avant-garde popular was potentially patronizing, but it was not necessarily a contradiction: it looked to a future in which the taste and ideology of the 'masses' were aligned with those of subversive intellectuals against the establishment.

Some Britons would remember this as a moment when radical artistic voices challenged mainstream culture, while others would dismiss the *Sensation* artists as troublemakers seeking attention. Most of these artists, even the most cynical among them, were trying to upset the world by communicating something important in a simple manner. *Myra* spoke of the horror of Hindley's crimes and the power of her mass-mediated image, and it did so with striking efficiency, but that was part of why so many people hated it. The strategy of popularizing the avant-garde by making its messages blunt and widely available had failed, for the qualities that made their work so accessibly interpretable and so often reproduced were also those that made it so alienating. Similarly, the success that had brought these artists and their provocative ideas to the attention of the public served to make them look like members of the establishment. Those elements of this phenomenon that were supposed to create a new culture only reinforced the old one.

These young artists failed entirely to make the avant-garde popular, but they had been motivated by idealistic ambitions, as well as cynical ones, and these mixed in complex ways. The amoral perspective and blunt statements of another artist featured in *Sensation*, Damien Hirst, revealed simple existential truths: 'Money is so important because so many people haven't got any. It's the key isn't it – more important than languages – it's the key to the world. It can save your life.'[5] The same lack of scruples, however, would allow him to earn an estimated £350 million in the two decades after *Sensation*. By the end of that period, he was going to be the proud owner of a £40 million mansion, rendered in the off-pink cream beloved of its creator, the great eighteenth-century architect John Nash. It surveyed London's Regent's Park on one side, and a generously sized garden on the other. Far beneath the lawn the artist would build an 'iceberg' basement big enough for both a 25-metre pool and wide studio spaces with double-height ceilings.

During the period in which Hirst amassed his wealth, contemporary art retreated from the front pages to its former position of irrelevance, but it returned there laden with immense financial value. Since Hirst and his generation made their foray into mainstream culture, the contemporary art market has grown by 1,370 per cent, and its annual turnover is now $1.5 billion.[6] The artists from *Sensation* whom we remember believed or claimed that they were exploiting money and fame for the sake of challenging the mainstream. Instead, they helped to create a market in which speculators buy and sell artworks expressing politically

radical ideas, but for millions of dollars. Subversion serves as an advert for a cornucopia of investment products.

This book has told stories of radical groups, ideas and policies, and the way they had removed from them their demands for structural change, their attacks on state violence and on capitalism, in order to win mainstream visibility. The reign of Hirst and his contemporaries had a similar effect. It created an art market filled with works that profess to be critical, or even queer, feminist or anti-racist, but which are bent to the will of financial speculators. They are exhibited in their homes or, more likely, packed up in their warehouses, valuable yet meaningless.

Since the 1960s, the British avant-garde art scene had been dominated by feminists, Marxists and later also by a few punks. Their work was variously clever, angry, wordy or obscure, and much of it was beautiful or exciting, but none of it was popular or widely understood. Moreover, during the 1980s, government cuts to arts funding had forced galleries, and then the rest of the art world, to focus on populist art that attracted sponsors. Some galleries chose to focus on familiar names from Renaissance and Impressionist painting. Others, however, committed themselves to discovering contemporary artists whose work would draw crowds, but which would also challenge an audience's expectations.

In the art department of Goldsmiths, a college of the University of London, Michael Craig-Martin was teaching his students how to take advantage of this very particular

set of opportunities. His approach was reflected in his most famous work, which he had created in 1973: a glass of water sitting on a glass shelf, accompanied by a text explaining that the glass on the shelf is, in fact, an oak tree. This piece was intended to communicate, in strikingly simple fashion, the transformative thinking that is involved both in religious faith and in conceptual art-making. Craig-Martin encouraged his young pupils to produce work that, like *An Oak Tree*, used any media available (an artwork did not need to be a painting or a sculpture) to express ideas visually and clearly – so clearly that they hardly needed to be interpreted at all.

'I was a catalyst for certain things,' the tutor would later admit. 'But what happened with that group of people happened because of a certain chemistry amongst them.'[7] In 1988, one of Craig-Martin's second-year students, a twenty-three-year-old from Leeds called Damien Hirst, organized an exhibition. He was a chunky, spiky-haired young man, smiley, rude and clever. With the help of his fellow classmates Abigail Lane and Angus Fairhurst, Hirst started planning a show of Goldsmiths students and alumni. This, in itself, was unexceptional, but the professionalism and scale of the venture were unusual. Following the lead of advertising mogul and art collector Charles Saatchi, whose gallery had opened four years earlier in an old paint factory, the young group chose to exhibit in a cheap industrial venue, a Port of London Authority building on the Surrey Docks. At this time, the Docklands of east London were a strange jigsaw. One road might be dominated by empty industrial

buildings, long sheds of grubby corrugated iron, cavernous red-brick warehouses with tumble-down walls, and, behind temporary hoardings, vast planes of concrete, out of the cracks of which sprung tall bedraggled weeds. Only a couple of streets away, however, a steel and marble tower would be rising slowly from a busy building site.

Hirst extracted £14,000 from various sponsors, and he and his team made their professionalism visible to the outside world by spending a portion of these funds on a glossy exhibition catalogue. They called the exhibition *Freeze*. The title reflected the desire that had been implanted or, at least, nurtured by Craig-Martin to create simple images that had a striking effect on the viewer, but the direct inspiration for the show's name came from a piece by one of the exhibitors, Mat Collishaw's *Bullet Hole*. This large close-up photo of a head wound was the only work in the show that would remain famous years later. It was presented as a grid of fifteen panels on a light box, and dedicated, the catalogue explained, 'to a moment of impact, a preserved now, a freeze frame'.

Like *An Oak Tree*, Collishaw's work revealed its ideas and themes to the viewer immediately. Its image of a glistening crimson crevasse, surrounded by parted hair, was taken from one of several pathology textbooks owned by Hirst, but many viewers saw in this saturated photograph the echo of a model's vagina, splayed across a porn magazine. Sex and death, their similarities and interrelations, the desire we have for both and the revulsion we have when faced by either; all this confronted the viewer

within a second, articulated not necessarily as ideas, but certainly as intense feelings.

Most of the work at *Freeze* was, however, not remotely shocking. Anya Gallaccio poured a ton of lead into a large rectangle on the floor, Michael Landy pinned a tarpaulin to the wall and folded it over itself in beautiful undulating shapes, and Sarah Lucas exhibited a crumpled piece of metal. Many of these young artists were still in thrall to the work of minimalist artists, and indeed many would continue to produce similar pieces. However, the work by this group that would be widely remembered – the art that was going to define their generation – would have more in common with Collishaw's photo. It would avoid the serious and experimental visual forms that the British avant-garde had long considered revolutionary, but which had so patently failed to change the world, and it would replace such radical aesthetics and form with iconoclastic concepts and content.

Like Blair's vision of a liberal new Britain, which would become deeply unstable and reactionary, like the anti-racist message translated into Macpherson's report, like the resentment of authority that led to a faux-modernization of the monarchy, and like the feminist slogans bandied around by the Spice Girls, a part of the avant-garde was leaving its powerless but principled position on the margins of British culture. This was an attempt to attract the public's attention and access the levers of power.

That process was either pragmatic, or cynical, or perhaps both. The artists did not hide their commercial ambitions, but they insisted that their aims were also idealistic. 'I want

to make art that everybody can believe in,' Hirst explained. He was not perfectly representative of his generation of artists, but his story, his attitudes and his art would be broadcast so widely and so intensely that they would come to represent his comrades' role in the broader culture better than anyone else's.

The pieces he exhibited at the Surrey Docks exemplified one of his strategies for making his work accessible, a method that still owed a lot to minimalism. *Boxes* was a collection of glossy cardboard cuboids, each painted a different bright colour and arranged where two walls met. They looked like video game pixels exploding out of the corner of the room. It was, in the minimalist tradition of the last few decades, an artwork about form and colour. If it left a viewer confused, that was because there was nothing to get – or, rather, anyone was supposed to be able to get it without trying very much. In this, it had moved far away from the impenetrable and elite art for which post-war modernists were criticized, albeit unfairly. Regardless of your knowledge of art history, you could experience the colours and shapes of Hirst's work, and that was pretty much it: an exercise in pure, joyful form.

Only three of the artists at *Freeze* seem to have sold any work at the exhibition,[8] but making money at that particular moment was not the point. The young artists wanted their work to be seen, and in this they succeeded. Among those who attended the show were two of the art world's most powerful men, the Royal Academy's Norman Rosenthal and, from the Tate, Nicholas Serota. Rosenthal was a progressive

young curator, but he had been slightly unwilling to travel all the way to London's eastern industrial boroughs just to see a student show. 'Somehow I'd got wind of this and it was an incredibly long way out, and I'm, in inverted commas, "a busy guy,"' he remembered.[9] However, Hirst would not be put off. He insisted that he pick Rosenthal up in his car and drive him all the way to the Docklands,[10] and the long journey was worth it. Rosenthal remembers being 'very happy at what I saw', and he thought highly of the young artists.[11] He would spend much of the next nine years planning a show that would define their careers, and his.

A third major art world figure who attended *Freeze* was Charles Saatchi, a fabulously wealthy advertising creative, a reluctant celebrity and the most famously ruthless art collector of his era. He was building a reputation for bulk-buying art and for dumping out-of-favour artists' work on the market, thereby undermining their careers. It would remain unclear to outsiders what had contributed most to his success: was he good at guessing which young artists would become successful, was he an expert in assisting the careers of his protégés, or did he simply buy such high volumes of cheap art that some of it was likely to make fabulous profits?

He was a quietly glamorous figure, usually in a well-cut suit, and his thick, dark curls fell over a small brow. He had big, watchful eyes, and a charmingly gentle smile. After looking around *Freeze*, the collector bought a few life-size paintings of hospital doors by Sarah Lucas's boyfriend, Gary Hume.[12] Hirst may not have been best pleased – he had a distinctly cool relationship with Hume[13] – but what

mattered was that Saatchi had been introduced to their work, and he had liked what he saw.

This was hardly the first student show that Saatchi had attended, but he was generally known for collecting the work of artists who were somewhat more established. The ad man and his then wife, journalist Doris Lockhardt, had built a respected collection of modern art. Her taste for post-war American work had shaped his preferences, and their collection of works by Bruce Nauman, Howard Hodgkin and other artists had turned out to be an excellent investment.[14]

The year after he saw *Freeze*, Saatchi began to sell his collection. This seemed to make sense. The art market was at its peak, and during this time Saatchi sold 200 works for a total profit of £15 million.[15] However, in late 1991 the recession that had begun two years before hit the art market and prices collapsed, and although it was the worst possible time to sell, Saatchi continued to do so. When he sold more than thirty paintings in one sale at Sotheby's, some observers suggested he had actually made a loss.[16] Whether or not that was the case, dreadful market conditions ensured his lots sold for millions less than predicted.[17]

Art world experts observed that no one sold in a market like this unless they had to.[18] Saatchi claimed that he was selling this work to finance buying earlier, more expensive artists,[19] but a perfect combination of financial and emotional forces seem to have led Saatchi to sell the artworks that he and Lockhardt had amassed over decades.

Saatchi was in debt to his ruthless and flamboyant dealer, Larry Gagosian, who in turn owed huge sums to

Sotheby's. Throughout 1991, the ad man continued to sell his art in bulk through the auction house, apparently paying off his dealer's debts in order to service his own,[20] which were substantial. The recession had not only hit the art market, but also the advertising industry, and the huge agency that Charles had founded with his brother Maurice, Saatchi and Saatchi, was in such serious financial trouble that the brothers would eventually leave the company that bore their names.

Charles had other, more complex and emotional reasons to get rid of most of his collection. His three-year sale had begun at almost exactly the time that he had separated from Doris, and it would end a year after their divorce was confirmed. The settlement was said to have been expensive for him, which must have contributed to his financial need, but it is also notable that Saatchi was selling the works that he and his ex-wife had collected together, often with her guiding his choices or selecting them independently of him. Saatchi had a new partner, Kay, who had more contemporary tastes. The sales looked like the kind of purge that marks the end of one relationship, and the beginning of a new one.

There was perhaps another, more general, emotional impetus to sell. Charles was a collector – as a child it had been comics, and later it had been nudist magazines – and, more generally, he was an obsessive. Journalists profiling Saatchi often repeated an anecdote about how, as an adult, he had for several years become so focused on go-karting that he had even undertaken a nine-eggs-a-day diet in order to lose weight so that he could ride faster. Saatchi's

obsessions never lasted long. His wives, his art collections, his companies and his careers: they had all come and gone.

The Goldsmiths group were young unknowns making art that hit you with an idea quickly, but which did not necessarily repay more sustained engagement. Saatchi was looking for cheap work in London, and as a creator of adverts he had a predilection for the visually stunning. They were the right artists for this moment, and Saatchi was the right collector for them. Like the feminist ideas being transmitted through the Spice Girls' marketing, and like the Lawrence campaign given publicity by the *Daily Mail*, these artists were going to be brought into the mainstream not by a sympathetic ally, but by someone in it for himself.

In Soho, a new gallerist was giving some of the Goldsmiths group their first taste of commerce. Karsten Schubert was a bespectacled twenty-six-year-old, somewhat bookish and intensely ambitious. Four months after the show at the Surrey Docks, he was staging a show of works by Gary Hume, Michael Landy and another *Freeze* exhibitor, Ian Davenport. Schubert's business was precarious: he was dependent on the cash he earned from selling older works on the secondary market and on the funding he received from an established art dealer. Nonetheless, he soon took on another three *Freeze* exhibitors, Angus Fairhurst, Mat Collishaw and Anya Gallaccio, and he published a book, *Technique Anglaise*.[21] Although its title confused Englishness with Britishness, this was probably the first text to identify the national character of the Goldsmiths group's nascent scene. They were arriving.

As well as giving the group exposure, Schubert was drawing other, rather different artists into their circle. One was Rachel Whiteread. She had little to do with Hirst and his friends, and her creations were very different to their work. *House* (1993), a concrete cast of the inside of a four-storey terraced building, had a monolithic quality that made it as spectacular as much of the work produced by the Goldsmiths group, but it was also quiet and melancholy, even spectral. Nonetheless, a tabloid scandal was constructed around *House* – the fundamental problem seemed to be that, in the minds of some journalists and members of the public, the work did not count as art – and this whiff of controversy, combined with Whiteread's youth, her association with Schubert and the fact that Saatchi collected her work, associated her with the *Freeze* artists. Their movement was growing more amorphous, but also more notorious.

Other members of this new generation continued to work independently, organizing further shows in former industrial sites in the East End. Sarah Lucas co-curated the *East Country Yard Show* with photographer Henry Bond, and Hirst co-curated two more *Freeze* exhibitions. After *Freeze III* had finished, he began working with his housemates Carl Freedman and Billee Sellman. The three lived together in a little house in Greenwich, in some form of *ménage à trois*. Freedman recalled that it was 'a bit too much like *Jules et Jim* sometimes'. In Truffaut's 1962 film, the two eponymous male friends are, respectively, the husband and the lover of the same woman, Catherine, and the three live together for several months. 'We thought it was workable,'

Freedman remembered. Sellman agreed that 'We had a very intimate and fun time for the first couple of years,' but that it eventually got too complicated.[22]

During this time, however, the friends started a company that capitalized on Hirst's success with *Freeze* by staging another two influential exhibitions. They still needed large sums from corporate sponsors, but now it was Sellman extracting the cash. Tall, charming and from the USA, she would dress up glamorously for one-on-one meetings with their middle-aged male donors.[23] She and the two boys presented themselves both as angry punks whose art worked best in old industrial spaces, and as self-consciously professional egotists who would never apologize for their ambition. They were rebel-entrepreneurs, pragmatists who broke the establishment's rules in order to aggrandize themselves. Although the artists they were exhibiting were students and recent graduates, still mostly from Goldsmiths, the three organizers hyped their shows so effectively that, when they opened *Modern Medicine* in March 1990, hundreds of art scenesters turned up. There were so many people there that the police thought the exhibition was a rave and tried to shut it down. Most of the work on show sold that night.

'He goes down the lists in *Time Out*, he goes down the lists in ... all those magazines,' Norman Rosenthal would say of Saatchi, years later, 'and he searches out every little bit of art that there is in London. And he gets into a taxi and he'll go to see fourteen or fifteen kind of shows or manifestations in one morning.'[24] *Modern Medicine* was only one of many shows the collector visited that week, and

although he bought from Hirst two recreations of medicine cabinets (these were early examples of a sculpture series that the artist would continue for more than two decades), it was at the Greenwich housemates' next show that Saatchi bought his first great work by Hirst. Appropriately enough, the show was called *Gambler*.

Saatchi arrived at the exhibition in his Bentley convertible. 'He was drawn immediately to this piece,' remembers Freedman, who was escorting him around the exhibition. 'Like a little kid in a sweetshop, really. Very fascinated by these little flies getting killed all the time, getting zapped. Asked how much it was, and it was £4,000. And he said "I'll take it."'[25]

Saatchi was standing in front of *A Thousand Years*, still one of Hirst's most extraordinary works. A glass box stood, a bit taller than an adult, beneath the vast arc of steel trusses that held up the old factory's roof. The box's thick frame, also steel, was painted black and divided into two adjacent cubes. Within one sat a cube a couple of feet across, fashioned in MDF with a circular hole cut in the middle of each side: a large die for a gambler who will always lose. In the other, a rotting cow's head lay in a pool of blood while its flesh was slowly consumed by tiny maggots. Some had matured into flies, and some of those were buzzing around or sat perched on the die, but most had flown into the Insect-O-Cutor hung from the ceiling of the box, and their bodies, hundreds of them, littered the floor.

This piece had emerged out of a crisis. Over the previous few months, Hirst had followed up his colourful *Boxes* with

'spot paintings', grids made up of differently coloured circles that he hand-painted to look machine-perfect. These were the first iterations of another long-running series of works, one that would run in parallel with the medicine cabinets, but they had also made him anxious. The twenty-four-year-old had become so focused on the technical elements of form and colour that he had begun to question art itself, and 'whether it was real or not'. He had felt he needed to make 'something about something important'. The result had been *A Thousand Years* and its similar, accompanying piece, *A Hundred Years*. They were about something important: 'a life cycle in a box'.[26]

Hirst was producing work that instantaneously presented to the viewer questions and thoughts with grand existential resonance. There were other ideas and allusions in there too – the black steel frames of these two life-cycle pieces alluded to those that encaged the subjects of many of Francis Bacon's most famous portraits – but that kind of analysis was secondary and unnecessary. This was not a representation of death, killing, chance and moral complicity; it was those things, and once they hit the viewer, much harder than the message of another, more metaphorical sculpture could, it was difficult to get much more out of it.

The formal elegance of the work gave the impression that this act of repeated killing was something legitimate – art – 'but actually,' insisted Hirst, 'what's going on is unacceptable'.[27] He had forced the viewer to act out their own complicity in violence, and after that there was nothing

to say. The Berlin Wall had fallen less that a year earlier, utopia was passé, and, like the others in his cohort who would define their generation of artists, the only politics Hirst could contemplate was pure critique. The feminists and Marxists who had preceded them had tried to engage in the messy complexity of imagining a new world, but that was not cool or sellable. This group were able to pose as both avant-garde and accessible partly because they maintained this crudely negative tenor so constantly.

Following the likes of Jeff Koons and Gilbert and George, Hirst was developing a distinct public persona, that of a cheeky, unpretentious party animal. He was becoming a brand, a permanent advert that pulled together a small number of product lines, each offering a different approach to grand existential questions, but all adopting a simplicity that made them commercially viable. The spot paintings and the medicine cabinets were already established, as was a third line, his paintings incorporating dead butterflies, which he had created for his debut solo show. Another category, his 'spin paintings', he and Angus Fairhurst would introduce to friends at a 1993 happening hosted by young gallerist Joshua Compston, *A Fête Worse than Death*. Paint and turpentine were splashed over a rotating canvas, creating an explosive and spontaneous creation, and then Hirst and Fairhurst exposed their painted genitals to the participant. The painting and the exposure both cost £1. Each of these product lines functioned, Hirst explained, 'almost like a logo, as an idea of myself as an artist'.[28] For the next two decades these categories would dominate Hirst's oeuvre.

The Goldsmiths group and their friends began to celebrate one success after another. In 1991 the Turner Prize had a new funder, the fashionable and progressive Channel 4, and the prize's rules were changed so that its nominations had to focus on younger artists. Karsten Schubert's Rachel Whiteread and Ian Davenport were in the running, alongside Davenport's fellow *Freeze* exhibitor Fiona Rae and the rather more established Anish Kapoor. The elder artist won, but the three young pretenders had set a precedent.

Hirst, however, was getting even more attention: exhibitions at public galleries, magazine covers, and then a Turner nomination of his own. His face – piercing little eyes above a wide snub nose – was everywhere; he was profiled in the Sunday papers and on TV, and key to his success was the support of Jay Jopling. This Eton-educated art dealer had approached Hirst, the son of a car mechanic, in 1990. Jopling was tall, cute, wore big glasses and was often in a suit. 'He seemed a bit of a toff,' thought Hirst,[29] but the two quickly became friends. Unlike most of London's gallerists, Jopling thought he could sell the work of this eccentric, brazen young man. Hirst, in turn, was impressed by the Brixton home of twenty-eight-year-old Jopling, or rather by the Donald Judd sculpture and Richard Prince photos that were on display there.[30]

Within two weeks Jopling was representing Hirst. He was both the artist's agent and his manager, a role that had hardly existed in the art world until he created it. 'There was very strong personal chemistry, shared ambition, an overriding

desire to get things done yesterday,' Jopling enthused about his relationship with Hirst. 'When we met, we left each other at 4 am, and at 9 am there he was at my house.'[31]

When, in 1991, Jopling had called Charles Saatchi, telling him that Hirst wanted to suspend a tiger shark in a steel and glass tank of formaldehyde, the collector had commissioned the piece almost immediately, and Jopling had demonstrated typical ingenuity by quickly sourcing a corpse for his artist. He knew that controversy would be Hirst's main selling point, and that the shark could give them a scandal. When Hirst exhibited the pickled fish with the grand title *The Physical Impossibility of Death in the Mind of Someone Living* at the Serpentine Gallery, Jopling's office called up one of Britain's right-wing tabloids, and proposed both a stunt and a headline to go with it. 'We got the *Daily Star* to take a bag of chips to one of Damien's fish-in-formaldehyde pieces,' remembers Jopling, 'and photograph it as "The most expensive fish and chips in the world".'[32] It was an early sign that this generation's strategy of gaining attention by shocking their audience might not succeed in popularizing avant-garde art, and might instead alienate people.

Hirst did not seem concerned by the *Star*'s response. Eliciting feigned shock from the red-tops, and thereby outraging the public, was a clever marketing strategy, but it also seemed to prove that this work was not just an act of commerce. His art, he thought, was challenging conservative mores. Mass media attention was helping to make his work accessible and meaningful, and he proudly reported that cab drivers – by which, presumably, he meant to signify

people with less class privilege who had little knowledge of contemporary art – would tell him 'your work's alright, really, isn't it?'[33] Like many of the protagonists in this book, he was willing to lose some credibility amongst his peers if he could get the attention of the public, shock elites, and in that way challenge society.

Like many artists before him, Hirst was using the media to construct himself as a celebrity. However, the art writer Kate Bush observed that unlike those earlier artists, such as Andy Warhol, Jeff Koons and Gilbert and George, Hirst made work that fed from the entertainment and news industries, but failed to analyse or subvert them.[34]

By contrast, many of Hirst's colleagues were creating artworks that confronted the media with brutal directness. His friend Sarah Lucas treated misogynistic tabloid stories as found objects, exhibiting a wall-sized copy of a real spread from the *Sunday Sport* that featured a salacious and mocking story about 'midget kiss-o-gram Sharon'. Although the facsimile had hardly been altered, Lucas argued that through her re-presentation of this article, she was satirizing it, so that it was 'converted from an offer of sexual service into a castration image'.[35] It was a simple tactic. Lucas placed the object in the liberal or progressive social context of a gallery, and instantly confronted viewers with the hypocrisy and cruelty of its sexism.

Lucas was attracting art world attention with this striking and witty work. She had a hard stare and a big laugh, smoked a lot and did not wear make-up. Her art was evidently critical, but when it was mentioned in the mainstream media,

its feminist meanings were downplayed, and sometimes all that was left were sniggering reports of Lucas's puerile tone.[36] Mass media tactics and accessible aesthetics were supposed to make challenging messages more approachable, but instead they were obscuring those messages.

Early in 1992, Hirst's pickled shark, the first of a new product line of animals in formaldehyde, had pride of place in a new exhibition at the Saatchi Gallery. As a result of the choreographed controversy, *The Physical Impossibility of Death* ... was already infamous, and even people from outside the art world wanted to see it.

Saatchi's show was called *Young British Artists*. Hirst was the only Goldsmiths alumnus or *Freeze* exhibitor included in the show, and only a minority of the artists featured in the five subsequent *Young British Artist* group exhibitions staged by Saatchi would generally be labelled as members of 'the YBAs'.[37] Indeed, in subsequent years, those who worked in the art world would rarely use the term, except without the distancing irony of 'scare quotes'. It would be too vague for their purposes, because the larger group of artists to whom it referred were only ever a very loose social group, and never shared an aesthetic. Nonetheless, the term was going to succeed in the broader public realm because the YBAs known to most members of the public made up a much smaller and tighter scene, sharing ideas, styles, bar tabs and beds.

Each of the six *Young British Artist* exhibitions held between 1993 and 1996 would attract between 50,000 and 75,000 visitors, a stunning achievement. *The Times* would be the first, but by no means the last, to compare Saatchi to

more ancient power-hungry patrons of the arts. An editorial crowned him a 'modern Medici'.[38]

While some young artists were making their way into the institutions of the art market, others remained by the sidelines. Lucas was a hot name on the scene but she was uncomfortable with such attention, or perhaps irritated by it, and so she focused on a relatively uncommercial venture with a friend. Tracey Emin had finished her MA at the Royal College of Art years earlier, but had decided not to become an artist. She had, instead, been working as a youth tutor for Southwark Council while doing a part-time philosophy course,[39] and although she found typing difficult, she wanted to be a writer. Emin struck many of those whom she met, especially the men, as mad, sexy and aggressive. Women were more likely to identify her as unashamed and brave. She had a way of cackling and muttering during conversation, and when deep in thought she would screw up her face. She drank a lot, sometimes she dressed quite glamorously, she seemed comfortable getting naked as part of her artistic practice, and she did not take fools gladly.

Looking for a studio space that they could also use socially, Lucas and Emin had found an old dentist's on the Bethnal Green Road, nestled in a patchwork Victorian terrace of shops near the top of Brick Lane. The pub next door was filled with smoke puffed out by the men who drank there all day. Only a short walk from the City of London, the area was still mostly working-class, but many of its textile factories had shut down, as had the huge brewery that

dominated the southern part of the district. The bagel shop around the corner pointed to its Jewish history, and farther down the narrow, bustling lane, now lined with curry houses, was the Bangladeshi mosque that had once been a synagogue, before that a Methodist chapel, and before that a church for Huguenot refugees.

Lucas and Emin's shop was covered in chipped blue paint, its windows protected by welded wire mesh. Inside they painted the walls magnolia, a mock-suburban contrast to the art world's ubiquitous white cubes. They built a counter, covering it with tabloid clippings, and on their makeshift shelves, or nailed to the wall, they placed their stock: 'I'm so fucky' T-shirts made by Lucas, and ones with the slogan 'Have you wanked over me yet?' by Emin; glass ashtrays with crudely cut-out photos of Damien Hirst stuck to the bottom, so that you could stub your fag out on his face. Those were made by Emin, while Lucas produced mobiles decorated with pictures of herself. Prices ranged from 50p to, half-jokingly, several hundred pounds. Customers included Joshua Compston, Norman Rosenthal and Anthony D'Offay, an established dealer who had bankrolled *Freeze*, and for six months Emin and Lucas ran the space as a shop during the week, while on weekends it functioned as an all-night bar: their friends were the main customers and brought their own booze. Unknown artists got drunk with famous collectors, and Emin built an art world reputation for herself that nearly matched that of her collaborator.[40]

Emin was interested in the work of German Dadaist Kurt Schwitters and Belgian conceptualist Marcel Broodthaers,

and she and her generation learned from the history of the avant-garde, from Dada to Expressionism to performance art, that it was not just a finished object but also the process of being an artist that could count as 'art'. At The Shop Emin and Lucas enacted the ideal of living their art: selling their work, or failing to do so, acted as a satire on the art market, and as they built their rebel reputations, they seemed to mock the role of the artist as celebrity. They were also, however, taking their first steps towards enormous fame.

One of the highlights of Emin's half-year at The Shop was her letter-writing performance. Visitors to the space could purchase the promise, from her, that she would send them a letter every month for a year. One of her customers was Jay Jopling, and he was impressed with Emin's confessional missives. 'It totally shocked me. Great art does kind of punch you in the tummy and spin your head and change the way you look at things.'[41] Jopling insisted that Emin create a show for him at White Cube, his new gallery, located in a tiny Mayfair space that Christie's let to him for free.

Jopling persuaded Emin to create an exhibition, but she had no idea what she would show. It was during an argument with Carl Freedman, Hirst's curator housemate and now her boyfriend, that she finally decided what her exhibition would consist of. Sitting in her small flat, Carl made plain his horror at her messily crammed rooms, filled with random objects of personal significance: notes, photographs and mementos. She recalled to documentary maker Vanessa Engle how he had told her 'You've gotta get rid of all this shit.' She had not been impressed. 'I said "It's

not a shit. They're my things." And he said "Well if you care about them so much, why don't you make it look like you do?" And that's how the idea come about, as making them into these iconic objects.'[42]

My Major Retrospective 1963–1993 featured more than a hundred small objects and photos, including, famously, a crumpled Benson & Hedges packet recovered from the hand of Emin's late uncle. A lorry had pushed his car under a bus while he was holding the cigarettes. The exhibition's joking title, which referred to the year of Emin's birth and the year that the show opened, indicated that these works could function as a review of the artist's life. By reinterpreting her past and herself, the show also pointed to the subject that would remain her artistic focus.

Dominating Jopling's small gallery and the dozens of small items that she exhibited there was *Hotel International*. It was a large quilt, hung on the wall and appliquéd with letters spelling out biographical phrases: 'Pam Cashin loves Envar Emin so much … KFC … Holy Trinity … You're good in bed'. Techniques such as appliqué and quilting had long been dismissed as feminine and as craft, rather than art. Similarly, Emin's subject matter was one that had long been ignored by the male-dominated art world: a woman's experience of her intimate relations. She was insisting on the artistic legitimacy of such work, and in so doing she built on decades of feminist art history, including the work of Rozsika Parker, and on the work of other recent women artists, few of them celebrated.[43] In an art scene gripped by irony, Emin's vulnerable and sincere approach was

unusual. Its explicitness, immediacy and clarity mirrored the bombastic oeuvre of the Goldsmiths group. However, it exposed Emin's psyche and her life in such an overwhelming way that it was more complex and more receptive to sustained analysis. By joining Jopling's list, Emin and her work seemed to be opening a new frontier for the YBAs.

'I wanted to make a difference in the world,' she would later explain. 'I wanted to do good things through my art.'[44] One way in which she showed greater self-possession and moral confidence than most of her friends was by refusing to sell to Saatchi. The collector supported the Conservatives – he and his brother had created the famous 'Labour Isn't Working' poster that had helped Thatcher to win the 1979 election – and on this basis, said Emin, she avoided any involvement with him. 'I still think Margaret Thatcher should be tried for crimes against humanity, against the Irish, the British and the Argentinian people – especially the Argentinian people, for the *Belgrano* going down,' she explained, referring to the sinking of an Argentinian naval cruiser by a British submarine during the Falklands War. 'I don't understand how she got away with it ... I didn't want to be associated with that.' Emin's work was not the only gap in Saatchi's collection. Several significant YBAs, especially those who made work that was video-based, markedly leftist or quietly gentle, found that he was not interested in buying.

Between drinking sessions with Emin, Jopling had been having an occasional quiet word with Gary Hume, the *Freeze* exhibitor who had sold his paintings of doors to Saatchi, and who was represented by Karsten Schubert. The art market

was collapsing, revenues were falling and the German gallerist was struggling. He was even younger than Jopling, more scholarly, not nearly so cut-throat a salesman and altogether less able or perhaps less willing to charm the artists whose work he sold, and on whom he therefore depended.

After a series of arguments with Schubert, Gary Hume left the gallery for White Cube in 1993, but in the same year Whiteread's *House* won the Turner. Schubert survived, but when Whiteread herself defected to Anthony D'Offay, the young gallerist's fate was sealed. A 'close associate' of Schubert was quoted as saying: 'It is a stab in the back. Everyone is reeling from the shock.'[45] The young gallerist had seen the YBAs coming before many others, but he had not been able to establish himself before they outgrew him.

It was a mean world precisely because everyone was doing business with their friends. Jay and Damien were doing so well that when Jopling's girlfriend Maia Norman left him for Hirst in 1994, it was very much in the gallerist's interest to carry on as before. Hirst, of course, had previous experience of a similar ménage, and although Norman's feelings about the matter are not a matter of record, the three appear to have remained friends. Such magnanimity was no doubt emotionally beneficial and, moreover, it was good for their bank balances. Jopling was getting Hirst all the right shows, the next year the artist directed the video for the biggest single of the summer, Blur's 'Country House', and only a few months later he won the Turner Prize. 'I saw one of my fish pieces in Jay's house,' Hirst would later recall in an unedifying interview. He was referring to a fish soaked in

formaldehyde and encased in acrylic. 'I said, "Did I give you that?" And he said "Yes, I think it was in exchange for my girlfriend." It's worth over a million now.'[46]

Hirst remained far wealthier and more famous than his fellow YBAs, but most of his cohort had now found major gallerists, patrons and collectors who favoured them. The YBAs attracted international attention and sold well abroad, and their youth and the vibrancy of their work was said to indicate that the UK was no longer a post-imperial backwater: London, at least, was apparently undergoing a renaissance. During 1995 and 1996, at least twelve major exhibitions around the world focused on British art, and several featured only artists from the broader YBA group.[47]

Having become active market players and, in some cases, public personalities, they were endorsed by senior ministers and promoted by the Arts Council. Critics Julian Stallabrass and Andy Beckett descibed the YBAs as something akin to the semi-official art movement of the British state.[48] Their scene was documented in the stylish black-and-white photos of Princess Diana's former step-brother, Johnnie Shand Kydd, and the names of their most shocking and well-marketed members were in the newspapers. Like so many of 1997's apparently rebellious movements and ideas, they were part of what they wanted to critique.

This gave their iconoclasm a platform, but it had another, more perverse, consequence: even when the YBAs were at their most radical, their conservative critics looked and felt not like the defenders of old-fashioned ideologies, but like subversives fighting the establishment.

These critics posed as the boy pointing out the nakedness of the emperor in his new clothes. The *Sunday Times*'s critic, for instance, dismissed out of hand the work of Chris Ofili, whose densely layered paintings combined abstraction with figurative moments and explored, amongst other themes, racism and colonialism. According to the review, Ofili's works were 'imitation Aboriginal paintings' that were 'not made any less vacuous (or more shocking) by the addition of real elephant turds'.[49] When the daily *Times* published a positive review of a different Ofili exhibition, describing how the artist did 'not interfere with the brazen reality of the elephant dung he applies to his meticulously crafted paintings', sarcastic letters were written to the editor: 'With such splendid artistic integrity Mr Ofili is surely destined to become a superstar of the cultural milieu.'[50] Now that they had been embraced by the elite, the YBAs found it was their critics who were, apparently, the rebels.

The Royal Academy had scheduled a global retrospective of twentieth-century art to begin in September 1997, and the show needed to be a blockbuster.[51] The Academy, a private association of artists and architects housed in a former aristocratic palace in central London, was not the most businesslike of organizations. Indeed, it had been running a deficit for several years and was now £2.1 million in debt.[52] However, this exhibition would be dominated by the famous dead white men – Picasso, Pollock, Warhol, etc. – who could draw huge crowds. It was exactly what the RA's Norman Rosenthal needed to be staging.

And then it was cancelled. It seemed that this logistically complex show, which involved borrowing works from around the word, had become too expensive.[53] A friendly and theatrical man, with heavy eyes and a thin nose, Rosenthal was respected for his work, over two decades, transforming the Academy so that it would match the world's greatest galleries as a space for temporary exhibitions. A cancelled show, however, was a big problem. The 1997/98 schedule had a gaping six-month hole in it, the prospect of paying off the Academy's mounting debts was fast receding, and some kind of exhibition had to be organized at short notice.

It was Charles Saatchi who saved the day. His collection was huge, it was available, and he had a significant interest in lending it to them, for anything he showed at the Academy would likely rocket in value. Rosenthal had previously tried to plan a YBA exhibition, but that show had never transpired.[54] Saatchi's custom was to demand that exhibitions featuring his artworks feature only his artworks – that was better for their prices – and Rosenthal, it seemed, had refused to stage such a show. Certainly, he had not needed to take the PR risk of exhibiting only artworks owned by a single, controversial individual, especially one whose collection was incomplete.

Now, however, the curator had little choice, and Saatchi had the upper hand. The exhibition would not simply be dominated by Saatchi's collection, it would contain only works that he owned. *Sensation: Young British Artists from the Saatchi Collection* was green-lit. It would show the work of nine of the sixteen artists exhibited, just nine

years before, in the first *Freeze*, an astonishing success for a student show. Like many of the shocks of 1997, *Sensation* would be the climax of an extraordinary journey from the margins to the mainstream.

The RA's forthcoming exhibition had to be a definitive survey of the YBAs' scene, so Saatchi went on a spending spree. He had to quickly buy pieces by Gillian Wearing and Sam Taylor-Wood, Mat Collishaw recreated *Bullet Hole* for him and Michael Landy built the collector a costermonger stall. He had previously made similar works, satires on the art market, by buying, repainting and exhibiting such market stalls. However, in what seemed like an added dig at Saatchi's commercialism, Landy mocked-up a new stall, and added extra decoration to it.

Most of the major works in the exhibition had been sold to Saatchi by Jay Jopling. One piece, however, had not come from the White Cube owner. Tracey Emin still refused to let Jopling sell the collector her work, so Saatchi approached another dealer to buy something second-hand: *Everyone I Have Ever Slept With 1963–1995.*[55] This camping tent, appliquéd with the names of friends, lovers and relatives, was another act of revelation, by turns raw, melancholy and nostalgic. Gallery visitors were encouraged to lie down inside the tent, joining the absent Emin and her named companions. However, it had been constructed into something vaguely scandalous by the press, who implied that the piece simply listed all the people Emin had had sex with. Even supposedly serious critics described it as evidence that she was 'fascinated by sex'.[56] This artwork, which delicately

explored the self of both the artist and the viewer, had been publicly mocked and misrepresented, and it was now being sold, against the artist's will, to a man she despised.

The Academy told the media that the show would sell 300,000 tickets,[57] but their confidence began to falter, and the chief executive of the RA's commercial wing quietly told a reporter that that they were expecting only 150,000.[58] Contemporary art, it was widely imagined, would never fly with the unpretentious British. The number of visitors that the Saatchi Gallery had drawn to each of its YBA shows was impressive for an institution of that size, but 75,000 sales would be considered a dismal failure at the RA.

Throughout the spring and the summer, Rosenthal and his team dripped stories to the press, replicating the controversy-bating approach with which the YBAs were already identified. The curator began tentatively by informing reporters that he expected the artists exhibiting in *Sensation* eventually to join the Academy. The statement may have seemed innocuous, but the RA was a venerable and achingly conventional institution, and a flurry of publicity was produced.[59] The Academy offered Rachel Whiteread membership and, predictably, she refused. The RA told the papers, and the exhibition had another day in the news.[60]

The Academy's team knew that the exhibition featured two artworks that were bound to attract attention: Hirst's tiger shark and the largely unknown palm-print portrait of Myra Hindley.[61] They informed the press of their plans to hang the painting in the gallery six months before the exhibition was scheduled to begin, and, fortunately for their

strategy, the boss of a minor child protection charity leapt to comment on the announcement, telling a newspaper that the painting was 'a sick exploitation of dead children'.[62] Soon dozens of journalists were calling up the families of children raped and murdered in the early 1960s by Hindley's then boyfriend Ian Brady with her assistance.

For weeks, the children's parents, the last three decades of whose lives had been dominated by those acts of extra-ordinary cruelty, complained in the press and on TV about the painting, and tried to persuade the RA not to exhibit it.[63] The painter, Marcus Harvey, admitted that he was not sure, yet, how he felt about his own work, but he hoped to remind people of the real meaning of the photo of Hindley, and how it had been given so much power by the press. 'The image has a kind of hideous attraction. I wanted to bring it back to textural reality. She's like a piece of cultural ornamentation, like a bowl of fruit.'[64]

What particularly upset the families of Brady and Hindley's victims was that the painting avoided castigating her. They did not care that Harvey had intended to analyse the iconic power of a famous image. 'They are making a film star out of her,' insisted Ann West, mother of Lesley Ann Downey, who had been raped, tortured and murdered by Brady and Hindley in 1964. Harvey, like many of his fellow YBAs, was finding that his subversive ideas were not amplified by his ultra-clear communication methods, but obscured by them.

The story ran and ran. No show at the RA had ever received so much coverage before its doors had opened. An

MP complained about *Myra*,[65] and somewhat callous quotes praising the painting's artistic merit, first from Harvey, and then from the RA, kept the controversy in the news.[66]

Indeed, it began to gain momentum. Hindley herself, fifty-nine years old and beginning to suffer the effects of smoking forty cigarettes a day, wrote to the *Guardian* from H Wing of Durham Prison, supporting the case of her victims' parents.[67] They, in turn, accused her of promoting her campaign for release, and repeated past threats to sue her.[68] Quotes from the RA and Harvey's gallerist, Jay Jopling, helped bring attention to Hindley's missive, as did an open letter from the Academy replying to Hindley.[69] The RA's curators ensured that everyone remained in suspense by refusing to say if they would hang the painting or not, while one academician tried to stop Rosenthal showing the work, thus sparking a protracted internal inquiry.

The Academy continued to receive criticism from all sides. After the *Sun* printed the Academy's telephone number, Sir Peter Blake, the academician famous for his cover art for the Beatles' *Sgt. Pepper's Lonely Hearts Club Band*, reported that a caller had threatened their switchboard worker: 'Unless you tell me it's withdrawn, I'm coming round to the Academy and I'm going to stab the first person I see.'[70]

There would be about forty other artists exhibiting alongside Harvey, and the RA needed to build excitement around other pieces in the exhibition. The press office informed journalists that the gallery would be forced to display warnings for visitors who might perhaps be shocked

by Jake and Dinos Chapman's sculptures, which featured mutilated shop window dummies and naked conjoined prepubescent figures, their noses replaced with erect penises and their mouths with sex doll anuses. The brothers' gallery helpfully added that they too thought the work would attract public anger.[71] More articles appeared in the papers, and shortly before the exhibition opened, the RA prompted a last couple of stories by announcing that children would be banned from entering some galleries.

On the evening of 16 September, the RA held its private view. Gavin Turk arrived dressed as a tramp. Michael Heseltine, who had been deputy prime minister until Labour had taken power four and a half months earlier, was overheard telling Jay Jopling: 'I don't like any of this'. The gallerist was apparently rather pleased. 'That', he explained to the sixty-four-year-old Tory, 'is why you lost the election.'[72]

On the morning of the 18th, *Sensation* opened to the public and *Myra* was attacked. Peter Fisher, a middle-aged artist, pulled the huge canvas to the floor, and threw ink at it. Jacques Role, another middle-aged artist, heard the sound of the painting fall, and saw it lying, covered in red and black. 'I thought it was wonderful,' he would explain to a reporter later that day. Role crossed the road to luxury food store Fortnum & Mason, bought a box of eggs, exited, crossed the road again and walked back into the RA. He was disappointed with what he found there. 'When I came back to the exhibition there were even more people around the painting. I thought, "Golly, what the first guy did didn't

help at all.'" He was apparently surprised to find that sabotage and controversy had not discouraged visitors from examining Harvey's work. 'So I threw three or four eggs at the painting.'[73]

As she stood outside the Academy's tall Italianate façade, Winnie Johnson told reporters: 'I hope they put it back so others can have a go at it.' Her twelve-year-old son, Keith Bennett, had been sexually assaulted and murdered by Brady, with Hindley's help, in 1964. Bennett's body had never been found.

While a protester with a loudhailer implored members of the public not to enter the gallery – they mostly ignored her – Johnson stood near by in a blue summer dress, her hair curled and pulled back, a neat line of lipstick on, and her face blank.[74] Occasionally, she broke into deep sobs. Although much aged, she still looked like her boy, whose face had been captured in a photo of him grinning from behind his spectacles, an image that across three decades had been reproduced on millions of newspaper pages: the same big cheeks, the same long chin and the same squinting eyes. The painting of Hindley, she told a reporter, had been made 'to make money and glorify her name ... I think it's totally sick. And anybody that goes in to see it, and stops and looks at it, is a sick as her.'[75]

Sensation attracted as many visitors in its first day as had the RA's previous blockbuster shows of big names and canonical artworks, and even after that impressive beginning, sales rose. The RA was not going to remove Harvey's work[76] but, once the attacks on the painting had

produced the appropriate flurry of headlines, and after those headlines had encouraged even more members of the public to join the gallery's long box office queues, Saatchi withdrew charges against Role and Fisher.[77]

The YBAs were attracting enormous attention, and they were challenging public taste, but it was not clear that this challenge was breaking down conventional mores, for the public was reacting against them. 'The picture of Myra Hindley created with child handprints is sick,' insisted one man writing to the *Sun*. 'There are many people who would like to leave their handprints on Hindley, the "artist" and Royal Academy chiefs.'[78] Another letter indicated that its writer had also completely misunderstood the Chapmans' pieces. They were, he said, 'the glorification of paedophilia'.[79] Opinion polling at the time suggested that such letters were indicative of a general alienation from the YBAs, and nearly two decades after *Sensation*, a respected pollster's research on what the public considered to be 'art' would find that Tracey Emin's *My Bed*, a 1998 recreation of her chaotic bedroom during a period of deep emotional crisis, was deemed worthy of the term by only 12 per cent of those polled. A spot painting by Hirst would fare only slightly better, with 27 per cent.[80] Despite their extraordinary name recognition, none of the YBAs would ever appear in lists of the public's favourite artists.

Hirst had made clear many times that he wanted his work to be popular, Emin was often upset by how misunderstood her work was and other YBAs reacted similarly to aggressive responses from journalists and the public, but that does not

mean they hoped wholeheartedly that their work would be enjoyed as widely as that of Constable, say, or Jack Vettriano: it would not have been cool. In any case, the pleasure that these young artists seemed to take in provoking anger indicated that they were ambivalent about how they wanted to be perceived. Years later, Emin reflected on the conservative vitriol that had been directed at Chris Ofili and his 'dung paintings' of the Virgin Mary when *Sensation* transferred to the Brooklyn Museum: 'When it went to America, what a triumph, morally, that it caused there was amazing.'

There seems to have been an assumption among the YBAs' supporters that such anger was necessarily disruptive, and creatively so. They were not attempting to persuade their viewers of an alternative viewpoint – they were not trying to get the viewer to agree with them – but only to break down the viewer's assumptions about the world.

In a very limited way, they seem to have been successful. Of the minority who would later tell pollsters that they considered Emin and Hirst's works to be art, a disproportionate number were children at the time of *Sensation*. Young people in Britain were mostly learning to accept the world in which they were growing up – a world that was filled with conversation about the *Daily Mail*'s 'MURDERERS' front page and the Macpherson report, if not about Stephen Lawrence himself; a world in which feminist slogans had entered pop culture – but many older Britons were reacting against the liberalization of British culture.

In the UK, *Sensation* would long be remembered as having signalled that the country could look forward to a

marginally more liberated cultural future. Art critic Jonathan Jones would describe how 'Charles Saatchi's YBA show promised a new Britain that was keen to shove conservatism aside'.[81] Nonetheless, it was acts of opposition against the YBAs and *Sensation* that felt and looked rebellious, and this pointed to a strategic weakness for all the wannabe radicals of 1997. Their journey into the mainstream had made them seem elitist, especially in the eyes of older Britons, and their conservative opponents were consequently able to masquerade as rebels. Just as supporters of the police complained about the anti-racist movement having even a marginal influence on government policy, and just as many conservatives complained about the 'political correctness' of multiculturalism, the YBAs' critics presented themselves as underdogs. The anti-modern art brigade, at least, had a point: Winnie Johnson was one working-class woman fighting both an austere arts institution and a millionaire collector, and the *Sensation* exhibitors had become, in the words of one much-cited newspaper commentary, 'The New Establishment'.[82]

After six months, the exhibition closed. It had been an unparalleled success for the Academy – 300,000 tickets had been sold, netting the RA about £2 million in income and returning them to financial good health.[83] *Sensation* had been a triumph for Rosenthal and his colleagues, but also for the most prominent YBAs and, they believed, for the strategy implicit in their work. Years later, Sarah Lucas would tell Vanessa Engle with great satisfaction that the exhibition had brought contemporary art to new kinds of

people, those who would not otherwise have seen work by her and her friends.[84] Hundreds of thousands of people had been exposed to their art, millions more had heard about it through the papers and TV news, and she and her fellow artists cared deeply about this. Tracey Emin, agreeing, would remark: 'One thing about Saatchi, which is fantastic, is he gets a phenomenal response to the exhibitions that he puts on, like *Sensation*. 300,000 people.'[85]

The YBAs – or the ones most people had heard of, anyway – had enthusiastically brought their accessibly provocative art into the mainstream. Commentators would soon identify this as a sign of Britain's 'revived fortunes'[86] and part of a wider renaissance in 'BritCulture'.[87] The success of these artists was part of a wider emergence of 'British talent … as a highly saleable cultural commodity'.[88] This success, however, only made their work seem more establishment. The lack of complexity or subtlety that characterised much of their work had gained it attention, but it had been mocked and resented nonetheless. Some people in Britain were marching into a brave new world of postmodern deconstruction and ironic culture games; most were not.

Sensation made the YBAs famous in a way they had never imagined. They were in the papers all the time and they were friends with all the right people, selling their work to the stars and collaborating with them. Among their fans were Kate Moss, Alex James, Keith Allen, Dave Stewart, Elton John, Stella McArtney and Mario Testino. They were

hanging out at the Groucho Club, Tracey Emin got together with Mat Collishaw, and Sam Taylor-Wood lent some of her credibility to Jay Jopling by forming with him the art world's most visible power couple.

As Michael Craig-Martin observed, White Cube's owner was at the centre of the scene. 'At least half a dozen of his artists have public faces. They have questions about Damien Hirst on *Who Wants to be a Millionaire?* and Jay is known as a dealer in the way that Steven Spielberg is known as a director.'[89]

Even the most mainstream of art collectors now wanted YBA work. Dozens of pieces were snapped up and transported to a secret Soho store belonging to the Government Art Collection. These purchases, explained a spokesperson, 'demonstrate the importance the government attaches to supporting successful young British artists'.

Like the Lawrence campaign and the perceived modernization of the royal family after the death of Diana, the success of the YBAs overlapped somewhat with New Labour's attempts to construct a sense of national community that embraced all sorts of people, as long as they did not step too far out of line. From the new YBA entries to the government art collection, Robin Cook selected for his glittering Victorian suite in the Foreign and Commonwealth Office a print by Chris Ofili, whose work interrogated and celebrated black culture and the African diaspora. This was a striking contrast to the exterior of the FCO's home, built in the style of an Italianate palace and decorated with a relief depicting the personification of 'Africa' as a bare-breasted woman

under a banana tree, holding a chain in one hand and her child in another while a hippopotamus looks on. Both Tony Blair and Gordon Brown chose less confrontational prints by Rachel Whiteread. The prime minister also opted for a Damien Hirst piece musing on consumerism and beauty – an image of the King's Road fashion district overlaid with semiprecious stones – while the Chancellor selected prints by Gavin Turk and Mark Quinn that confronted his guests at the Treasury with menacing images of body parts.[90]

The YBAs had become accepted by the most conventional of cultural players much faster than previous generations of artist-rebels, but they were doing something else new. Extending the logic of The Shop, these famous young artists made not merely life, but the life of a celebrity, into art.

One morning in December 1997, Tracey Emin woke up in her Shoreditch flat with an appalling hangover. Weak sunlight ebbed through the floor-length camel-coloured curtains and up the breezeblock walls, painted white. She had injured her finger a few days before, and the previous night she had been celebrating with her friend Gillian Wearing, who that evening had won the Turner Prize. The combination of prescription painkillers and free booze had been very effective. Her head ached.

The phone rang. It was Wearing, laughing down the phone about the night before. She told Emin what had happened. A few hours after the Turner Prize party, Emin had appeared on Channel 4 as part of a panel discussing 'Is painting dead?'. The ten critics, plus Emin, had come

straight from the prize-giving to ruminate, still wearing black tie, on the state of the art world. They sat on chic armchairs of black leather and chrome in the middle of a dark gallery, its shadowed walls rust red. Emin, several drinks down, muttered confusedly while smoking a succession of fags with her injured hand, which looked like it was being held together by its elaborate splint. The others conversed elegantly for the cameras about the nature of art, and occasionally she made high-pitched interjections. Finally, she announced: 'I want to be with my friends. I'm drunk.' No one was terribly surprised. 'I want to phone my mum. She's going to be embarrassed by this conversation. I don't care. I don't give a fuck about it.'

Opposite her sat Norman Rosenthal, with lipstick kisses on either cheek that were presumably the result of award ceremony celebrations. He giggled embarrassedly, and then looked slightly sick. Emin first decided to stay, and the conversation restarted, but then she thought better of it. 'I want to leave. I've got to go somewhere. I'm going to leave now. Don't you understand? I want to be free,' she exclaimed irritably, all the while smiling at her silliness and pulling ineffectually at her lapel microphone. 'Get this fucking mic off!' She got up, a little unsteadily, while some of the panellists tittered. 'I don't give a toss about any of this lot,' she said, pointing in the vague direction of critic Waldemar Januszczak, who was wearing a particularly garish canary-yellow bow tie, 'but I think he's really lovely.' Januszczak grinned, apparently forgetting that behind him stood a young cameraman.

Emin put the phone down. Wearing had to be winding her up. She dragged herself downstairs, through the cold grey morning to a café, and absent-mindedly opened the *Guardian*. There on page two was a photo of herself, the splint on her hand, wearing the same dress that she had worn last night, and a headline: 'Sixty Minutes, Noise: by art's bad girl'. The article confirmed Wearing's account.

Emin still remembered nothing; the world was not as it seemed. 'It was like a Kafka novel,' she would later recall.[91] More than that, however, it was like an artwork by Tracey Emin. Journalists repeated the anecdote, that week and over the years, because it illustrated so perfectly the painfully self-destructive experiences that she portrayed in her confessional oeuvre. It not only helped make her a major celebrity; it also gave greater meaning to her artistic practice. Indeed, it was part of that practice. Through the years, she revealed in her artworks, in books and in press interviews the details of her loneliness, her drinking, being raped as a teenager and her unhappiness after an abortion. The art was not only in the gallery; it was her life and it was on the front pages. Using her fame, Emin was once again pushing the frontier of the YBAs' work.

That year she had sold 'art bonds': autobiographical videos and an 'Official Bond Form' that assured buyers that her work 'concentrates on the beautiful things of this world'. She explained: 'I see no reason why the spiritual and the material should not go together.' She was tightening the warp and weft of her life, her practice and her income. 'Art has become a currency.'[92]

While Emin became more comfortable with her new role – she began selling to Saatchi, formed a friendship with him, and eventually became a Conservative Party supporter – Hirst pursued a similar strategy of fame-as-art. As his selling-power increased, his studio workers churned out more and more iterations of his various product lines: the spot paintings and spin paintings, the medicine cabinets, the butterfly paintings and the pickled animals. Meanwhile, his friends explained that Hirst was actually satirizing commerciality.

This approach reached its apotheosis in 2007, when Hirst commissioned jewellers Bentley & Skinner to make him a new piece, one that did not fall into any of his conventional product lines. They cast a human skull in platinum, and covered it in diamonds. They added a simple symmetrical arrangement of larger diamonds on its forehead, and in the jaw they set real human teeth. The finished work stated bluntly the power and violence of wealth and the ultimate futility of money, but when Hirst's gallery was offered £35 million for the skull, they refused the offer, before eventually selling it for $100 million. The commerciality of the project went farther than simply attempting to make money, however existentially futile that activity might be, for it emerged that Hirst's gallery had been able to achieve that sum, and thereby firm up the market's estimation of Hirst's prices, only by paying for it themselves. The buyers of the work were Hirst, Jopling and, Hirst said, 'an investment group' – which, it turned out, meant his business manager and a Ukrainian businessman who collected Hirst's work.[93]

As well as a commercial process, explained Hirst's allies and friends, this had been a performance that communicated a critique of capitalism even more powerfully than the jewel-encrusted skull. Michael Craig-Martin described the tactic as an 'elaborate game with money'.[94] Like Emin's life history, Hirst's market dealings not only gave meaning to this or that artwork; they were art itself. Like many satirists, Hirst was not entirely denouncing the victim of his wit – art, the market, capital. He was, instead, mocking them by joining in with an ostentatiously ridiculous degree of enthusiasm, and becoming enormously rich in the process. He was having his cake and eating it.

It was not a form of art that the vast majority of gallery visitors would recognize. At best, most would be spurred to such criticism of the art world by Hirst's work without realizing that he might have intended that. If his work was provoking viewers to think critically about life, death and money, then it was doing so at the cost of alienating them further from contemporary art in general.

The YBAs wanted to make iconoclasm accessible, and their motivations extended from idealism, to seeking attention, to making money. Conveniently for them, these seemed to be wedded, not opposed. Using the aesthetics of advertising, these pop art punks thought they were drawing both attention and cash towards ideas that could challenge convention, but their mainstream style drew attention to itself, rather than to the message it was supposed to convey. The media and the public were, in turn, put off by the

YBAs' artworks, so that rather than undermining icons and prejudices, these young artists often reinforced them.

As their market-friendly model transformed them into millionaires and celebrities, those who disliked the YBAs' deconstructive art came to see themselves not as reactionaries, but as underdogs. The YBAs hoped *Sensation* would undermine Britain's pompous cultural establishment, but it only assured many Britons that contemporary artists were members of the elite, and that this elite had completely different values to them. That was, at least, what happened to Britain's older generation during the period that began with *Sensation*. However, the YBAs' omnipresence ensured that those growing up at the time perceived their work as natural and normal, and also that those young people felt similarly comfortable with a broader culture that did not take society's idols and assumptions seriously. The YBAs helped to construct a culture that was necessarily going to change, but the direction of that change was impossible to predict.

At the closing ceremony for the London 2012 Olympics, tens of thousands cheered, a great fire burned, a succession of pop bands played and hundreds of athletes marched around the Olympic Stadium. Underfoot lay a specially designed platform traversing the 130-metre-wide arena. It was composed of an enlarged spin painting of red, white, blue and black, overlaid with a cross and diagonal lines formed with giant facsimiles of newspaper print quoting famous British writers. Hirst called it *Beautiful Union Jack Celebratory Patriotic Olympic Explosion in an Electric Storm Painting*.

The ceremony's designer had chosen Hirst to 'express the energy, diversity, anarchy and multiplicity of contemporary British culture', for the artist's work was supposedly so widely accepted that it could reasonably provide the basis for national pageantry.[95] The vast majority of those watching, however, did not even consider the painting to be art. The YBAs had not fomented rebellion, but they had helped make reaction seem subversive.

6 / COCAINE SUPERNOVA

An elegant brown sedan with a cream roof turned slowly into Downing Street. The small crowd of autograph hunters on the pavement cried out and, in front of them, the jostling TV crews shouted at each other. As the car stopped at the tall wrought-iron gates, one man at the front of the crowd asked 'Who's this guy?', but everyone else knew exactly who this guy was. 'I'd only signed off the dole four years earlier,' Noel Gallagher would recall, 'and I arrived at Downing Street in a Rolls-Royce.'[1] It was a second-hand one that his label had bought him as a gift, but it was what it was.

Farther down the road, inside Number 10 and up on the first floor in the grand state rooms of the prime minister's official residence, Tony Blair was chatting to the guests who had already arrived. Several of that evening's invitees were celebrities but, as he and his spin doctors would have anticipated, Gallagher's invitation had attracted by far the most press attention.

Blair was trying to encourage journalists and the electorate to see him as youthful and cool, and he was doing so with a degree of success that former prime ministers had never dared strive for. Over three years in charge of his

party he had weakened Labour's traditional alliance with the trade unions but, having done so, it had become all the more important for him to associate his leadership with the macho, white and working-class identity that dominated the prevailing stereotype of organized labour. By hanging out with Gallagher, Blair was connecting himself to a genre of music that celebrated being British, being a lad and being rebellious in a way that seemed glamorous, but which had little prospect of changing the world.

Bands like Oasis were going to give Britons the impression that an age of rock'n'roll rebellion was upon them. Throughout the mid-1990s their music had gained in popularity, but in 1997 it would achieve a new kind of success: it became a bland orthodoxy. It was the strongest expression in pop culture of the broader promise of that year, that the future would be fairer and more egalitarian. Labour was not going to return to socialism, but this new, national rock music seemed to prove that the wider culture would become more representative of the country as a whole, and the working class in particular.

This genre was supposed to say something meaningful about Britain as it really was, about the importance of the lives and experiences of ordinary young Britons. It looked like proof that much more of what people saw on their TVs, heard on the radio and saw in the papers would, from now on, be built upwards from ordinary experience. A large section of mass culture seemed to be transforming from a bland soporific contrivance into a more authentic creation of the grass roots. The greatest positive legacy of these

musicians is that pop songs reflecting the reality of life in the UK no longer seem unusual.

Like the previous chapters of this book, the story of Gallagher et al. is one of deradicalized messages accessing a wider audience. Their generation of guitar bands, like the Spice Girls' feminism-lite, was exploited by the music industry, but their work was appropriated a second time when they were used to bolster Tony Blair's political project. These bands had found fame under the Conservatives, but their scene became strongly connected to New Labour nonetheless. As it had entered the mainstream it had become less weird and iconoclastic, and more like something that could fit neatly into the new prime minister's project. His involvement with the scene, in turn, made it more pervasive and bland than it had ever been. 'I'm from the rock'n'roll generation,' Blair explained. Rock'n'roll would never be the same again, and British culture would become no more representative of the lives of ordinary people. Instead, the pervasive whiteness and parochial focus of the late 1990s indie rock scene would feed a national culture that was unaware of how much it shared with the outside world, and how dependent it was on it. Therein lay the cultural grounds for anti-migrant resentment and Brexit.

At the gates of Downing Street, a rock star was waiting to hang out with the people who defined Britain's new establishment. Britpop was about to achieve its crowning glory: not the moment of its best work, but the time when it became the most extreme version of the compromise that

it embodied. How had a pop music movement become so popular, and in the process become so irrelevant and elite?

'Damon's seen the future and it's not shopping malls in Michigan – it's greasy spoons and cafés,' relayed his admiring bassist, Alex James.[2] Blur's singer Daman Albarn had toured the USA and hated it, and now he was writing songs that felt new, but which were about something very familiar. He was producing music about Britain; about home. Albarn's London was one of squats, indie gigs, drugs and art students, but he wrote, not a little patronizingly, about a city so grim that, according to the last line of one of his new tunes, eventually released as 'Sunday Sunday', your best chance of escapism was the opportunity to 'bingo yourself to sleep'.

From that attempt at social realism emerged occasional moments of psychedelic weirdness, sometimes breaking out into philosophizing and abstracted angst. In 'Oily Water', Albarn described drinking the substance and feeling it 'slipping down my spine' as he developed a 'sense of self in decline'. He was documenting the UK through pop while rebelling against the country's conservativism, partly through his melancholically critical attitude, and partly by partying hard. It sounded like the authentic voice of Britain, rather than its elite. His tunes echoed the very British influences of music hall, the Kinks and David Bowie, modernized by synths and post-punk guitar riffs. It felt both accessible and challenging.

The YBAs had adopted a strategy for expressing dissenting ideas using familiar style and imagery, and,

similarly, Blur had decided to write songs in which engaging tunes were the vehicle for lyrics with a message about Britain. The previous generation of punk and post-punk musicians, like the modernist artists who had preceded the YBAs, had insisted that if the aesthetics of an object or of music were innovative, this could provoke the viewer to think new thoughts and experience new feelings even more effectively than a clearly expressed concept. By contrast, both the YBAs and Blur prioritized clarity of concept over experimentation; they were subordinating the needs of form to those of content. It was accessible, rather than hostile. It seemed egalitarian.

Albarn was reaching new creative heights, but did not feel secure. 'If you try and sign them, I'll never speak to you again,' he told his A&R man when he heard that a new band was on the scene.[3] Daman Albarn was a cute and skinny indie kid with eyes that glinted under heavy brows. He partied with artists in south London squats and played gigs across the capital's regular venues. His band was doing well and, in an alternative way, they were extremely cool. It cannot, then, have seemed reasonable for him to feel so threatened by this new band, Suede, who, if they were rivals to his own outfit, posed only a very distant threat. Fronted by singer Brett Anderson and guitarist Bernard Butler, they had not recorded a single record, but nonetheless Albarn ordered his label not to go near them.

The two bands never did get on, and as Blur edged towards chart success, Justine Frischmann, who had played guitar for Suede and had spent three years in a relationship

with the band's signer, Brett Anderson, swapped him for Albarn, and Suede for her own group, the achingly cool and punkier Elastica. There was a significant overlap between the two relationships, and the break-up was painful.

Anderson poured his heartache into brilliant, angry, sexy new songs, and like his ex's new squeeze, he was singing about Britain, or parts of it, at least. 'Suede have always had a very strong sense of where we came from,' mused Anderson. 'I find England strange and unique and beautiful.'[4] He would sometimes play Vera Lynn's 'The White Cliffs of Dover' over the PA before he and the band went on stage,[5] but generally Suede's Anglo-Saxon grit was expressed in a less self-conscious manner. His lyrics were gently suffused with an English vernacular and imagery that had rarely entered the top of the pop charts in recent years. As is so often the case, this Englishness would later be labelled 'British': this genre's branding was always dominated by the UK's largest nation.

Anderson's musical references were a bit more recent than Albarn's. He was inspired by the Smiths, and emulated the storytelling of Morrissey, who had constructed songs with narratives that were proudly parochial but nonetheless resentful of the status quo. 'It was a thing about being born as a taxi driver's son and how I was expected to end up as that,' Anderson recounted. 'I didn't want to end up living in a council house in Haywards Heath. I always thought there was more to life.'[6]

He was somewhat over-egging his lack of cultural privilege. His mother was an artist, and like a high proportion

of indie scenesters, he was one of the 20-or-so per cent of people of his generation who went into higher education.

Albarn had also inherited his intellectually curious and artistically knowledgeable approach from his bohemian, though not wealthy, parents. Before forming Blur, he had gone to drama school, but had dropped out.

These young musicians were not working-class Brits writing about working-class Brits, but they were representing the everyday experiences of people in a world they knew. Sometimes they fetishized the lives of others as 'authentic', but often they wrote with great sincerity.

Anderson's co-writer, Bernard Butler, was also interested in national themes and influenced by the Smiths. His jangly guitar parts, riffs and melodies echoed those of Smiths guitarist Johnny Marr, a master of chimes and arpeggios that themselves owed much to the English and Irish folk revivalists of the 1960s. These national, sometimes retro, elements of Suede's sound helped them plug into a national tradition, not of flags and military bands, but one that was supposedly more ancient and popular, in the sense that it was 'of the people'. It was not necessarily a left-wing movement, but it posed as a rebellion, sometimes against pretentious middle-class mores, sometimes against the rich and sometimes against cosmopolitan civilization.

It is testament to the influence of Blur and Suede that twenty years later, this attention to the imagery and sounds of home does not seem unusual. Though there had always been bands who talked about their home towns in their lyrics, this nascent scene was defined by that sense of place.

In late April 1992, Albarn discovered that he had been right to feel threatened by Suede. Anderson and Butler had not even released a single yet, but on the cover of *Melody Maker* they were announced as 'THE BEST NEW BAND IN BRITAIN'. From the cover of the paper stared Anderson's eyes, maintaining their signature ruminative and wary stare, half hidden under his lank black fringe.

Like the new scene itself, Suede were following the traditional route to popularity by gradually gathering allies in the critical press. But there was something different about this band. In Anderson's style – long hair, eye make-up, blouses – and somewhere in Butler's languorous, swooning guitar parts there lay a punkishly camp heart. Anderson's singing was marked by falsetto yelps and a fay vocal delivery. He was known for slapping the mic against his arse, which he would jiggle about the stage as his arms flailed laconically. ('Interesting use of the microphone there!' an embarrassed TV presenter would later observe after the band's first appearance on the BBC's *Top of the Pops*.[7]) He made attention-seeking statements about his entirely theoretical bisexuality, and Suede's drummer, Simon Gilbert, was gay. Gilbert was also out, and in the early 1990s, plenty of straight guys on the scene found Suede's queerness threatening. At a gig in Greenock, on the west coast of Scotland, a huge punk screamed at the band: 'You effete, southern wankers!', and at a show farther along the Clyde, in Glasgow, members of the crowd mocked the band with chants of 'Up the Gary Glitter! Up the Gary Glitter!'[8]

Anderson later admitted that he had acted camp largely to annoy people, but some people on this scene seemed to think Suede's queerness disqualified them from talking about, or for, Britain. This had its own logic, for masculinity has long been linked to nationalism. Damon Albarn told *Melody Maker* that, while he and Blur were fighting for the UK's culture, Brett Anderson was 'far too obsessed with his own sexuality, or lack of it, to be able to articulate anything about Britain'.[9]

Suede were gaining traction, and Blur's management at Food Records were unhappy. Albarn had tested a few of his new songs on them, but they informed him and the band that what they had produced was arty, unmarketable nonsense.[10] The subversive tendency represented by Suede and Blur would have to make a compromise with the mainstream through the medium of the pop music market, just as, years later, the Spice Girls' 'feminism-lite' would. Albarn's label boss Dave Balfe insisted that Damon had to write him a commercially viable single.

Albarn, given his orders by the boss, spent part of Christmas Day 1992 at his parents' piano, reluctantly churning out an elegant tune about a London populated by hopeless people with names like Susan and Jim, just trying to survive or to make their boring lives a little more exciting. He called it 'For Tomorrow', and Balfe approved: you could listen to it. When the band's US label demanded another, even more commercial, single, Albarn did not even complain, and duly wrote them a heavier rock song, another somewhat condescending lament for sad, lonely people living in grey

English cities, places filled with 'townies' and people who drink sugary tea and who are bombarded by the 'bleeps' of modernity. When the band laid it down as a demo, Albarn called it 'Americana', but it would eventually be given the title 'Chemical World'.[11] Brett Anderson's lyrics had merely evoked British experience and Butler's folkish jangles had only echoed British sounds, but Albarn's new lyrics were explicitly national in their imagery and intention. He was defending the UK from 'coca-colonisation' by Nirvana and other US imports, he claimed. These songs, he said, were 'the most significant comment on popular culture since *Anarchy In The UK*'.[12]

A couple of months later, Albarn's new album was almost finished. It was supposed to give him a central role in Britain's pop culture, but just at that moment, Brett Anderson got in his way again. First, Anderson got on the cover of *Q* magazine, which proclaimed Suede 'The band of 1993' alongside an offer for a free minidisc. Then, in February, Suede got another boost. Millions of Britons were at home watching ITV's broadcast of the Brit Awards, featuring live performances by Rod Stewart and Simply Red – huge, entirely unchallenging stars with an unapologetically American style. When Mick Hucknall was presented with the Best Male Artist award by Lisa Stansfield and Richard O'Brien, he appeared in a wide Armani-style suit, his long red hair falling down his back. Hucknall thanked 'everyone at the Simply Red information service', and O'Brien asked him to 'do the decent thing … otherwise we're left with a socking great hole in the ITV network at peak viewing time'.

Everyone smirked as Hucknall strolled over the stage to perform 'Wonderland'.

There was no similar chumminess when four messy, skinny boys in variously lacey and grungey clothes appeared on screen and slid around the stage. Suede's rendition of their upcoming single 'Animal Nitrate', a song about aggressive gay sex enabled by poppers, was occasionally punctuated by the sound of Anderson once again smacking the mic on his bum.

Those viewers who did not realize that they were watching something new must, at least, have understood that they were watching something different. In this song, set 'in your council home', Anderson was offering feelings, images and language that were more indelibly British than anything that his fellow performers at the Brits would or could describe. They were not singing about the guy who 'jumped on your bones'. Suede constructed a vision of their nation that was unmistakably critical but not remotely dismissive, a land where class hierarchy and cloudy skies were the unremarkable background to pilled-up raucousness.

This band seemed rebellious, but they spoke to their audience, which was a national one, of familiar things in familiar ways. Not long later, Suede were number one in the albums chart. Albarn was an indie hero, but Anderson and Butler were stars.

The music press loved it, and they had a clear story to tell. 'Yanks Go Home!' screamed the cover of *Select*. The magazine was celebrating Suede's success, and that of several other British

bands, and beneath its headline appeared a portrait of a pale Brett Anderson, dramatically backlit with his eyes so heavily made up that he looked like he might have been in a fight.[13] Beside him the magazine advertised its free gift of a poster for *Reservoir Dogs*, Quentin Tarantino's recently released ultra-violent hit movie, and behind Anderson's twisting body was an image of a Union Jack. 'Who do you think you are kidding, Mr Cobain?' asked the feature, referencing the *Dad's Army* theme song about 'Mr Hitler'. It was an unsubtle comparison of the influence of US mass culture on Britain to the Nazis' domination of Europe, and of Britain's plucky resistance to a greater foe. Though some fans thought Blur had begun this trend, many critics thought the band were already on the way out. They were not featured in the article.

Melody Maker followed suit with a 'cool Britannia' cover that did feature Blur, and which celebrated with a bizarrely reactionary headline, a reference to *Star Wars*: 'The Empire Strikes Back!'[14] While Albarn's focus on British themes had been connected to his criticisms of US consumerism, this was plain, albeit light-hearted, xenophobia.

Perhaps, however, this was not so surprising. The Union Jack had been widely associated with the far right, and the appearance of the flag on the cover of a music magazine might until recently have raised eyebrows. The *Select* cover, however, represented a new attitude to this national imagery. Like Geri Halliwell in her Union Jack four and a half years later, the magazine's repetition of these symbols and phrases in an apparently non-political, mainstream context seemed almost to empty them of meaning. This new

music from Britain and about Britain had, from the start, made a particular claim, even if it had not done so explicitly: that this was the real sound of 'real' people, people who were neither foreign nor posh; and that nationalism was demotic and working-class – and therefore potentially subversive.

The nation was here represented by men who were white and, therefore, supposedly indigenously British. It was not just the *Select* bands, or the others on the current scene, whom this applied to. Albarn's writing, like Anderson and Butler's, nodded to older bands who were thought to be especially British, and who were, without exception, white. They mentioned them in their interviews, and covered their songs, but they, the music press, their fans and their marketing managers ignored the fact that this music had originated in the multiracial genre of rock'n'roll, which itself came out of the African-American traditions of gospel, blues and rhythm and blues. Without Yanks, many of them African-American, this new genre could never have existed. It was a second-generation influence, but that influence was consistently ignored. If that had been acknowledged, the definitive characteristic of this new scene – its Britishness, defined in conventionally white terms – might not have been convincing. It was never suggested that Britishness might always be a hybrid of 'native' and 'migrant'.

While Albarn watched Suede steam ahead, he and his band plotted their revenge. Blur's design consultants, Stylorouge, worked with the band to design the sleeves of the new album and its singles. Some were illustrated with images that dismissed the monstrosities of imported

Americana: a quadruple-decker burger, its meat oozing with bloody ketchup, or a scarlet Ferrari-style sports car in front of a soft-focus Manhattan and the Brooklyn Bridge. Others echoed the imagery of Britain's comforting mid-century 'golden age': a steam train on one, and on another, Second World War Spitfires in silhouette, hanging above the clouds. These images brought together nostalgia, patriotism and industrial – that is, working-class – masculinity, so that all three reinforced and seemed connected to each other. As it entered the mainstream, this scene was becoming more closely aligned with ideas and values that made groups that were already privileged – men, the country's rulers, white people – more powerful. The subversiveness of a new rock'n'roll rebellion was not simply being watered down in order to gain it attention; it was becoming increasingly suffused with actively reactionary feelings and ideas.

'We're in a period of accelerated recycling of old culture,' Albarn complained. 'We're all living on the pinnacle of this huge rubbish tip.' It was a strange criticism to make, when his music, its marketing and his press statements all eulogized the past. In order to publicize their new album the band sat for Paul Spencer, a photographer known for his images of young members of British subcultures. He produced a stunning image for their publicity material. On the wall behind the band a graffito had been painted with a brush – rather than with a spray can, which could have evoked the imagery of African-American hip hop culture. The phrase read: 'BRITISH IMAGE 1'. Albarn wore a Fred Perry polo shirt and jeans rolled up to reveal the tops of his Doc

Martens. He held a Great Dane by the collar. Bassist Alex James's long fringe told you which decade the photograph had been taken in, but these styles were associated both with the Mods, a 1960s youth movement associated with sharp tailoring, and with the skinheads, a more recent subculture and one closely associated with the far right. Like the *Select* cover, this knowing picture caused little fuss in the music press. A 'British Image No. 2' involving striped blazers and cups of tea was also created, but largely forgotten.

In May 1993, *Modern Life Is Rubbish* was finally released. It had taken fifteen months to create, but the result was a gorgeous dissection of late twentieth-century Britain or, at least, a simplistic version of it. What Suede's album had only implied, Blur's stated with bracing clarity. It was their second LP, it was mature and crafted, it sometimes sounded as if it was sneering at 'ordinary' lives, it was a concept album and it had only a couple of dud tracks. Suede's self-titled debut, by contrast, was more autobiographical and less self-conscious, but more mixed in quality. Though connected by their rivalry, and by their interest in talking about where they were from, the two bands were taking very different approaches. *Modern Life* only made it to number fifteen – a great success for an indie band, but somewhat embarrassing given Suede's achievement in topping the charts. Nonetheless, Blur were on the up.

Blur's first 'British Image' quickly became a blueprint for their fellow scenesters' fashion choices, and at the same time that devotees of this genre were unifying under an aesthetic, a label started to cohere to its music: 'Britpop'.

This was not a new phrase. Data available through news and journal aggregation tools show that specialist music journalists had used it occasionally since the mid-1980s, and that since 1990 it had appeared with gradually increasing frequency, but still not that often. Music writers used the phrase to represent a very diverse group of bands, from the synths of Erasure, to the punk-folk polemics of Billy Bragg, to the experimental shoegaze rock of My Bloody Valentine. All were British, but not all produced guitar-based records and by no means all of them were talking about concerns particular to their home country, let alone referencing musical styles that were somehow 'British'.

Accordingly, *Melody Maker*'s May 1993 review of *Modern Life Is Rubbish* characterized what Blur and Suede had been doing for the last few years not as characteristically 'Britpop', but simply as 'their own take on Britpop resurrection'.[15] As 1993 wore on, other bands, particularly the Auteurs and Pulp, rose to prominence within the large and loosely articulated 'Britpop' landscape – James, Radiohead and Shed 7 lay on its outskirts – and as they did so, they began to redefine it as their own.

Critics had helped the genre to cohere by giving its leaders visibility, but indie magazines could not make a genre dominate the mainstream, and Britpop would not go any farther if only the music press and cool kids on the scene were willing it to do so.

'How do you feel about the prospect of being Mr Nasty in the newspapers?'[16] The question came from Marmaduke

Hussey, chairman of the BBC's board of governors, a former managing director of Times Newspapers and husband to one of the Queen's ladies-in-waiting. At the Corporation he was known as the man who had been installed by Thatcher to purge the Beeb of left-wingers. Tall, plump and greying, with dark arched eyebrows that gave him the appearance of a man perennially surprised, he did not look like someone who was going to help popularize a new kind of rock'n'roll. His colleagues were similarly unlikely purveyors of pop rebellion. Beside him sat John Birt, the BBC's director general, a man who loved bureaucratic jargon so much that he was frequently compared to a Dalek, and Liz Forgan, Director of Radio at the Corporation, who later admitted that she 'would never have willingly bought a pop record or turned on a pop music station, ever'.[17]

The rising popularity of Suede and Blur represented the acceleration of long-term social trends, not least the destructive fetishization of working-class culture. However, as in the stories described by the previous chapters, a lot of luck and coincidence would contribute to these bands' success. One particular event of immense good fortune was taking place, at that moment, in Broadcasting House.

Forgan was there to choose the new Controller of Radio One, the BBC's pop music station aimed at young people, and the two greying men beside her were there to sign off her decision. In front of them sat a thirty-four-year-old man named Matthew Bannister, who relayed the event later to writer Simon Garfield. Bannister, a thickset young man with a pleased but gentle look about him, was widely thought to

be going places, but Hussey was checking that he was up to the task that they wanted to set him.

Right-wing critics of the Corporation were demanding that it shrink, arguing that it was too similar to its increasingly popular commercial rivals and that it posed a threat to them. Birt's management, in turn, wanted to show that they were listening, and they needed a new Controller for Radio One who would demonstrate, very publicly, that the Beeb was taking action.[18] However, the figure who would lead those reforms was sure to become unpopular. Would this young man be willing to take the flak?

In October 1993, when Bannister started his new job, Radio One was relatively popular but dominated by middle-aged star DJs. 'It wasn't exactly the station of hip youth,' the new Controller would later recall. 'It was the station your mum listened to.'[19]

That would have to change, if he was going to put Birt's strategy into action. Firstly, Bannister was supposed to bring young listeners back from the new commercial stations to the BBC's supposedly youth-oriented station. More difficult, however, was his second task. To justify its existence, Radio One had to do what its commercial rivals would not do: risk listening figures for the sake of nurturing new talent and new sounds. This was expressed as an ethical commitment to the ideal of public service broadcasting, but it was crucial, Birt believed, if the BBC were to survive. Just as Virgin Records' motivation for promoting the Spice Girls with the slogan of 'girl power!' had not been the label's commitment to the feminist

struggle, Bannister was not supporting transgressive new music for its own sake.

The station's long roster of old, male presenters made sexist jokes on air, played novelty records, wore comfortable jumpers and ignored anything vaguely cutting-edge. Their ridiculousness was sufficiently obvious that Harry Enfield's long-running sketch about terminally uncool DJs Smashie and Nicey became almost as famous as the Radio One talent they parodied.

But the DJs were also terrifically popular, and aware that Bannister wanted them gone. Dave Lee Travis, who would later be found guilty of sexually assaulting a researcher at the BBC, and who was then one of the most famous people in British radio, knew he was in danger, and he angrily quit live on-air. Soon Simon Bates, whose fate was similarly sealed, also jumped ship with maximum press attention. Over several months the new Controller got rid of several other DJs and producers and this series of sackings and forced resignations was dubbed the 'Night of the Long Knives', a reference either to Hitler's purge of his rivals in the Nazi Party or to Harold Macmillan's aggressive 1962 cabinet reshuffle, which had earned the same epithet.

Matthew Bannister made another, more surprising, decision. He brought to the BBC the new type of Britpop, the kind that sang about home, typified by Blur and Suede. In his schedule's recently vacated slots, he placed young, unknown DJs whose playlists were filled with new music that had little chance of reaching the tops of the charts and were marked by a preponderance of indie bands. Suddenly,

being broadcast into half the country's teenage bedrooms were self-consciously 'outsider' music genres, and the new Britpop was at their forefront.

'Britpop was a gift to us,' recalled DJ Jo Whiley, who was fully on board with the Corporation's aim of distinguishing the station from its bland competitors. 'We were the only people to pick on that stuff and dared to put these bands live on the radio.' In late 1993, Radio One was the only big station that placed a demo twelve-inch called 'Columbia' by an unknown band from Burnage on its playlist. Whiley and her fellow DJ Steve Lamacq hosted *The Evening Session*, which became the biggest UK radio platform from which guitar bands could launch their careers, and the following year they gave this new Mancunian group – their name was Oasis – their first live radio event. British guitar bands fed off such exposure, and eventually their stars were getting coverage on other radio networks and on television. At BBC One's headline pop music programme, *Top of the Pops*, twenty-something producer Ric Blaxill started to focus episode line-ups on UK indie bands. However, it had been Radio One which had got there first. 'No other station was interested in [Britpop bands] for at least a year,'[20] Whiley recalled. It was a struggle against the odds for her and Lamacq. 'We did fight the Britpop wars together'.[21]

Ratings for both Radio One and TOTP collapsed.[22] The headlines were dreadful, and DJs, journalists and politicians called for Bannister and Blaxill to be sacked. This, however, was all part of the plan. The BBC had made its point: it was not the same as its commercial rivals.

Even then, the Beeb did not stop. Trevor Dann, Radio One's head of production, eventually banned records that had been made before 1990, and he refused to let DJs play even new singles from embarrassing old rockers like Status Quo, who duly sued. Head of marketing at the station Sophie McLaughlin was elated. 'Radio One had finally established what the new music policy was: "new music first", cutting edge, the only place you could hear the exciting stuff.' Similarly, a promotions executive, Nigel Sweeney, remembered how 'Trevor completely focused the playlist, and it championed Britpop'. Sweeney was paid by some of the world's biggest labels to persuade producers at Radio One that they should play those labels' bands. From his position telling both those who produced pop music and those who played it what the other side wanted, the impact of Bannister and Dann's reforms was clear. 'It was no coincidence that all the major record companies then ran around trying to sign up all the Britpop bands they could find.'[23]

Despite their failure to replicate Suede's chart success, Blur were feeling positive. Even with a couple more commercial tracks recorded, their label boss Balfe had remained cold about the album, but it had done better than he had feared. People other than indie kids and scenesters were paying attention to these new guitar groups, and now Blur's tour was selling well.

Their breakthrough came in the middle of several fields of cider-infused mud, observed by stoned teenagers wearing baggy jumpers and novelty T-shirts. This was the Reading Festival. Their friend and producer Stephen Street told

biographer Stuart Maconie that there were 10,000 fans in the tent with them, jumping around under the canvas, and that there were 5,000 more outside, hoping to get in.[24] The heaving crowd knew the words and sang along with most of the songs. Someone chucked their asthma inhaler at the band, and Albarn and guitarist Graham Coxon had a go on it before trying to return the implement to its owner.

The set ended, but the sweaty, steaming mass of fans screamed for more. Albarn fondly explained to them that they were a 'bunch of fucking reprobates' before the band leapt into a half-sung and half-spoken jaunty narration of a wander around an English park. It was well received, and had exactly the sing-along catchiness and easily detectable rhythms that Blur's managers had insisted that the band produce.

Another new song that they played at gigs around this time was about young Brits heading to the Med for hedonistic summer fun. That went down well too, and when they released 'Girls And Boys' as the first single from their next LP, their popularity exploded. The song seduced fans with its classic disco beat of 120 beats per minute. 'It's a blatantly contrived hit,' boasted their label's new boss, Andy Ross.[25] The single went straight to number five. It was the song of the summer.

Albarn was singing about 'ordinary' lives in a manner that both titillated and disgusted: those young Brits on holiday, moving en masse to the Med to take drugs and have sex on sunny beaches. Suede's assessment of the nation had been casual and critical, but as the British indie rebellion had begun to cement its place high up the charts,

it was increasingly defined by Blur's mocking and ironic perspective. Albarn was criticising a society that provided no opportunities – the girls and boys of his song were out of work 'because there's none available' – but he was also mocking those jobless individuals, dismissing them in his lyrics as being 'like battery thinkers'. That the subjects of his songs would sing along to these words, perhaps unthinkingly, only seemed to reinforce his point – and its snobbery.

The new Blur songs did not represent the working class. They were ventriloquizing them. 'It's the travels of the mystical lager-eater,' explained Albarn, perhaps referencing the title of Thomas De Quincey's 1821 *Confessions of an English Opium-Eater*. De Quincey had based that memoir on his own experiences, but Albarn was 'seeing what's going on in the world and commenting on it'.[26] He sang his lyrics in a strained estuary accent that was not his own, and it was by affecting the role of the 'noble savage' in this way that he voiced his thoughts about contemporary culture and its impact on ordinary people. Albarn was hurt by the accusation that his song was 'a dig at those 18-30 people'. He insisted it was 'more a celebration'.[27]

When Albarn adopted working-class stylings, he was reinforcing his claim to be a representative of national culture, for while the country's upper-middle and upper classes are often derided as suspiciously cosmopolitan, less privileged classes of UK-born white Britons are generally represented in mainstream discourse as authentically British. The accent that Albarn had put on was also a signal that he was a real man. Men who were hermetically sealed

from the world by white-collar work could be dismissed as feminine, and Albarn was insisting that he was anything but. He had started going to dog races, and his brand consultants suggested that the cover of his next LP could be an image of two greyhounds at full pelt.

He was linking himself to 'lad culture', the mainstream arrival of which was announced by the appearance of *Loaded* magazine on newsagents' shelves in April 1994. 'Super LADS', screamed its cover. Retailing at 95p, it sported a bright orange masthead which hung above a moody black-and-white shot of Gary Oldman, his lips pursed around a half-smoked cigarette. The magazine would go on to feature such articles as 'Arses – an appreciation', the subjects of which were, of course, all female.

The 'new lad' was not just a middle-class guy trying to be macho; he was a middle-class guy trying to be macho in a way that was specifically associated with Britain's white working class, and which was therefore implicitly anti-establishment. A lad let everyone know he was a lad by demonstrating how much he cared about football, often focusing on England's national team. Laddishness was associated with the tabloids and their culture, their soft porn content, their jingoistic politics and their unabashed lack of subtlety. Lager was another key trope. In a country that was supposedly being 'feminized' and which was increasingly dominated by upper-middle-class tastes, lad culture allowed middle-class men to play with very particular, and specifically conservative, elements of working-class culture. In doing so, they made nationalism and masculinity seem rebellious.

The lad's slightly more gentle side was presented in *Men Behaving Badly*, a hugely popular TV sitcom that ran from 1992 to 2000, and which featured two flatmates who spent their lives on the sofa drinking beer. In each episode, these two middle-class men would generally cook up some dishonest or selfish scheme that would usually go wrong: one of them might try to sell an expensive LP belonging to someone else, or he would dress up in a sombrero to spy on his girlfriend, whom he suspected of cheating on him. The episodes generally ended with their bad behaviour forgiven by their long-suffering partners because the men's callousness, their laddishness, had not reflected their true, honourable feelings or their real, gentle personalities.

Like Blur in their 'British Image' hard-man pose, the lad had an eyebrow raised at all times. His macho behaviour was effortful and therefore ironic. He was not a perfect adult specimen; he was a slightly childish beta male, and although he might behave aggressively or oppressively when acting out his laddish persona, his apparently civilized, middle-class 'true' self could always deny that he 'meant it'.

The new lad was widely discussed in comment pages, but he was not simply a fad dreamed up by cultural critics. Football fandom, flag-waving and lager-drinking were no longer the rituals of a working-class subculture, they were those of a mass culture pursuit. The Euro 96 tournament had played some part in encouraging this change, but the groundwork had been laid by the creation in 1992 of the Premier League. This had injected many millions of pounds into English football, and had been accompanied, in the

early 1990s, by higher ticket prices and the replacement of terraces, where fans stood, with stands, where they had to sit. These changes were partly a response both to violence between supporters, and between supporters and police, and to overcrowding accidents, some of which would later be found to have been greatly exacerbated by police action. Nonetheless, a game that had often provided a place where working-class men could create their own culture increasingly mirrored the bland corporate culture that surrounded it. Fans were policed and controlled with increasing precision: how they travelled to the game, where they moved when they arrived at the stands, what they did there, how much they drank and who they bought their alcohol from.

In the meantime, lads were spreading across British culture. The big new indie bands were dominated by men posing in this traditionally masculine way and forgoing the camp theatrics that Suede had played with. Guitar bands in the UK responded to this wider trend as to a gravitational pull. The exceptions – bands like Pulp, with singer Jarvis Cocker's skinny suits and limp wrists, and punkier, feminist groups like Elastica – provided respite from such laddishness, but made no serious dent in it. Because pop music was paying attention to everyday British experience, it was becoming a key way in which mass culture was appropriating sections of ordinary life. These sections were those, like football, rock'n'roll and the pub, where working-class communities had at times had a degree of autonomy.

Parklife was the second album of Blur's *Life* trilogy, which they presented as a survey of the minutiae of Englishness – standing in, as it often did, for British culture. (All three records in this triumvirate were originally intended to contain the collection's operative term in their titles, but the series' final instalment, *The Great Escape*, would break this rule.) A couple of *Parklife*'s tracks contained moments of brilliant complexity: 'This Is A Low' was an extraordinary tour around the geography of the BBC's *Shipping Forecast* dripping with kitsch psychedelia.

The record's big singles, including 'Girls And Boys', were more boisterous and silly. They mocked ordinary English people, and were easily accused of condescension, but they were finely crafted pop that tapped into the lad trend. Thus, when the LP was released in April 1994, Blur finally got the number one album that they had been waiting for. It was in the top 40 for ninety weeks, and is now one of the handful of records that define British pop history.

In September, *Parklife*'s title track was released as a single. It nostalgically evoked half a century of urban existence in the UK: dustmen, pigeons and endless cups of tea. This world was sharply distinguished from modern efficiency and, overlooking the Indian origins of tea, from anything supposedly foreign. In his cockney narration, actor Phil Daniels mockingly quoted the slogan of German car manufacturer Audi, insisting that parklife had nothing to do with '*Vorsprung durch Technik*'. It was all set to a bouncy riff and punctuated by foot-stomping shouts that echoed the best of Madness. Blur were harking back to a fictional

golden-age Britain, its nationhood and its masculine and working-class gobbiness.

With a mixture of danceable beats, easy tunes and memorable refrains, Albarn's new record varnished the parochialism of *Modern Life*, making it more listenable. Coxon complained about being forced to play his bandmate's pop tunes, but Albarn judged that compared to its predecessor, '*Parklife* was a more articulate version, better crafted and better perceived'.[28] He had insisted for years that British pop music should be about Britain, and now he had tweaked its sound so that not just indie kids, but everyone, would listen.

After Suede's surprise success, music PRs, industry executives and managers had sought out similar but slightly less risky bands, and Radio One was now promoting them. The new British indie scene became blander and blander, as bands such as Space, Cast and Ocean Colour Scene hit the top ten. Meanwhile, Suede were finishing a new album that reached ambitiously beyond their earlier themes of Anglo-Saxon melodrama. *Dog Man Star* entered the charts at number three, but fell quickly, and would largely be forgotten. The overly enthusiastic compromise between subversion and the mainstream that this book has traced was here taking place not through the moulding of a single band, as it would in the history of the Spice Girls, but through a process of reselection and refinement, as one band was replaced by another. Anderson got heavily into coke, then crack, and then heroin,[29] and meanwhile Blur were topping the charts with their new, accessible sound. The fortunes of Suede and Blur had reversed once again, and, indeed, for the last time.

One of the macho British indie bands that had caught the eye of the BBC's producers was Oasis. In early April 1995, the management of this new Manchester band, which had been championed by Radio One's *Evening Session*, sent copies of the group's forthcoming single to the UK's radio stations. Most pop networks largely ignored 'Some Might Say', but Radio One's producers continued to support the young Mancunians. They were witty, modish and looked like they could shift a few LPs, but because most commercial stations were not plugging them, their new single was exactly the kind of record that Radio One was supposed to be playing: it was a song that strategically positioned the BBC's station as popular, but more forward-looking than its rivals. Radio One put the new Oasis song at the top of their playlist for three weeks, and on 6 May it entered the charts at number one. The band's course was set but, even then, when they had knocked Take That's 'Back For Good' from pole position, the commercial stations paid them so little attention that, one music journalist claimed, their track got into the Top 50 radio airplay list only on the back of the BBC's plays.[30]

That week, the impact of Bannister and Dann's reforms was not limited to pushing Oasis to the top of the charts. Radio One had placed at the head of its playlist another single that commercial pop stations were mostly ignoring.[31] It had been recorded by Pulp, whose biggest hit to date had reached number 19. The Beeb championed 'Common People' nonetheless, and soon it went all the way to number two, bested only by a cover of 'Unchained Melody' by TV drama heartthrobs Robson & Jerome.

Both Oasis and Pulp were going to become stars because Radio One was being repositioned as a station for new music, but the big differences between these two incarnations of UK indie would become especially apparent towards the end of June at Glastonbury. 'I'd like to be somebody else,' sung Liam Gallagher, hunched, as ever, and craning up to the mic. This was 'Shakermaker', a favourite from the previous year's album *Definitely Maybe*. It sounded sufficiently similar to the 1971 Coca-Cola advert jingle 'I'd Like To Teach The World To Sing' that the older song's writers would eventually launch a legal challenge against Oasis and win. The band were playing an underwhelming set at the Pyramid stage on the first night of the festival, but the band was headlining, Liam had his raincoat on and was doing his bobbing, knees-slightly-bent, dance, and they were playing a set of mostly brilliant songs. The fans had everything they needed.

As his elder brother Noel, the band's songwriter, began his guitar solo, Liam turned, his arms bent out in a 'have it' gesture, and from the side of the stage he brought on a friend, a man in an Adidas tracksuit, swigging from a beer bottle as his spiky bleach-blond hair glowed in the pink stage lights. The two danced for a moment, bending and grooving together in what looked like a gentle pastiche of a soul singer's moves. Liam leaned down to pick up his tambourine and then turned to the mic to start the second verse. His mate got the message, and bounced offstage.

For a moment that would go down in pop history, the Glastonbury appearance of Robbie Williams, of teen

favourites Take That, was brief and without drama. It was, however, telling. The styling and sound of British guitar bands were increasingly conventional and, as a consequence, their place in the pop industry had become more central. Even boy band members could now be a little bit rock'n'roll.

'Like southern England personified,'[32] was how Noel Gallagher described the *Parklife* LP. He was not complimenting Albarn's ability to convey a sense of place through pop. Rather, it was a typically laddish, wry bit of banter. It was also, however, the kind of perspective that was sifting out of UK indie anything that smelled of experimentation. Only a year after the unthreateningly straight lads of Blur had solidified their superiority over the fay boys of Suede, they were being challenged by another, even more masculine group. Oasis, who did not have to go to dog races in order to appear working-class, increasingly looked like Blur's rivals as the pre-eminent band of indie guitar music in the UK, the one whose even more conventional masculinity defined what the genre was.

The next night at the Pyramid stage, everything seemed different. The pogoing crowd were chanting the lines of 'Common People' and on stage were Pulp, standing in for the Stone Roses. Jarvis Cocker was in his early thirties, but remained boyish and stick thin, his long hair parted foppishly at the side. Under the heavy lights, he jiggled around in his customary early 1970s tailoring, tonight accessorized with Cuban heels. His dancing was, at one moment, prancing and skittish – he seemed amused by his own moves – and at another, languorous and limp-wristed. When he paused to

stare into the crowd, he had a way of half-closing his eyes. Was he bored? Was he high? Was he trying to seduce us?

His song mocked the posh kids who confect a working-class persona, 'Because you think that poor is cool'. In the mid-1990s Glastonbury was marginally more affordable than it would later become (it was £65 that year) but its punters were nonetheless a mostly middle-class crowd. The song had reached second place in the charts three weeks earlier, and its lyrics' target was fairly obvious – Cocker seemed to be thinking of Albarn and his mockney stylings – but those words could as easily have been aimed at the crowd that was repeating them. 'Sing along with the common people,' they chanted back at Jarvis as he wriggled to the song's increasingly frantic, buzzing riffs. Just as the more subtle elements of *Parklife* had been drowned out by its effervescent singles, Cocker's verbal criticisms were not as strong as the broad cultural forces that were encouraging fans to mimic Blur's proletarian playacting. Similarly, the brilliant queenliness of Pulp's singer was destined to remain the strange shadow gender beside the pervasive machoness of Oasis.

Few of the fans at the Pyramid stage on either night recognized that the success of these Glastonbury headliners was, to a great extent, the achievement of pen-pushers at Broadcasting House. 'Some Might Say' and 'Common People' were only two of the many records that were made hits with Radio One's support, which itself had been motivated by the BBC's institutional need to distinguish itself from the competition, and to survive. It was not only

Oasis and Pulp who owed some of their success to Bannister and Dann's self-interested actions, but also Supergrass, and more disposable British indie bands like Northern Uproar and Cast.[33]

This was the moment when people who knew very little about pop music began to throw around that magic term 'Britpop'. Analysis of the British music press shows that during the month following Glastonbury, July 1995, usage of the phrase suddenly jumped. Before January that year it had never appeared in the mainstream music press more than nine times in one month. But *Parklife* had dominated February's Brit Awards, and in March, Elastica's first album had sold faster than any UK debut since that of Oasis the year before. Slowly, during the spring of 1995, the phrase had become more popular. The month after Elastica's debut came out, 'Some Might Say' had given Oasis their first number one single. 'Common People' had been a hit in June and in the first few days of July Supergrass's 'Alright' had gone to number two, outsold only by the Outhere Brothers' 'Boom Boom Boom (Way-Ooh)'. That month the word Britpop was printed not nine but ninety times in the big music papers and magazines, and thereafter it remained similarly popular for years.[34]

It was probably no coincidence that this new genre was rocketing into the cultural stratosphere at exactly the moment that a new band was appearing in its vanguard, a band whose songs were less stylistically ambitious. Noel's lyrics were not layered with irony and his melodies were not complex. Liam walked into parties with a swagger that

would have been treated as ridiculous if he had not been so famous. On this basis, some indie fans dismissed Oasis as unintelligent and simplistic, unlike their apparently more subversive Britpop forebears. But the Gallaghers could construct a celebratory and aggressive sound in a way that neither Anderson and Butler nor Albarn and Coxon had ever managed, and that was how the brothers confronted the world. Their songs contained carefully layered mountains of guitars, above which rumbled Liam Gallagher's hoary, drawling vocals. The Beatles provided one, very obvious, reference point, but their songs combined the anger of the Sex Pistols with both the sentimentality and the stadium-filling grandeur of Status Quo.

Although their songs lacked the playful experimentation of Suede and Blur, Oasis were ruder, more brutal with their guitars, and more culturally pervasive. In these ways they were more challenging than anything Britpop had yet achieved. Noel connected his songs' anthemic qualities with the trenchant political subversion of the republican and Irish nationalist movements. 'The first music I was ever exposed to was the rebel songs the bands used to sing in the Irish club in Manchester,' he remembered. 'I think that's where Oasis songs get their punch-the-air quality.'[35]

Oasis's upbringing in Burnage was well fabled. Their father had been an alcoholic and had beaten the boys frequently. Noel developed a stammer and Liam was also deeply affected, as was their older brother Paul. Eventually, their mum, Peggy, walked out, and took the boys with her. Noel and Liam got into trouble at school, and then with

the police. They both spent years doing manual work or on unemployment benefits – Liam had been known as 'Doley' by his friends, according to a girlfriend from the time. They had got into rock'n'roll, and then they had become superstars.

Suede criticized Britain and Blur mocked it, but the Gallaghers knew the country's injustices more sharply than their Britpop forebears. Perhaps that was why, in their songs, the injustice of society was almost taken for granted. Their focus was not complaining, but partying. In 1994's 'Cigarettes and Alcohol', Noel's lyrics had asked why you should 'find yourself a job when there's nothing worth working for?'. Rather than focusing on the song as an act of social criticism, however, he proudly described this track and Primal Scream's 'Rocks' as 'the only youth anthems for as long as I can remember that just say "Go out and get pissed, fall about, jump up and down in the air, listen to some music, smoke something, snort something and have a good time".'[36] That was where Oasis's subversion lay.

Lad culture was sexist and chauvinistic, but Oasis demonstrated why it also felt rebellious: it stood completely apart from bourgeois good taste. They were the bad boys of rock, spitting, fighting, shouting and snorting for the cameras and for the fans. Their popularity reflected the deep attraction felt by many towards such an explosive rejection of polite, middle-class behaviour.

'I'm just me and I know I'm a lad,' explained Noel. 'I can tell you who isn't a lad – anyone from fucking Blur.'[37] The antagonism between the bands may have started at the *NME* Brat Awards 1994, when Liam suggested to Damon

that either his band was 'full of shit, or full of shit'.[38] Or it may have kicked off properly at the 'Some Might Say' release party, where Albarn flirted with a woman who was going out with one of Oasis's mates. In any case, a wonderful rivalry had emerged for the papers to follow.

Around this time, Albarn was finishing a song satirizing Dave Balfe, who had made a fortune from *Parklife* despite disliking it and who had, more generally, dismissed Blur's chances of success. Albarn narrated how Balfe had begun to tire of his hard-working, hard-partying lifestyle as a label boss – 'Caught in a rat race, terminally' – before selling the record company and buying a very nice place in Bedfordshire – 'a farmhouse that has acquired pretensions over the years' was Balfe's description of the home he had bought for his young family.[39] 'A very big house in the country' was how Albarn's chorus characterized it.

Along with a couple of other potential singles that the Blur songwriter was working on at the time, this track replicated the foot-stomping, sing-along energy of *Parklife*'s big hits. Like the songs of the Spice Girls, Albarn's songs were digestible, but this partly obscured their subversive message. The song's relentless bouncy oompah and massive, monolithic brass were supposed to satirize the hypocritical excess of a man who is 'reading Balzac' while 'knocking back Prozac'. The thumping tune and orchestration were intended to be obnoxious, an expression of what the song mocked, but they were also the heart of what made the song pleasurable. It seemed almost impossible, then, for the lyrics to warn the listener away from indulgence and

thoughtlessness. Like all the angry concepts and people described in this book, which were repackaged to appear less intimidating, they gained an audience but lost much of their reason for being. Albarn's song was in danger of becoming the thing it was attacking.

Blur were gearing up to release this new single when they received dismaying news. Oasis's management announced that the band would release their next single, 'Roll With It', just before 'Country House' was slated to appear. Blur's sales, and their chart position relative to Oasis, would likely be hit. But they didn't want to embarrass themselves by moving their release date farther from Oasis's, and thereby admitting defeat. So, at Albarn's behest, they brought 'Country House's release date forward. Both singles would come out on 14 August 1995.[40] 'I'm going on holiday that week,' Albarn told a reporter. 'I'm not getting involved. And I am going to leave specific instructions that if I come back on Sunday and we're not number one, someone is going to suffer some sort of grievous bodily harm.' Evidently he understood that who won would be a question of promotion, rather than the fundamental quality of the two competing products.

The *NME* declared this 'The Britpop heavyweight championship', but, as usual, the *Sun* led the way with its headlines: 'Hit's a war!', 'The Gig Fight!', 'Oasis Mum is Blur fan', 'You Blur-ty rat! Oasis fan Mandy gives hubby the boot because he's mad about pop rivals'.[41] It was the height of summer, and editors were looking for soft stories to pad out their papers. When Blur shifted their release date, the

news media immediately focused on the question of who would reach number one. The story became so huge that it was on CNN and the front page of the *Oslo Times*.[42]

The press needed an angle, and the one they took was class war. Blur were the 'the art school boys from the capital', purveyors of 'arty-farty middle class pretension'. Oasis, by contrast, were 'the gutsy lads from the North' offering 'working class sincerity'.[43] Perhaps Albarn would have preferred the rivalry to have been represented as being between two working-class groups, but if so, he was disappointed, for journalists mocked his dog race stylings. Nonetheless, the press's portrayal of this battle of the bands as a class war was a cartoon version of the country's social structure. The difference between these classes was not a violent and unjust relationship. Instead, it had been reduced to a difference of branding. In another small way, working-class experience had been drained of meaning.

Blur, explained Noel Gallagher in a comment reproduced widely, were 'a bunch of middle-class wankers trying to play hardball with a bunch of working class heroes'. Albarn, in an unusually magnanimous moment, announced: 'May the best band win. Whatever happens, we won't be speaking to each other next week.'[44] His spokesman, though, was perhaps more honest: 'If you've seen one Oasis gig you've seen them all.'[45] And drummer Dave Rowntree also indicated that Albarn was desperate to win. 'Damon threatened pretty much everyone with the sack if we lost,' he remembered. 'Oasis may have started the feud, but at its highpoint, Damon was doing much more to fuel the controversy.'[46]

Journalists involved in a symbiotic relationship with the bands reported these stories, even though they suspected they were only half real. 'Noel Gallagher is a very shrewd, intelligent man,' mused the *Mirror*'s showbusiness columnist Matthew Wright. 'I can't believe it's all impulse. There has to be an element of consciously allowing situations to develop.'[47] Rowntree suggested to Stuart Maconie that the other Gallagher brother was equally self-aware: 'I bumped into Liam in a toilet, mysteriously enough, at the height of it all, and I said to him "This is all bollocks, isn't it?" He said "Yeah, of course, but it sells records, doesn't it?"'[48]

Both band's labels also did what they could to boost sales, offering the same single in multiple versions, each with different B-sides, so that each counted as a different sale when the official charts were compiled. Both bands released a CD and a cassette version of their singles, but while Blur released a second CD version of 'Country House', Oasis put 'Roll With It' out on seven-inch, which was more expensive. The headlines, helpfully, continued: 'Working class heroes lead art school trendies,' announced the *Guardian*; 'Blur takes clear lead in battle of the bands,' insisted the *Sunday Times*, asking its readers: 'Which side are you on?'

Blur listened to the top 40 countdown with executives from EMI at Soho House, a new members' club in London's West End. They had beaten Oasis 274,000 units to 216,000. CD sales between the two bands had been similar, but the Oasis vinyl had not sold well. The win was going to give Blur a huge marketing buzz when their new album, *The*

Great Escape, was released a few weeks later, and everyone celebrated, except Coxon. 'I was really trying to hold in my feelings about the situation,' he would later tell Maconie. 'But I drank a lot and spilled wine all over people. I was a bit of an arsehole but the mood was so self-congratulatory. Everyone was telling me that I ought to be happy.'

The party went on into Monday morning, and if revellers ambling down Soho's Old Compton Street late that night had looked up into London's hazy sky, glowing with light pollution, they might have noticed a disturbance in the window of an anonymous Georgian terrace on the corner opposite the Prince Edward Theatre. Graham Coxon was extremely drunk, he had had enough, and he was trying, albeit half-heartedly, to jump out of the window.[49]

Noel did not like losing. He told journalist Miranda Sawyer: 'The bassist and the singer – I hope the pair of them catch fucking AIDS and die because I fucking hate them two.'[50] The AIDS comment was telling. 'Blur are not lads,' Liam later declared. 'Pearl Jam are not lads … Suede are not lads. Are you starting to get the drift now? Frankie Goes to Hollywood were not lads.' Rather than lads, Blur were 'southern puffs'. The homophobic implications were clear.[51]

Gallingly, Oasis's next single, 'Wonderwall', was also beaten to the top spot, this time by yet another insipid cover from Robson & Jerome. Despite losing the battle for number one, and despite the mixed reviews for their LP, *(What's The Story) Morning Glory?*, Oasis were still cool, not least because they were tough. Noel and Liam fought

constantly. One brother would square off to the other, or to someone else, and attention in the press was guaranteed.

Blur's fame and glory did not suddenly disappear, but they felt they were falling and they did not know where they would land. Oasis, remembered Rowntree, 'were really on the up. They were all drugs and fighting and spitting and we were these old men.'[52] Britpop was soon declared to have died at the end of 1995,[53] but it had not disappeared. Rather, it was now so huge that is was no longer cutting edge.[54] It had stopped being a trend and was no longer entering the mainstream; it was the mainstream itself.

Noel had first met Tony Blair in November 1994. The leader of the opposition had been invited to the Q Awards by his old friend Mark Ellen, the magazine's founding editor. Ellen had been in a band with Blair when they were at Oxford, a short-lived outfit called Ugly Rumours, and he had once gone out with Anji Hunter, Blair's director of government relations and the aide generally known as the Labour leader's gatekeeper.

Blair made an awkward speech at the awards in which he emphasized the importance of rock'n'roll, and afterwards Ellen walked the Labour leader up the stairs to the exit of the Park Lane Hotel. The moment provides one of the highlights of John Harris's account of Britpop and New Labour.[55] 'I was just trying to get him out of the crowd, without him getting too bothered by people,' recalled Ellen. 'It had gone so well: he'd made a great speech, he'd met lots of people, he'd had a fantastic time – couldn't stop saying what a great

time he was having – so as far as I was concerned, we had ninety-nine per cent concluded a very successful day.'

And at that point, they bumped into Noel Gallagher. 'We'd just come out of the shithouse, having hoovered up a few quid's worth,' remembered Oasis's tour manager Ian Robertson. 'And there he was.' It was Tony Blair. Ellen remembered that moment well. 'Charging down the stairs came Noel Gallagher. The imagination ran riot: he looked a little … accelerated. He said something like "Fuckin' hell! Fuckin' do it for us, man!" He put his arm around him, and he clapped him on the chest: "Fuckin' do it for us, man!" Tony went "Oh right. OK." And then he said to me "Noel Gallagher!" And I said *"Noel Gallagher!"'*

Discovering that someone like Gallagher might have a positive view of him and his project was an extraordinary boost for Blair, as was the hope that the rock star might be willing to express those feelings publicly. Noel was an entrepreneur, of sorts, an image of individual aspiration and a sign of meritocracy, but he was also everything Blair was not. The Labour leader's slick presentation, his past as a lawyer, his accent – which was markedly posh despite the occasional forays of its vowel sounds down the Thames Estuary – these were helpful to him in some ways, but they did not endear him to the Labour heartlands. The New Labour leadership seemed to conceive of the British working class as instinctively conservative, aggressively nationalistic and dangerously resentful of their rulers in Westminster. Becoming identified with a working-class hero, someone like the Oasis songwriter, would be a public relations dream.

The dream was fulfilled at the 1996 Brit Awards. 'There are seven people in this room who are giving a little bit of hope to young people in this country,' Noel drawled into the mic while swaying slightly. He was on stage collecting an award. 'That is me, our kid, Bonehead, Guigs, Alan White, Alan McGee' – that was the band's five members, plus their label boss – 'and Tony Blair. And if you've all got anything about you, you'll go up there and you'll shake Tony Blair's hand, man. He's the man! Power to the people!' Just as lad culture made masculinity and nationalism seem subversive, Oasis associated Tony Blair with their supposed assault on the establishment. Blair wanted to hail Britpop as part of a broader renaissance in British culture, but such a connection to a senior politician, and a definitively unconfrontational one, did not augur well for rock'n'roll rebellion.

The brothers would always insist that they were the real deal. 'I worked on building sites,' Noel observed, years later, while being interviewed for seminal Britpop documentary *Life Forever*. He was sitting on a tall wing-backed chair in the hall of a country house, decorated with wall hangings and seventeenth-century oil portraits, while describing the difference between himself and the members of Blur. 'That fundamentally makes my soul purer than theirs.'[56]

The Gallaghers' celebrity lifestyles might have seemed to contradict Britpop's supposedly unpretentious and rooted character. However, the brothers were so unembarrassed about the trappings of celebrity – not just old oil paintings and cocaine, but future prime ministers too – that their casual disregard for the views of Britain's moral guardians only

became more obvious. Nowhere was this clearer than in their openness about their coke habits, which they were happy to talk about on Radio One. 'They're actually songs that do touch you,' Noel said of 'The Drugs Don't Work' and 'Bitter Sweet Symphony', two hits by Richard Ashcroft's band The Verve. Noel and his brother were drunk, and halfway through an interview with Steve Lamacq. 'But I will say that drugs do work.' 'It's the truth though,' interjected Liam. 'Either that or he's got a shit drug dealer. I know what he's saying, but drugs do bloody work, Richard. He knows the score. The last time I bloody met him I chopped him out one.'[57] Noel joked that he and his brother might just have made themselves ineligible for foreign visas. 'For anybody who's listening from the American Embassy, coffee is really good.'

In early 1996, Noel began to consider a new album. Mick Jagger had invited him and his girlfriend Meg Matthews to stay at his home on Mustique, a private island beloved of plutocrats and royalty. The house stood on stilts dug into the white sands of L'Ansecoy Bay, just a few feet from the lapping waves of the Caribbean. Its Japanese-style gazebo overlooked a wide croquet lawn and a long winding pond home to several giant Koi carp. Stoned and drunk on rum punch, Noel would sit in the coral pink billiards room, or on the veranda that looked over the sea.

There he wrote many of the songs that he was shaping into a new album, scheduled for release in 1997. He and Meg were joined by Kate Moss and her boyfriend Johnny Depp.[58] The movie star, who was just about to start filming *Donnie Brasco* with Al Pacino, occasionally jammed with

Noel, and he would eventually record a slide guitar part for one of the songs that Gallagher wrote there, 'Fade In/ Fade Out'.[59] These did not sound like propitious circumstances in which to determine the future of Britpop, but producer Owen Morris flew out to join the party, set up a little studio in a private cabin and discovered that Noel was producing gold. '"My Big Mouth" sounds fuckin' excellent,' Gallagher told *Select*, 'like a cannon going off in your head. There's about four like that, quite Stooges-like … "It's Gettin' Better (Man!!)" is like the big fuckin' party tune, quite camp as well. Our Liam with his fuckin' hand on his hips!' Morris would conclude, of those sessions: 'They do sound amazing … far better that the actual album.'[60]

Before that LP could be recorded, Oasis got even bigger. In August they played two legendary gigs in the grounds of Knebworth House, with crowds of 125,000 each night; 2.6 million applications had been made for tickets. Later that summer, Liam and Patsy were regularly in the tabloids fighting. The *Sun* followed the story particularly assiduously: 'Patsy and Liam in big jet bust up', 'Pregnant Patsy dumps rat Liam', 'Liam's back onside with angry Patsy', 'Patsy's got Liam down at heel – She has tattoo of Oasis lover', 'Patsy's ring cost me an arm, a leg and a head! – Liam tells us of his wedding joy'.[61] When the band went on tour in the USA, the brothers fought so much that the band nearly broke up, and now even the *Times* was interested: 'Oasis lead singer refuses to take off on US tour', 'Oasis brothers find peace an ocean apart', 'Same old tune as the Oasis singer flies out to lead their big reunion'.

Oasis recorded most of their new album at Ridge Farm, West Sussex. The brothers had made up, once more, and 'It was like being the band again,' reported Noel. 'Just sitting up all night talking bullshit and making music.'[62] The Gallaghers and their mates were hoovering up vast quantities of coke, but he insisted they were making headway. 'We were at work. We weren't passed out on the floor with a bottle of Jack Daniel's.'[63] He would later admit, however, that he and his producer had soon become lazy. They had got the album's production wrong, and had never bothered to fix it. His spare and lean demos mutated into dense layers of guitar. 'We were fuelled by youth and cocaine,' he would recall, and this had produced a grandiose and indulgent sound, something very different to the carefully crafted aggression of their previous records. 'Everything was going to be bigger and better.'[64]

Five weeks before the new album was due to be released, pressure was mounting to build marketing momentum. Alan McGee, the boss of Oasis's label Creation Records and a long-term Labour supporter, told Noel that they had been invited to a party hosted by Blair at Downing Street, and insisted they go. Gallagher was initially unwilling, but at the same time curious. He was tempted by the prospect of getting 'to look at the curtains',[65] and a call to his mum also encouraged him. 'It's not every day you are invited to No 10,' Peggy explained. 'So I just told Noel not to be so daft and make sure he went along. He just said, "OK Mum, whatever you say."'[66]

Noel had been right to be wary. In the official photographs released after the party, the working-class hero

is smiling nervously behind his champagne flute while Tony grins, his eyes wide and gleaming, his hands waving expansively. The two stand in the Green Room, which had once served as Sir Robert Walpole's dining room, and which is decorated with heavily gilded stucco and the portraits of eighteenth-century statesmen. Standing with them is Meg, looking much less nervous than either of the men, while Cherie Blair remains close at hand, chatting to another group near by.

Gallagher would later recount to John Harris his conversation with the prime minister about the night of the election. 'We were chatting away, and I said "Oh, it was brilliant, man, because we stayed up till seven o'clock in the morning to see you arrive at the headquarters. How did you manage to stay up all night?" And this is his exact words, he leant over and said: "Probably not by the same means as you did."' Gallagher was impressed.[67]

The optimism and sense of collectivity that had been built through years of Britpop expansion were now moulded into a spectacle, a polite drinks party attended by a clutch of celebrities. Ian McKellen and Vivienne Westwood were among the others who had turned up, but the one who seemed to matter most was the rock star with whose encouragement voters might come to see Tony Blair as a little more macho and authentic.

After joking with Gallagher about his coke habit, the PM left Noel, potentially allowing him to enjoy the party. One source of pleasure, however, was off the cards – Gallagher was followed around by Alastair Campbell, whose job it was

to ensure that the rocker did not misuse the Downing Street toilets. 'I did get followed to the toilets quite a lot. I think they were quite concerned that I was going to ... there were quite a few phone calls going into McGee: "He's not going to misbehave, is he?"'[68]

As McGee had hoped, the wide coverage of the party helped to build hype for the album. The *Sun*, as ever, was on the money: 'No 10 Wonderball', 'Noel goes straight in at No 10', while the *Evening Standard* simply quoted an entire song line: 'All my people, right here right now. D'you know what I mean?' Oasis's publicists were aided in creating this fuss by a change of heart on the part of the music press, for the band's previous album, (*What's The Story) Morning Glory?*, had experienced a similar trajectory to *Modern Life Is Rubbish*. It had been badly treated by reviewers following its release, but nonetheless the band's popularity had risen significantly. Chastened, the critics were now primed to give as warm a response to Oasis's new record as they had given to *Parklife*. Indeed, anticipatory five-star reviews began to appear in the second week of August. Creation were contacting their email database of hundreds of thousands of Oasis fans, which, the label said, they were using to construct 'a very loyal fan base that will go out and buy the records in week one of release'.[69] The forthcoming LP's first single, 'D'You Know What I Mean?', went straight to number one and sold faster than any Spice Girls single ever had.[70] The machine was set to produce huge sales.

On 21 August 1997, the two brothers from Burnage sold more records than there were people in Salford,

Rochdale and Stockport put together. *Be Here Now* was the fastest-selling album in British history and, crucially, it filled the news bulletins and tabloids with pictures of teenagers queuing for a copy, giving it traction in the purview of people who were not Oasis fans.

'It's just something you can tell your grandchildren,' one teenager in an Umbro Manchester City kit explained to a reporter as he sat on the pavement outside a record store. 'The biggest album of all time. I mean, I was there.' Elsewhere that day, a boy with braces queuing with his friends at the Virgin Megastore in London told the news crew that he was less impressed. 'It's just the same old stuff. It's like, you know, guitar rock, dad rock. All the same.'

Indeed, the record would soon be recognized as dull, overwrought and free of the style and flare that had made Oasis challenging, charming and meaningful. The band's previous two albums would both remain in the charts for nearly four and a half years, while their third LP would fall out of the Top 75 in just forty-four weeks.[71] But at that moment in August 1997, everyone wanted to hear it. It was Britpop's swansong.

Outside the world of Oasis, exciting things were happening and, following the lead of Suede's *Dog Man Star*, British rock'n'roll was moving on. Blur's self-titled 1997 album was heavy with depressive intimacy, and low on chirpy observational lyrics and mockney accents. It was soon followed by Radiohead's dystopian *OK Computer* and Spiritualized's *Ladies and Gentlemen We Are Floating*

in Space, which was even more emotionally critical and musically experimental than their previous work. Next came The Verve's mordant *Urban Hymns* and Pulp's fantastically moody *This Is Hardcore*. The Manic Street Preachers bookended this extraordinary period with *Everything Must Go* and *This Is My Truth Tell Me Yours*.

Some of these albums' songs spoke of familiar, quotidian experience, and most of them challenged their listeners' ears, but none provided what Britpop had promised: an accessibly subversive national pop culture. At the time, *Be Here Now* was considerably more successful and visible than the more complex and forward-thinking records of Oasis's rivals and, crucially, it was Oasis who were present throughout the mass media. They filled the tabloid front pages read by millions, rather than simply appearing on the covers of the music magazines read by a select group of teenagers and twenty-somethings. Noel's lyrics were so well known that they were paraphrased, without reference, by newspaper headlines. The vision projected by Britop, that of a mainstream dominated by the interests and experiences of ordinary people, was not going to materialize.

'It's sort of not exciting any more,' Noel Gallagher told Steve Lamacq during that drunken radio interview. 'We are the establishment.'[72] Britpop had been coolest in 1995, but it was in 1997 that Britpop attained the status of a bland, pervasive orthodoxy. The heights of pop culture were not going to become more authentic or relevant to the grass roots in the way that Britpop had promised.

Football, rock'n'roll and the pub, places where working-class communities have sometimes had significant autonomy, have increasingly been appropriated by mainstream culture and regulated by government. The diversity of working-class culture has been ignored and suppressed in the mainstream, which is dominated by snobbish liberal stereotypes of the working class as homogeneously white, macho, nationalistic, racist – even lumpen and dissolute.

Members of this class have been represented primarily as the demi-monde visible in Channel 4's *Benefits Street*, or as the archetypical supporter of the English Defence League, bigoted and clad in sportswear. More recently they have been represented as the 'left-behinds' who, in supposedly ignorant desperation, voted for Ukip and Brexit. At the same time, the glamorization of macho behaviour by the Britpoppers, amongst others, has helped an anti-feminist backlash to build. Men's rights activists attack the women's movement, not least its anti-rape policies and rhetoric, and online trolls have created new methods for threatening women and harassing them.

Britpop's rebellious macho nationalism had not been rebellious, because it had become a game for middle-class fans, an opportunity to play with a few specific conservative elements of working-class culture. Through this, and through a broader culture of laddism and parochial arrogance, British culture would be encouraged in its sexism and xenophobia.

Mainstream culture would increasingly be filled with national signifiers that were as empty as Geri Halliwell's

Union Jack dress, Blair's invocation of 'the People's Princess' and 'new Britain', and the celebrity excesses of Britpop. British culture was abundant with Union Jacks and the labelling as 'Great British' of things – TV shows, music festivals, supermarket advertising campaigns – that were not distinctively British, except in their location. This was understood as an effective branding strategy in the liberal media, the personnel of which identifies itself as considerably more cosmopolitan than its imagined audience. However, the consequences of suffusing our culture with soft nationalism have been far-reaching. Whether or not Brexit will open the UK to a world of trade, as its advocates claim, its supporters were motivated more by the prospect of sealing off the country from the rest of the globe.

Britpop did not cause this, but it was the most significant cultural movement in a wider trend, one that has had a mixed impact. In programmes like *The Great British Bake Off*, national tropes are combined with ethnically diverse casts, anaesthetizing the association of patriotism with the far right and presenting the nation as a multiculture. At the same time, the Union Jack has come to signify a chirpy ordinariness, and the nation is used as a levelling and egalitarian lens through which to perceive society, one that obscures an increasingly unequal and brutal reality. If we are all simply, only or primarily British, the implicit argument goes, then, in the infamous words of David Cameron as he laid out his proposals for an aggressive programme of austerity, one that would hit the living standards of women and the working class hardest, 'we are all in this together'.

In 1996, the England supporters' anthem 'Three Lions' had celebrated the idea that 'football's coming home', but it was not a simplistically triumphant song. Its singers admitted readily 'That England's gonna throw it away', and that past glories were likely to remain in the past. Comedian Frank Skinner, one of the lyricists of the original song, later pointed out to John Harris: 'It's not blindly optimist, because when people get like that you just think, "Oh God, they're just being stupid."'[73]

Like lad culture, patriotism often operated with a wry smile, but that irony covered up a deep ambivalence. Britain was caught between, on the one hand, fatalistically accepting a world where Britannia no longer ruled the waves, one where her industries lay rusted and unused, and, on the other, the need to repeat the mantra of its belief in those faded glories. New Labour's apparatchiks recognized that harking back to something that had never existed could hold the country back, but Blair understood that harnessing nostalgia – memories of a golden age for white working-class masculinity – would win him votes while he pushed through a free market agenda. If he was concerned about how most Britons would feel when that golden age was not recreated, then he did not let it show. Before the 1997 election, he reworked the lyrics of Skinner's song into something more definitively confident, telling his party members: 'Seventeen years of hurt never stopped us dreaming. Labour's coming home.'

7 / SYSTEMIC RISKS

Kirkcaldy overlooks the Firth of Forth, just where it opens into the cold and choppy waters of the North Sea. In the 1950s, this large town's air was full of the strong smell of linseed oil, an ingredient used by the linoleum factory up the hill from St Brycedale's.

The kirk's pastor, the Reverend Dr John Ebenezer Brown, was a clever man with a square, heavy brow. It was a kind face, but a stern one. A grin might have looked incongruous on it. As a Presbyterian minister, he was so fervently opposed to such sinful activities as shopping on the Sabbath that, if his sons wanted to read a Sunday paper, they had to buy it in secret. Generally, though, they lived up to the standards expected of 'sons of the manse' – the middle boy especially. Before he was even a teenager, Gordon was donating to African refugees the proceeds of a gazette that he wrote and printed. It often featured his socialist commentaries on Westminster politics.

After two terms at Edinburgh University, a rugby injury left Gordon lying in a hospital bed for several weeks and partially sighted for the rest of his life. The fear that he would go blind seems to have led to a serious depression, but he nonetheless built a successful academic career, showing great prowess as a political historian and

student leader. By the time Gordon Brown became shadow Chancellor in 1992, he had a life story that his aides could mine for details to drop into chats with any journalist who needed colour for their write-up of Labour's view on the Tories' monetary policy. Brown was messy, he was gloomy and he was not handsome, but an aura was constructed around him, that of a reassuringly dour disciplinarian, someone to be relied on.

Brown was going to make a series of choices that would eventually destroy that reputation. Those decisions, concentrated in the months before and after the 1997 general election, were not irreversible, and they were by no means the only events that determined what followed: a credit crisis, a recession and many years of brutal cuts to the welfare provision that many working-class and lower-middle-class people in the UK depend on. However, that period around the 1997 election would turn out to be the last significant moment when, hypothetically, another route entirely might have been chosen.

Instead, Brown set upon a course that would greatly exacerbate the mistakes made and the damage inflicted by his predecessors in government, the Conservatives. He would not weaken the bias in British politics towards the economic assumptions of neoliberalism, including its advocates' commitment to fiscal austerity and low taxation. He would get the UK into debt without challenging the idea that government debt would necessarily poison the British economy. Most notoriously, he would not merely leave capitalism's centres of power unreformed; he was

going to ensure that they were even less regulated than they previously had been.

He thought he was getting a good deal from the forces of global capital. Financial services in the UK provided enormous tax revenues, and if he allowed Britain's banks to operate relatively unregulated, so that they could take bigger risks, their enlarged profits would help to fund his expansion of welfare and public services while sparing him the pain of making the political case for taxes generally. Meanwhile, such free market policies would give his higher spending political cover from the neoliberal right.

The free market, in turn, received cover from New Labour's limited social democratic reforms. Marxists had long dismissed state provision of welfare as a sop to the working class, a pre-emptive effort to stave off pressure for greater change. Brown was a true believer in the welfare state, but through his policies the neoliberal system itself would come to benefit from welfarism to an even greater degree than it previously had. This was the most abstract, but perhaps the most momentous way in which, over many years but especially in 1997, marginalized ideas and groups compromised too much with those in power, and were thereby exploited.

Brown's vision, as grand and strategic as that of any prime minister, was of a future in which capitalism had been harnessed for the benefit of ordinary people, and in which ordinary people had been bound into supporting capitalism. It was not a future in which outcomes were necessarily much more equal, but it was supposed to be one

where opportunity was distributed more equitably, and one that was excised of extreme poverty.

After the spring of 1997, when Brown was going to roll out the details of his economic plan, few critics would note that his vision reflected the doomed dynamic of New Labour's post-imperial compromise, in that it would please nobody. Its violent borders caused immense hardship and only encouraged anti-migrant feeling, its ethical foreign policy was defective and its multiculturalism was too often flat and superficial. Brown hoped his economic concessions to the right would achieve an ideal equilibrium, but like so many acts of piecemeal and counter-effective reformism that year, his strategy was only delaying an inevitable combustion.

Labour expected a general election in the spring of 1997, and as it slowly neared, its central issue only became clearer. 'If the campaign had one crucial battle, one defining fight, it was over tax,' remembered Philip Gould, Labour's communications director and chief pollster.[1] Labour had a record in government of overspending and then being kicked out of office. Rather than pledge to increase revenues by raising taxes, however, Gould and his fellow free market Labourites wanted to reassure voters by promising to keep taxes low. His friend, shadow Chancellor Gordon Brown, was a keen advocate of this approach, but it was immensely unpopular with most Labour MPs. If their party reinforced the Conservative message that taxation was bad, then a Labour government would not be able to spend enough, either to support the generous welfare state and large public

sector that they believed in, or to stimulate the economy during a downturn, as they believed was sensible.

When the party's leader, John Smith, died suddenly in 1994, Brown had been keen to replace him. However, the shadow Chancellor was already so closely identified with his right-wing tax policies that he had been persuaded that he did not have enough support in the party. The leadership race had been won by his charming young friend Tony Blair, who also believed in low taxes, but who had won plaudits as an aggressive shadow home secretary.

Brown, still shadow Chancellor but now deeply resentful of his new boss, had maintained his low-tax polices. Indeed, he had gone farther, with his aides briefing journalists that he wanted to be known as the 'Iron Chancellor', a sobriquet previously associated with the cynically effective late nineteenth-century statesman and legendary practitioner of realpolitik Otto von Bismarck. At one Labour party meeting, a member described the leadership's strategy back to them. 'I know what you're trying to do,' she said, looking Blair in the eye. 'You're trying to get Tories to vote Labour!'

Gould explained Labour's strategic premise with passion. 'The key target was the aspirational classes – working-class achievers and the middle class under pressure … I came from this class and believe I understand it. It is the pivot around which progressive politics must revolve.'[2] An infamous Conservative Party poster during the 1992 campaign had warned voters of 'Labour's tax bombshell' and Gould was certain that his party had lost the election

because of its high-tax policies. As the next general election neared, Gould would recall, 'I wanted revenge.'[3]

For months before the anticipated election, Labour and the Tories threw accusations of tax hikes, past and future, back and forth at each other. 'The Tories Hit You Where It Hurts',[4] 'Labour's £30 billion Cover-up ... that would cost the average family around £1,200 a year',[5] '22 Tory Tax Rises Since 1992'.[6]

In January, with the national vote certain to take place some time in the next few months, Brown finally cut the problem off at the head. He promised not to expand VAT, that the basic rate of tax would not go up under Labour, and neither – this promise enraged his socialist backbenchers – would the top rate. A few weeks later, Stan Greenberg, a famous US pollster who had come to Britain to help Labour, brought good news: 'Labour has won the tax issue and is making further gains. Labour is now trusted over the Tories on taxes by 11 per cent.'[7] Taking no chances, Brown announced another extraordinary pledge: if they won the election, Labour would maintain the Tories' curbs on the pay of public sector workers, one of Labour's main constituencies, and they would stick to Tory spending limits for their first two years in office.

Brown also vowed to set in law the 'golden rule'. This meant he was promising that during the course of an economic cycle – a period that starts with a boom, continues with slow growth or contraction, and which ends when the next boom begins – the government would pay off its debts, except for those incurred in order to pay for infrastructure

and other investments. Brown hoped to present Labour, and particularly himself, as 'prudent'. It was a word that echoed his roots in the kirk – not hawkish, but paternalistic and cautious. The notion that those in power might be caring, but strict and careful too, filled many voters with great hope.

Months later, John Major was walking down a passageway in the Palace of Westminster, home to the House of Commons. The palace's long, tall corridors are panelled in dark wood, and the floors, carpeted in elaborate patterns that hide the dirt, squeak underfoot. According to Andrew Rawnsley, Major bumped into Jack Straw, and gently challenged his Labour rival. 'Why on earth are you sticking to our spending plans?' he asked him. 'We never would have.' Straw smiled ruefully. 'Yes, but you have more latitude than us.'[8]

Although committed to deregulating markets, keeping most sectors privatized and keeping taxes relatively low, Brown was desperate to expand public spending. Like David Blunkett, he wanted to 'talk tough and act tough *and* liberal'.[9] The shadow Chancellor hoped to achieve marginal centre-left reforms, but he was not going to try to change the rightward trend of economic wisdom. He saw no political space to challenge the prevailing assumption that taxes should be minimal and that markets should be left alone.

The shadow Chancellor had helped form Labour's low-tax strategy but now he feared he was being forced to take it too far, as Robert Peston would later reveal.[10] Gould had pressured Brown to promise that he would not increase

the higher rate of income tax, but the shadow Chancellor knew that if he always did what his pollsters told him to do, he would never be able to raise taxes. Without that option, he knew that his hopes of expanded state spending would remain unrealized and he would not be an Iron Chancellor, but a 'neutered' one. Perhaps it was simply the short-term necessity of winning the election, but something made him go ahead with the plan anyway. A precedent was set.

Five days after Labour won its first landslide, Brown made another move. He had promised to keep taxes low, so he needed a different source of funding for his expansion of public services. A key part of his solution, which he announced in an unusually grand press conference at the Treasury, was a 'revolution at the Bank'.

Brown and his adviser Ed Balls had decided to fund-amentally change how the UK's central bank and financial regulator, the Bank of England, operated, and one key element of those reforms, as the Chancellor explained, was that he was going to hand over his control of interest rates to the Bank. The City was pleasantly surprised by this news, which offered them the prospect of stable inflation; financial journalists were a little shocked, but impressed; and parts of the Labour Party were annoyed by the loss of a political advantage. But when Brown explained the details of his revolution to Eddie George, the rotund, chain-smoking governor of the Bank, George was furious.

That was because Brown had in mind another change, one that he had previously assured George was not yet

confirmed, and which George had, accordingly, assured his staff was not happening. Andrew Rawnsley reported how George was given the bad news in Brown's office at 11 Downing Street.[11] The two men sat either side of the Chancellor's wide mahogany desk, sandwiched between two tall bookcases filled with identical red leather-bound books. George's Bank, Brown informed him, would be stripped of its role as City watchdog, responsible for preventing banks from taking huge risks and going under. The bank would lose about five hundred staff and much of its authority over the financial services industry.

The Governor was furious. He got in the back of his car and told the chauffeur to take him back to Threadneedle Street. He then lit the first of many Rothmans and began to dictate his resignation later, but he quickly changed his mind, and instead he did something extraordinary. He went public. Normally amiable, he was now 'very angry', he told the *Times*.[12] Brown wanted him to resign, but he was going nowhere.

In the 1980s and 1990s, the Bank of England had been blamed for the collapse of several financial institutions. Its many critics argued that inadequate regulation had allowed these banks to take risks that were too great and, accordingly, Brown and Balls now planned to give the Bank's job of supervising the banking industry to a new, separate, body, which would eventually be named the Financial Services Authority.

'We set up the FSA,' Brown would recall years later, 'believing the problem would come from the failure of an individual institution.'[13] If the economy was going to be

threatened, he and most of his peers thought, it would be by single banks that took outlandish risks, like the ones that the Bank of England had previously failed to regulate properly. Even so, the FSA was only supposed to engage in 'light touch' supervision. A later chair of the FSA, Adair Turner, would explain: 'It was not the function of the regulator to cast questions over overall business strategy of the institutions.'[14]

The UK's banks could hypothetically pose a threat to its economy, not only if one large risk-taking bank collapsed on its own, but also if an institution got into trouble and thereby endangered the rest. That could happen because the country's investment banks all lent vast sums to each other and were therefore co-dependent, bound to each other in a web of debt. However, Brown, like so many in the Treasury and in the City, was relatively unconcerned about this 'systemic risk'. He told the Bank of England that it would retain its responsibility for publishing reports identifying such threats, but that it would not get any regulatory powers to deal with the problems it identified.

The kind of regulation that would dampen such risks would also constrain profits, and neither the government nor the Bank nor the City wanted to give attention or status to the job of identifying systemic risk. Brown, having 'neutered' his own tax-raising powers, saw in the banks not only a potential growth sector, but also an easy source of revenue. Rates would not have to be high, for the City's profits were so impressive that it could enjoy a generous tax regime and still provide the large revenues that the

Chancellor hoped to spend on public services. Moreover, a booming financial sector would benefit the rest of the economy. Because the banks would be unfettered, Brown believed, they would become a source of common welfare.

In the 1960s and 1970s, British banks had been forced to keep large reserves of capital tucked away in order to help them weather any financial storms. This was a potentially effective way to prevent a credit crunch, but the regulation enforcing it had been greatly weakened in the 1980s. And Alastair Darling, Labour's chief secretary to the Treasury and now the man in charge of building the new bank regulator, made clear that New Labour believed regulation was still too heavy handed.

Darling was a quiet man, largely unknown outside his party. On meeting him in the 1980s, Neil Kinnock had declared, 'I'm not having that bearded Trot in the Commons,' but since his days in the International Marxist Group, Darling's views had shifted significantly to the right. Often seen sporting a jazzily patterned tie under a big, pointed collar, he had toured the City's boardrooms before the 1997 election, assuring company directors that his party was on their side. He agreed with them that financial institutions could be trusted to regulate themselves because it was in their interests to protect their shareholders by avoiding too much risk. Indeed, this would be New Labour's consistent position for the coming decade, and Gordon Brown was going to steadfastly oppose international efforts to coordinate banking regulation. Capitalism was supposedly being harnessed

to the interests of ordinary people, but it looked like the financiers were calling the shots.

Three weeks after the general election, when Brown had just announced his revolution at the bank, Darling reiterated that there was too much in the way of 'belt and braces' in the regulation of investment banks. 'The amount of supervision you will require for Barclays and for an independent financial adviser in Reading high street is very different.'[15]

The distinction between the two, however, was increasingly blurred. Ordinary customers' cash was being used by investment banks to back their purchases of risky assets, and one such asset, the mortgages of ordinary customers, was being traded in huge volumes by those banks, even though the housing market seemed to be forming a bubble. Using retail customers' deposits as leverage made the banks feel safe to take bigger risks, because they guessed that if their investments turned bad, governments would subsidize their losses rather than let ordinary people lose their cash.

Relaxed regulation of banks' capital ratios was having a similar effect, allowing those institutions to cut their reserves and take on riskier assets. If more of those assets turned into liabilities than the banks expected, the system was supposed to be safe because the risk was spread: each bank was in debt to some of its rivals and lending to others, and the huge bundles of mortgages that had become popular with traders over the last decade were divided and shared between different financial institutions.

Spreading risk across the system like this, rather than allowing it to concentrate in a single place, was generally

sensible, but it was encouraging ever more risky behaviour. Brown, the Bank of England and the City had all become confident about the economy's stability, partly as a result of the 'great moderation', the steady low inflation that many richer economies had enjoyed since the mid-1980s. It was because of this moderation that the Bank of England had been able to keep interest rates much lower than they had been in the 1970s and 1980s, and consequently banks had been able to lend more to each other, and to invest in riskier assets. There were other, more structural factors encouraging borrowing. Since the 1970s, production, jobs and investment had moved with increasing speed from richer countries to emerging economies. Manufacturing and industry in China, the oil-producing countries and other regions had produced capital, and this had been lent back to the richer, but now less productive, economies. It was this cheap credit that had funded the UK and the USA's continued growth.

While New Labour encouraged the banking industry to grow as a proportion of the economy by taking on risky assets, UK household debt would rise from £500 billion in 1997 to £1,300 billion in 2007, the highest, in relation to GDP, of the G7.[16] This happened while other developed economies adopted economic strategies that were less dependent on cheap credit from emerging economies: creating higher-skilled jobs, maintaining the manufacturing sector, and improving productivity levels. If the UK had pursued a strategy that was less dependent on debt, it might have mitigated at least some of the dangers facing its

economy. Households, businesses and governments needed more and more credit to survive, and banks stood at the top of a Byzantine architecture of lending and bets.

In his first statement in the House of Commons after the general election, Brown was in a jolly mood. He started by mocking Ken Clarke, with whom he had earlier that month swapped positions: 'May I first welcome the shadow Chancellor to his new job?' There were laughs from the massed ranks on the Labour back benches. Brown gave a long speech on the benefits of deregulating the banks, and his wider 'revolution', using a phrase with which he would forever be associated: 'It is now the time to get away from the short-termism, the boom and bust.'[17]

'Welcome to Sheffield! The beating heart of Britain's industrial north!' In the summer of 1997, thousands of people in cinemas across Britain giggled and cried through a new, home-grown movie, the opening sequence of which featured clips from a 1971 promotional film for the Yorkshire municipality. In smooth 'received pronunciation' tones, the promo's narrator continued: 'The city's rolling mills, forges and workshops employ some 90,000 men and state-of-the-art machinery to make the world's finest steel.' Slightly grainy footage of men hard at work rolled by and, later, images flicked past of the city's more smartly dressed inhabitants engaging in modern leisure pursuits. The reassuring voice returned: 'They can spend the day lounging by the pool, watching one of our top soccer teams, or browsing in the shops.'

Since the early 1970s, the industrial towns and cities of northern England, of Scotland and of Wales had been so fundamentally decimated that by 1997 simply repeating such optimistic propaganda functioned as a joke. It was an angry joke, but one that anyone could get, and four months after Blair and Brown moved into Downing Street, *The Full Monty* became a surprise global hit. It told the story of former steelworkers trying to make some cash by starting a striptease act: 'this Chippendales malarkey' – as one of the guys puts it – 'a Yorkshire version.'

More people appreciated *The Full Monty* than could relate to the YBAs' work, and the film was more thoughtful and acerbic than what counted as Britpop by 1997. However, just as New Labour treated the globalizing markets that had destroyed Sheffield's industry as an unstoppable juggernaut to be welcomed, the movie presented industrial and social decline as a simple fact of life, as unchangeable as it was true.

In one famous scene, the men stand bored and silent, corralled by a rope barrier in the queue at a JobCentre. They have been practising their routine for a while, and are finally getting the hang of it. Donna Summer's 'Hot Stuff' comes on the radio, playing from some faraway tinny speakers. Clad in an old duffle coat, one of the younger guys from the striptease act smiles and gently sways in time with Giorgio Moroder's instrumentals. In front of him stands a trendier lad in a baggy denim jacket, his hair gelled back. It's his best mate in the striptease act – later in the film, his boyfriend – and he also starts to nod along to the beat. Their fellow amateur strippers farther up the queue cautiously join in,

looking straight ahead, as if nothing were happening, but moving their shoulders in time with the beat. And then, as Donna Summer calls out that she's 'Looking for some hot stuff', they all perform a synchronized double hip thrust. The other people in the queue do their duty as Englishmen, and pretend not to notice.

The friendship and purpose that the striptease plan gives the men makes standing in the dole queue, and life in general, bearable for them. However, this being a story of ordinary people, rather than heroes, it offered its characters and its audiences no prospect of greater change.

The New Labour government was holding back employment regulation, even though Britons now endured some of the worst working conditions in Europe and worked the longest hours. If they were agency workers or were employed by a small firm then they had far weaker union rights and less protection against unfair dismissal than other European workers. The low-wage, precarious work taken on by men and women like those portrayed in *The Full Monty* was making the lives of millions of people in the UK increasingly stressful and constrained.

Brown's attempt to square low taxes with high spending did not succeed. He expanded public service provision, but tax revenues never caught up with his spending, partly because he raised rates, but not enough, and partly because the 2001 global downturn suppressed the Treasury's receipts. Government borrowing had to rise, and Brown justified this on the sensible basis that he needed to stimulate growth, but this did not spur new support in Britain's political culture

for the idea of spending your way out of a recession. The ideological impact of Brown's earlier commitments to fiscal probity would not be undone by his self-interested change of emphasis. He still wanted to be prime minister, and soon. He was doing whatever he could to maintain his reputation for prudence.

The pro-markets culture that Brown had fostered now ensured that most observers poured scorn on his borrowing and the expanded public sector that it funded. One senior figure who took that line, albeit generally in private, was Mervyn King, who had taken over from Eddie George as governor of the Bank of England. Inflation was his key concern. He was proud of his role chairing the Monetary Policy Committee's monthly meeting, which decided interest rates, and he always presented the inflation report that informed its choice to the public. However, he let someone else present the Bank's reports on financial stability and systemic risk. A Financial Stability Committee member would later reveal to the *Financial Times*'s Chris Giles that on a rare occasion that King had bothered to attend the committee, he had fallen asleep.[18]

The general mood of the City in the mid-2000s is apparent in the minutes of a meeting that took place at the Bank of England on 11 July 2007. Non-executive members of the Bank's Court, its board of directors, were being briefed, along with Governor King. They sat in the Court Room, a grand hall, the walls of which were painted a cool mint green and decorated with the gilded stucco portraits of monarchs and ancient deities.

The directors were informed that, as Gordon Brown was about to become prime minister, his successor as Chancellor, Alastair Darling, would be meeting Bank officials that month. Those in attendance discussed various subjects: pensions, and a special open day for the Bank. Halfway through the long meeting, one of the Court's members asked the official whose job it was to assess systemic risks to the financial system about his recent analysis of the system's stability. Had he produced any new observations? Andy Haldane, who would soon become the Bank's chief economist, sat at the ring-shaped mahogany table. He was a tall, slim, confident man, his hair slicked back. Framing the Court's anteroom behind him, there stood a row of slender columns topped by gold acanthus leaves. He explained his new assessment method to the Court. 'It had not identified any looming gaps.'[19]

Before the summer had ended, New York and London were gripped by a credit crisis. It spread from one institution to another across the financial hubs of the world. Systemic risk had bred contagion. Soon many countries' economies had fallen into recession, and in the USA and the UK several banks were bailed out at extraordinary expense to the state. The sums were so vast that in the UK they dwarfed the debts that Brown had accrued over several years of welfare and public sector expansion. There was little appetite amongst Britain's political and media class for a large-scale fiscal stimulus that might have kept the economy going.

Instead, economic hawks claimed that austerity would be good for the UK economy, because inefficiently targeted

state spending would be replaced by more rational private expenditure. They promoted this view almost unopposed, for New Labour's tactical focus on low taxes had not only forced Brown into borrowing too much; it had also set the ideological tone of his administration and Blair's. During that time, Britain's political class had disparaged both the Keynesian argument for state borrowing – it could bolster economic demand – and the social argument for welfare and a strong public sector. Moreover, they had marginalized the individuals and institutions promoting such centre-left ideas. Consequently, when the UK's deficit ballooned, arguments against austerity found few mainstream supporters.

Brown had funded his relatively generous public services with an economic model that had promoted widespread risk-taking, and which had consequently worsened the credit crisis. Now the ideology of that same model had made a social democratic response to the crisis politically impossible.

Austerity would not maintain its position as established political wisdom for ever. Countries that were less concerned with quickly cutting their deficits, like Germany and the USA, grew faster than countries that cut harder, like the UK, Ireland, Spain and Portugal. Significantly, the IMF later confirmed that this pattern had not appeared simply because economies instituting austerity measures were also those that had already been performing poorly. The Fund demonstrated that countries with severe austerity programmes had not only underperformed compared to those with looser fiscal policies, they had also generally done

worse than IMF economists had predicted, while those that had cut less had generally exceeded expectations.[20]

The idea that cuts could encourage growth would become less and less convincing, and the other justification for cuts – credit markets potentially losing faith in Britain – would turn out to have been exaggerated. No industrialized country, except Greece, found that interest rates on its debt rose significantly, despite these countries having instituted a variety of fiscal policies.[21]

This evidence would emerge too late for the millions of people in Britain who depended on those parts of the welfare state that were cut. The new prime minister, David Cameron, and his Chancellor, George Osborne, would take on the job of shrinking the state with alacrity. They would succeed in cutting only as much as Darling himself had promised to cut but, as the Labour Chancellor had said of his own plans, this was 'deeper and tougher' than anything Margaret Thatcher had ever achieved.[22]

CONCLUSION: CRISIS

Recession and austerity had an appalling impact, and from all corners of society resentment built into a roar of anger. A series of radical groups stalked Britain's elite and entered its public sphere; each understood that they were competing to take advantage of a great crisis of legitimacy.

First came the English Defence League, a network of violent Islamophobic groups based on football hooligan firms. In the autumn of 2010 they became popular in many of the towns and cities where deindustrialization had prompted mass unemployment and the breakdown of communities. The League was only the first manifestation of a tide of protest and of demands for change. Leftist movements that for years had struggled to gain support now held rallies that attracted hundreds of thousands of people, and in November 2010 student protesters rioted and fought with police.

Demonstrations by UK Uncut and other anti-austerity groups continued into the next year as trenchant opposition to free markets and to elements of the state became mainstream. In the middle of a summer of protest, however, Catherine Middleton and Prince William celebrated their nuptials. Security for the wedding cost £20 million, but criticism was minimal. Many of those who did attempt to protest peacefully near the wedding were roughly treated

by the police, and their cases received little attention. The royal family's privileged position seemed to bother only a minority of Britons, for the Windsors were shielded by the failure of Blair's attempt to modernize the monarchy. The crisis of legitimacy extended only so far.

A few weeks after the ceremony at Westminster Abbey, somewhere between 10,000 and 15,000 people joined five days of rioting and looting across several of the cities and towns of England.[1] In Birmingham three bystanders were tragically killed by a car, but the violence was otherwise almost exclusively directed towards the police. As with the anti-austerity riots and EDL members fighting with the cops, these riots reflected an enormous degree of hostility towards the establishment. Such anger was especially strong among the black, mixed-race and Asian people who made up a majority of those involved in the English riots. Macpherson, multiculturalism, a more generous welfare state and public sector: none of these had lived up to their promises.

That winter, pollsters recorded rising support for the small, hard-right and anti-EU United Kingdom Independence Party. Demands for change, evidently, were being expressed not just on the streets but also via the ballot box, and electoral conditions were ideal for a party like Ukip, which cast itself as underdog, jester and rebel combined. Ukip's voters were mostly lower-middle-class,[2] and if they had not yet been squeezed hard by the recession and by austerity, then they could expect to be so soon.

They were angry with a state dominated by distant liberals who cared, it was variously said, too much about

outsiders, or not enough about UK-born British citizens, or not enough about the white British ethnic majority. The UK's elites were haemorrhaging legitimacy, but some among them – most prominently Ukip's charismatic leader, Nigel Farage, privately educated and a former broker and trader in the City – managed to insulate themselves from popular resentment by presenting themselves as rebels.

The real radicals – the progressive ideas and marginalized groups whose awkward alliances with Britain's rich and powerful have been the subject of this book – now found themselves assailed from two sides.

On the one hand, recession and austerity were hitting them hardest, for New Labour's promises of a fairer future had not been realized, and minority ethnic communities, women, migrants and the working class as a whole were experiencing sharp falls in living standards. On the other hand, because these groups had been associated with New Labour's plans for a new Britain, they were now resented as if they were part of the establishment. This association of oppressed groups with the 'political correctness' of the liberal elite was a long-standing element of right-wing rhetoric, but in a climate of resentment and anger, it gained currency. Because anti-racism and multiculturalism had been so effectively appropriated by mainstream politics and culture, Ukip's dual attack against the politicians who directed globalization and those who struggled to survive within it made sense to many in the UK.

The New Labour contract had been sealed with the promise that liberalism would work for everyone, but such assurances

had been undermined by years of economic and political crisis. Tony Blair's predictions in 1997 about where Britain and the world were headed had not come true.

Now, he was watching his legacy unravel. It was September 2014. Tall and grey, the former prime minister was sat on stage in Kiev in a sleek white armchair, the high wall behind him decorated with an image of Europe composed of ice-blue 3D geometric shapes. He was at a conference to promote the Europeanization of Ukraine and the marketization of its economy, a project that had dramatically stalled in the last six months. Ukraine's Crimean peninsula had been annexed by Russia, and there had been unrest in the Russian-speaking east of the country, a coal-mining area called Donbass.

Events in Ukraine may have seemed irrelevant to political upheaval in the UK, but both were part of a wider pattern across the globe, the collapse of liberal political and economic assumptions and many of the governments most committed to them. Blair understood that developments in Britain were influenced by, and feeding into, that worldwide process, and he was in Kiev to encourage anti-Russian liberals with their work, but he was also going to deliver another, parallel, message. Three thousand kilometres north-west of Donbass, another relatively impoverished industrial region was on the verge of seceding from one country, with the intention of being absorbed into a much larger polity. In five days' time, Scotland would vote on whether or not to leave the UK, and the plan of the Scottish Nationalists, who controlled the Edinburgh parliament

created by Blair's devolution referendum, was to be 'independent, within Europe'.

New Labour was supposed to have prevented this kind of disruption in 1997 by infusing the nation-state with moderated versions of hard left ideas: devolving power from the centre of the Union, making foreign policy internationalist, acknowledging multicultural diversity and funding an enlarged welfare state. Thus building a freer, fairer and more equal future involved complex compromises. The Lawrence campaign had cooperated, albeit uneasily, with the *Mail* and New Labour. The Windsors had been modernized into celebrities. Girl power had made feminism unthreatening. Britpop had offered a top-down mass culture that reflected grassroots experiences. The YBAs had used the strategies of advertising to articulate challenging ideas.

Onstage in Kiev, Blair's interlocutor asked him: What would his preferred outcome in the Scottish referendum be? 'I hope' – he swallowed and rocked gently backwards, his eyebrows jumping up in a look of alarm – 'that Scotland votes to stay part of the United Kingdom. Um, and, for all the reasons given by all the main party leaders in the UK, in the twenty-first century, to, to rip up the alliance between our countries would not be sensible, politically, economically or even emotionally.'[3]

'Sensible'. Blair remained convinced that he knew the truth and, perhaps as a result of this certainty, the former prime minister was choosing to highlight exactly those reasons for unity that most repelled many Scots. They, no

less than others in the UK, sought to punish elements of the establishment and to remove themselves from their control. The nationalists were going to lose the vote a few days later, but that would seem only to strengthen the SNP and their plans for independence.

Blair had won power in less obviously troubled times with his vision of a society that would be reconstructed by benign elites, people who listened to marginalized groups without giving them power. This idea of what Britain could be had never accommodated resentment, and as Britain's political culture had become more outraged, the image of the future projected by the events of 1997 had lost all its persuasive power.

Blair's devolution project was supposed to have headed off Scottish independence, but instead he seemed to have improved its prospects. The legacy of 1997 was filled with failures and counter-effects like this, the result of sabotage and accident. The *Mail* had used the Stephen Lawrence story to advance its reactionary agenda, and the Macpherson report had made few dents in police racism. The welfare state had acted as cover for New Labour's dangerous deregulation, and the party's broadly liberal branding had seemed to excuse both anti-migrant policies and, after 9/11, the authoritarian surveillance of Muslim communities. Blair and Campbell had channelled a whirling mixture of public feelings about Diana into their political project, and their supposed modernization of royalty had allowed the Windsors to regain some distance from the rest of society. Girl power had been an advertising ploy, and

the Spice Girls' feminism-lite had often encouraged girls to conform to society's sexist and individualistic demands. The Britpop years had climaxed when its bands were most laddish, and its music was most unchallenging. Avant-garde art had reached the front pages while becoming an investment opportunity.

The strengthening of the independence movement in 2014 was not the last crack to emerge in liberal dreams for a new Britain. Two years after the Scottish referendum, Tony Blair again found himself defending another key element of New Labour's liberal programme from populist revolt.

This time, he was in front of an audience of teenage schoolchildren. Standing at his lectern, he paused and looked around the wood-panelled Victorian lecture theatre of Ulster University. Beside him was Sir John Major, with whom he had previously visited this country to promote the Northern Ireland peace process. Now they were joining forces to fight Brexit in the city that is known officially as Londonderry, but which is known by nationalists as Derry.[4] The city, like Northern Ireland overall, would vote to remain in the EU, but despite very concrete economic threats to the region if it left, a substantial minority there was going to vote to leave. Once again, extreme dissatisfaction with the status quo was being expressed however it could be.

At a time when a large proportion of the public seemed resentful of elites, of being controlled and talked down to, Blair again sought to dismiss voters' feelings as irrational. If the UK left the EU, he explained to the audience, then the ninety-four-year-old open border between Northern Ireland

and the Republic would be called into question. This could have an appalling impact on community relations and on the local economy. While discussing the border, he described how 'The Leave people say "It will just stay"' – his hands made a flippant shooing-away motion – 'but when you go into the detail you realize how difficult, if not impossible that is.' He winced a little. 'It would make a nonsense of their entire argument for leaving, which is all to do with the—' He paused. He seemed almost lost, and made an empty circle shape with his hands. 'With the free movement of people within the European Union.' Later, he looked out, far beyond the half-dozen rows of children in their uniforms. 'I believe' – he was now describing the rectitude of a 'Remain' vote, but something slightly caught in his throat, he blinked and looked downwards, seeming almost moved – 'it's right and sensible.' That word again: 'sensible'.

The previous year he had made a corresponding point to an audience of Labour supporters. 'I honestly don't believe you will get any of those Ukip votes back by playing their game on immigration.' Some in the party were advocating a triangulation of anti-migrant feeling, which was what Blair had attempted when he had been in power. Now, however, he discouraged the use of that tactic: it would not bring voters back. 'I really don't think that will happen. Because the truth is the answer to some guy who's unemployed in one of the seaside resorts in the UK, the answer to his problem is not stopping Polish people coming to this country.'[5]

The collapse of Blairism began to reach its climax in the Brexit vote and in the rise of anti-migrant politics, but

New Labour had enabled this surge in right-wing populism. The party had always defended its right flank carefully, but this had only encouraged violence and antipathy towards migrants and Muslims.

The marginalized ideas and groups of 1997 had benefited little from the compromises that they had made with the mainstream but, as a result of those compromises, those on the margins were perceived as being allied to the liberal establishment, and this was used as an excuse to attack them. Welfare spending was blamed for the UK government's indebtedness, and it was cut viciously, despite the state's enormous debts having mostly been accrued by bailing out the banks and as a result of the global downturn. Anti-racism and any support for migrants were dismissed as 'political correctness'. Republican criticism of monarchy was similarly rejected. All avant-garde art, even work that was made relatively far from the influence of the rich and powerful, appeared not just alien, but elitist. 'Feminism-lite' seemed so pervasive that men's rights activists used it to justify unleashing sadistic attacks against women in public life. And, conversely, in the hands of middle-class men, lad culture and chauvinistic football nationalism appeared rebellious or ironic.

Between the Scottish and Brexit referendums, another vote had taken place. Because Labour had lost the 2015 election, a leadership competition was organized, and a surprising front-runner emerged. Jeremy Corbyn was a veteran backbencher who advocated traditional left-wing policies, including a more internationalist foreign strategy

and less punitive action against migrants. His supporters were, in large part, members of the hard-left anti-austerity movement that had emerged half a decade earlier.

Seeing another keystone of his legacy beginning to loosen, Tony Blair decided to intervene once more.[6] Again, he was sitting on stage, relaxed, but this time he was in London. Behind him stood a dark purple screen, and repeated many times across it was the logo of the group co-hosting the talk. *Progress*, the emblem announced, *Labour's Progressives*.

Corbyn would be the wrong choice for Labour leader, the former prime minister told his audience, because he was fighting the natural direction of history. 'The way we all live our lives today is, in a sense, more individualistic. It's the reality.'[7] This, Blair explained, was why collective institutions – he seemed to mean the unions, nationalized industries and traditional welfare state with which Corbyn was associated – were outdated and ineffective and that, he indicated, automatically meant that a party advocating for them would lose elections. 'The modern world means that you have to change with it, and if you don't, you get left behind … It's the only way you implement your principles in the real world.' He mused on the subject of Corbyn's move away from New Labour's winning platform. 'That seems, to me, not sensible.'

Corbyn won the leadership vote by a substantial margin, supported especially by Labour members from the north of England and by less affluent members, and he convincingly won a second leadership race the following summer. He lost

a general election the following year, but he was nonetheless widely treated as having triumphed after increasing Labour's share of the national vote by 9.6 percentage points under exceptionally tough political conditions.[8]

Blair's belief in the universality of his historical vision made him confident that he could divine the future and identify the policies that would meet its structural demands. Since the economic crisis, however, the future had looked less like the one dreamed of in 1997. It was less market-oriented and less tolerant, less cosmopolitan and less fair. Hard-left and far-right accounts of the UK's future – where it was headed if it did not change course, and the new directions to which it could feasibly be reoriented – now corresponded more fully with how most voters perceived the world.

Elites absorb marginal ideas, soften them and exploit them. They do so safe in the knowledge that they are employing a strategy that has served their forebears well. However, the stories told in this book show that the dynamic between the centre and the margins is much more complex than that. Sometimes, in trying to exploit subversives, the powerful overreach themselves. The radical people who appear in this book knew the risks that they were taking when they cooperated with those in control, but they did so in the hope of beating elites at their own game. They exploited power, and wielded it to a radical agenda, if only for marginal gains.

The tactics of the establishment can backfire in other, subtler, ways. This book has charted the progress of

subversive ideas that were appropriated for perverse ends, but those ideas have also been taken seriously, not least by those young people who were growing up in 1997. For a decade, now, they have stood on the streets of Britain demanding change. The dream of that year contained both the seed of its own destruction and the possibility of hope.

NOTES

INTRODUCTION

1 'The Oasis diaries – 18 months inside the biggest band in the world', *Q* magazine, September 1997.

1 NEW LABOUR, NEW BRITAIN

1 'Overseas aid – Short's long view', *Guardian*, 21 May 1997.
2 P. Comerford, 'Largest empire down to its last few hundred thousand', *Irish Times*, 28 June 1997, p. 12.
3 'Final farewell to Hong Kong', *The Times*, 1 July 1997, p. 1; 'A last hurrah and an empire closes down', *Guardian*, 1 July 1997, p. 1; A. Marshall, 'End of empire for perfidious Albion', *Independent*, 30 June 1997.
4 'The battle of the century for Chinese and foreign media', *Guangzhou Daily*, 1 July 1997, p. 62, cited by A. Knight and Y. Nakano (1999), 'Preface', in A. Knight and Y. Nakano (eds), *Reporting Hong Kong*, London: Curzon, p. xviii.
5 A. Knight and Y. Nakano (1999), 'Preface', in A. Knight and Y. Nakano (eds), *Reporting Hong Kong*, London: Curzon, p. xvii.
6 'The Patten Girls', *Private Eye*, 11 July 1997, p. 18.
7 A. Campbell (2011), *The Alastair Campbell Diaries*, vol. 2: *Power and the People 1997–1999*, London: Hutchinson, diary entry 30 June 1997, p. 77.
8 Ibid., p. 75.
9 'Hong Kong: the countdown to the handover of Hong Kong continues with parties into the night', ITN news story, 27 June 1997.
10 E. Iritani, 'Locally, many Chinese upbeat on Hong Kong. Despite reservations, nearly half in survey favor colony's return to mainland control', *Los Angeles Times*, 15 June 1997; Associated Press Newswires, 'Poll: most Hong Kong people "neutral" about handover', 30 June 1997.
11 www.nytimes.com/learning/general/onthisday/big/0630.html.
12 A. Campbell (2011), *The Alastair Campbell Diaries*, vol. 2: *Power*

and the People 1997–1999, London: Hutchinson, diary entry 30 June 1997, p. 78.

13 T. Blair (2010), *A Journey*, London: Hutchinson, p. 126.

14 T. Blair, quoted in A. Campbell (2011), *The Alastair Campbell Diaries*, vol. 2: *Power and the People 1997–1999*, London: Hutchinson, diary entry 24 October 1997, p. 189.

15 www.nytimes.com/learning/general/onthisday/big/0630.html.

16 A. Campbell (2011), *The Alastair Campbell Diaries*, vol. 2: *Power and the People 1997–1999*, London: Hutchinson, diary entry 30 June 1997, p. 77.

17 T. Blair (2010), *A Journey*, London: Hutchinson, p. 126.

18 A. Marshall, 'End of empire for perfidious Albion', *Independent*, 30 June 1997.

19 J. Kampfner (1998), *Robin Cook: The Life and Times of Tony Blair's Most Awkward Minister*, London: Phoenix.

20 M. Binyon, 'Cook makes grand entrance for role on the world stage', *The Times*, 13 May 1997.

21 Ibid.

22 B. Thomson, quoted in R. Dinwoodie, 'Leaked document reveals secret "network"', *Herald*, 29 January 1997.

23 R. Dinwoodie, 'Leaked document reveals secret "network"', *Herald*, 29 January 1997.

24 P. Dardanelli, 'Democratic deficit or the Europeanisation of secession? Explaining the devolution referendums in Scotland', *Political Studies*, 53(2), June 2005, pp. 320–42.

25 'Blair makes conference pledges to Scotland', *Inverness Courier*, 11 March 1997, p. 2.

26 'Abattoir standards report: cabinet row', ITN News, 7 March 1997.

27 N. Ascherson, 'Twenty years ago devolution died, now the dream has been resurrected', *Independent on Sunday*, 9 March 1997.

28 See, for instance, 'Devolution in England – me too', *The Economist*, 30 September 1995; R. Hattersley, 'Why the nation state is now out of date', *Guardian*, 4 September 1997; N. Cohen, 'Whitehall or Wakefield?', *Independent on Sunday*, 28 April 1996; Dept of the Environment, 'John Prescott promises a radical approach to the regions', M2 Presswire, 2 June 1997.

29 T. Blair, 'Labour Party: Tony Blair, at the Scottish Labour Conference', ITN, 7 March 1997.

30 N. Ascherson, 'Twenty years ago devolution died, now the dream has been resurrected', *Independent on Sunday*, 9 March 1997.

31 'Day of the long knives', *Herald*, 8 March 1997.

32 R. McCrae, 'Labour Party: Tony Blair, at the Scottish Labour
 Conference', ITN, 7 March 1997.

33 R. McCrae, quoted in 'Day of the long knives', *Herald*, 8 March
 1997.

34 M. Curran, quoted in R. Dinwoodie, 'Day of the long knives',
 Herald, 8 March 1997.

35 R. Dinwoodie, 'Labour Scots declare civil war – purge follows
 U-turn', *Herald*, 14 January 1997.

36 J. Lane (dir.), *Mill Hill Self-Hate Club*, Creation Records, 1996.

37 'Fanclub play for Labour', *Highland News*, 8 March 1997; 'Labour
 intensive party', *Highland News*, 15 March 1997; 'Blair makes
 conference pledges to Scotland', *Inverness Courier*, 11 March 1997,
 p. 2.

38 www.theguardian.com/theguardian/2013/sep/13/scotland-
 devolution-referendum-victory.

39 Ibid.

40 P. Dardanelli, 'Democratic deficit or the Europeanisation of
 secession? Explaining the devolution referendums in Scotland',
 Political Studies, 53(2), June 2005, pp. 320–42.

41 P. Sawer and J. Hartley-Brewer, 'Are Britain's colours beginning to
 flag?', *Evening Standard*, 26 September 1997; WAN Survey, 'British
 split on BA's new look', *World Airline News*, 17 October 1997.

42 www.theguardian.com/politics/1997/oct/01/speeches1.

43 'Conservative Party conference: Lady Thatcher BA livery row', ITN
 News, 9 October 1997.

44 J. Straw (2012) *Last Man Standing*, London: Macmillan.

45 www.theguardian.com/politics/1999/jul/24/labour.jackstraw.

46 S. Pollard (2005) *David Blunkett*, London: Hodder and Stoughton,
 p. 278.

47 D. Blunkett (2006), *The Blunkett Tapes*, London: Bloomsbury,
 p. 453; and D. Blunkett, quoted in R. Hattersley, 'Home truths',
 Guardian, 7 March 2004.

48 'The exodus of Romanies', *Czech News Agency Business News*,
 21 October 1997.

49 D. Jones, 'On the Dover run with the gipsy invasion', *Daily Mail*,
 22 October 1997.

50 'East European asylum seekers given shelter', *Kent Messenger Extra*
 (Dover and Deal edn), 18 July 1997, p. 3.

51 S. Cranshaw, 'Gypsies left to face chilly welcome at the cliffs of
 Dover', *Independent*, 21 October 1997.

52 S. Millar, '"Asylum" distrust is rife in port', *Guardian*, 21 October
 1997.

53 S. Farrell, 'Letters – the "plague" of refugees is growing weekly',
 Dover Express, 16 October 1997.

54 Ibid.

55 G. Prosser, quoted in 'MP calls for clamp down on bogus asylum
 seekers', *Dover Express*, 25 September 1997, p. 12.

56 S. Farrell, 'Letters – the "plague" of refugees is growing weekly',
 Dover Express, 16 October 1997.

57 A. Mannall, 'Letters – "free loaders and spongers"', *Dover Express*,
 16 October 1997.

58 'Nearly 60 Romany Czechs still waiting at Calais ferry terminal', in
 Czech News Agency Business News, 21 October 1997.

59 N. Walter, 'Scandal of child refugees kept in UK jails', *Observer*,
 14 December 1997.

60 A family of two adults and two children would receive £89.49 to
 £128.64 a week in benefits. It appears families were almost always
 accommodated in a single B&B room, but even if individuals had
 each been given single rooms, their hotel costs would be only £280
 a week for an entire family. A single individual's place in a detention
 centre, by contrast, cost £449 a week. 'Too expensive journey', in
 Czech News Agency, 21 October 1997; B. Flynn, '3,000 gypsies
 head for Britain', *Sun*, 20 October 1997; and R. Ford, 'Authorities
 count the cost of providing for refugees', *The Times*, 21 October
 1997.

61 See, for example: Amnesty International, *Irregular Migrants and
 Asylum-Seekers: Alternatives to Immigration Detention*, Index
 number: POL 33/001/2009, 1 April 2009; R. Sampson, G.
 Mitchell and L. Bowring (2011), *There Are Alternatives: A handbook
 for preventing unnecessary immigration detention*, Melbourne:
 International Detention Coalition.

62 L. Back et al., 'New Labour's white heart' (2002), *Political Quarterly*,
 73(4): 445–54.

63 Nova TV documentary, cited by J. Culik, 'TV channel's false promise
 of escape from persecution', *Scotsman*, 20 October 1997.

64 C. Bremner, '"Tourists" who take the bus to a new life', *The Times*,
 21 October 1997; 'Romany asylum seeking in Canada, Britain',
 Czech News Agency Business News, 23 October 1997.

65 Nova TV documentary, cited by K. Connolly, 'Sun, seaside and
 singing for TV's Romany exiles', *Guardian*, 21 October 1997;
 A. Lee, 'Star of Czech documentary tells why he sang praises of
 Britain', *The Times*, 23 October 1997.

66 S. Millar, '"Asylum" distrust is rife in port', *Guardian*, 21 October
 1997.

67 D. Kennedy, 'Gypsy family clutches at paper homes', *The Times*, 24 October 1997.

68 Quoted in 'Nearly 60 Romany Czechs still waiting at Calais ferry terminal', *Czech News Agency Business News*, 21 October 1997.

69 K. Connolly, 'We see your tolerant island waiting to embrace us', *Observer*, 26 October 1997.

70 Slovak government spokesperson quoted in R. Boyes and R. Gledhill, 'Romany refugees head for Britain after Canada closes the door', *The Times*, 20 October 1997.

71 'Slovakia cannot stop Romanies' exodus to Britain', *Czech News Agency Business News*, 21 October 1997.

72 L. Jury, 'Further group of Slovak gypsies arrive', *Independent*, 22 October 1997.

73 Quoted in 'Gypsies in England', National Public Radio report by Michael Goldfarb, 20 October 1997.

74 Czech Interior Ministry spokesperson quoted in 'Britain not preparing to introduce visa regulations for Czechs', *Czech News Agency Business News*, 15 October 1997.

75 S. Cranshaw, 'Gypsies left to face chilly welcome at the cliffs of Dover', *Independent*, 21 October 1997.

76 J. Ungoed-Thomas, 'Wish you weren't here: the visitors in shell-suits', *Daily Mail*, 20 October 1997.

77 'Kent asylum crisis was enough to make a press officer reach for his strait jacket', *PR Week*, 7 November 1997.

78 B. Trench, quoted in M. Drohan, 'Gypsy asylum-seekers flood intro Britain', *Globe and Mail*, 21 October 1997.

79 'MP calls for clamp down on bogus asylum seekers', *Dover Express*, 25 September 1997, p. 12.

80 A. Lee, 'Parents protest at influx of Slovak', *The Times*, 21 October 1997.

81 'Asylum seekers', *Dover Express*, 23 October 1997, p. 3; 'County wants asylum seekers' relief money', *Kent Messenger Extra* (Dover and Deal edn), 17 October 1997, p. 7; 'Temporary school may be set up for Slovak children', *Kent Messenger Extra* (Dover and Deal edn), 31 October 1997, p. 5.

82 I. Shepherd, quoted in A. Lee, 'Parents protest at influx of Slovak', *The Times*, 21 October 1997.

83 Quoted in A. Lee, 'Parents protest at influx of Slovak', *The Times*, 21 October 1997.

84 'Government acts on asylum seekers', *Kent Messenger Extra* (Dover and Deal edn), 31 October 1997, p. 1.

85 'Czech and Slovak Gypsies', ITN News, 14 November 1997.

86 'Asylum crackdown relief for Dover', *Lloyd's List International*, 3 November 1997.

87 C. Nelson, 'Letters: Asylum seekers and persecution', *Dover Express*, 13 November 1997.

88 J. Mitchell, '"Grateful" refugee tells of her ordeal at the hands of racists', *Dover Express*, 23 October 1997, p. 6.

89 Ensuring that citizens did not feel that they were in competition with migrants for resources was a common theme of pro-migrant rights groups. See, for instance, 'Dover: asylum seekers', ITN News, 28 October 1997.

90 N. Syson, 'Invasion of Giro Czechs', *Sun*, 21 October 1997.

91 S. McGinty, 'Gypsies flood into Britain in asylum quest', *Sunday Times*, 19 October 1997.

92 'Slovakia cannot stop Romanies' exodus to Britain', *Czech News Agency Business News*, 21 October 1997; 'Nearly 200 Romanies travel to Britain in last few days', *Czech News Agency Business News*, 23 October 1997.

93 ITV's left-leaning *World in Action* told the stories of Roma in eastern Europe who had been attacked by skinheads. An episode of *First Sight* told the Dover story in detail.

94 D. Williams, P. Field and C. Gysin, 'Script for a scam', *Daily Mail*, 24 October 1997.

95 M. Streeter and C. Brown, 'Immigration chiefs fear influx of more gypsy "refugees"', *Independent*, 23 October 1997.

96 N. Syson, '25,000 say kick out the gipsies', *Sun*, 24 October 1997.

97 'Boot out spongers', *News of the World*, 26 October 1997.

98 B. Dineen, 'Labour hypocrisy over asylum seekers', *Yorkshire Post*, 27 October 1997.

99 'Britain toughens up asylum procedures in action against Romanies', *Czech News Agency Business News*, 27 October 1997.

100 'New curb on bogus asylum seekers', *Independent*, 28 October 1997.

101 B. Murphy, 'Straw blitz on gipsy spongers', *Sun*, 28 October 1997.

102 'Government acts on asylum seekers', *Kent Messenger Extra* (Dover and Deal edn), 31 October 1997, p. 1.

103 T. Blair (2010), *A Journey*, London: Hutchinson, pp. 204–5.

104 R. Ford, 'Gypsies fail to find a refuge from race rally', *The Times*, 14 November 1997.

105 'National Front immigration march: violence', ITN News, 15 November 1997.

106 Ibid.

107 K. Sengupta, 'Two hurt as racists march in Dover', *Independent*, 16 November 1997.

108 Ibid.; J. Mitchell, 'Pleas for a ban on NF asylum march', *Dover Express*, 13 November 1997, p. 3; S. Nardone, 'When racialism marched through the streets of a town that has known too much confrontation', *Dover Express*, 20 November 1997, pp. 2–3.

109 I. Jack, 'Blair urges moral vision for ex-colonial club', *Guardian*, 25 October 1997.

110 J. Penman and S. O'Shea, 'A dream start to summit', *Scotsman*, 25 October 1997.

111 W. Russell, 'New broom warns "elites"', *Herald*, 25 October 1997.

112 L. Donegan, 'Echoes of Empire fade', *Guardian*, 25 October 1997.

113 T. Blair, quoted in *Time*, 27 October 1997.

114 S. Bhatia, 'Scots fury as tartan banned from summit', *Observer*, 26 October 1997.

115 A. Kundnani, 'The death of multiculturalism', *Race & Class*, 43(3): 68.

116 Ibid.

117 'Portrait of the week', *Spectator*, 1 November 1997.

118 www.migrationobservatory.ox.ac.uk/resources/briefings/uk-public-opinion-toward-immigration-overall-attitudes-and-level-of-concern/#kp2.

119 Julius M., quoted in 'Romanies returning from Britain refuse to face journalists', from *Czech News Agency Business News*, 21 October 1997.

2 MURDERERS

1 B. Hagerty, 'Paul Dacre: the zeal thing', *British Journalism Review*, 13(3): 11–22.

2 Staff reporter, 'He was only a Black boy – why bother?', *The Voice*, 17 February 1997, p. 3.

3 B. Cathcart (1999), *The Case of Stephen Lawrence*, London: Viking, p. 189.

4 www.theguardian.com/healthcare-network/2014/oct/28/tackle-mental-health-inequality-black-people.

5 www.independent.co.uk/news/lawrence-lawyers-took-wrong-route-1076869.html, accessed 5 December 2014.

6 B. Cathcart (1999), *The Case of Stephen Lawrence*, London: Viking; 'Stephen's mother: I saw police screw up piece of paper with guilty names', *Evening Standard*, 25 March 1998; D. Mackay, 'Nick Pryer; I gave police a list of Stephen suspects. They screwed it up', *Mirror*, 26 March 1998.

7 'Wall of silence from white youths at Lawrence inquest',
 Independent, 12 February 1997.
8 *Today* programme interview with Mrs Knight, transcribed in
 'Mothers break six year silence to defend suspects in Lawrence case
 interview', *Guardian*, 20 February 1999.
9 'Wall of silence from white youths at Lawrence inquest',
 Independent, 12 February 1997.
10 Staff reporter, 'He was only a Black boy – why bother?', *The Voice*,
 7 February 1997, p. 3.
11 A. Daniels and D. Campbell, 'Unlawfully killed in an unprovoked
 racist attack by five white youths', *Guardian*, 14 February 1997.
12 D. Lawrence with M. Busby (2006), *And Still I Rise*, London: Faber
 and Faber.
13 K. Ture (then known as Stokely Carmichael) and C. V. Hamilton
 (1968), *Black Power: The Politics of Liberation*, London: Jonathan
 Cape, 1968.
14 Lord Scarman (1982), *The Scarman Report: The Brixton disorders
 10–12 April 1981: Report of an inquiry*, Harmondsworth: Penguin,
 1982.
15 www.stop-watch.org/uploads/documents/StopWatch_
 consultation_final.pdf, p. 8, accessed 25 November 2014; see also
 S. Stafford, 'Hot air or a wind of change on race', Observer, 16
 February 1997, p. 25.
16 www.stopsearchlp.org.uk/news/8/15/SSLP-appear-before-the-
 London-Assembly-to-give-evidence.html#sthash.KmkNxoZg.dpuf,
 accessed 25 November 2014.
17 L. Bridges, 'Race, law and the state', Race and Class, 36(1): 61-76
18 A. Sivanandan, 'Race, class and the state: the black experience in
 Britain', *Race and Class*, 17(4): 347–68.
19 C. Gutzmore, 'Capital, "Black youth" and crime', *Race and Class*,
 15(2): 13–30.
20 D. Lawrence with M. Busby (2006), *And Still I Rise*, London: Faber
 and Faber, p. 56.
21 D. Lawrence, cited by B. Cathcart (1999), *The Case of Stephen
 Lawrence*, London: Viking.
22 D. Lawrence with M. Busby (2006), *And Still I Rise*, London: Faber
 and Faber.
23 www.bbc.co.uk/news/uk-26466867; www.bbc.co.uk/news/av/
 uk-26471275/doreen-lawrence-still-wounded-despite-inquiry.
24 'Mandela meets with kin of slain London youth', Wire dispatches
 and staff reports, *Washington Times*, 7 May 1993.
25 www.civitas.org.uk/pdf/cs05.pdf.

26 *Daily Mail*, 15 May 1993.

27 M. Durham, 'Hostile Mail changed tack on Lawrence justice campaign', *Observer*, 16 February 1997.

28 D. Lawrence with M. Busby (2006), *And Still I Rise*, London: Faber and Faber.

29 *Daily Mail*, 14 February 1997.

30 Dacre himself admitted it had been racist previously. B. Hagerty, 'Paul Dacre: the zeal thing', *British Journalism Review*, 13(3): 11–22.

31 J. Ungoed-Thomas and M. Harvey, *Daily Mail*, 14 February 1997, pp. 6–7.

32 Ibid.

33 www.theguardian.com/uk/2012/jan/03/stephen-lawrence-verdict-guilty-murder.

34 news.bbc.co.uk/1/hi/uk/282600.stm.

35 Cited by R. Greenslade, 'Two cheers for journalism', *Guardian*, 24 February 1997.

36 Analysis using ProQuest online tool.

37 *The Stephen Lawrence* Story, Channel 4, 15 February 1997.

38 'Paul Dacre's big Friday', *Independent*, 17 February 1997.

39 J. Bennetto, 'Lawyers want that "Maril" is judge and jury over Lawrence', *Independent*, 15 February 1997, p. 5.

40 P. Younge, 'The sound of silence', *The Voice*, 17 February 1997, p. 9.

41 'Editorial: The true meaning of contempt', *Daily Mail*, 16 February 1997, p. 8.

42 publications.parliament.uk/pa/cm199697/cmhansrd/vo970113/debtext/70113-24.htm.

43 D. Lawrence with M. Busby (2006), *And Still I Rise,* London: Faber and Faber, 2006.

44 Ibid.

45 D. Garfinkel and M. Brace, 'Howard considers call for Lawrence inquiry', *Independent*, 14 February 1997.

46 J. Straw (2012), *Last Man Standing: Memoirs of a political survivor*, London: Macmillan.

47 D. Lawrence with M. Busby (2006), *And Still I Rise*, London: Faber and Faber.

48 Ibid.; J. Straw (2012), *Last Man Standing: Memoirs of a political survivor*, London: Macmillan.

49 A. Fresco, 'Police "were jeered at and abused" – the Lawrence report', *The Times*, 25 February 1999.

50 'Mothers break six year silence to defend suspects in Lawrence case interview', *Guardian*, 20 February 1999.

51 R. Stone (2013), *Hidden Stories of the Stephen Lawrence Inquiry: Personal Reflections*, Policy Press, p. 43.

52 www.gov.uk/government/uploads/system/uploads/attachment_data/file/277111/4262.pdf.

53 R. Stone (2013), *Hidden Stories of the Stephen Lawrence Inquiry: Personal Reflections*, Policy Press, pp. 64–7.

54 D. Lawrence with M. Busby (2006), *And Still I Rise*, London: Faber and Faber.

55 'Excerpts of racial killing report', Associated Press, 24 February 1999.

56 www.civitas.org.uk/pdf/cs05.pdf.

57 www.gov.uk/government/uploads/system/uploads/attachment_data/file/277111/4262.pdf (46.26).

58 www.gov.uk/government/uploads/system/uploads/attachment_data/file/277111/4262.pdf (6.34).

59 'Stephen Lawrence murder inquiry report made public', ITN, 24 February 1999.

60 J. Straw (2012), *Last Man Standing*, London: Macmillan.

61 J. Morrison, 'Blair says racism must end after report damns police', 24 February 1999.

62 A. Fresco, 'You can't beat it for forceful opinions – and the best gossip', *Times*, 15 January 2010

63 'Tragedies both', Leader, *Police Review*, 106(5510): 4.

64 www.theguardian.com/uk-news/2016/may/21/four-police-forces-no-black-officer-mp-inquiry-cheshire-north-yorkshire-dyfed-powys-durham.

65 www.bbc.co.uk/news/uk-16257377.

66 D. Lawrence with M. Busby (2006), *And Still I Rise*, London: Faber and Faber.

67 Ibid.

68 www.theguardian.com/uk-news/2016/mar/02/stephen-lawrence-former-police-officer-avoids-charges-over-alleged-spying; library.college.police.uk/docs/homeoffice/StephenLawrenceIndiReview/review-volume1.pdf.

69 Home Office figures, cited in 'UK government: race and the criminal justice system – annual statistics published today', Presswire, 9 December 1999.

70 http://www.bbc.co.uk/news/uk-24902389 ; http://www.bbc.co.uk/news/uk-politics-40874448

71 *Police Review*, May 2002.

72 www.opendemocracy.net/opensecurity/deaths-in-british-police-custody-no-convicted-officers-since-1969; www.inquest.org.uk/statistics/deaths-in-police-custody.

73 blog.policy.manchester.ac.uk/featured/2014/08/the-decline-of-
 racial-prejudice-in-britain/; www.britishfuture.org/articles/less-
 racist-anxious/.

74 www.theguardian.com/media/2000/dec/11/advertising.
 broadcasting; ligali.org/pdf/ASA_Delete_Expletives_Dec_2000.
 pdf.

75 www.theguardian.com/theguardian/2012/feb/11/saturday-
 interview-stuart-hall.

76 www.independent.co.uk/news/science/white-people-become-less-
 racist-just-by-moving-to-more-diverse-areas-study-finds-9166506.
 html.

77 Analysis using ProQuest.

78 news.bbc.co.uk/1/hi/in_depth/uk/2002/race/1998159.stm.

79 J. Treadwell et al., 'Shopocalypse now: consumer culture and the
 English riots of 2011', *British Journal of Criminology: Delinquency
 and deviant social behaviour*, 53(1), p. 7.

80 J. Kawalerowicz and M. Biggs, 'Anarchy in the UK: economic
 deprivation, social disorganization, and political grievances in the
 London riot of 2011', *Social Forces*, 94(2): 673–98; and M. Moran
 and D. Waddington (2015), *Riots: An International Comparison*,
 Palgrave Macmillan, p. 12.

81 www.theguardian.com/uk/2011/dec/05/summer-riots-consumerist-
 feast-looters.

82 T. Newburn, R. Diski, K. Cooper, R. Deacon, A. Burch and M.
 Grant, '"The biggest gang"? Police and people in the 2011 England
 riots', *Policing and Society*, 2016, p. 14; T. Newburn, R. Deacon, B.
 Diski, K. Cooper, M. Grant and A. Burch, '"The best three days of
 my life": pleasure, power and alienation in the 2011 riots', *Crime,
 Media, Culture*, 2016.

83 www.theguardian.com/uk/2011/dec/08/were-the-riots-about-race.

84 T. Newburn, 'Reading the Riots', *British Society of Criminology
 Newsletter*, no. 69, Winter 2011, p. 13; T. Newburn, R. Diski, K.
 Cooper, R. Deacon, A. Burch and M. Grant, '"The biggest gang"?
 Police and people in the 2011 England riots', *Policing and Society*,
 2016, p. 12.

85 T. Newburn, R. Diski, K. Cooper, R. Deacon, A. Burch and M.
 Grant, '"The biggest gang"? Police and people in the 2011 England
 riots', *Policing and Society*, 2016, p. 13.

86 Metropolitan Police, cited by J. Kawalerowicz and M. Biggs,
 'Anarchy in the UK: Economic Deprivation, Social Disorganization,
 and Political Grievances in the London Riot of 2011', Social Forces
 (2015) 94 (2), pp. 673-698.

87 trustandjustice.org/resources/intervention/procedural-justice.

88 T. Newburn, R. Deacon, B. Diski, K. Cooper, M. Grant and
 A. Burch, '"The best three days of my life": pleasure, power and
 alienation in the 2011 riots', *Crime, Media, Culture*, 2016, p. 13.

89 www.bbc.co.uk/news/uk-16438933.

3 THE PEOPLE'S PRINCESS

1 P. Hounsfield, in J. Sutherland (dir.), *Diana: The Witnesses in the
 Tunnel*, ITN Factual for Channel 4, 2006.

2 A. Morton (1998), *Diana: Her True Story – in her own words*,
 London: O'Mara, p. 282.

3 R. Kay, 'The Diana I knew', *Daily Mail*, 1 September 1997, pp. 4–5.

4 A. Morton (2004), *Diana: In pursuit of love*, London: Michael
 O'Mara, p. 244.

5 Ibid., p. 244. L. Hussell, 'Diana – the final verdict', *Daily Record*, 4
 September 1999.

6 A. Morton (1992), *Diana: Her True Story – in her own words*,
 London: O'Mara, p. 284.

7 J. Lichfield, 'After Diana: a tragedy yes, a conspiracy never',
 Independent, 25 August 1998.

8 A. Morton (1992), *Diana: Her True Story – in her own words*,
 London: O'Mara, p. 284.

9 G. Collard, quoted in J. Noveck, 'Authorities: Diana's driver was
 drunk, driving at very high speed', Associated Press, 1 September
 1997.

10 L. Hussell, 'Diana – the final verdict', *Daily Record*, 4 September
 1999.

11 A. Morton (2004), *Diana: In pursuit of love*, London: Michael
 O'Mara, p. 245.

12 J. Stevens (2006), *The Operation Paget inquiry report into the
 allegation of conspiracy to murder*, London: Metropolitan Police,
 downloads.bbc.co.uk/news/nol/shared/bsp/hi/pdfs/14_12_06_
 diana_report.pdf, p. 144.

13 M. Gregory, 'Of course there was no "flash before the crash"',
 Spectator, 27 October 2007.

14 C. Dickey and M. Hosenball, 'A needless tragedy', *Newsweek*,
 22 September 1997.

15 N. Allen, 'Drunk Henri Paul taunted paparazzi', *Daily Telegraph*,
 8 April 2008.

16 'Di's last 8 seconds', *Daily Mirror*, 14 January 1998.

17 Lord Stevens (2006), *The Operation Paget inquiry report into the allegation of conspiracy to murder*, London: Metropolitan Police, downloads.bbc.co.uk/news/nol/shared/bsp/hi/pdfs/14_12_06_diana_report.pdf, p. 421.

18 Ibid., pp. 462–3; J. Lichfield, 'After Diana: a tragedy yes, a conspiracy never', *Independent*, 25 August 1998.

19 A. Morton (2004), *Diana: In pursuit of love*, London: Michael O'Mara, p. 245.

20 A. Alderson, '"They should have saved Diana's life"', *Daily Telegraph*, 11 March 2001.

21 www.nbcnews.com/id/5296085/ns/dateline_nbc-books/t/more-secrets-dianas-final-years/#.VWx64FXBzGc.

22 P. Allen and S. Boniface, 'She's alive!', *Sunday Mirror*, 11 November 2007.

23 R. Rat, in J. Sutherland (dir.), *Diana: The Witnesses in the Tunnel*, ITN Factual for Channel 4, 2006.

24 L. Hussell, 'Diana – the final verdict', *Daily Record*, 4 September 1999.

25 P. Allen and S. Boniface, 'She's alive!', *Sunday Mirror*, 11 November 2007.

26 R. Rat, in J. Sutherland (dir.), *Diana: The Witnesses in the Tunnel*, ITN Factual for Channel 4, 2006.

27 D. Ward, 'Diana's haunting last words', *Daily Record*, 26 October 2007.

28 L. Hussell, 'Diana – the final verdict', *Daily Record*, 4 September 1999; P. Allen and S. Boniface, 'She's alive!', *Sunday Mirror*, 11 November 2007.

29 A. Morton (1992), *Diana: Her True Story – in her own words*, London: O'Mara, p. 285; R. Rat, on *NBC News: Nightly News*, 3 September 1997.

30 P. Majendie, 'Doctors at crash scene thought Diana would survive', *Reuters News*, 13 November 2007.

31 L. Hussell, 'Diana – the final verdict', *Daily Record*, 4 September 1999.

32 K. Lennox, in J. Sutherland (dir.), *Diana: The Witnesses in the Tunnel*, ITN Factual for Channel 4, 2006. R. Greenslade, 'Diana inquest is not getting at "the truth"', *Guardian*, 31 October 1997.

33 K. Lennox, in J. Sutherland (dir.), *Diana: The Witnesses in the Tunnel*, ITN Factual for Channel 4, 2006.

34 A. Holden (1988), *Charles*, London: Fontana.

35 B. Campbell (1998), *Diana, Princess of Wales: How Sexual Politics Shook the Monarchy*, London: The Women's Press, p. 98.

36 B. Campbell, 'The man who would be king', Part 2, 13 June 1998.

37 J. Dimbleby, *The Prince of Wales*, London: Little, Brown, p. 381;
 see also: 'They weren't on the right side to wave at me or to touch
 me', Princess Diana, in Martin Bashir's *Panorama* interview with
 the Princess of Wales, BBC One, November 1995, www.bbc.co.uk/
 news/special/politics97/diana/panorama.html.

38 A. Morton (1997), Diana: Her true story – in her own words,
 London: Michael O'Mara, p. 45.

39 B. Campbell (1998), *Diana, Princess of Wales: How Sexual Politics
 Shook the Monarchy*, London: Women's Press, p. 131.

40 C. Walker (dir.), *Reinventing the Royals*, ep. 1, Genie Pictures for the
 BBC, 2015.

41 M. Billig (1992) *Talking of the Royal Family*, London: Routledge, p. 158.

42 J. Whelan, 'The dark side of Diana', *Sydney Morning Herald*,
 31 October 1998.

43 'Diana, Princess of Wales: Death', Official Website of the British
 Monarchy, www.royal.gov.uk/historyofthemonarchy/the%20
 house%20of%20windsor%20from%201952/dianaprincessofwales/
 death.aspx, last accessed 21 April 2015.

44 R. Lacey (2008), *Monarch*, New York, p. 391.

45 R. Lacey (2002), *Royal*, London: Little, Brown, p. 352.

46 J. Sutherland (dir.), *Diana: The Witnesses in the Tunnel*, ITN Factual
 for Channel 4, 2006.

47 G. Thompson, 'Diana: the story of the story', *Independent*,
 1 September 1998.

48 Ibid.

49 M. Wober (2000) *Media and Monarchy*, Huntington, NY: Nova
 Science Publishers, p. 227.

50 A. Morton (2004), *Diana: In pursuit of love*, London: Michael
 O'Mara, p. 251.

51 A. Campbell and R. Stott (eds) (2007), *The Blair Years: Extracts from
 the Alastair Campbell Diaries*, London: Hutchinson, p. 233.

52 *Star*, 1 September 1997, p. 2.

53 *Daily Mail*, 3 September 1997, p. 6.

54 *New York Post*, 1 September 1997, p. 1.

55 By one in the afternoon, 10.4 million Britons were watching the
 rolling news coverage of Diana's death, but that still accounted for
 only one in six of the population.

56 M. Wober (2000), *Media and Monarchy*, Huntington, NY: Nova
 Science Publishers, pp. 154–5; S. Robinson, 'Two weeks that
 reaffirmed our faith in royalty and confounded the critics', *Daily
 Telegraph*, 13 April 2002.

57 M. Wober (2000), *Media and Monarchy*, Huntington, NY: Nova
 Science Publishers, p. 151.
58 T. Blair (2010), *A Journey*, London: Hutchinson.
59 Ibid., p. 144.
60 A. Campbell and R. Stott (eds) (2007), *The Blair Years: Extracts from
 the Alastair Campbell Diaries*, London: Hutchinson, p. 234.
61 Associated Press, 'RAF Northolt: Prince Charles returns with body
 of Princess Diana', 1997.
62 Associated Press, '"People's princess" comes home. Britain grieves
 "English rose"', 1 September 1997.
63 G. Elgood, 'Diana flowers to be removed from palaces', *Reuters
 News*, 11 September 1997.
64 See, for instance, R. Koenig, 'What an American way to behave',
 Evening Standard, 5 September 1997; and I. Jack, 'Those who felt
 differently', *Guardian*, 27 December 1997.
65 R. Turnock, 'Interpreting Diana: television audiences and the death
 of a princess', London: BFI, 2000, p. 55.
66 *Guardian*, 8 September, p. 7.
67 Ibid.
68 R. McKibbin, 'Mass Observation in the Mall', in M. Merck (ed.),
 After Diana: Irreverent Elegies, London: Verso, 1998, pp. 18–19.
69 R. Turnock, 'Interpreting Diana: television audiences and the death
 of a princess', London: BFI, 2000, p. 116.
70 M. Wober (2000), *Media and Monarchy*, Huntington, NY: Nova
 Science Publishers, p. 116.
71 A. Campbell and R. Stott (eds) (2007), *The Blair Years: Extracts from
 the Alastair Campbell Diaries*, London: Hutchinson, pp. 237, 234,
 235.
72 P. Mandelson (2010), *The Third Man: Life at the Heart of New
 Labour*, London: Harper Press, p. 234.
73 L. Halligan, 'Ceremony to reflect affection of the people', *Financial
 Times*, 2 September 1997, p. 10.
74 'People power hits Windsor', *Evening Standard*, 1 September 1997.
75 N. Watt, 'No mention of accident as Princes join church service', *The
 Times*, 1 September 1997.
76 A. Campbell and R. Stott (eds) (2007), *The Blair Years: Extracts from
 the Alastair Campbell Diaries*, London: Hutchinson, p. 238.
77 A. Campbell and R. Stott (eds) (2007), *The Blair Years: Extracts from
 the Alastair Campbell Diaries*, London: Hutchinson, p. 237.
78 A. Holden, *Express*, 3 September, p. 7, cited by M. Wober (2000),
 Media and Monarchy, Huntington, NY: Nova Science Publishers,
 p. 177.

79 C. Walker and P. Tilzey (dirs), *Reinventing the Royals*, ep. 1, Genie Pictures for the BBC, 2015.

80 '100,000 pilgrims turn palace into shine of remembrance', *Scotsman*, 3 September 1997.

81 A. Campbell and R. Stott (eds) (2007), *The Blair Years: Extracts from the Alastair Campbell Diaries*, London: Hutchinson, p. 239.

82 R. Lacey, 'The truth about Diana and the Queen', *Daily Mail*, 28 January 2012.

83 R. Lacey (2002), *Royal*, London: Little, Brown, p. 367.

84 R. Lacey, 'The truth about Diana and the Queen', *Daily Mail*, 28 January 2012.

85 Ibid.

86 A. Campbell and R. Stott (eds) (2007), *The Blair Years: Extracts from the Alastair Campbell Diaries*, London: Hutchinson, p. 240.

87 T. Blair (2010), *A Journey*, London: Hutchinson, p. 147.

88 D. Ljunggren, 'Poll gives support to beleaguered UK royal family', *Reuters News*, 8 September 1997.

89 M. Wober (2000), *Media and Monarchy*, Huntington, NY: Nova Science Publishers, pp. 117–18; 'Opinion poll suggests Prince of Wales should give up his right to be king in favour of Prince William', *The Times*, 7 September 1997.

90 'WHERE IS OUR QUEEN? WHERE IS HER FLAG?', *Sun*, 4 September 1997, p. 1.

91 'YOUR PEOPLE ARE SUFFERING SPEAK TO US MA'AM', *Daily Mirror*, 4 September 1997, p. 1.

92 A. Campbell and R. Stott (eds) (2007), *The Blair Years: Extracts from the Alastair Campbell Diaries*, London: Hutchinson, p. 240.

93 *Sun*, 3 September 1997, p. 8.

94 'SHOW US YOU CARE', *Express*, 4 September 1997, p. 1.

95 A. Campbell and R. Stott (eds) (2007), *The Blair Years: Extracts from the Alastair Campbell Diaries*, London: Hutchinson, p. 241.

96 D. Arbiter and L. Barrett-Lee (2014), *On Duty with the Queen, My Time as a Buckingham Palace Press Secretary*, Dorking: Blink Publishing, p. 196.

97 Ibid., p.196.

98 A. Campbell and R. Stott (eds) (2007), *The Blair Years: Extracts from the Alastair Campbell Diaries*, London: Hutchinson, p. 243.

99 www.royal.gov.uk/HistoryoftheMonarchy/The%20House%20of%20Windsor%20from%201952/DianaPrincessofWales/TheQueensmessage.aspx.

100 'As a lasting memorial, close the firm', *Guardian*, 9 September 1997.

101 A. Campbell and R. Stott (eds) (2007), *The Blair Years: Extracts from the Alastair Campbell Diaries*, London: Hutchinson, p. 243.

102 A. Campbell, in C. Walker (dir.), *Reinventing the Royals*, ep. 1, Genie Pictures for the BBC, 2015.

103 S. Boggan, F. Abrams and J. Moyes, 'MPs back Earl's call to liberate Princes', *Independent*, 8 September 1997.

104 A. Campbell and R. Stott (eds) (2007), *The Blair Years: Extracts from the Alastair Campbell Diaries*, London: Hutchinson, p. 235.

105 R. Turnock, 'Interpreting Diana: television audiences and the death of a princess', London: BFI, 2000, p. 90.

106 S. Bradford (1997), *Elizabeth*, London: Mandarin, p. 457.

107 T. Leonard, 'Royal spin doctor comes clean about Prince Harry exposé', *Daily Telegraph*, 28 October 2003.

108 C. Walker (dir.), *Reinventing the Royals*, ep. 1, Genie Pictures for the BBC, 2015.

109 The press also noted this change: A. Hamilton, 'Thaw in Prince's cold war with press', *The Times*, 6 November 1997.

110 W. Bagehot (1867), *The English Constitution,* Chapman and Hall, p. 63.

111 *Guardian*, 1 September 1997, p. 18, cited by M. Wober (2000), *Media and Monarchy*, Huntington, NY: Nova Science Publishers, p. 176.

112 A. Edwards, 'Journey to a royal wedding', *Sun*, 30 April 2011.

113 V. Murphy and M. Fricker, 'Here comes the pride', *Daily Mirror*, 29 April 2011.

114 C. Walker and P. Tilzey (dirs), *Reinventing the Royals*, ep. 2, Genie Pictures for the BBC, 2015.

115 K. Allen, 'UK workers' wage squeeze is longest since the 1870s', *Guardian*, 16 July 2013. Kings College London/Ipsos Mori Jubilee Debate Poll, London: Ipsos Mori, 2012. M. Easton, 'Why does the UK love the monarchy?', bbc.co.uk/news, 29 May 2012.

116 R. Palmer, 'First family snap', *Daily Express*, 20 August 2013.

117 'Our Prince George is a right royal rascal', *Daily Express*, 20 August 2011; 'Our little rascal', *Daily Mirror*, 20 August 2011

118 'W. Bagehot (1867), *The English Constitution,* Chapman and Hall, p. 86.

4 GIRL POWER

1 'Artyfacts – art news in brief', *Guardian*, 9 August 1996,

2 L. Elliott and S. Ryle, 'Second front – Spice odyssey', *Guardian*, 11 March 1997.

3 T. Brabason and A. Evans, 'I'll never be your woman: the Spice Girls
 and the new flavours of feminism', *Social Alternatives* 17(2), pp.
 39–42 (p. 41).

4 See, for instance, J. Harlow, 'Wannabe like me?', *Sunday Times*,
 27 October 1996; J. Dingwall, 'Watch this spice', *Scottish Daily
 Record*, 23 July 1996.

5 S. Pond, 'Manufactured in Britain. Now selling in America', *New
 York Times*, 16 February 1997.

6 P. Perrone, 'Obituary: Bob Herbert', *Independent*, 13 August 1999;
 R. Yates, 'Inside story – if you wanna be our manager', *Guardian*,
 13 November 1997; C. Blackhurst, 'Five little rich girls', *Independent
 on Sunday*, 18 May 1997.

7 R. Morais and K. Bruce, 'What I wanna, wanna, really wannabe.
 How do you turn a pop act into a brand name? Study what Simon
 Fuller does with his Spice Girls act', *Forbes*, 22 September 1997.

8 *The Fuller Picture: The Simon Fuller Story*, BBC Radio 2, 15 January
 2014.

9 D. Sinclair (2009), Spice Girls Revisited: How The Spice Girls
 Reinvented Pop, Omnibus Press.

10 C. Driscoll, 'Girl culture, revenge and global capitalism: cybergirls,
 riot grrls, spice girls', *Australian Feminist Studies*, 14(29): 173–93.

11 J. Harlow, 'Wannabe like me?', *Sunday Times*, 27 October 1996.

12 R. Morais and K. Bruce, 'What I wanna, wanna, really wannabe.
 How do you turn a pop act into a brand name? Study what Simon
 Fuller does with his Spice Girls act', *Forbes*, 22 September 1997.

13 The Spice Girls (1997), *Girl Power!*, Seacaucus, NJ: Citadel Press.

14 'Nice 'n' Spicy', *Smash Hits*, 11–24 September 1996, p. 22.

15 J. Dingwall, 'Watch this Spice', *Scottish Daily Record*, 23 July 1996.

16 K. Coman and A. Kaloski, 'Spicing up girls' lives', *Trouble and Strife*,
 Winter 1998/99, 38: 2–9 (p. 7).

17 R. Giese, '13 year-old girls rule the world', *Toronto Star*, 14 February
 1998.

18 'The Box's progress improves music TV picture', *Music Business
 International*, 1 December 1996.

19 J. Harlow, 'Wannabe like me?', *Sunday Times*, 27 October 1996;
 'Public demand poised for public demand', *Music Week*, 12 July
 1996.

20 D. Pride, 'British music biz finds appetite for "pure pop"; teen acts in
 the 90s present many faces', *Billboard*, 2 November 1996.

21 Ibid.; D. Sinclair (2004) *Wannabe: How The Spice Girls Reinvented
 Pop*, London: Omnibus.

22 'Club chart commentary', *Music Week*, 12 July 1996.

23 'Radio powers Spice Girls to silver', *Music Week*, 27 July 1996.

24 K. Coman and A. Kaloski, 'Spicing up girls' lives', *Trouble and Strife*, Winter 1998/99, 38: 2–9; another, similar study of Jewish Israeli girls produced similar findings. See D. Lemish, 'Spice Girls talk: a case study in the development of gendered identity', in S. Inness (ed.) (1998), *Millennium Girls: Today's girls around the world*, Lanham, MD: Rowman & Littlefield.

25 K. Coman and A. Kaloski, 'Spicing up girls' lives', *Trouble and Strife*, Winter 1998/99, 38: 2–9 (p. 5).

26 Ibid., p. 8.

27 Ibid., p. 9.

28 'I'm NOT sleeping with Emma Bunton; she wasn't my Baby love says fired boss', *Mirror*, 10 November 1997; see also 'Revealed – secret fortunes of the rock godfathers', *Sunday Times*, 30 November 1997.

29 M. Sawyer, 'We've too much passion to stop', *The People*, 28 December 1997.

30 V. Davidson, 'Spice Boys', *Sunday Mail*, 10 August 1997.

31 L. Mulvey (1989), Visual and Other Pleasures, London: Macmillan

32 J. Davies, '"It's like feminism, but you don't have to burn your bra": Girl Power and the Spice Girls' breakthrough 1997', in A. Blake (ed.) (1999), *Living through Pop*, New York: Routledge, p. 165.

33 'Feminism and empowerment: a critical reading of Foucault author(s): Monique Deveaux', *Feminist Studies*, 20(2); *Women's Agency: Empowerment and the Limits of Resistance*, Summer 1994, pp. 223–47.

34 L. O'Brien (2002), *She Bop II: The Definitive History of Women in Rock, Pop and Soul*, London: Continuum, p. 463.

35 T. Marcus, 'Oh Melanie! The spiciest of the Fab Five uncovered', *I-D*, November 1997.

36 Brown in a radio interview, quoted by T. Brabason and A. Evans, 'I'll never be your woman: the Spice Girls and the new flavours of feminism', *Social Alternatives*, 17(2): 39–42 (p. 41).

37 T. Marcus, 'Oh Melanie! The spiciest of the Fab Five uncovered', *I-D*, November 1997.

38 Ibid.

39 L. O'Brien (2002), *She Bop II: The Definitive History of Women in Rock, Pop and Soul*, London: Continuum, p. 464.

40 *Hotshots!*, Special, p. 14, cited by J. Davies, '"It's like feminism, but you don't have to burn your bra": Girl Power and the Spice Girls' breakthrough 1997', in A. Blake (ed.) (1999), *Living through Pop*, New York: Routledge, p. 167.

41 J. Press, 'Notes on power: the selling of softcore feminism', *Village Voice*, 23 September 1997.

42 A. Coulson, *Sun*, 29 October 1996.

43 'Come-on: Did you know a spice girl?', *Sun*, 30 October and 25 November 1996; see also M. Wright, 'Do You know a Spice Girl's secret? Call me on 0171 293 3950. Don't worry about the cost – I'll phone you back', *Daily Mirror*, 4 September 1996.

44 R. Sayid, 'If you wannabe my cover', *People*, 24 November 1996; S. Hoare, 'She's Geri Halliwell nice', *Sun*, 4 November 1996.

45 news.bbc.co.uk/1/hi/uk/politics/28887.stm.

46 Ibid.

47 *Q* magazine interview, December 2000.

48 M. Sawyer, 'We've too much passion to stop', *People*, 28 December 1997.

49 J. Atkinson, 'Wanna babies', *Sun*, 26 November 1996.

50 A. Coulson, 'Spice Girls get a Roger in', *Sun*, 17 June 1997.

51 K. Coman and A. Kaloski, 'Spicing up girls' lives', *Trouble and Strife*, Winter 1998/99, 38: 2–9 (p. 5).

52 Ibid., p. 5.

53 D. Lemish, 'Spice Girls talk: a case study in the development of gendered identity', in S. Inness (ed.) (1998), *Millennium Girls: Today's girls around the world*, Lanham, MD: Rowman & Littlefield.

54 'Will Asda deal hit the Spice trade?', *Marketing*, 2 October 1997.

55 archive.spectator.co.uk/article/14th-december-1996/14/spice-girls-back-sceptics-on-europe.

56 L. Elliott and S. Ryle, 'Second front – Spice odyssey', *Guardian*, 11 March 1997.

57 The Spice Girls (1997), *Girl Power!*, Seacaucus, NJ: Citadel Press.

58 K. Coman and A. Kaloski, 'Spicing up girls' lives', *Trouble and Strife*, Winter 1998/99, 38: 2–9 (pp. 5–6).

59 J. Press, 'Notes on power: the selling of softcore feminism', *Village Voice*, 23 September 1997.

60 D. Glaister, 'Spice Girls help set a new record for Britain', *Guardian*, 13 February 1997.

61 'Union cracker', *Sun*, 25 February 1997, p. 1.

62 'The girls were exactly what Channel 5 really, really needed', *PR Week*, 11 April 1997

63 i.dailymail.co.uk/i/pix/2012/08/19/article-2190704-1485C2B7000005DC-281_634x473.jpg.

64 D. Sharrock, 'Union flag dress banned in Ulster', *Guardian*, 31 July 1997.

65 V. Davidson, 'Spice Boys', *Sunday Mail*, 10 August 1997.

66 T. Marcus, 'Oh Melanie! The spiciest of the Fab Five uncovered', *I-D*, November 1997.

67 C. Rae, 'So sorry you've left Geri Halliwell, lots of love, Charles', *Sun*, 14 August 1998.

68 J. Davies, '"It's like feminism, but you don't have to burn your bra": Girl Power and the Spice Girls' breakthrough 1997', in A. Blake (ed.) (1999), *Living through Pop*, New York: Routledge, pp. 163–4.

69 T. Cooper, 'Coming soon, what you really really want', *Evening Standard*, 13 March 1997.

70 V. Davidson, 'Spice Boys', *Sunday Mail*, 10 August 1997.

71 A. Qassim, 'How the band led the brand to expand Pepsi's market share', *Campaign*, 7 November 1997.

72 A. Coulson, 'Spice flavour crisps', *Sun*, 14 June 1997.

73 M. Wright, 'Spice and Lineker banned', *Mirror*, 18 July 1997; 'Gary Lineker commercial', *Marketing*, 24 July 1997.

74 A. Coulson, 'Spice snap up £1m', *Sun*, 28 June 1997.

75 V. Davidson, 'Spice Boys', *Sunday Mail*, 10 August 1997.

76 Ibid.

77 D. Sinclair, 'Mistresses of the universe', *The Times*, 3 November 1997.

78 Icons press release, published as 'The MESSI brand launches the world's first individual card collection', *Press Association National Newswire*, 3 April 2013.

79 C. Barrett and B. Cardew, 'Spice Girls: the power of Brand Spice', *Music Week*, 10 November 2007.

80 A. Coulson, 'Geri Halliwell gave me split hint', *Sun*, 8 November 1997; R. Morais and K. Bruce, 'What I wanna, wanna, really wannabe. How do you turn a pop act into a brand name? Study what Simon Fuller does with his Spice Girls act', *Forbes*, 22 September 1997.

81 P. Brech, 'Youth marketing – dipping into the fountain of youth', *PR Week*, 8 August 1997.

82 N. Munk, 'Girl Power', *Fortune*, 8 December 1997, pp. 133–9.

83 Ibid.

84 J. Van Meter, "All Spice", US Vogue, January 1998.

85 A. Newton, cited by S. Phillips, 'Talent: Spice Girls', *Music Week*, 18 October 1997.

86 'Why adding spice to brands leaves bitter aftertaste', *Marketing*, 4 June 1998.

87 R. Yates, 'Inside story – If you wanna be our manager', *Guardian*, 13 November 1997.

88 G. Di Pietro Nicholl, 'Letter – Added Spice', *Guardian*,
 13 November 1997.
89 P. Conroy, quoted in C. Barrett and B. Cardew, 'Spice Girls: the
 power of Brand Spice', *Music Week*, 10 November 2007.
90 forums.denden.co.uk/viewtopic.php?f=4&t=14213&p=2487170.
91 T. Carey, 'Mark Verghese, 4 Spice Girls tried to seduce me', *Mirror*,
 25 April 1997.
92 Two days later, 'Spice Up Your Life' entered the US charts at
 number 32; 'Floppy Spice', *Sun*, 6 November 1997.
93 M. Sawyer, 'We've too much passion to stop', *People*, 28 December
 1997; R. Yates, 'Inside story – If you wanna be our manager',
 Guardian, 13 November 1997; *Q* magazine interview, December
 2000.
94 J. Todd, 'Spice Girls dump their boss', *Mirror*, 8 November 1997.
95 C. Sutton, M. Bell, N. Pisa and N. Vincent, 'SPITE GIRLS!', *Sunday
 Mirror*, 9 November 1997.
96 'Spice Girls sack man who made them £30m', *The Times*,
 8 November 1997.
97 J. Kierans, 'There is life in Spring yet', *Mirror*, 10 November 1997.
98 J. Todd, 'Spice Girls dump their boss', *Mirror*, 8 November 1997;
 R. Yates, 'Inside story – If you wanna be our manager', *Guardian*,
 13 November 1997; A. Coulson and D. Mohan, 'Spice girls sack
 boss', *Sun*, 8 November 1997.
99 R. Yates, 'Inside story – If you wanna be our manager', *Guardian*,
 13 November 1997.
100 J. Weatheup and C. Reid, 'Spice manager £10m kiss-off', News of
 the World, 9 November 1997
101 www.theguardian.com/culture/2003/jul/27/artsfeatures.
102 R. Yates, 'Inside story – If you wanna be our manager', *Guardian*,
 13 November 1997.
103 www.standard.co.uk/news/spicing-up-for-a-comeback-6950748.
 html; 'I'm NOT sleeping with Emma Bunton; she wasn't my Baby
 love says fired boss', *Mirror*, 10 November 1997;
 'Pick of the year – Highs & Lows – Pop – Music', *Sunday Times*,
 28 December 1997.
104 M. Wright, 'Baby Em in secret date with guru', *Daily Mirror*,
 17 November 1997.
105 *Q* magazine interview, December 2000.
106 R. Yates, 'Inside story – If you wanna be our manager', *Guardian*,
 13 November 1997.
107 B. Campbell, 'The problem with Girl Power', *Guardian*,
 11 November 1997.

108 Q magazine interview, December 2000.
109 groups.google.com/forum/#!topic/alt.fan.Geri Halliwell-Halliwell/
LJQNFTPbCuk.
110 *The Fuller Picture: The Simon Fuller Story*, BBC Radio 2, 15 January
2014.
111 B. Campbell, 'The problem with Girl Power', *Guardian*,
11 November 1997.
112 M. Sawyer, 'We've too much passion to stop', *People*, 28 December
1997.
113 Q magazine interview, December 2000.
114 M. Wright, 'Baby Em in secret date with guru', *Daily Mirror*,
17 November 1997.
115 '1.4m copies in the shops 191,000 copies sold – has the bubble
burst?', *Daily Mirror*, 11 November 1997.
116 D. Sinclair, 'Spice put through the mill', *The Times* (Media
supplement), 21 November 1997.
117 B. Campbell, 'The problem with Girl Power', *Guardian*,
11 November 1997.
118 D. Sinclair, 'Spice put through the mill', *The Times* (Media
supplement), 21 November 1997.
119 'The Spice crisis: girl power starts running out of steam', *Daily Mail*,
15 September 1997.
120 D. Whitworth, 'Sweet taste of success starts turning sour for Spice
Girls', *The Times*, 15 November 1997.
121 M. Wright, 'Which Spice Girl irritates YOU most?', *Daily Mirror*,
12 November 1997.
122 '1.4m copies in the shops 191,000 copies sold – has the bubble
burst?', *Daily Mirror*, 11 November 1997.
123 'Spice Girls record', *Music Week*, 8 November 1997.
124 'Charts analysis: Oasis dig out seventh helping of glory', *Music Week*,
18 October 2008.
125 C. Midgley, 'The bursting of the Britpop bubble', *The Times*,
29 November 1997.
126 'CD blow to Geri Halliwell & Co', *Sun*, 10 November 1997.
127 'James Sterngold at the movies', *New York Times*, 21 November 1997.
128 M. Sawyer, 'They were the Girl Power Rangers', *Observer*,
21 December 1997.
129 C. A. Olson, 'New shows in the works from "Idol" creator',
Reuters,18 May 2008
130 rapecrisis.org.uk/statistics.php.
131 www.theguardian.com/world/2017/mar/09/women-bearing-86-of-
austerity-burden-labour-research-reveals.

132 http://www.gingerbread.org.uk/uploads/media/17/8737.pdf ; http:// wbg.org.uk/news/new-research-shows-poverty-ethnicity-gender-magnify-impact-austerity-bme-women/

133 J. Press, 'Notes on power: the selling of softcore feminism', *Village Voice*, 23 September 1997.

134 L. O'Brien (2002), *She Bop II: The Definitive History of Women in Rock, Pop and Soul*, London: Continuum, p. 464.

5 SENSATIONALISM

1 www.flashartonline.com/app/uploads/2016/03/CS28_0036_ Sensation_OHSH-720x556.jpg.

2 www.independent.co.uk/news/arts-sensation-as-ink-and-egg-are-thrown-at-hindley-portrait-1239892.html.

3 T. Harrison, M. Oliver and E. Wilson, 'I am just so glad I did it', *Mirror*, 19 September 1997.

4 K. Cashell (2008), *Aftershock: The Ethics of Contemporary Transgressive Art*, London and New York: I. B. Tauris.

5 www.theguardian.com/artanddesign/2012/apr/02/damien-hirst-retrospective-tate-modern.

6 Figures for 2000 to 2016: www.artprice.com/artprice-reports/ the-contemporary-art-market-report-2016/contemporary-art-market-2016.

7 V. Engle (dir.), *Britart*, ep. 1, BBC, 8 March 2002.

8 Angus Fairhurst, a piece of whose was bought by Julian Opie; Fiona Rae, one of whose paintings was bought by Richard Salmon; Gary Hume, whose doors were sold to Saatchi. It was Ian Davenport who got a gallerist.

9 N. Rosenthal, in V. Engle (dir.), *Britart*, ep. 1, BBC, 8 March 2002.

10 www.theguardian.com/artanddesign/2002/nov/25/art.artsfeatures.

11 N. Rosenthal, in V. Engle (dir.), *Britart*, ep. 1, BBC, 8 March 2002.

12 www.telegraph.co.uk/culture/art/3554260/Gary-Hume-the-doors-that-unhinged-the-establishment.html.

13 G. Hume, in V. Engle (dir.), *Britart*, ep. 1, BBC, 8 March 2002.

14 G. Norman, 'Style and collecting – how Jasper Johns saw his value cut by half', *Independent*, 16 November 1991.

15 P. Bickers, 'Sense and sensation', *Art Monthly*, no. 211, November 1997, pp. i–6 (p. 4).

16 P. Robinson, 'Saatchi "a big loser" at art sale', *Evening Standard*, 18 November 1991.

17 G. Norman, 'Charles Saatchi "dumps" unwanted art at Sotheby's', *Independent*, 15 November 1991.

18 J. Zeaman, 'Art world in relief contemporary works boost weak
 auctions', *The Record*, 17 November 1991.

19 G. Norman, 'Charles Saatchi "dumps" unwanted art at Sotheby's',
 Independent, 15 November 1991; P. Robinson, 'Saatchi "a big loser"
 at art sale', *Evening Standard*, 18 November 1991.

20 G. Glueck, 'One art dealer who's still a high roller', *New York Times*,
 24 June 1991; J. Zeaman, 'Art world in relief contemporary works
 boost weak auctions', *The Record*, 17 November 1991.

21 L. Gillick and A. Renton (eds) (1989), *Technique Anglaise: Current
 Trends in British Art*, London: Karsten Schubert and Thames and
 Hudson.

22 Freedman and Sellman, in V. Engle (dir.), *Britart*, ep. 1, BBC,
 8 March 2002.

23 Sellman, in ibid.

24 N. Rosenthal, in V. Engle (dir.), *Britart*, ep. 2, BBC, 15 March 2002.

25 C. Freedman, in V. Engle (dir.), *Britart*, ep. 1, BBC, 8 March 2002.

26 D. Hirst, cited in D. Hirst and G. Burn (2001), *On the Way to Work*,
 Faber and Faber, p. 128.

27 D. Hirst, in V. Engle (dir.), *Britart*, ep. 1, BBC, 8 March 2002.

28 Interview with Hirst by David Bowie, in *Modern Painters*, July 1996,
 quoted in D. Lister, 'Death, passion and contradiction, by Bowie and
 Hirst', *Independent*, 14 June 1996.

29 M. Field, 'The cubist: how Jay Jopling created the artist as superstar',
 Evening Standard, 15 October 2009.

30 Ibid.

31 J. Wullschlager, 'Lunch with the FT: Jay Jopling', *Financial Times*,
 2 March 2012.

32 M. Field, 'The cubist: how Jay Jopling created the artist as superstar',
 Evening Standard, 15 October 2009.

33 D. Hirst, in V. Engle (dir.), *Britart*, ep. 2, BBC, 15 March 2002.

34 K. Bush, 'Young British art', *Artforum International*, 1 October
 2004.

35 'Arts: Who's NOT a pretty girl then?', *Liverpool Echo*, 4 November
 2005.

36 This is the case even now. See, for instance, D. Woode, 'It's a
 toss-up', *Sun*, 7 February 2014.

37 Between 1993 and 1996 Rachel Whiteread, Sarah Lucas, Marcus
 Harvey, Gavin Turk, Jenny Saville and Marc Quinn exhibited in
 these shows and are often classed as YBAs; Mark Wallinger and
 Langlands & Bell also featured in the Saatchi Gallery exhibitions
 and are sometimes referred to as YBAs, but their work is very unlike
 that of other artists given the label. The same is true of the more

minor Keith Coventry, Hadrian Pigott, Glenn Brown and Simon Callery, all of whom were featured in *Sensation*.

38 'Modern Medici – patron of pickled cows moves to Piccadilly', Editorial, *The Times*, 28 February 1997. This label was more famously used a few months later by Lisa Jardine in her catalogue essay 'Modern Medicis: art patronage in the twentieth century in Britain', in *Sensation*, pp. 40–48.

39 B. Barnicoat, 'Before they were famous', *Guardian*, 23 June 2015.

40 G. Muir (2009), *Lucky Kunst: The Rise and Fall of Young British Art*, London: Aurum; www.theguardian.com/artanddesign/2013/ aug/12/tracey-emin-sarah-lucas-shop; www.tate.org.uk/art/artworks/emin-lucas-the-last-night-of-the-shop-3-7-93-t07605.

41 M. Field, 'The cubist: how Jay Jopling created the artist as superstar', *Evening Standard*, 15 October 2009.

42 T. Emin, in V. Engle (dir.), *Britart*, ep. 2, BBC, 15 March 2002.

43 R. Parker (1983), *The Subversive Stitch: Embroidery and the Making of the Feminine*, London: Women's Press.

44 B. Barnicoat, 'Before they were famous', *Guardian*, 23 June 2015.

45 S. Boseley, 'Art world rocked by "bloody divorce"', *Guardian*, 5 November 1996.

46 M. Field, 'The cubist: how Jay Jopling created the artist as superstar', *Evening Standard*, 15 October 2009.

47 These took place in: Minneapolis, Houston, Copenhagen, Rome, Wolfsburg, Baden-Baden, Sydney, Johannesburg, Melbourne, Paris, Tokyo and Venice (the Biennale).

48 J. Stallabrass, *High Art Lite: British Art in the 1990s*; see also A. Beckett, 'Shock art to shop art', *Guardian*, 28 August 1997.

49 Cited in T. Ingram, 'Soiled canvas gets bagging', *Australian Financial Review*, 4 November 1993.

50 'Pat on the back', Letter, *The Times*, 21 November 1995.

51 A. Thorncroft, 'Shark investment at the RA – off the wall', *Financial Times*, 1 March 1997.

52 J. Armstrong and P. Byrne, 'Artless – fury at child-fingerprint portrait of monster Myra', *Daily Mirror*, 26 July 1997; A. Thorncroft, 'Shark investment at the RA – off the wall', *Financial Times*, 1 March 1997; F. Owen, 'Behind the scenes at the RA', *Spectator*, 13 December 1997.

53 A. Thorncroft, 'Shark investment at the RA – off the wall', *Financial Times*, 1 March 1997.

54 P. Bickers, 'Sense and sensation', *Art Monthly*, no. 211, November 1997, pp. i–6.

55 www.theguardian.com/artanddesign/2011/jul/10/charles-saatchi-british-art-yba.

56 W. Januszczak, 'Watch these spaces', *Sunday Times*, 22 September 1996.

57 'Britart makes London world culture capital', *Observer*, 20 July 1997.

58 A. Beckett, 'Shock art to shop art', *Guardian*, 28 August 1997.

59 M. Macdonald, 'Wild-child artists look forward to an academic old age', *Independent*, 28 February 1997.

60 D. Lister, 'Stuffy and stifling – why a top woman artist has spurned the RA', *Independent*, 13 June 1997.

61 'The roving brief: the week in … fashion', *Observer*, 2 March 1997.

62 P. Waugh, 'The giant painting of Myra "designed to shock"', *Evening Standard*, 25 July 1997.

63 J. Armstrong and P. Byrne, 'Artless – fury at child-fingerprint portrait of monster Myra', *Daily Mirror*, 26 July 1997; V. Chaudhary, 'Anger at Hindley portrait', *Guardian*, 26 July 1997; 'Hindley portrait causes outrage', *Scotsman*, 26 July 1997.

64 G. Burn, 'The height of the morbid manner', *Guardian*, 6 September 1997.

65 I. Carlisle, 'Why the RA should hang Myra', *The Times*, 18 August 1997; G. Burn, 'The height of the morbid manner', *Guardian*, 6 September 1997; 'Hindley portrait causes outrage', *Scotsman*, 26 July 1997.

66 V. Chaudhary, 'Anger at Hindley portrait', *Guardian*, 26 July 1997.

67 I. Carlisle, 'Why the RA should hang Myra', *The Times*, 18 August 1997.

68 M. Hindley, 'Myra Hindley's portrait plea', Letter, *Guardian*, 31 July 1997.

69 C. Elliot, 'Withdraw portrait of me, urges Hindley', *Guardian*, 31 July 1997.

70 G. Burn, 'The height of the morbid manner', *Guardian*, 6 September 1997.

71 'Shocking? Not us, say artists as academy issues a taste warning', *The Times*, 20 August 1997.

72 E. Barr, 'Diary', *Guardian*, 18 September 1997.

73 D. Glaister, 'Hindley art damage "extensive"', *Guardian*, 20 September 1997.

74 www.dailymail.co.uk/news/article-2190192/Winnie-Johnson-The-mother-refused-search-sons-body.html.

75 A. Garrels, 'London sensation', Report on NPR, 20 September 1997.

76 D. Glaister, 'Hindley art damage "extensive"', *Guardian*,
 20 September 1997; J. Moyes, 'RA's "Sensation" show proves a hit',
 Independent, 27 September 1997.
77 'Portrait charges dropped', *Herald*, 18 October 1997.
78 'Dear Sun', Letter, *Sun*, 22 September 1997.
79 Ibid.
80 yougov.co.uk/news/2016/10/10/it-art-according-general-public-
 probably-not/.
81 J. Jones, '1997 or bust: how Tony Blair and Damien Hirst let us all
 down', *Guardian*, 26 August 2015.
82 'Arts – the new establishment', Introduced by M. Collings, artists'
 biographies compiled by R. de Lisle and A. Auerbach, *Independent
 on Sunday*, 31 August 1997.
83 'We made £2m out of Myra portrait', *Scottish Daily Record*,
 13 February 1998; A. Garrels, 'London sensation', Report on NPR,
 20 September 1997.
84 S. Lucas, in V. Engle (dir.), *Britart*, ep. 3, BBC, 22 March 2002.
85 T. Emin, in ibid.
86 'What are we like?', *Scotsman*, 23 February 2000.
87 M. Bracewell, 'The new rock and roll', *Guardian*, 27 December 1996.
88 V. Thorpe, 'Focus – Masters of the arts – the British aren't coming.
 They've arrived', *Observer*, 13 June 1999.
89 M. Field, 'The cubist: how Jay Jopling created the artist as superstar',
 Evening Standard, 15 October 2009.
90 L. Powell, 'I don't know much about politics …', *Guardian*,
 4 November 1999.
91 V. Engle (dir.), *Britart*, ep. 1, BBC, 8 March 2002.
92 J. Windsor, 'A different class of bond', *Independent*, 25 January
 1997.
93 M. Field, 'The cubist: how Jay Jopling created the artist as superstar',
 Evening Standard, 15 October 2009.
94 www.theguardian.com/artanddesign/2008/jun/01/art.
95 www.damienhirst.com/news/2012/olympics.

6 COCAINE SUPERNOVA

1 Cited in L. Randall (2012), *Noel Gallagher: The biography*, London:
 John Blake, p. 160.
2 S. Maconie (1999), *Blur: 3862 Days: The official history*, London:
 Virgin, p. 118.
3 D. Barnett (2003), *Suede: Love and poison*, London: André Deutsch,
 p. 48.

4 S. Egan (ed.) (2015), *Bowie on Bowie: Interviews and Encounters*, London: Souvenir Press.

5 D. Barnett (2003), *Suede: Love and poison*, London: André Deutsch, p. 11.

6 Ibid., p. 47.

7 Ibid., p. 114

8 Ibid., p. 17.

9 D. Albarn, in T. Sheehan, 'Our culture is under siege', *Melody Maker*, 25 September 1993, p. 28.

10 S. Maconie (1999), *Blur: 3862 Days: The official history*, London: Virgin, pp. 137–8.

11 D. Cavanagh and S. Maconie, 'How did they do that?', *Select*, July/August 1995.

12 J. Harris, 'A shite sports car and a punk reincarnation', *NME*, 10 April 1993.

13 *Select* magazine, April 1993.

14 'Blur: England's dreamers', *Melody Maker*, 25 September 1993, p. 1.

15 P. Mathur, 'Contemporary fault – adjust your mind-set', *Melody Maker*, 15 May 1993.

16 M. Hussey, quoted by M. Bannister, in S. Garfield (1998), *The Nation's Favourite*, London: Faber and Faber, p. 4.

17 L. Forgan, quoted by M. Bannister, in ibid., p. 4.

18 S. Nye, N. Godwin and B. Hollows, 'Twisting the dials: lesbians on British radio', in C. Mitchell (ed.) (2000), *Women and Radio: Airing Differences*, London: Routledge, p. 79; J. Birt, in S. Garfield (1998), *The Nation's Favourite*, London: Faber and Faber, p. 20.

19 M. Bannister, in N. Mirsky (dir.), *BBC Radio One – Blood on the Carpet*, BBC Four, 30 September 2007.

20 J. Whiley, in S. Garfield (1998), *The Nation's Favourite*, London: Faber and Faber, pp. 112, 228.

21 www.bbc.co.uk/news/entertainment-arts-26603822.

22 W. Phillips, 'Ratings – television', *Broadcast*, 21 March 1997.

23 N. Sweeney, in S. Garfield (1998) *The Nation's Favourite*, London: Faber and Faber, p. 239.

24 S. Maconie (1999), *Blur: 3862 Days: The official history*, London: Virgin, p. 156.

25 A. Ross, quoted in S. Maconie, 'How do they do that?', *Select*, July 1995.

26 P. Moody, 'Blur: We can be Eros … just for one day', *NME*, March 1994.

27 Interview in the *NME*, in S. Maconie (1999), *Blur: 3862 Days: The official history*, London: Virgin, p. 174.

28 N. Williamson, 'The Blur years', *The Times*, 11 September 1999.

29 www.nme.com/news/music/suede-152-1378122.

30 S. Frith, 'Radio off', *Village Voice*, 13 June 1995.

31 Ibid.

32 N. Gallagher, quoted in P. Moody, 'Blur: We can be Eros … just for one day', *New Musical Express*, March 1994.

33 A. White, 'Boo Radleys, Supergrass … BBC Radio 1: "Real Love" not sufficiently fab', *Billboard*, 23 March 1996; A. Frean, 'Simply music to his ears – media and marketing', *The Times*, 8 November 1995.

34 Based on analysis using the ProQuest online tool.

35 'I thought I'd been stabbed', *Irish Times*, 3 October 2008.

36 Cited by L. Randall (2012) *Noel Gallagher: The biography*, London: John Blake, p. 93.

37 *Vox* magazine, October 1994.

38 Cited by L. Randall (2012) *Noel Gallagher: The biography*, London: John Blake, p. 102.

39 www.theguardian.com/music/2008/dec/13/people-inspired-pop-songs-muses.

40 S. Maconie (1999), *Blur: 3862 Days: The official history*, London: Virgin, pp. 202–3.

41 *Sun*, 14 August 1995.

42 S. Maconie (1999), *Blur: 3862 Days: The official history*, London: Virgin, p. 205.

43 E. Pilkington, 'Blur leave Oasis in the shade', Guardian, 21 August 1995

44 *Sun*, 14 August 1995.

45 *Sun*, 16 August 1995.

46 S. Maconie (1999), *Blur: 3862 Days: The official history*, London: Virgin, p. 206.

47 R. Gray, 'How Oasis created a publicity supernova', *PR Week*, 21 February 1997.

48 S. Maconie (1999), *Blur: 3862 Days: The official history*, London: Virgin, p. 205.

49 S. Maconie (1999), *Blur: 3862 Days: The official history*, London: Virgin, p. 208.

50 N. Gallagher, quoted by M. Sawyer, *Observer*, 18 September 1995.

51 S. Maconie (1999), *Blur: 3862 Days: The official history*, London: Virgin, p. 204.

52 Ibid., p. 224.

53 Said the *Guardian* at the end of 1996.

54 C. Sullivan, 'Pop – punk folkies in PVC knickers', *Guardian*, 31 December 1996.
55 J. Harris (2003), *The Last Party: Britpop, Blair and the demise of English rock*, London: Fourth Estate, pp. 189-90.
56 J. Dower (dir), Live Forever: The Rise and Fall of Brit Pop, 2003
57 N. Gallagher and L. Gallagher, in 'Oasis FM and blinding', *New Musical Express*, 1 November 1997.
58 L. Randall (2012), *Noel Gallagher: The biography*, London: John Blake, pp. 130–32.
59 Ibid., p. 120.
60 owenmorris.net/oasis/.
61 A. Coulson, 'Liam's back onside with angry Patsy', *Sun*, 13 May 1996, p. 15; A. Coulson, 'Patsy's got Liam down at heel – she has tattoo of Oasis lover', *Sun*, 30 May 1996, p. 19; A. Coulson, 'Patsy's ring cost me an arm, a leg and a head! – Liam tells us of his wedding joy', *Sun*, 1 August 1996, p. 21; A. Coulson, 'Patsy and Liam in big jet bust up', Sun, 18 March 1996; A. Coulson, 'Pregnant Patsy dumps rat Liam; Husband Jim comforts her', Sun, 25 March 1996
62 *NME*, 12 July 1997.
63 C. Klosterman, 'Noel Gallagher after Oasis', *Grantland*, 20 September 2011.
64 M. Odell, 'The SPIN Interview: Noel Gallagher', *Spin*, 1 October 2008.
65 Cited in L. Randall (2012), *Noel Gallagher: The biography*, London: John Blake, p. 160.
66 L. Rock, 'I'm ma'd for it!', *Mirror*, 31 July 1997.
67 J. Harris (2003), *The Last Party: Britpop, Blair and the demise of English rock*, London: Fourth Estate.
68 Ibid., p. 344.
69 'Marketing focus – music to marketers' ears', *Marketing*, 22 May 1997.
70 'Oasis hit is twice as Spice', *Sun*, 11 July 1997.
71 www.officialcharts.com/artist/3993/oasis/.
72 'Join Noel–Liam. Radio One interview with Steve Lamacq', 1997/98, cited by L. Randall (2012), *Noel Gallagher: The biography*, London: John Blake, p. 177.
73 J. Harris (2003) *The Last Party: Britpop, Blair and the demise of English rock*, London: Fourth Estate, p. 302.

7 SYSTEMIC RISKS

1 P. Gould (1998), *The Unfinished Revolution: How the modernisers saved the Labour Party*, London: Little, Brown, p. 278.

2 Ibid., p. 118.

3 Ibid., p. 174.

4 C. Reiss, 'Labour in "feelbad" offensive', *Evening Standard*, 19 March 1996.

5 A. Bevins, 'Fuses blow over Tory tax "bombshell"', *Independent*, 21 November 1996.

6 'Excerpts from speech by UK Labour's Brown', *Reuters News*, 20 January 1997.

7 Greenberg, cited in P. Gould (1998), *The Unfinished Revolution: How the modernisers saved the Labour Party*, London: Little, Brown, p. 285.

8 A. Rawnsley (2000), *Servants of the People: The inside story of New Labour*, London: Hamish Hamilton, p. 38.

9 S. Pollard (2005), *David Blunkett*, London: Hodder and Stoughton, p. 278.

10 R. Peston (2005), *Brown's Britain*, London: Short Books, pp. 253–4.

11 A. Rawnsley (2000), Servants of the People, London: Penguin

12 J. Sherman and R. Miller, 'Brown's treatment of Governor prompts anger in City', Times, 23 May 1997

13 R. Blackden, "Gordon Brown: I made a big mistake on banks", *Daily Telegraph*, 10 Apr 2011

14 "FSA head: Gordon Brown helped fuel banking crisis", *Daily Telegraph*, 26 Feb 2009

15 D. Smith and F. Kane, 'City superman – Business Focus – Interview – Howard Davies', *Sunday Times*, 25 May 1997.

16 D. Smith, 'Debt's a burden, but not for most', *Sunday Times*, 7 January 2007.

17 hansard.millbanksystems.com/commons/1997/may/20/bank-of-england-and-financial-regulation.

18 www.ft.com/cms/s/2/f853d068-94b7-11e1-bb0d-00144feab49a.html.

19 www.bankofengland.co.uk/archive/Documents/archivedocs/codm/20072009/codm2007b.pdf.

20 www.washingtonpost.com/news/wonk/wp/2012/10/12/imf-austerity-is-much-worse-for-the-economy-than-we-thought/?utm_term=.29e55682f24f.

21 www.theguardian.com/business/ng-interactive/2015/apr/29/the-austerity-delusion.

22 Darling concedes cuts could be tougher than 1980s, BBC News, 25 March 2010, http://news.bbc.co.uk/1/hi/8587877.stm

CONCLUSION: CRISIS

1 J. Kawalerowicz and M. Biggs, 'Anarchy in the UK: economic deprivation, social disorganization, and political grievances in the London riot of 2011', *Social Forces*, 94(2): 673–98; and M. Moran and D. Waddington (2015), *Riots: An International Comparison*, Palgrave Macmillan, p. 12.
2 yougov.co.uk/news/2014/02/24/where-ukip-gets-its-support/.
3 yes-ukraine.org/en/photo-and-video/video/drugiy-den-roboti-11-yi-shchorichnoyi-zustrichi-yes/robochiy-obid-toni-bler-u-napryamku-do-primirennya.
4 www.youtube.com/watch?v=p_Rmvds7a2c; www.youtube.com/watch?v=fSZ9is7wnt0.
5 www.youtube.com/watch?v=nvyahh1WEQ8.
6 London; www.youtube.com/watch?v=nvyahh1WEQ8.
7 www.youtube.com/watch?v=nvyahh1WEQ8,
8 A. Travis, "Labour can win majority if it pushes for new general election within two years", Guardian, 11 June 2017

ZED

Zed is a platform for marginalised voices across the globe.

It is the world's largest publishing collective and a world leading example of alternative, non-hierarchical business practice.

It has no CEO, no MD and no bosses and is owned and managed by its workers who are all on equal pay.

It makes its content available in as many languages as possible.

It publishes content critical of oppressive power structures and regimes.

It publishes content that changes its readers' thinking.

It publishes content that other publishers won't and that the establishment finds threatening.

It has been subject to repeated acts of censorship by states and corporations.

It fights all forms of censorship.

It is financially and ideologically independent of any party, corporation, state or individual.

Its books are shared all over the world.

www.zedbooks.net
@ZedBooks